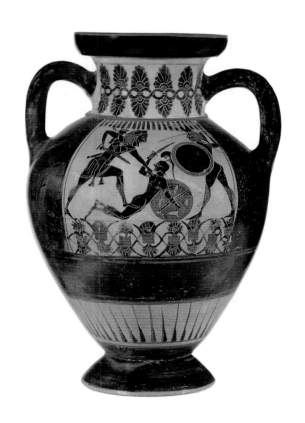

GREEK VASES

IN THE SAN ANTONIO MUSEUM OF ART

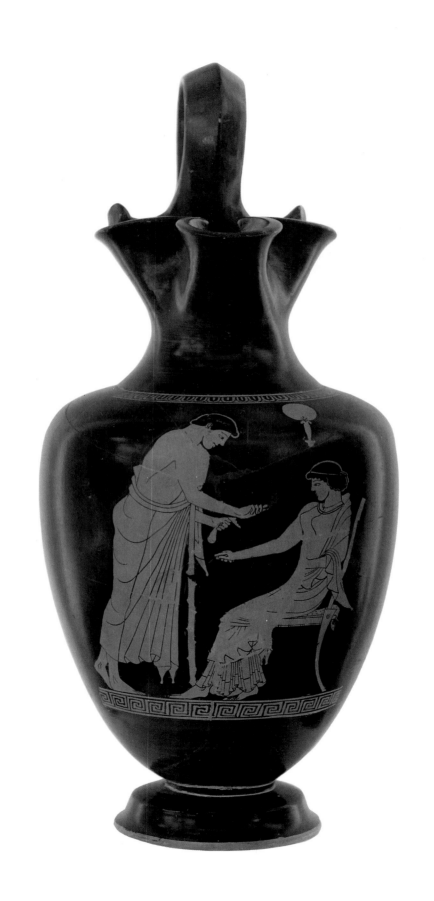

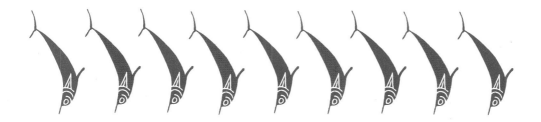

GREEK VASES

IN THE SAN ANTONIO MUSEUM OF ART

Edited by H. ALAN SHAPIRO, CARLOS A. PICÓN and GERRY D. SCOTT, III

With the assistance of DEBRA Z. SCHAFTER

SAN ANTONIO MUSEUM OF ART SAN ANTONIO, TEXAS

Production of the catalogue was
supported by grants from the
National Endowment for the Arts,
a federal agency, and the
Sarah Campbell Blaffer Foundation.

COVER:
Painted detail
Black-Figure Neck-Amphora
Cat. No. 38

HALF TITLE PAGE:
Black-Figure Neck-Amphora
Cat. No. 39

FRONTISPIECE:
Attic Red-Figure Oinochoe
Cat. No. 70

Library of Congress Catalogue Card Number: 95-73323
International Standard Book Number: ISBN 1-883502-04-7
Manufactured in Japan.
Published by the San Antonio Museum of Art
200 West Jones, San Antonio, Texas 78215.

TABLE OF CONTENTS

FOREWORD

With every passing year, the San Antonio Museum of Art's collection of Western Antiquities has grown dramatically and has become better known to specialists and enthusiasts of Egyptian, Greek, and Roman art of the ancient period. Most of the collection has been on display since the 1991 opening of the San Antonio Museum of Art's Ewing Halsell Wing for Ancient Art, when its unveiling was heralded by a scholarly symposium drawing leading authorities from around the world, as well as interested participants from this region. Many of these objects had never before been displayed publicly. The spectacular installation of the Ewing Halsell Wing within the Museum's award-winning restored Lone Star Brewery facility enhances the timeless beauty of these superb works and draws thousands of visitors to the Museum each year.

The San Antonio Museum of Art, which until 1994 remained under the aegis of the San Antonio Museum Association, has acquired ancient coins and other miscellaneous antiquities periodically since 1938. These objects were displayed sporadically on the second floor of the Witte Museum until 1981, when the Jones Avenue Museum building was inaugurated. The year 1986 was a watershed year, as Gilbert M. Denman, Jr. donated the majority of his collection of Classical art, and Dr. Carlos A. Picón joined the staff as the first Curator of Western Antiquities. In 1986 the Museum also began negotiating with the trustees of the Stark Museum in Orange, Texas, which housed an extensive collection of ancient glass, as well as important Egyptian, Greek and Roman objects. Museum of Art Trustee Margaret Pace Willson and her husband, glass sculptor Robert Willson, donated the funds for the purchase of the entire collection at the original acquisition cost paid by the Stark family in the 1920s, a sign of the strong support of the Stark Museum and Foundation. Recognizing the generosity of these individuals, the collection is now known as the Stark-Willson Collection. Another Museum Trustee, Mrs. Marie Smith Schwartz of Greenwich, Connecticut, then advanced the funds necessary to construct and endow the Arnold and Marie Smith Schwartz Gallery of Ancient Glass for the display of the exquisite ancient glass in the Stark-Willson Collection. Today, the gallery contains a remarkable survey of core-formed, cast, mosaic and blown glass. A spectacular Egyptian etched dish of the Roman period is but one of the many treasures in the collection. It is considered to be among the largest and best preserved examples of ancient glass known today.

To augment the collection, selected purchases have been made with funds provided by the Grace Fortner Rider Fund, an endowed fund established in 1978 to acquire major examples from the rich and varied cultures of the Mediterranean and the Tigris-Euphrates regions. Some of the Museum's inferior coins have been deaccessioned, and selected superior examples were acquired between 1985 and 1995. Gilbert Denman expanded the coin collection greatly by donating representative examples bearing the images of each Roman Emperor, no small feat in light of the brevity of some of their reigns. Mrs. Nancy Hamon of Dallas, a National Trustee, donated the funds for the creation of The Estelle Blackburn Gallery in honor of her mother, a long-time San Antonio resident. The Blackburn Gallery was designed to showcase the ever expanding collections of Cycladic, Minoan, Mycenaean, Cypriot, Attic and South Italian ceramics, primarily donated by Gilbert Denman, as well as the decorative arts of ancient Greece and Rome. The collection of Greek and South Italian vases is the subject of the present publication, which provides thorough documentation by an international team of distinguished scholars who have participated in this collaborative effort.

Finally, the axial arrangement of the three contiguous antiquities galleries culminates in the enormous Gilbert Denman Gallery for Ancient Sculpture. This light-filled space with its bleached-brick facing, twenty-five foot beamed ceilings exposing the building's industrial origins and Brazilian granite floors, provides an ideal setting for the display of outstanding examples of ancient sculpture. Of particular note are the heroic Lansdowne *Marcus Aurelius,* the lovely Wilton House *Sleeping Ariadne,* and the second-century Roman *Deer Hunters' Sarcophagus.* These and other treasures of the collection will be described in publications currently in progress.

The final galleries under installation are the Egyptian Galleries. The Edward and Betty Marcus Foundation of Dallas, the Starr Foundation of New York, and the USAA Foundation of San Antonio have provided generous grants to underwrite the long-term loan of Egyptian antiquities from the permanent holdings of the Museum of Fine Arts, Boston, and their installation. Shipped in several groups, these Old, Middle and New Kingdom sculptures and decorative arts objects offer an excellent survey of the artistic achievements in the Nile Valley. The loan is of enormous value in presenting the full scope of art in ancient Egypt, and it greatly enhances the Museum's impressive Egyptian collection, which continues to increase through purchases and gifts. The San Antonio Museum of Art also has benefited enormously from long-term loans from the J. Paul Getty Museum and the Vaughn Foundation of Houston, for which we are very grateful.

Both Dr. Carlos Picón and his successor as Curator of Ancient Art, Dr. Gerry Scott, have organized a series of changing exhibitions focusing on particularly outstanding pieces and groupings, as well as numerous lectures, gallery talks, and other presentations designed to illuminate aspects of the collection. In early 1995, both the College Art Association and the Association of Art Museum Directors met at the Museum of Art in conjunction with their annual conferences.

Many of these art historians and directors had last visited the Museum at its opening in 1981 when there were no Western Antiquities on display. Thus, they were thrilled to see the more than two thousand ceramics, stone reliefs, sculptures, glass objects, bronzes, mosaics, coins and other artifacts in this collection drawn from the many diverse cultures of the ancient world. Most were pleasantly surprised with the extent of the collection, and with its high quality. Until the publication of this catalogue, however, the only serious knowledge of the collection was limited to those fortunate enough to see it firsthand, or hear of it secondarily by word of mouth. At long last, a wider audience will now have access to these outstanding artworks.

I am grateful to Dr. Shapiro and Dr. Picón, who initiated this catalogue, and to Dr. Scott, who has seen it to fruition, as well as to the many contributors whose collaborations have resulted in a thorough description of the Museum's Greek and South Italian vase collection. The National Endowment for the Arts has provided invaluable support towards this publication effort, as has the Sarah Campbell Blaffer Foundation of Houston, Texas. We are deeply indebted to both organizations. This scholarly reference book, the first in a projected series of studies devoted to the Museum's ancient collection, will be enjoyed and consulted for generations to come.

DOUGLAS K. S. HYLAND
Director

PREFACE

Art museums in the United States owe their existence to private collectors and private endowment, unlike their European counterparts which with few exceptions, notable the Ashmolean and the British Museum, go back to the amassed treasures of Popes and crowned heads. Some, like the Frick Museum in New York and the Walters Art Gallery in Baltimore, have kept their original buildings. Others, and here one thinks of the Musée d'Orsay in Paris and the San Antonio Museum of Art, have transformed abandoned buildings (a railway station in Paris; a brewery in San Antonio) into museums. The J. Paul Getty Museum began as a ranch in Malibu, added a Roman villa twenty years ago, and will, thanks to its fabulous endowment, soon open an ambitious complex on a hilltop in Brentwood. Shared by all, however, is the financial backing based on private generosity that created and continues to support them.

In the nineteenth century classical antiquities were an essential component of art museums, even if mostly represented by plaster casts, but gradually had to cede their dominant position to artistic achievement of other areas and periods, when the desire to be encyclopedic called for a redistribution of space and a more impartial allocation of purchase funds. If ancient art continued as an integral part of our proud inheritance, its survival in American museums is in no small measure due to the consistent devotion to this field by collectors who, for generations, shared the enjoyment of their possessions with scholars—teachers and curators alike—and indirectly benefited museums and their evergrowing number of visitors. When a curator of their acquaintance despaired of obtaining an object offered to his department in a museum for budgetary or other reasons, many a collector not infrequently extended a helping hand, either by supplying the museum with additional funds needed to secure the purchase, or by stepping in and buying it, for the time being, as it were, for his own collection, often with the tacit understanding that such a desirable object would ultimately find a permanent home in the museum.

Each American museum has its Honor Roll of Benefactors who either helped its building and budget with an endowment or enriched it by ceding to it their collection. Such donations, of course, do not come about accidentally, but result from the respect and admiration for the aims and the performance of a musuem, often reinforced by personal friendship with members of its staff. There are, of course, times when a collector is forced to sell, breaking up what he had been at pains to assemble, but even then some collectors have offered their collections to a museum on favorable terms, rather than having them dispersed at public auction. Albert Gallatin, compelled to give up his town house in Manhattan in 1941, sold his collection of 271 vases to the Metropolitan Museum of Art for a token sum, well below what he himself had spent, and in the last twenty-five years of his life had the pleasure of seeing his objects integrated and properly exhib-

ited in the museum which he continued to visit regularly. His friend Joseph Clark Hoppin bequeathed his vases to Harvard in 1925, and it is not without interest to quote from the preface of the first American fascicule of the *Corpus Vasorum Antiquorum* Hoppin's humble assessment: "No attempt has been made to form a well-balanced collection, as pieces were bought from time to time as they were offered, and consequently the collection is rather of a haphazard nature". This bequest, however, formed the nucleus of the teaching collection at Harvard and in the years to come inspired others, notably David M. Robinson and Frederick M. Watkins, to think of Harvard as a worthy repository of what they had prized.

In New York collecting has been a way of life for many generations, and it is not surprising that soon after the modest start of the Metropolitan Museum in rented quarters its birth was welcomed by collectors with such enthusiasm that private donations of works of art, coupled with public subscriptions for purchases, were the only sustenance the museum received in its first thirty-odd years before purchase funds were established (of which the most significant was that of Jacob S. Rogers on the settlement of his not inconsiderable estate in 1903). Among those collections that reached us in the early years was a choice of Attic vases donated by Samuel Ward in 1875; the King collection of ancient gems and the Charvet collection of ancient glass both came to the museum in 1881: the former the gift of the museum's first President, John Taylor Johnston, the second acquired and donated by Henry G. Marquand, a Trustee who eight years later became the second President.

The Cesnola collections of Cypriot antiquities had been acquired between 1872 and 1876 in several installments and were displayed in the Douglas Mansion on 14th Street, the second site of the Metropolitan Museum that had soon outgrown its first rented quarters—a young ladies' dancing academy at 681 Fifth Avenue. The excavator Louis P. di Cesnola (as he became known after he left his native Italy) accompanied his collection to New York and supervised its installation, thus drawing attention to his organizational talents. These were not lost on the Trustees who began to realize the need for a professional staff, and the former career officer, first in his native Italy and later in the Union Army, filled the bill. The collection had been the fruit of eleven years spent as American Consul in Larnaka after the end of the Civil War. In 1877 he was appointed Secretary of the Museum and Trustee *ex officio* and two years later just before the museum moved to its present site in Central Park was elected Director, a post he held until his death in 1904 at the age of seventy-two. While not a scholar himself nor interested in hiring scholars as curators he had the strong support of certain powerful Trustees and survived more than one attempt to oust him.

The professionals finally put the museum on a more equal footing with its nearest rival, the Museum of Fine Arts in Boston, when J. P. Morgan was elected president in 1904, and instead of having merely three curators—one for paintings, another for sculpture and a third for casts—regular departments were organized along more art-historical lines and classical art began to emerge as something more distinguished than the vast accumulation of Cypriot antiquities that had long filled many galleries. When Edward Robinson, a classical archaeologist, resigned his directorship of the Boston Museum in 1905 to become Assistant Director in New York, certain changes began to be felt at once.

The Morgan collection, which spanned many centuries and different fields, was given by his son in 1917, and many other bequests and donations have since followed, usually divided among

the different departments, now fully established. The Classical Department, formed in 1909 and later named the Greek and Roman Department, had for many years the advantages of a salaried purchasing agent, John Marshall, who lived in Rome and received a letter of credit for his purchases. While depriving the curators (Edward Robinson through 1924, and Miss Richter thereafter) of discovering objects themselves, they and the museum profited from the favorable conditions then prevailing in Europe, and Christmas came many times a year when the different Marshall sendings arrived in New York. This period ended with the death of John Marshall, in 1928, but in the meantime many a dealer, notably Jacob Hirsch and Joseph Brummer, had established themselves in New York, and the transition from the former method to the free choice of the curator was an easy one.

In the period after the end of the Second World War (which coincides with my professional labors at the Metropolitan Museum) two collectors stand out: Walter C. Baker and Norbert Schimmel. Of the two, the former began in 1931, the latter not until the early fifties, yet both, quite independently, looked toward the museum for guidance and inspiration and expressed their loyalty through great bequests and gifts. Gilbert Denman has had no difficulty following the same course. His first antiquity, an Apulian epichysis, had been given to him by his mother a long time ago. In the sixties he already had assembled the nucleus of a collection and became known to scholars with his contribution to Herbert Hoffmann's great Texan exhibition *Ten Centuries that Shaped the West* shown in Houston, Dallas, and San Antonio in 1970-1971. If the objects selected by the owner and the organizer represent a proportionally fair choice, it may be observed that twenty years ago the collection was heavily weighted in favor of Cypriot, Greek, and Roman sculptures with only one bronze (a bust of a maenad), one Roman architectural relief (Victory sacrificing a bull) and two vases: the Apulian epichysis mentioned above, and an Attic black-figured neck-amphora acquired in New York in 1963.

The first volume of Mr. Denman's donation to the San Antonio Museum of Art demonstrates not only how the collection has grown since the 1960s, but also how the collector has broadened his outlook and built up over the years a well-rounded assembly of classical art. There are, indeed, few museums as fortunate as the San Antonio Museum of Art to acquire so rich a collection in a given field in so short a span of time, not by bequest, but donated by a benefactor who continues to add to his original munificence. The biggest gain of his enlarged horizons is to be seen in the area of Greek pottery. As early as 1973 Mr. Denman expressed interest in building up a collection of Greek vases in which every shape would be represented, "to be the beginning of a classical collection of our local museum, to which I may give my accumulation some day" (letter to the undersigned of March 7th, 1973). This project was revived three years later when we met for the first time on a plane to New Harmony. Finally, on my first visit to San Antonio on September 20th 1983, I at last *saw* his collection and could appreciate, in the presence of the many new acquisitions, how, and in what direction his 'accumulation' had grown. Since then we have been in constant touch, and it should come as no surprise that the first catalogue of the Gilbert M. Denman collection is that of his vases.

It has recently become fashionable to dampen the enthusiasm for Greek vases by belittling their artistic merit and stressing the low prices they fetched in antiquity. True collectors, however (and this has been of benefit to museums) have not become deterred in their noble quest. This is as it should be: who in his right senses would spurn a Renaissance drawing merely because it did

not command the princely sums of a commissioned fresco or altarpiece? Enjoyment, moreover, is a private matter, not easily enforced or regulated. What other field of ancient art gives us today such a wealth of information about every aspect of ancient life, the revelation of how artists viewed and drew the imagined world of their gods and heroes? Where else but on vases do we see each phase of an athlete's action—be he a runner, a jumper or a discobolus—so accurately depicted, or the tragic confrontation in battle, the excitement of the hunt, the detailed depictions of artisans and craftsmen at work, the many occupations of women, the religious festivals and sacrifices, the entertainment offered by musicians and dancers, the revels of komasts and amorous encounters? Nothing that catches the artist's eye is omitted; animals, whether wild or domesticated, are part of the panorama; ships set sail or land; children play or go to school; physicians treat the sick, and the dead are mourned. In addition to this extraordinary spectrum of subjects, we have, and this should not be ignored, a variety of styles governed as much by contemporary convention as by artistic diversity. Corporeal perspective is first ignored and then developed, just as the different moods from triumphant radiance to sorrowful depression are mirrored with increasing accuracy on these vases.

No two visitors to a museum, of course, will instinctively react on a first viewing of a work of art the same way, let alone grasp the full significance of a picture and all its details. The catalogue, however, compiled by a galaxy of experts and lavishly illustrated, provides a wealth of information that goes beyond the traditional labels or entries in a checklist. The publication, moreover, will attract visitors to the San Antonio Museum of Art to see for themselves the donation of a great collector.

DIETRICH VON BOTHMER
New York

ACKNOWLEDGEMENTS

It is a great pleasure to record our thanks to the many friends and colleagues who have made this catalogue possible. Foremost, we are grateful to Gilbert M. Denman, Jr., who not only collected and donated the majority of the vases in this publication, but who has also given his enthusiastic and sustaining support to the effort to bring the collection to a wider audience through exhibition and publication. We are similarly grateful to the Trustees of the Sarah Campbell Blaffer Foundation and to the National Endowment for the Arts for generous grants which provided funds for research, photography, and production.

We also wish to extend our gratitude to those who have contributed essays and entries: William R. Biers, Dietrich von Bothmer, Herman A. G. Brijder, Beth Cohen, Halford W. Haskell, Karl Kilinski, II, Adrienne Lezzi-Hafter, Jenifer Neils, John H. Oakley, Martin Robertson, Gerald P. Schaus, H. A. Shapiro, Erika Simon, and A. D. Trendall.

In the production of this catalogue many friends and colleagues have also lent us their invaluable aid, and we extend our sincere thanks. Photographers David Loggie, Roger Fry, Peggy Tenison and Laurie Hall, each contributed work of the highest quality. Special thanks are also owed to Robert Guy, Joseph Bravo, Lori Bravo, Jacklyne Lawrence, Lisa Deam and Patty C. Spencer for their careful assistance in many details.

The draft text of the manuscript benefited from the editorial assistance of Ulla Kasten, for whose precision we are grateful. The catalogue was designed by Sue Allen. Finally, we owe a significant debt to the assistance of Debra Z. Schafter, without whose many contributions and patient labor this catalogue would not have been produced.

H. A. SHAPIRO
Professor
Department of Classics
University of Canterbury
Christchurch, New Zealand

CARLOS A. PICÓN
Curator in Charge
Department of Greek
and Roman Art
The Metropolitan Museum of Art

GERRY D. SCOTT, III
Curator of Ancient Art
San Antonio Museum of Art

CONTRIBUTING AUTHORS

William R. Biers	W R B
Herman A. G. Brijder	H A G B
Beth Cohen	B C
Halford W. Haskell	H W H
Karl Kilinski, II	K K I I
Adrienne Lezzi-Hafter	A L – H
Jenifer Neils	J N
John H. Oakley	J H O
Gerald P. Schaus	G P S
H. A. Shapiro	H A S
Erika Simon	E S
A. D. Trendall	A D T
PREFACE	Dietrich von Bothmer
INTRODUCTION	Martin Robertson
APPENDICES	Carlos A. Picón and Debra Z. Schafter

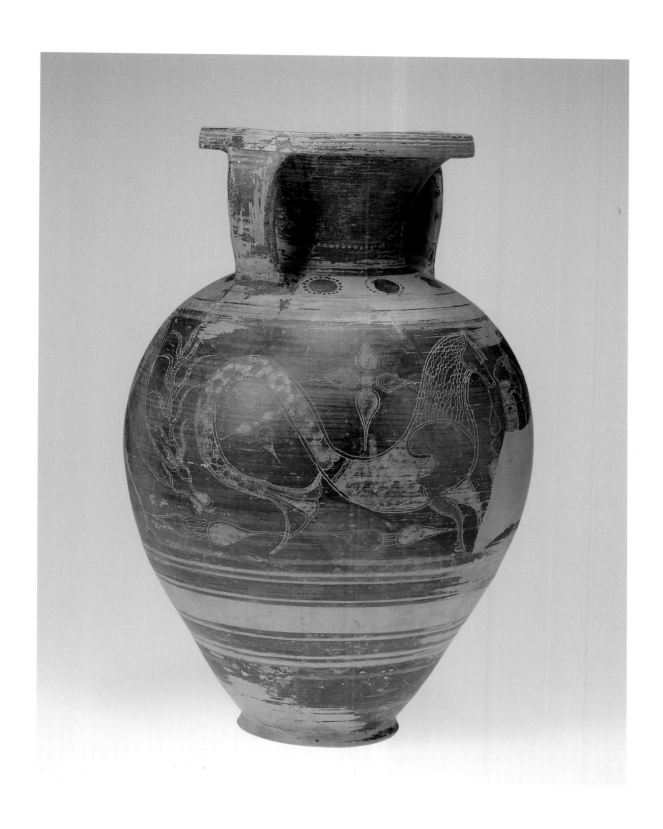

PLATE 1 Etruscan Black-Figure
Amphora. *Attributed to the Brown
Painter. Ca. 620–600 B.C. Animal frieze.
See Cat. No. 26*

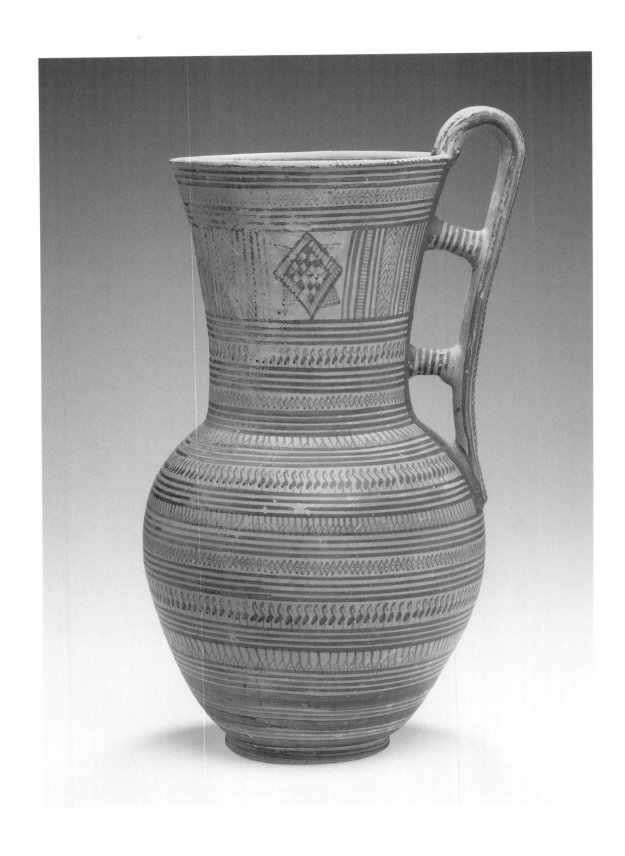

PLATE II Attic Late Geometric
Oinochoe. *Soldier-bird Workshop.*
Ca. 730–720 B.C. See Cat. No. 9

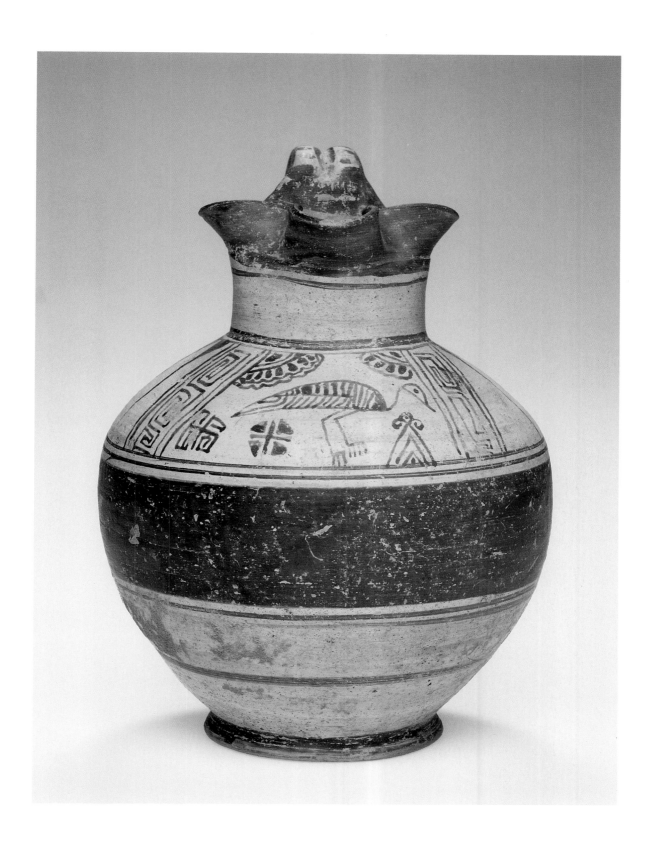

PLATE III Carian (East Greek)
Oinochoe. *Ca. 625–600 B.C.*
Waterbird. See Cat. No. 18

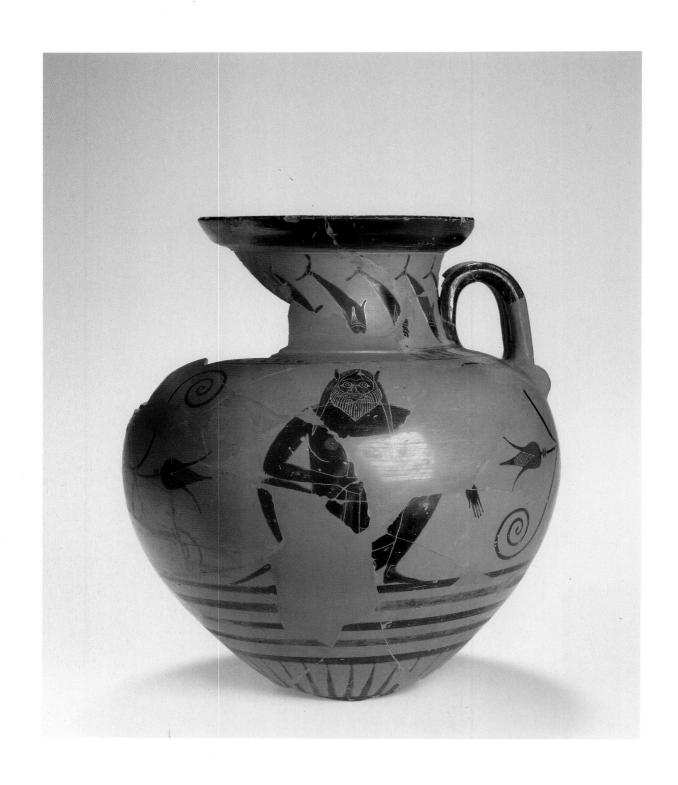

PLATE IV Attic Black–Figure
Neck–Amphora. *Attributed to
the BMN Painter. Ca. 540 B.C.
Satyr. See Cat. No. 44*

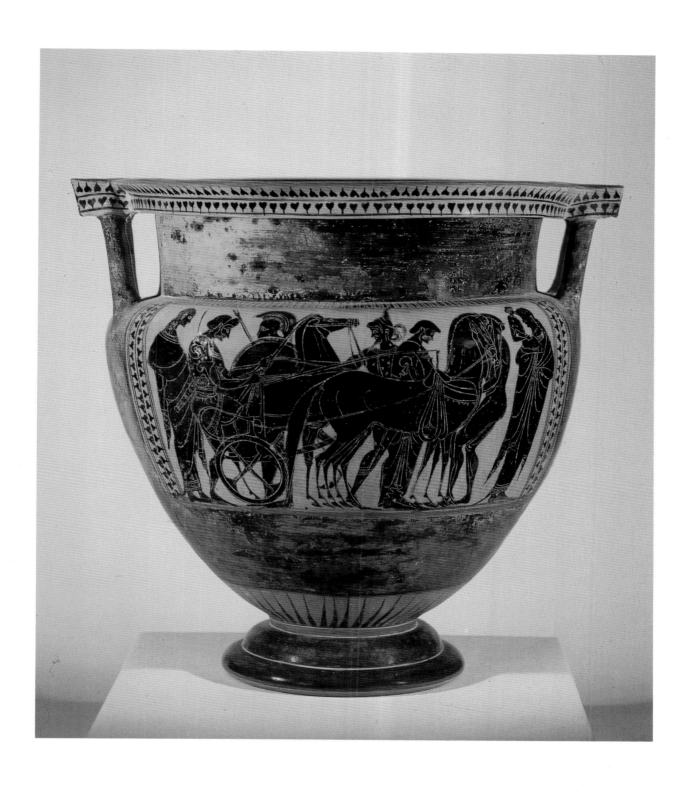

PLATE V Attic Black–Figure
Column-Krater. *Manner of the
Lysippides Painter. Ca. 530–520 B.C.
Harnessing a chariot. See Cat. No. 45*

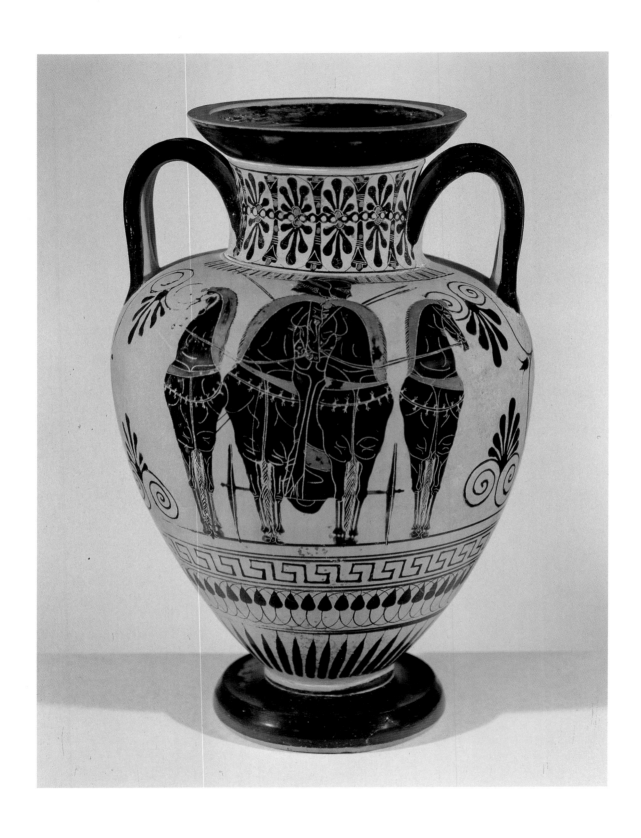

PLATE VI Attic Black-Figure
Neck-Amphora. *Manner of the
Lysippides Painter. Ca. 525–515 B.C.
Frontal chariot. See Cat. No. 52*

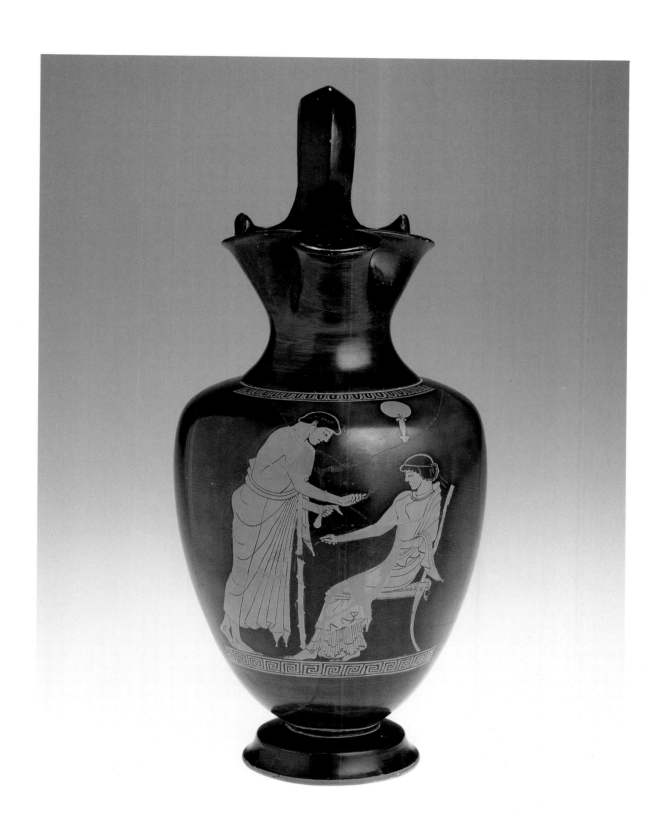

PLATE VII Attic Red-Figure
Oinochoe. *Attributed to the Berlin
Painter. Ca. 490–480 B.C. Youth
and woman. See Cat. No.* 70

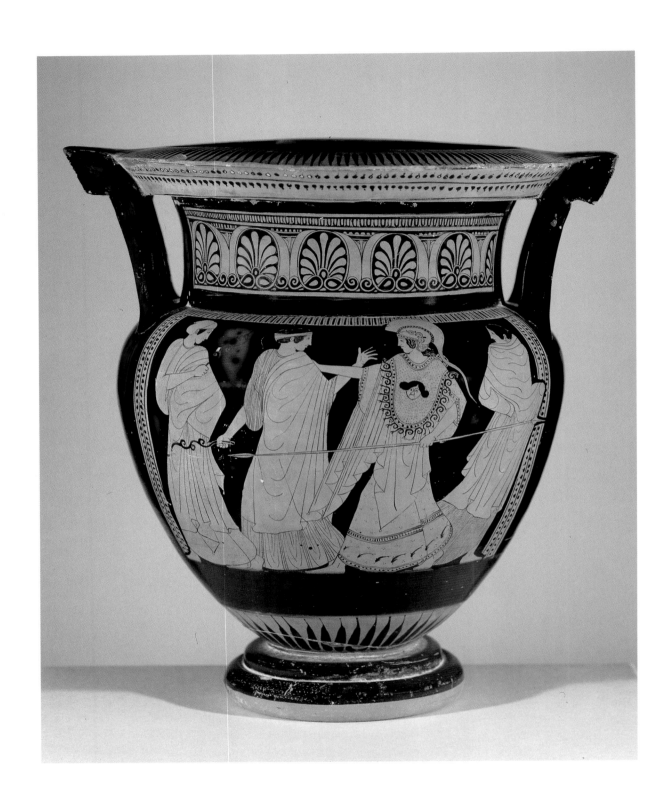

PLATE VIII Attic Red-Figure
Column-Krater. *Attributed to the*
Orchard Painter. Ca. 470–460 B.C.
Athena and the Daughters of Kekrops.
See Cat. No. 77

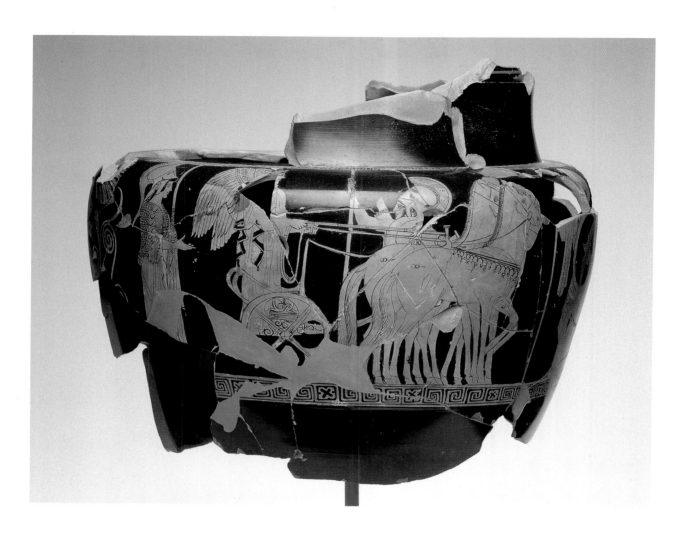

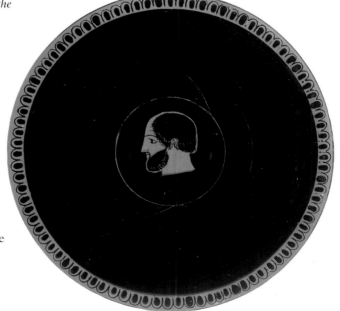

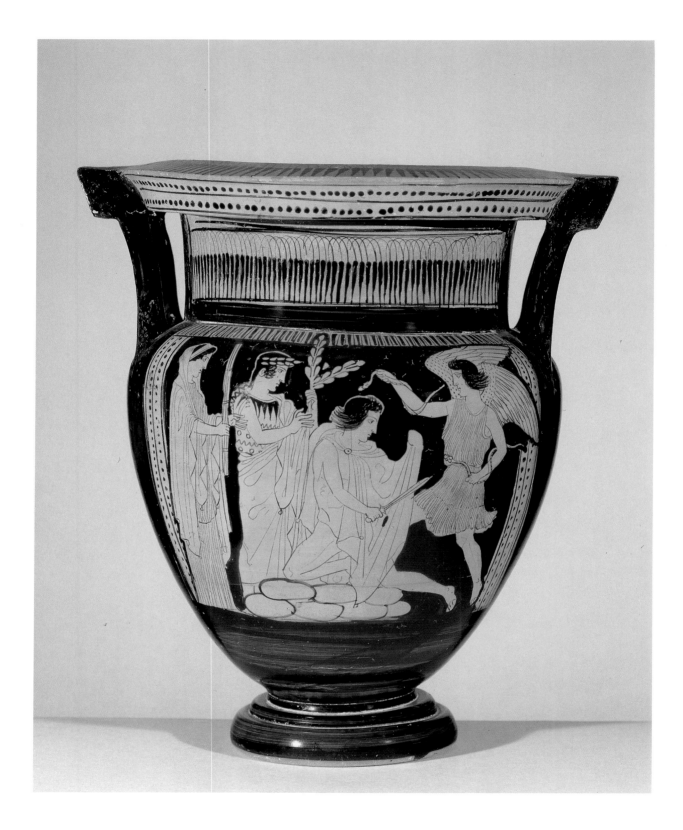

PLATE XI Attic Red-Figure
Column-Krater. *Attributed to the Naples
Painter. Ca. 450–440 B.C. Orestes
at Delphi. See Cat. No. 88*

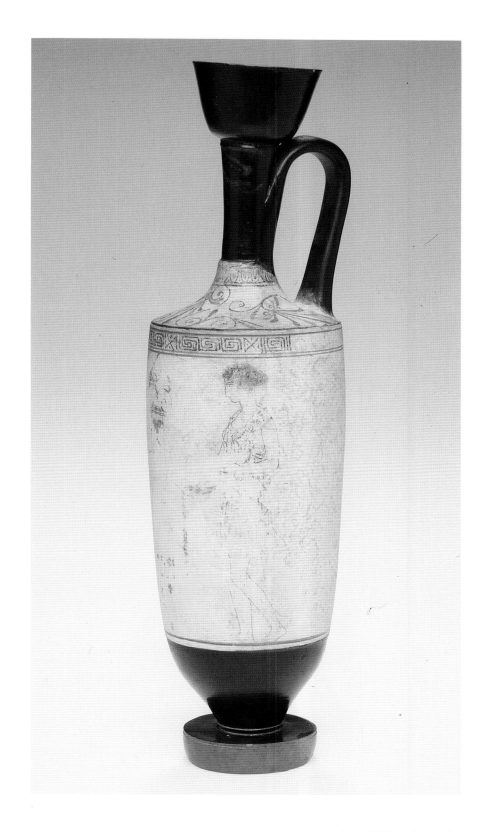

PLATE XII Attic White-Ground
Lekythos. *Bird Group; Manner of the
Bird Painter. Ca. 440–430 B.C. Youth
and woman at a tomb. See Cat. No. 98*

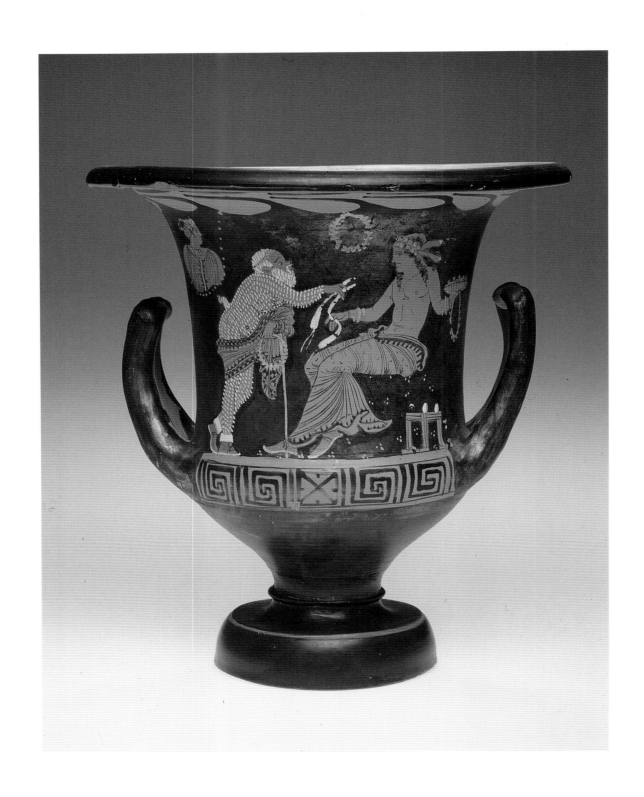

PLATE XIII Paestan Red-Figure
Calyx-Krater. *Attributed to the Workshop
of Asteas. Ca. 350–340 B.C. Papposilen
and Dionysos. See Cat. No. 119*

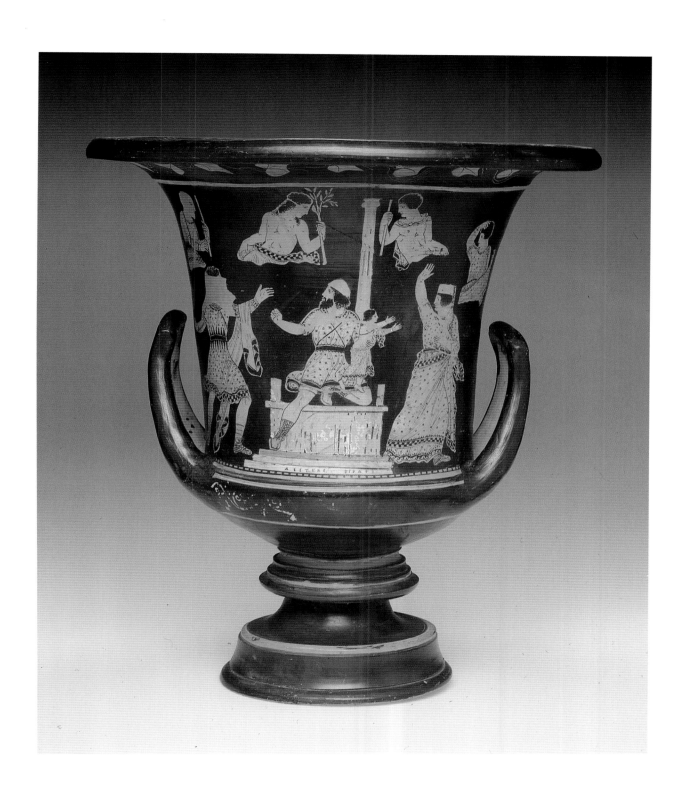

PLATE XIV Paestan Red-Figure
Calyx-Krater. *Signed by Asteas.*
Ca. 340 B.C. Telephos holding
the infant Orestes. See Cat. No. 118

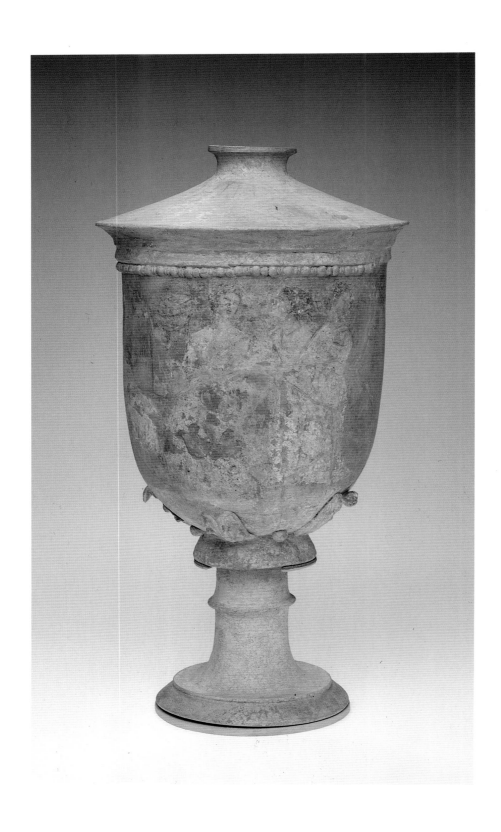

PLATE XV Centuripe-Ware Lidded
Bowl with Stemmed Foot. *Mid-3rd
century B.C. See Cat. No. 126*

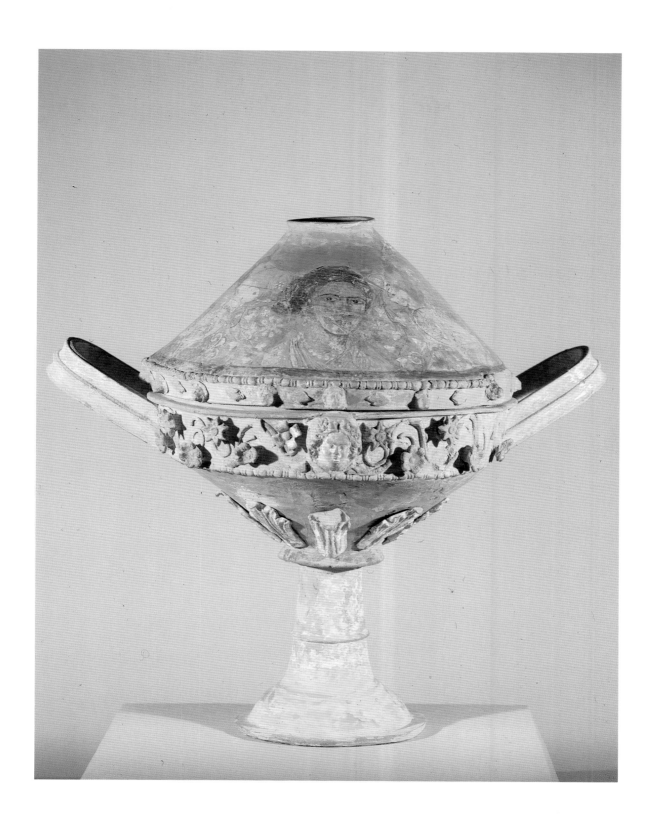

PLATE XVI Centuripe-Ware Lekanis
with Lid, Handles and Stemmed Foot.
Mid-3rd century B.C. See Cat. No. 127

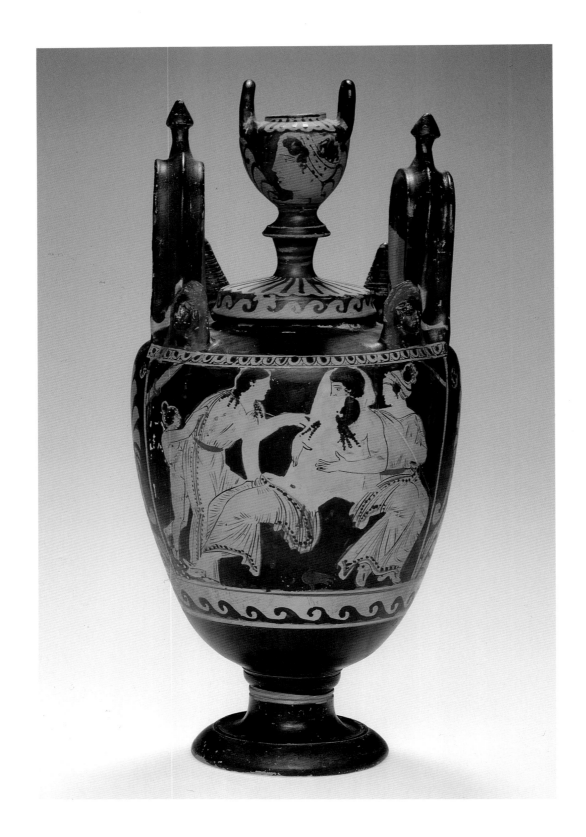

PLATE XVII Paestan Red-Figure
Lebes Gamikos. *Attributed to the Painter
of Naples 1778. Ca. 320 B.C. Embracing
couple.* See *Cat. No. 124*

GREEK VASES

IN THE SAN ANTONIO MUSEUM OF ART

INTRODUCTION

To create, at this time, a new collection of classical antiquities which shall both be generally representative and contain works of really high quality, might seem an unrealizable dream. It is, however, being realized at San Antonio. The prime credit, of course, goes to Gilbert Denman, first for his taste and skill in forming the collection, then for his generosity in making it over to the San Antonio Museum of Art. Generous, too, have been other donors and lenders, as well as the Ewing Halsell Foundation, which helped finance the building; and the young Museum is happy in being able to call on the scholarship and flair of Carlos Picón and Alan Shapiro for the display and cataloguing of the collection as well as for building it up.

The choice of the Greek vases for the first catalogue is a wise one. Pottery, though easily breakable, is virtually indestructible, and most lost cultures are therefore better documented through their pottery than in any other way. Greece is no exception in this; but in another way Greek pottery is very unusual, in that, in certain times and cities, it stands in a quite exceptionally close relation to contemporary fine art. Much splendid Greek sculpture has come down to us (there are fine examples in the museum); we even have, from recent years, great Greek wall-paintings, though these are not available to collectors; but for a continuous history of a single craft we have to look to pottery, and the painted pottery of Greece gives us at the same time a kind of miniature history of Greek art.

The artistic quality of Greek vase-painting, and the closeness of its relation to the major arts, vary greatly in different centers of production and in different periods. Of outstanding importance are the 'black-figure' vases made from the late seventh century, especially those of sixth-century Athens, and the 'red-figure' made in Athens from the later sixth throughout the fifth and fourth, and from the later fifth also in several cities of South Italy and Sicily. These show figures, and figure-compositions, of a kind one normally associates rather with easel or wall-painting than with the decoration of pottery; and they are of value alike for the intrinsic beauty of the best work and for the light it throws on the development of drawing in Greece. Within this too, however, the variation in quality is very great. Most vase-decorators show no ambition to be 'artists', and the true artists among them are much of the time content to produce more or less conventional decoration. The builders of a new collection of Greek vases must aim to make it representative of the whole range of development of the potters' craft, and at the same time to acquire a few pieces to make clear its importance in the history of art. These ends the makers of the San Antonio collection are well on the way to achieve.

At the beginning are a few specimens of Neolithic and Bronze-age pottery, ending with several late Mycenaean pieces: stirrup-jars and kylikes with the very simple decoration typical of the decline into the dark ages, and one larger jar with the favorite octopus in a highly stylized form.

There is no representative at present of the new 'Protogeometric' style which comes in the eleventh century B.C. and marks the beginning of a continuously traceable development into Archaic and Classical times, though some rather later pots from Iron-age Cyprus share the Protogeometric predilection for concentric circles. Nor is there anything from the earlier centuries of Geometric pottery. There is, however, a fine representative of the late Geometric style of Athens, where it particularly flourished: a big oinochoe, its purely abstract decoration modified only by three rows of birds, themselves formalized almost into abstractions. This dates from the second half of the eighth century, and to around 700 B.C. belongs another big Attic vase, a neck-amphora with fine figure-decoration in a new style.

When human and animal figures are drawn on Geometric vases they are thin silhouettes, angularized to make them fit in with the bands of rectilinear ornament with which they are surrounded. The neck-amphora retains the layout of a Geometric pot, ringed with narrow or broader bands of ornament or figures, and both ornament and figures have still the very linear character of Geometric drawing; but the effect is quite different. The character of the pattern-bands is simplified and they are thoroughly subordinated to the figure-scenes, and the figures are surrounded with patterns in which curves (spirals and plant-forms) are prominent. Moreover, the silhouette of the figures is modified by some outline drawing, notably in the sphinxes' wings; and the sphinxes themselves are foreign to Geometric art. They are a borrowing from the east, and such borrowings are so frequent at the time that the name Orientalizing is given to this phase of Greek art, though in truth orientalism is only one aspect of the change.

This phase lasts from the later eighth century through the seventh, and beyond that in East Greece (the cities of the Asia Minor coast and the islands off it). These produced an attractive unambitious ware, the vessels covered with white slip on which animals and florals are drawn in silhouette and outline with a good deal of added red. The Museum has a very pretty fragment, still of the seventh century, and three interesting pots which appear to be sixth-century Carian imitations.

In Corinth, where a distinctive, rather simple form of Geometric had been produced, the seventh century sees a refinement of this: small vases of very elegant make decorated with close-set fine lines. The Museum has two examples of this attractive style, a kotyle (a drinking vessel of Corinthian invention) and another favorite shape, a pyxis (lidded box). Corinthian potters of this period also developed an exceedingly fine style of animal and figure drawings, not represented here, and perfected for it the 'black-figure' technique. In this the figures are drawn in black silhouette and details are incised, that is, cut in the black with a sharp instrument, and patches of cherry-red and occasionally other colors are added over the black. Though there is nothing here of this early phase of Corinthian Orientalizing, known as Protocorinthian, which lasted into the second half of the seventh century, there are several pieces from the later seventh and earlier sixth century when this black-figure animal style was conventialized and mass-produced for export, especially to Etruria. We have another kotyle, a different form of pyxis, and an alabastron and an aryballos. These two types of oil-flask or scent-bottle are the mainstay of Corinthian production. The prettiest of these Corinthian vases in San Antonio is a lekanis, a shallow bowl with elaborate handles. A second example of the shape was made not in Corinth, but in Boeotia which in the first half of the sixth century produced much lively black-figure following Corinthian and Attic models. The Corinthian lekanis has no picture within, but the Boeotian has a tondo with an oc-

topus: not a unique picture at this time, but the subject is much less popular than it was in the Bronze Age.

Both in Protocorinthian and Corinthian many vases are decorated only with patternwork. A pretty pot-bellied jug (olpe) in San Antonio, of late Protocorinthian shape is black with incised scale-pattern on the upper part of the body and red stripes below.

In Attica the seventh century is a period of experiment in vase-decoration, especially on large pots in the tradition of Attic Geometric. There is nothing from that phase here (and indeed there is little to be seen outside Greece). Before the end of the century Athenian potters had taken over the black-figure technique from their Corinthian rivals. It was perhaps felt that the black silhouette was more effective as decoration for the curved surface of a pot than outline drawing or any alternative decorative scheme. Whatever the reason, black-figure becomes the most usual form of vase-decoration in most centers of production over most of the sixth century, and Attic potters of the turn of the seventh and sixth centuries develop it in a particular way which becomes the model for others.

Corinthian clay is pale, Attic naturally darker with an orange tint. At this time the potters of Attica develop this orange color evidently as a deliberate contrast to the shiny black they achieve. They also make a substantial use of white, laid over the black, for woman's skin and other things, as well as the cherry red. This distinctive color-scheme is often imitated by potters in other centers; for during the first half of the sixth century Athens becomes the dominant producer of fine painted pottery. In the century before, while Corinthian was widely exported, Attic seems to have been produced purely for local use. By the middle of the sixth century Corinth has virtually ceased production of figured pottery, while vast quantities of Attic are found around the Mediterranean, especially in Etruria and the Greek cities of South Italy and Sicily. Alongside their more or less mass-produced small animal pots Corinthian potters had another line in large, careful vases with figure-scenes; and in the latest phase (roughly the second quarter of the sixth century) the pictures on these are often painted on a reddish slip presumably meant to imitate the effect of Attic.

When Corinth ceases production, around the mid-century, a new ware appears which imitates Attic more directly. This is known as Chalcidian, because the form of Greek alphabet found in inscriptions on these vases is that in use at the Euboean city of Chalcis. It is probable, however, that the actual center of production was one of the Greek cities of South Italy. San Antonio posesses a beautiful amphora from an early stage of this ware: as fine a piece of black-figure drawing as any of the Attic vases in the collection can show. The ware, however, was only in production for two generations. Before the end of the century it had ceased, as had all figured vase-painting outside Attica. The museum has one more piece of non-Attic black-figure from this period: a Laconian cup. Laconia (the district of which Sparta was the dominant city) had produced a local pottery from Geometric times, and during the middle decades of the sixth century had a particular line in black-figure cups with big pictures on the white-slipped interiors in an often effective style. The San Antonio cup, from late in the series, is without figure-decoration: a circle on a reserved disc at the center of the interior; outside a band of lotus-buds between distinctive horizontal palmettes beside the handles.

The Attic black-figure series begins with an excellent amphora of the early sixth century. The amphora is a store-jar with two handles from shoulder to neck. The earlier form (it goes back to Geometric times, and we looked at an early orientalizing example) has the neck sharply offset from the body. A new type, to which our vase belongs, is created about the end of the seventh century. This has no separate neck, but a contour in a continuous double curve from offset lip to offset foot. It is conventionally known as 'amphora', the other as 'neck-amphora'. The amphora ceases to be made before the end of the fifth century, while the neck-amphora continues in production, constantly reshaped, till the end of Greek painted pottery. The black-figure 'amphora' is normally a black vase, only a panel reserved on each face for the decoration; the 'neck-amphora' a clay-colored vase, the figure-scenes circling the pot or separate floral ornaments under the handles. There are black-figured representatives of both shapes in San Antonio, and they include exceptions to both rules.

The earliest piece shows in each panel (one is ruined, but the other well preserved) only a single large bird, head turned over back, surrounded by rosettes; but the drawing is strong and makes an attractive piece of decoration. Of similar character is another which belongs to a large class with a single horse's head in either panel. These two lack a feature regular in later examples of the shape: a narrow reserved band at the foot decorated with black rays or leaves.

The earliest-looking of the amphorae in the Museum with this feature shows on one side two horsemen, on the other men at work in a vineyard. The subject is interesting, but the style incompetent and peculiar. The decorative scheme too is odd for an amphora: the black at the handles is omitted, so that the panels merge. This has led to the suggestion, which may be right, that this is not really Attic work, but an imitation, made in Etruria, of an imported vase. The same thing is suggested for a neck-amphora in the collection which has the opposite pecularity: the vase is black, like an amphora, and the badly drawn pictures (Herakles fighting Kyknos and a four-horse chariot seen from the front, both common subjects on Attic vases) are isolated in panels. Whatever the truth about the origin of these vases, the range of quality in black-figure drawing is nicely illustrated by comparing the horses and their riders with those on the beautiful Chalcidian amphora.

There is some black-figure in San Antonio which is certainly Etruscan: two lively neck-amphorae of the second half of the sixth century. The earlier, with a boar in a panel on either side, belongs to a class known as Pontic, the later to a large group of which the principal artist is called the Micali Painter. On either side of this, two satyrs caper round a krater. A third neck-amphora, also of good quality, is earlier (orientalizing) and not strictly black-figure in technique, since the whole field is blackened and the fantastic animals drawn on it with incision and patches of color. There is also a strange footed alabastron with a ram's head which belongs to the Italo-Corinthian class (Etruscan pots based on Corinthian models); and two pretty kantharoi and a jar in the native Etruscan bucchero, a coarse grey clay polished to the black surface with some stamped or incised decoration.

To return to Attic black-figure. The Kyknos neck-amphora, if it is not Attic, is imitated from a large group of Attic vases known as Tyrrhenian. These, mostly neck-amphorae, are the product of a single workshop which seems to have aimed almost exclusively at the Etruscan market. They

are sometimes lively but never careful, with friezes of animals in the orientalizing tradition and figure-scenes in a main picture on the shoulder. San Antonio has two typical examples. One has on the front a battle of Greeks and Amazons, on the back a man making up to a woman; the other a chariot-race and men reclining at feast with women. Meaningless letters appear in the background of the chariot-race; and on better vases of the group, as on other finer work of the period, meaningful inscriptions (names of characters portrayed, painters' or potters' signatures) are frequent.

Of similarly old-fashioned character is a stouter neck-amphora that shows a bearded head on each side of the neck and, on the body, a pair of lions and a pair of cocks, like those on the Chalcidian amphora. This Attic neck-amphora, and a large column-krater in the same style (with bearded heads on the handle-plates; on the back a mantled man between lions; on the front a frontal four-horse chariot betwen pairs of men), belong to a circle that produced a fine vase-painter, Lydos ("Lydian"). This is one of a class of ethnic names to which a good many of the known names of vase-painters and potters belong. Such appellations were often given to slaves, and another Lydos, who signs a later and weaker vase, actually describes himself as a slave. The fine mature work of the first Lydos dates to a time after the mid-century, but before we go on to see how that period is represented in the Museum, we should glance at the development of the drinking-cup in Attic black-figure.

We looked at the Corinthian kotyle. This shape is imitated in Attic, but the favorite cup there and elsewhere is the shallow bowl with a narrow outturned rim and a low foot. This derives from a Geometric model. San Antonio has no example of the type, but two of the remodelling effected by Attic potters in the second quarter of the sixth century. Here the foot has been made much taller, the offset rim much taller also and rising vertically from the bowl. This shape, conventionally known as "Siana cup", is the first form of the stemmed kylix which, variously reshaped over the centuries, remains a staple of Attic production and is often the vehicle of the finest work. The fullest form of decoration for a kylix is a tondo within and pictures outside also. Siana cups regularly have all this. Some of them have the figures on the outside overlapping bowl and rim; in others the figures are confined to the bowl and the rim has a band of floral pattern (occasionally a subordinate figure-scene). Two principal artists specialized in the decoration of Siana cups. One of those in San Antonio, with overlap decoration, a symposium on the outside and a woman's head in the tondo, is in the manner of the earlier of the two, the C Painter. He is given this name because of his adherence to Corinthian models; and a woman's head in the tondo is a favorite in Corinthian cups, rare in Attic. The second cup is in the manner of the C Painter's follower, the Heidelberg Painter. The interior has a fight, the exterior men and women in conversation. Here the decoration is 'double-decker': the figures are confined to the bowl and there is an ivy-wreath on the rim.

After the mid-century a new more elegant type of kylix ousts the Siana: the Little Master. Here the bowl is supported on a tall, slender stem which spreads to an almost flat foot. The Laconian cups are of similar form and perhaps inspired the Attic potters. Little Masters come in two main forms, Lip-cup and Band-cup. In both, foot, stem and lower part of bowl are black (edge of foot and a stripe on the bowl reserved). On the Lip-cup the tall straight rim is sharply tooled off from the upper part of the bowl. Both are reserved, and the junction marked by a black line. Any figurework is normally confined to a small picture on the center of the lip on either side, and be-

low this, in the handle-zone, there is almost always an inscription (invitation to drink, signature) or imitation inscription (string of letters or pseudo-letters). The Band-cup often has a molded ring at the junction of stem and bowl, never found on a Lip-cup. The lip is not sharply tooled off from the bowl and is black. The picture is in the reserved handle-zone and generally extends from handle to handle. In both types there are often palmettes at the handles. A tondo is sometimes found in large, careful Lip-cups, scarcely ever in Band-cups.

The Museum has an example of each, neither with a tondo. The Lip-cup (pseudo-inscription, no palmettes) has the same picture repeated on both sides: Atalanta wrestling with Peleus. The run of Lip-cups is superior to the run of Band-cups, but though the San Antonio example is not bad it has not the quality of the excellent Band-cup, on which similar elements are combined to make two different scenes. Here there are palmettes at the handles.

The pot-painting of this period is dominated by three figures: Lydos, whom we've already noticed; the painter who worked with, and perhaps was the same as, the potter Amasis; and Exekias who signs as both painter and potter. They are not represented in the Museum, but the style of the time is shown on amphorae by minor painters: the Painter of Berlin 1686, the Princeton Painter, the Taleides Painter. A piece of good quality shows on one side a young man playing the *kithara* between columns on which stand cocks; on the other, between columns supporting sphinxes, a formal picture of Herakles wrestling with the Nemean lion—perhaps the subject of the kitharode's song. These designs show the influence of the prize-vases for games and competitions at the Panathenaic festival.

At this time the neck-amphora is remodelled as a broader vase with elaborate floral designs under the handles. The earliest and finest (though very fragmentary) of several examples in San Antonio is untypical in having leaping dolphins on the neck and a single figure, a self-indulgent satyr, on either side of the body. Normally the body has compositions of several figures, the neck a band of lotus and palmette. Such is one ascribed to the manner of the Lysippides Painter, more interestingly represented by a large column-krater with departing warriors. This artist and the Antimenes Painter, to whose manner a hydria in the collection is attributed, dominate black-figure production in the generation after Exekias and are associated with the first painters of red-figure.

Red-figure is a reversal of black-figure, the ground being blacked in, the figures reserved in the color of the clay. It thus preserves the strong decorative effect of the silhouette but, since details are now not cut in the shiny black but drawn with brush or pen, a greater freedom of naturalistic representation is possible. The invention seems to have taken place before the end of the third quarter of the sixth century, and till about the end of the century the two techniques flourish side by side. After that red-figure prevails, though mass-production of poor black-figure continues long, and it is retained for the Panathenaic prize-vases beyond the lifetime of red-figure.

There is nothing here of the earliest red-figure, but a ruined cup with satyrs is ascribed to an artist of the second generation, Oltos. The Little Master cup-types were replaced by a quite different form: a short, stout stem supporting a deeper bowl with no modulation at the rim. The main decoration is a large pair of eyes on either face of the exterior, often a figure between them, sometimes others at the handles. The Museum has two black-figure examples, one signed by a potter, Nikosthenes, who worked with many painters in both techniques. Neither has any tondo-picture, but often there is a gorgoneion and this is taken over when the type is adopted for

red-figure. In the Eye-cups of Oltos and his contemporary Epiktetos a figured tondo is regular, first in black-figure, then as here in red-figure like the outside. In their later work the shape is re-modelled once more. The slender stem is merged into the bowl, so that there is a continuous double curve from lip to wide foot. This remains the regular form of the kylix throughout the rest of Attic vase-painting, though other types are used alongside it. Relatively early examples (first quarter of the fifth century) in San Antonio are one in black-figure of the so-called Leafless Group, which illustrates the decline of the technique, and a small one, decorated inside only with a picture of Iris, by the Eucharides Painter.

There is nothing in the Museum by any of the Pioneers, the group of great painters, Euphro-nios, Euthymides and their companions, who in the late sixth century established the primacy of red-figure. Oltos and Epiktetos survived into their time and were influenced by them, and a pe-like with Peleus and Thetis seems to be a work of a lesser artist in the same situation. The pelike is a new form of amphora invented in the circle of the Pioneers, and the Museum has a contem-porary black-figure example with warriors dancing to the pipes. The Pioneers' fine black-figure contemporaries, the Leagros Group, are represented by two neck-amphorae. One of these, with Herakles and Amazons, is attributable to a late member of the Group, the Nikoxenos Painter, who worked also in red-figure, as did his pupil the Eucharides Painter.

In the generation after the Pioneers, red-figure artists divide loosely into two groups, those who specialize in cup-decoration and those who prefer pots. In both classes some of the finest of all vase-painting is produced. The Eucharides Painter's cups are slight and he is primarily a pot-painter, but though he can do good work in that field he never equals his best contemporaries, the Kleophrades Painter and the Berlin Painter. The Kleophrades Painter is represented here only by a small fragment. It gives just part of a figure's drapery, but what a difference in quality from the drapery on the Eucharides Painter's cup.

This fragment is from a big vase with elaborate pictures such as are typical of the painter. The Berlin Painter's major works are of the same kind, but he had also a line of smaller vessels and his representation here is from that side of his production. He was the first to popularize a small neck-amphora, the Nolan amphora, which became a favorite in Attic pottery. The Berlin Painter's are usually very black vases with a single figure in each side and no or little ornament, a principle in accord with the taste of the time but particularly beloved of the Berlin Painter, who applies it equally on small and larger pots. A fragment shows a youth (Theseus perhaps) running with spears, no doubt in pursuit of a girl on the other side. It is lively and pretty; but the vase be-longs to the artist's old age, when he had lost or abandoned the wonderful strength and harmony of line which marks his earlier masterpieces. A minor but attractive work of the early period is in the collection: a jug with two figures, a young man offering money to a seated woman.

The composition on this vase is untypical, but the details of drawing make it certain that it is from the Berlin Painter's hand. Interesting in this connection is a fragment of another such wine-jug (oinochoe). The mouth and upper part, of splendid technique, remain, and part of a young warrior standing with helmet and spear. This at a quick glance has more than the other jug a look of the Berlin Painter, but on detail of drawing it is certainly attributable to a craftsman known as the Harrow Painter, most of whose vases seem more or less mass-produced hackwork. The best

pieces, however, have charm; and he obviously admired the Berlin Painter, and when, as here, he imitates the master's work directly (perhaps rather copied it) he comes surprisingly close.

Complete vases and fragments of finer quality can be used in the same way to illustrate the cup-painting of this period, and the pots and cups of the classical age which follows. In a similar manner black vases can fill out the picture presented by figured ones. Calyx-kraters, bell-kraters and column-kraters are excellently illustrated in red-figure examples. There is only a substantial fragment of a red-figure volute-krater, but a complete example in plain black (something not often found) allows the spectator to visualized the figured vase as a whole.

I could go on; but perhaps I have said enough to show how such a collection is of value to illustrate both the history of the craft of painted pottery in Greece, and the way Greek drawing developed and the heights it could attain. There are still gaps, of course, some more significant than others. The alabastron and two lekythoi with decoration on a white ground are not of a quality to suggest the range and beauty of this technique. We notice the absence of any sample of the Panathenaic prize-vases which span Attic vase-painting from the middle of the sixth century to after the end of the fourth. The fourth century indeed is hardly represented from Attica; but the more interesting red-figure wares of South Italy make a fine showing. In any case the essential is that a fine basic collection has been formed, which can be built on to make something really outstanding. It will be fascinating to compare this Catalogue with a new edition which will surely appear in ten or twenty years' time.

MARTIN ROBERTSON
Cambridge

NOTES TO THE CATALOGUE The catalogue is divided into chronological and geographical sections. For the convenience of the general reader, each of the three main sections is preceded by a brief historical introduction. Individual catalogue entries tend to be arranged in chronological order within these sections. "No." is used to refer to entry numbers in the present catalogue. Entry numbers in any other publication appear as "no." Illustrations are not numbered consecutively, but have been given the same number as the relevant entry with the addition of a letter when appropriate, for example, "Fig. 25A."

As the purpose of this catalogue is to present as fully as possible the San Antonio Museum of Art's collection of Greek vases, three appendices have been provided as a supplement. Appendix A lists the museum's unattributed whole vases, while Appendices B and C give the museum's attributed and unattributed vase fragments, respectively. For the use of the general reader, glossaries of terms and vase shapes have also been included.

The preparation of this catalogue has been a lengthy undertaking involving a large number of contributors. Many of the entries were written in the late 1980's and in the process of production it has not been possible to update the individual entries prior to publication.

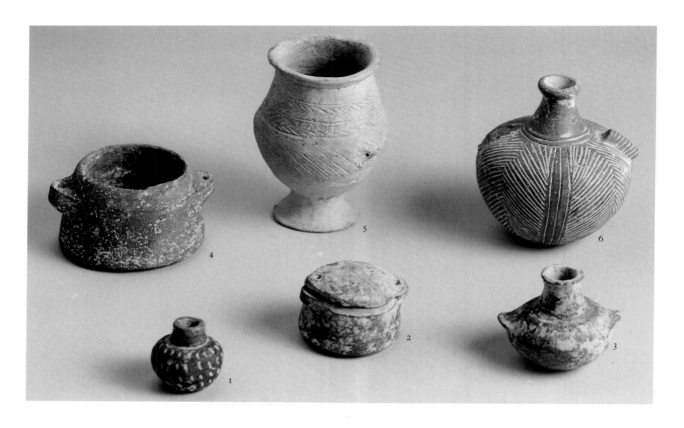

I

SIX EARLY CYCLADIC VASES
Early Cycladic Period
3rd millennium B.C.
Gift of Gilbert M. Denman, Jr.
85.119.1-6

Six vases in the collection were made
in the Cycladic Islands. They all belong
to the Early Cycladic period (3rd mil-
lennium B.C.), a rich period during
which the islanders, to judge from
traded goods and depictions of ships
on some of their pottery, ventured
overseas.

Our vases are probably tomb offer-
ings, although not necessarily from the
same place. Rich Cycladic tombs could
contain pottery, marble vases, bronze
pieces, tools, obsidian, bone and stone
jewelry, silver vessels, and lead models
and figurines. Most tombs contained,
however, only a few clay pieces. The
grave goods generally present everyday
items, and their inclusion in graves sug-
gests a concern with the afterlife.

We have no idea what these vases
contained, although bottles found else-

where similar in shape to Cat. No. 1
(1) sometimes contained some sort of
blue pigment. H W H

1. Miniature Cycladic Bottle
Ca. 2700 B.C.

This tiny bottle, while it has many par-
allels for the shape, has a very unusual
decorative motif of vertical oval im-
pressions. Based on its shape, it proba-
bly belongs to the Kampos phase of the
Cyclades (transitional Early Cycladic
I–II, Pelos and Keros).

DIMENSIONS: H. 4 cm.; Diam. of rim
1.7 cm.; Diam. of base 2.2 cm.
CONDITION: Intact.
SHAPE AND DECORATION: Miniature
bottle or aryballos of burnished brown
clay. Globular body, collar neck. Oval
impressions on body.
BIBLIOGRAPHY: Unpublished.
LITERATURE: For this shape, see Doumas,
Burial Habits 18; G. Papathanasopoulos,
ArchDelt 17 (1961–62) pl. 66c-d. For the
decorative motif, see Thimme, *Cyclades*
133, fig. 115.7–8; 134, fig. 118.7–9 (Kam-
pos Phase).

2a,b. Conical Cycladic Pyxis
with Lid
Ca. 2700 B.C.

This clay pyxis, conical in shape, repre-
sents a development from a slightly ear-
lier cylindrical type. It belongs to the
Kampos Phase (EC I/II).

DIMENSIONS: H. 3.5 cm.; Diam. of rim
4.2 cm.; Diam. with handles 6.5 cm.;
Max. Diam. 5.9 cm.; Diam. of lid 6 cm.
CONDITION: Pyxis intact; lip broken and
repaired.
SHAPE AND DECORATION: Conical pyxis
with lid in dark reddish brown clay with
rounded bottom. Two horizontal lug-
handles, with hole pierced through
lid/handle. Burnished surface.
BIBLIOGRAPHY: Unpublished.
LITERATURE: For similar vases, see Za-
pheiropoulou, 33, fig. 1a-b; 38. For simi-
lar pieces on Crete, see S. Xanthoudides,
ArchDelt 4 (1918) 147, fig. 7.31–32, 7.34;
151, fig. 9.73.

3. Cycladic Bottle
Ca. 2700–2500 B.C.

This small Cycladic bottle, or aryballos, has pinched handles and incised decoration. Its shape is unusual.

DIMENSIONS: H. 6.1 cm.; Diam. of rim 2.5 cm.; Diam. with handles 6.9 cm.; Diam. of base 2.4 cm.

CONDITION: Intact, but with minor chipping on mouth and handles.

SHAPE AND DECORATION: Squat ovoid shape with collar neck in burnished brown clay with vertical lines; lightly incised.

BIBLIOGRAPHY: Unpublished.

4. Conical Cycladic Pyxis
Ca. 2700 B.C.

The shape of this two-handled pyxis, conical in shape, suggests that it belongs to the Kampos Phase (EC I/II).

DIMENSIONS: H. 5.5 cm.; Diam. of rim 10.4 cm.; Diam. with handles 10.4 cm.; Diam. of base 9.3 cm.

CONDITION: Intact, except for missing cover.

SHAPE AND DECORATION: Conical pyxis in coarse red clay with traces of burnishing.

BIBLIOGRAPHY: Unpublished.

LITERATURE: Comparable vases appear in Doumas, *Cycladic Art* 66 no. 24 (#628, Grotta Pelos: Pelos). For similar pieces on Crete, see S. Xanthoudides *ArchDelt* 4 (1918) 147, fig. 7.31–33; 151, fig. 9.73.

5. Cycladic Collared Jar
Ca. 2500 B.C.

A typical Early Cycladic form. Comparisons with similar shapes elsewhere suggest an Early Cycladic II date for this vase.

DIMENSIONS: H. 12.6 cm.; Diam. of rim 7.1 cm.; Diam. with lugs 9.1 cm.; Diam. of foot 5.7 cm.

CONDITION: Intact, but with minor chipping on foot.

SHAPE AND DECORATION: Footed, collared jar in dark clay covered in buff slip. Foot is trumpet-shaped, vertical lug-handles are pierced, and the rim is outturned. Diagonal incisions appear on lower body, and just below neck are two zones of incised herringbone.

BIBLIOGRAPHY: Unpublished.

LITERATURE: Thimme, *Cyclades* 139, fig. 129.2, and compare 525–28 nos. 369–87; Doumas, *Burial Habits* 20, fig. 8.0; 23, fig. 12h; Doumas, *Cycladic Art* 156 no. 191 (#232, Keros-Syros: Amorgos).

6. Cycladic Pear-Shaped Flask
Ca. 2700 B.C.

Based on its shape and decoration, this globular pear-shaped flask with vertical lug-handles and incised decoration belongs squarely within the Kampos Phase (EC I/II).

DIMENSIONS: H. 11.5 cm.; Diam. of rim 2.8 cm.; Max. Diam. 9.6 cm.

CONDITION: Broken and repaired; one lug-handle lost.

SHAPE AND DECORATION: Flask with globular body and conical neck with out-turned rim in burnished dark reddish brown clay. Incised herringbone pattern appears on body with zones separated by vertical lines. Below neck are two vertical tubular lug-handles.

BIBLIOGRAPHY: Unpublished.

LITERATURE: For a very similar jar from Ano Kouphonissi, see Zapheiropoulou, 35, fig. 3a (Kampos Group); Doumas, *Cycladic Art* 74, fig. 37 (Kampos Group). On Crete, see S. Xanthoudides *ArchDelt* 4 (1918) 150, fig. 8.49.

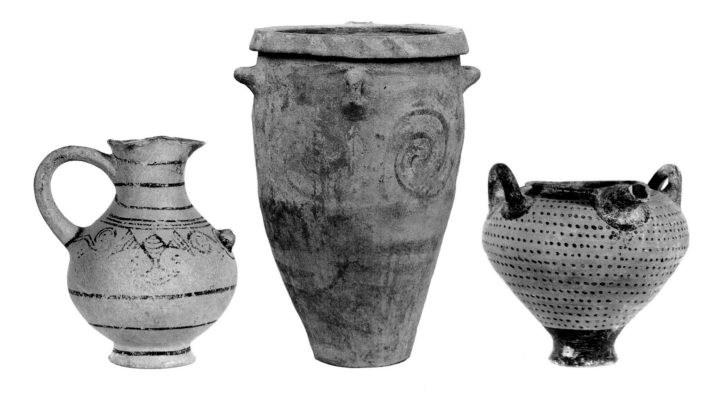

2

CYCLADIC NIPPLED BEAKED JUG

Ca. 2000–1700 B.C.
Gift of Gilbert M. Denman, Jr.
86.134.194

This jug, ornamented with plastic "breasts," comes from one of the Cycladic islands of the Aegean. Its decoration is typical of Middle Cycladic vases, especially at Phylakopi on the island of Melos, and it is entirely possible that our vase comes from there. HWH

DIMENSIONS: H. 10.9 cm.; Max. Diam. 8 cm.; Diam. of base 3.9 cm.
CONDITION: Intact; surface eroded on neck.
SHAPE AND DECORATION: Globular body in buff clay with pinched mouth; short conical base with concave undersurface. Decoration consists of a band at the base, two bands on the lower body and a hatched design on body (curvilinear style) in dark brown paint.
BIBLIOGRAPHY: Unpublished.
LITERATURE: For similar vases, see *Excavations at Phylakopi in Melos* (London 1964) pl. XIV.6a (City II.ii, Middle Cycladic early); E.J. Forsdyke, *Catalogue of the Greek and Etruscan Vases in the British Museum* vol. I, pt. 1 *Prehistoric Aegean Pottery* (London 1925) 62, fig. 72.

3

STORAGE JAR

Ca. 18th–17th century B.C.
Gift of Gilbert M. Denman, Jr.
85.106.3

Two-handled storage vessels such as this are commonly found in Minoan storage areas, including in the palaces at Knossos and Phaistos. With its characteristic light-on-dark decoration, it dates to the earlier palace period on Crete. HWH

DIMENSIONS: H. 78.5 cm.; Diam. of mouth 47 cm.; Diam. of foot 22.5 cm.
CONDITION: Complete and mended except for bottom wall.
SHAPE AND DECORATION: Conical jar (slightly concave lower in body) in coarse brown clay (black at surface) with two horizontal handles and one vertical handle just below rim. Decoration in cream paint on black surface: band at base; main zone of running spiral, with two bands below; narrrow bands at body top; oblique dashes on rim.
BIBLIOGRAPHY: Unpublished.
LITERATURE: For a similar jar from Knossos, see A. Evans, *The Palace of Minos at Knossos* vol. II, pt. I (New York 1964) pl. IXd1 (h. 0.75), with which this example may be compared in the proportion of height to width. G. Walberg has dated the Knossos example to Classical Kamares (Type 100): *Kamares* (Uppsala 1976) 45.

4

MINOAN (OR MYCENAEAN) HOLE-MOUTH JAR

Ca. 1500 B.C.
Gift of Gilbert M. Denman, Jr.
85.106.2
Variegated stone pattern

The hole-mouthed jar is a very common form in the early part of the Late Bronze Age, both in Greece and on Crete. It is not easy to decide where the San Antonio vase was manufactured, since fine vases of this period from Greece and Crete are often extremely similar in fabric and finish.
 HWH

DIMENSIONS: H. of rim 15.3 cm.; H. of handle 16.7 cm.; Diam. of rim 10.1 cm.; Max. Diam. 17 cm.; Diam. of foot 5.6 cm.
CONDITION: Intact; spalling on body and intentionally pierced hole on upper foot.
SHAPE AND DECORATION: Footed conical body with two horizontal handles and a bridge spout. Covered in dark buff slip and decorated with brown to dark brown paint: broad band at foot; broad band at body top/rim; variegated stone in reddish brown clay. Handles and spout are painted solidly.
BIBLIOGRAPHY: Unpublished.
LITERATURE: For a comparable jar, see Mountjoy 13–14, fig. 6. For the shape and motif, see Furumark, *MPA* shape 100 and motif 76.1.

5

MYCENAEAN TRANSPORT
STIRRUP JAR
13th century B.C.
Gift of Gilbert M. Denman, Jr.
86.134.17
Octopus decoration; incised "Cypro-
Minoan" sign on each handle

This vase, called a "stirrup jar" from
the two stirrup-shaped handles, was
probably manufactured in Greece and
exported to Cyprus. It belongs to an
Aegean type exported throughout the
eastern Mediterranean, found in mar-
kets as far afield as South Italy in the
west to Cyprus and Egypt in the east.
These vases were used to transport
olive oil and wine in bulk.

The octopus motif is typical for these
jars. The San Antonio vase bears a
highly stylized version developed from
a motif first appearing on Cretan pot-
tery some two centuries earlier.

A sign in the so-called Cypro-Mi-
noan script can be seen incised on each
handle. It is of a script that was used
widely on Cyprus and in the Levant,
but its significance is uncertain. It may
be an indication of the importer, ex-
porter, owner, destination, or origin.

HWH

DIMENSIONS: H. 35.8 cm.; Diam. of
spout 5.4 cm.; Max Diam. 25.2 cm.;
Diam. of base 9.6 cm.
CONDITION: Broken and repaired.
SHAPE AND DECORATION: Furumark,
MPA Shape 164 in coarse brown clay
with inclusions (mostly purple and
brown) and covered with brown slip.
Decoration is in dark brown paint: band
at base; displayed octopus on front, with
tentacle from each side encircling body as
a deep wavy line, and two tentacles
springing from head running up either
side of spout. Two bands appear at bot-
tom and top of main zone. A band con-
nects bases of handles and false neck, and
spout and false neck; loops on shoulder at
back; band around false neck base, an-
other at spout rim; a band on each handle
joins on disk to form circle. The strokes
of the incised sign on each handle are
fairly deep and even (especially on one
handle), with little chipping.

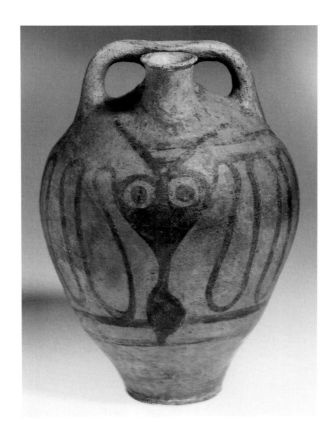

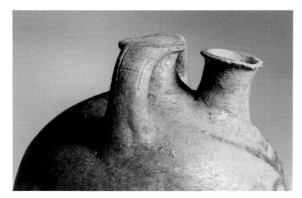

BIBLIOGRAPHY: Unpublished.
LITERATURE: For the octopus motif in
Cyprus, see H. W. Catling and V. Kara-
georghis, "Minoika in Cyprus," *BSA* 55
(1960) 108–27. For a discussion of
Cypro-Minoan signs on transport stirrup
jars, see H. W. Haskell, "Were LM III B
Inscribed Stirrup-Jars Palatial?," *Kadmos*
25 (1986) 85–86.

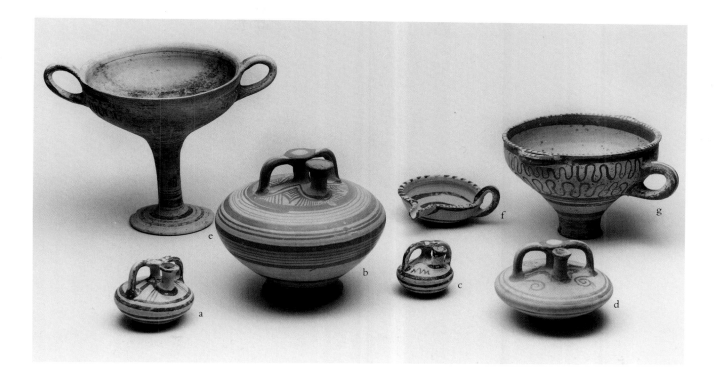

6

MYCENAEAN GREEK TOMB GROUP, POSSIBLY FROM CYPRUS
Late 14th–13th century B.C.
Gift of Gilbert M. Denman, Jr.
85.106.1 a–g

Seven vases found together are thought to belong to a single tomb group. While most of the vases were manufactured in Greece, some at or near Mycenae, one (Cup, Cat. No. 6g) is a Mycenaean type vessel made on Cyprus. This gives a possible location for the tomb on Cyprus.

It is possible that the tomb was intended for Mycenaean settlers on Cyprus. Four of the vases of this group are stirrup jars, common offerings in Mycenaean tombs. These vases may have contained fine perfumed oil (perhaps imported from the Aegean) and, as such, are the Bronze Age equivalent of the classical lekythos. The other pots are drinking vessels, also found fairly commonly in Mycenaean tombs.

Several of the vases can be dated on the basis of their shape or decoration to the late 14th–13th cent. B.C. (LH IIIA:2–IIIB), and so the tomb must be of that period. H W H

a. Mycenaean Stirrup Jar

DIMENSIONS: H. 6.4 cm.; Max. Diam. 7.2 cm.; Diam. of base 2.5 cm.
CONDITION: Broken and repaired.
SHAPE AND DECORATION: Biconical in buff clay with light buff slip. Decorated in reddish-brown to brown paint: band at base and on body; vertical line groups on shoulder; bands along edges of handles and spout rim; spiral on disk.
BIBLIOGRAPHY: Unpublished.
LITERATURE: For the shape, see Furumark, *MPA* shape 180 (IIIB date).

b. Mycenaean Stirrup Jar

DIMENSIONS: H. 14.4 cm.; Max. Diam. 16 cm.; Diam. of base 7.8 cm.
CONDITION: Intact; spalling on body.
SHAPE AND DECORATION: Biconical body with conical foot in light reddish brown clay with light brown slip. Decoration in orange-red paint: band at base; line groups between bands on body; on shoulder, multiple stem and tongue. Double line connects bases of handles, spout, and false neck.
BIBLIOGRAPHY: Unpublished.
LITERATURE: For a similar vase which belongs to the IIIB:1 period, see Mountjoy 93, 106–08, and 107, fig. 131.1. For the motif, see Furumark, *MPA* motif 19 (IIIA:2); also compare Furumark motif 19 with Furumark motif 69, filled (IIIA:2) and chevrons Furumark motif 58.25–26

(IIIA:21). For a similar shape, see Furumark shape 182 (IIIB:1).

c. Miniature Aegean Stirrup Jar

The rather carelessly rendered features of this tiny stirrup jar do not allow for close dating or provenance.

DIMENSIONS: H. 5.4 cm.; Max. Diam. 5.4 cm.; Diam. of base 2.4 cm.
CONDITION: Intact.
SHAPE AND DECORATION: Squat biconical body, with tall false neck assembly and spout in buff clay. Decoration in dark brown paint: single bands on body; vertical zigzag on shoulder; band connects bases of false neck, handles, spout; vertical band on each handle, circle at disk edge; band at spout top.
BIBLIOGRAPHY: Unpublished.

d. Aegean Stirrup Jar

DIMENSIONS: H. 8 cm.; Max. Diam. 10.9 cm.; Diam. of base 4.2 cm.
CONDITION: Broken and repaired.
SHAPE AND DECORATION: Biconical stirrup jar with torus base in buff clay and slip. Decoration in brown paint: bands at base and on body; on shoulder, stemmed spirals with streamers; single band connects bases of handles, spout, and false neck; circle on disk; band at spout top/rim.

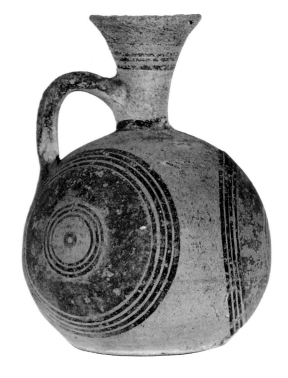

BIBLIOGRAPHY: Unpublished.
LITERATURE: For a similar jar, see
Mountjoy 107, fig. 130.1 (IIIB). For the
shape of this jar, see Furumark, *MPA*
shape 183 (IIIB).

e. Stemmed Mycenaean Kylix
Linear decoration

This popular drinking cup shape is
found in abundance at Mycenaean sites.
With its long, narrow stem, it stands at
an advanced stage in the evolution of
this type.

DIMENSIONS: H. 18.5 cm.; Diam. of rim
17 cm.; Diam. with handles 23.2 cm.;
Diam. of foot 8.7 cm.
CONDITION: Intact; chipping on foot.
SHAPE AND DECORATION: Stemmed
kylix in buff clay. Decoration in dark
brown paint: band/line groups on stem;
near top of bowl U pattern with vertical
line running down below every other U;
row of dots below rim.
BIBLIOGRAPHY: Unpublished.
LITERATURE: For a similar shape, see Fu-
rumark, *MPA* shapes 257-59,265
(IIIA:21). For the motif, see Furumark
MPA, motif 45.1

f. Mycenaean Spouted Cup with
High-Swung Handle

DIMENSIONS: H. 3.5 cm.; Diam. of rim
9.1 cm.
CONDITION: Cup unbroken; handle bro-
ken and repaired.
SHAPE AND DECORATION: Shallow
spouted cup with high-swung handle in
buff clay and slip. Decoration in reddish
brown paint; bands on body, dashes on
rim; vertical bands on handle; bands on
interior.
BIBLIOGRAPHY: Unpublished.
LITERATURE: For the shape, see Furu-
mark, *MPA* shape 253 (IIIB).

g. Cypro-Mycenaean Cup

This cup, imitating a Cypriote shape in
Mycenaean fabric and finish, suggests a
Cypriote location for this tomb group.
DIMENSIONS: H. 11.5 cm.; Diam. of rim
16 cm.; Diam. with handles 17.9 cm.;
Diam. of foot 4.4 cm.
CONDITION: Unbroken; drill hole
through base.
SHAPE AND DECORATION: Conical/piri-
form cup in reddish buff clay with light
buff slip. Narrow base, outflaring rim.
Vertical loop handle on bowl, two hori-
zontal loop handles at rim. Decoration in
reddish paint; broad band at foot above
which are band-line groups; main zone
with two registers of deep wavy line;
band at rim; dashes on rim, band at top of
interior.
BIBLIOGRAPHY: Unpublished.
LITERATURE: For the shape, cf. V. Kara-
georghis, *Excavations at Kition* I (London
1974) pl. LIV.12, CXLIII.12, imitation
BR II ware (see pp. 44, 58); idem, *Nou-
veaux Documents pour l'étude du Bronze Ré-
cent à Chypre* (Paris 1965) 206, no. 4; 207,
fig. 48.1, pl. XV.3–4; P. Åström, *Swedish
Cyprus Expedition* vol. IV (Stockholm
1948), pt. 1C, 363 (IIIA:2). For the motif,
see Furumark, *MPA* motif 52.14 (IIIB).

7

CYPRIOTE BICHROME JUG
Ca. 800–700 B.C.
Museum Purchase:
Stark-Willson Collection 86.138.88

DIMENSIONS: H. 13.2 cm.; Diam. of rim
4.2 cm.; Diam. of body 9.4 cm.; Diam. of
base 6 cm.
CONDITION: Complete. The surface is
worn around the mouth.
SHAPE AND DECORATION: Squat jug
with flat base, globular body, narrow
neck flaring out to a trumpet mouth. A
small round handle attaches to the neck
and shoulder. Decoration consists of lines
on the neck, three large concentric circle
ornaments around the body, and stripes
down the handle. Shape and decoration
place this small vase in Bichrome III of
Gjerstad's pottery classification for
Cyprus. It therefore belongs to the
Cypro-Geometric III or early Cypro-
Archaic I period.
ADDED COLOR: Red for the band on the
upper neck, and for the broad middle cir-
cle of the concentric circle ornaments.
Provenance: Ex coll. Stark (Orange,
Texas).
BIBLIOGRAPHY: Unpublished.
LITERATURE: For the shape and style, see
E. Gjerstad, *Swedish Cyprus Expedition* IV
(Stockholm 1948), pt. 2, 61–62, figs.
22.6, 9, and 10. GPS

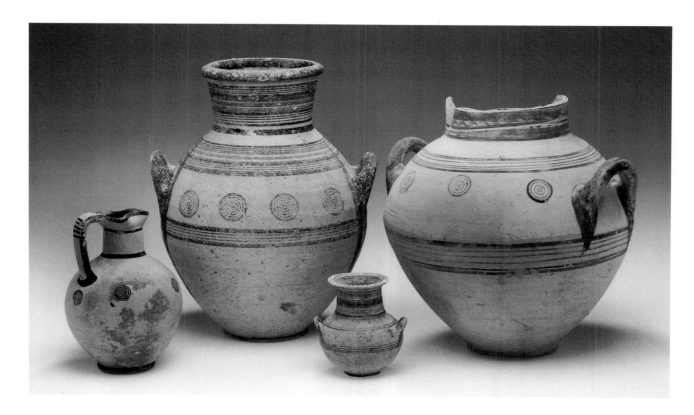

8

FOUR CYPRO-ARCHAIC VASES
Ca. 650–550 B.C.
Gift of Gilbert M. Denman, Jr.
86.134.18–21

DIMENSIONS: Jug (86.134.18) H. to handle top 18.9 cm.; Diam. of body 13 cm.; Diam. of foot 6.5 cm. Amphora (86.134.19) H. 33.9 cm.; Diam. of rim 14.4 cm.; Diam with handles 26.8 cm.; Diam. of foot 10.4 cm. Amphora (86.134.20) Preserved H. 30.2 cm.; Diam. with handles 30.5 cm.; Diam. of foot 10.5 cm. Amphoriskos (86.134.21) H. 11.2 cm.; Diam. of rim 6.7 cm.; Diam. with handles 10.3 cm.; Diam. of foot 4 cm.
CONDITION: All are preserved complete with the exception of one of the amphoras (86.134.20) which is missing its rim and part of the neck. A deep groove was incised around its neck in antiquity, perhaps for a cord or thong, later causing the neck to break at this point. The jug

has two dents in the body made during stacking in the kiln.
SHAPE AND DECORATION: The jug belongs to the White Painted IV style; the two amphoras and the amphoriskos are all probably Bichrome V. Except for the amphoriskos, which is a rarer shape, these vases are common Cypro-Archaic types, most frequently found in southern and eastern Cyprus.
ADDED COLOR: Amphora (19): group of 3 red lines on the neck and another on the shoulder. Amphora (20): red band on the neck just below the break. Amphoriskos (21): red band on the neck.
BIBLIOGRAPHY: Unpublished.
LITERATURE: For a comparison of the shape and decoration, see E. Gjerstad, *Swedish Cyprus Expedition* IV (Stockholm 1948), pt. 2, 56–57, fig. 29.13a (jug); 66–67, figs. 48.8, 50.8 (amphoras); 51.1 (amphoriskos). **GPS**

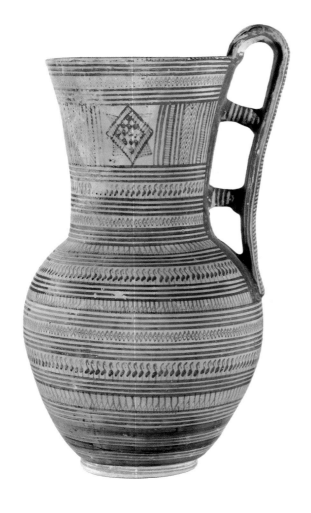

His work is careful and distinguished by the groups of four horizontal lines instead of the normal three to separate each ornament band.

BIBLIOGRAPHY: Unpublished.

LITERATURE: For the Soldier-bird Workshop, see *GGP* 64–65. For three pitchers by the same hand, but perhaps of earlier date, see *GGP* pl. 12a (Athens NM 18432); *CVA* (Munich 3) pl. 114.1–2; *ArchEph* (1898) pl. 3.6 (Eleusis 708).

10

ATTIC LATE GEOMETRIC/ EARLY PROTOATTIC NECK-HANDLED AMPHORA (LOUTROPHOROS)
Attributed to the Analatos Painter
Ca. 700 B.C.
Gift of Gilbert M. Denman, Jr.
86.133.23
A and B (Body): Procession of five chariots and one man on foot
(Neck): Sphinxes

The main panel on each side of the neck is decorated with a pair of sphinxes processing to the right. Each creature has a human head with long wiglike hair, wings, one of which droops down behind the front legs of the monster, and feline body. Two arms (rather than one arm in outline) extend from the chest of each sphinx and hold a bush with three pairs of inward curling branches. Long tendrils spring from the head of each sphinx.

The main scene on the body depicts a procession of five two-horse chariots each driven by a single figure holding a rod. A lone male figure walks between two of the chariots where the artist has left a little space. Minor figured friezes on the neck and shoulder consist of grazing goats to left (three on Side A, four on Side B), centaurs with human forelegs walking to right and holding a branch in each hand (three on each side), and grazing horses to left (three on each side).

This amphora is typical of vases produced especially for Athenian graves. The snakes in added clay on the rim and handles make the vase unsuitable for everyday use. They are meant as symbols of the Underworld. Likewise the early representations of sphinxes on the neck may be taken as *daemones* or spirits of the dead. The chariot procession on the body was commonly repre-

9 COLOR PLATE II

ATTIC LATE GEOMETRIC OINOCHOE
Soldier-bird Workshop
Ca. 730–720 B.C.
Gift of Gilbert M. Denman, Jr.
86.134.22

Decorated by the main painter of the Soldier-bird Workshop, this vase is unusual for him in having no prominent zone of decoration on the body comparable to the panels on the neck. Nevertheless, the three files of closely packed birds, the neatly done metopal panels with lozenge-stars, and the use of four horizontal lines between bands of ornament are typical for this painter's work. GPS

DIMENSIONS: H. at rim 46.3 cm.; H. at top of handle 50 cm.; Diam. of rim 21.1 cm.; Diam. of body 25.4 cm.; Diam. of foot 12.6 cm.

CONDITION: Broken and restored. Several pieces are missing, restored in plaster and repainted.

SHAPE AND DECORATION: The oinochoe sits on a low ring base and has a steeply rising wall curving inward to a tall, concave neck with no distinct rim. A long vertical strap handle rises from the lip, then curves down to the shoulder, and is reinforced by two struts joining the handle to the neck of the vase. This is the most common shape painted by the Soldier-bird Workshop. Four of the five other vases attributed to this painter by J. N. Coldstream are oinochoai of the same type. The three metopes in the broad zone of the neck are filled with lozenge-stars, a motif favored by this painter. Above this zone is a band of dotted lozenges, and below are "soldier" birds, and more lozenges. The body has only narrow bands of ornament, including three with dotted lambdas, two with "soldier" birds and one more with dotted lozenges. The painter has used each of his minor ornaments three times on the vase (dotted lozenges, "soldier" birds and dotted lambdas) never repeating an ornament in the band below, but also not using a repetitive pattern of the three ornaments.

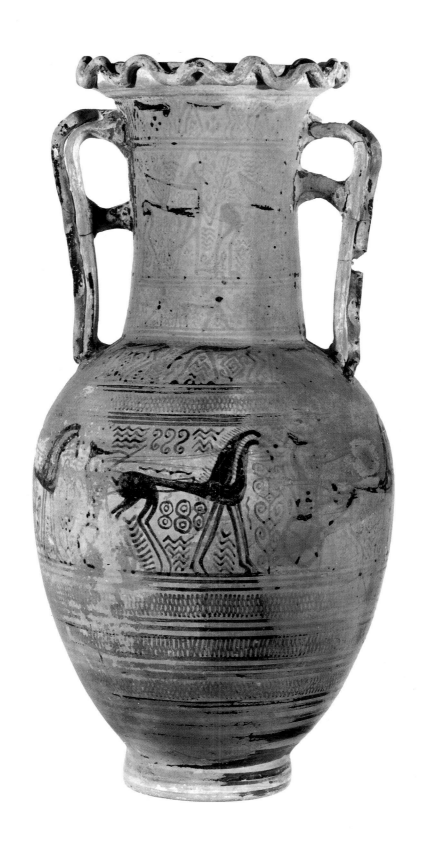

sented on Attic funerary vases, signifying a military, perhaps even heroic procession in honor of the dead man, accompanying the bier to the grave. It is interesting that two horses pull each chariot rather than a single horse found more commonly in early Protoattic.

This vase is an important early work of the Analatos Painter, the most significant figure in the development of early Protoattic vase painting. Learning his art from the Stathatou Painter, he adopted the new orientalizing motifs and transformed his figures from abstract depictions to coherent "viable" beings. The frieze of goats (or deer?) is similar to ones on vases by the Analatos Painter in Athens and Eleusis, but the closest comparison for composition and style is an amphora in Oxford (1936.599) attributed by J. M. Cook to the earliest phase of the Painter's career. The chariot procession is very similar, though on the San Antonio vase the filling ornament is more varied and there are still two horses pulling the chariots. A frieze of horses can also be seen on the Oxford vase, but with raised heads rather than grazing. A hydria recently acquired by the National Gallery of Victoria (Melbourne) is a slightly earlier work of the Analatos Painter still largely Geometric in style. The San Antonio vase shows freer use of curvilinear ornament, typical of the new Protoattic style.

The rendering of the sphinxes on the San Antonio vase is particulary novel, depicted with arms holding branches, a second wing drooping down below the body, and a volute tendril sprouting from the head. Both sphinxes and centaurs are new types in the Painter's repertoire.　　GPS

DIMENSIONS: H. 47.1 cm.; Diam. of rim 15.7 cm.; Diam. of body 22.8 cm.; Diam. of foot 10.5 cm.

CONDITION: The handles and base have been broken and repaired. Complete except for pieces of one handle-snake. The paint has peeled over large areas leaving a "shadow" on the vase surface.
SHAPE AND DECORATION: The Geometric neck amphora became more elongated over time with a high neck and long handles from the top of the neck to the shoulder. Eventually the handles needed to be reinforced either by a strut or a perforated strip of clay between neck and handle. This shape came to be called a loutrophoros from its special use in carrying ceremonial bath water for marriages. It was commonly used as a marker on graves of people who died unmarried, and so was decorated with funerary scenes. Stylistically the decoration on this vase has passed beyond the boundaries of the Geometric style and into the sphere of Protoattic vase painting, with new curvilinear ornaments and orientalizing floral motifs. It is therefore a noteworthy transitional piece between the two styles. The drooping wing below the body of the sphinxes is probably a misunderstanding of the area between the forelegs of Egyptian sphinxes as J. M. Cook noted.
BIBLIOGRAPHY: Unpublished.
LITERATURE: For the Analatos Painter, see J. M. Cook, "Protoattic Pottery," *BSA* 35 (1934–35) 172–76; J. M. Davison, "Attic Geometric Workshops: The Early Orientalizing Group," *YCS* 16 (1961) 51–52, 149; J. M. Cook, "Review of Brann, Agora VIII," *Gnomon* (1962) 821–22; E. Brann, "An Early Protoattic Amphora," *AJA* 64 (1960) 71–72; R. Hampe, *Ein Frühattischer Grabfund* (Mainz 1960) 30–35; Brann, *Agora* VIII; J.M. Cook, "A Painter and His Age," *Mélanges André Varagnac* (Paris 1971) 167–76. For the Melbourne Hydria, see R. G. Hood, "A New Greek Vase of c. 700 B.C.," *Art Bulletin of Victoria* 23 (1982) 38–50. For the area between the forelegs of Egyptian sphinxes, see J. M. Cook, *BSA* 35 (1934–35) 177, no. 2.

11

EARLY PROTOCORINTHIAN PYXIS AND LID

Ca. 700 B.C.
Gift of Gilbert M. Denman, Jr.
86.100.2a,b

The cylindrical pyxis is primarily a Protocorinthian shape which experiences a number of subtle variations in form to both the body and the lid. On this example the lid carries a flat knob and the vase has reflex rolled handles set horizontally. The zigzag waves in the handle zone recall the rows of wirebirds, themselves degenerate soldier-birds, which filled the reserved space between the handles on Late Geometric and Early Protocorinthian vases.

The decoration consists of subgeometric linear design. A series of thin, concentric bands encircles the body of the vase except in the handle zone. Here, alternating vertical bars and zigzag waves in sets of four occupy the space between the handles. A horizontal line is on each handle. The underside of the vase is blank. The interior is solid glaze except for two reserved rings near the lip. Thin concentric bands encircle a broad one around the knob, which bears two concentric circles about a large dot.　　KKII

DIMENSIONS: H. of rim 5 cm.; H. with lid 7.4 cm.; Diam. of rim 9.1 cm.; Diam. with handles 11.5 cm.; Diam. of lid 9.3 cm.
CONDITION: Both pyxis and lid unbroken. Chipping on rim of Side B of pyxis; abrasion to left of A/B handle. Center of Side B body is misfired.
BIBLIOGRAPHY: Unpublished.
LITERATURE: For the shape, decoration, and date, see Johansen, 82–83, there called "pyxis plates"; C. Brokaw, "The Dating of the Protocorinthian Kotyle," in *Essays in Memory of Karl Lehmann*, ed. L.F. Sandler (New York 1964) 49–54; *GGP* 104–11, there called a "flat pyxis"; *CorVP* 428, 446–47.
PARALLELS: For the shape and decoration of the San Antonio pyxis cf. Johansen, pl. 18,1; and Brokaw, in *op.cit.* fig. 19.

11

11

12

12

12

MIDDLE PROTOCORINTHIAN KOTYLE AND FOREIGN LID
Ca. 675 B.C.
Gift of Gilbert M. Denman, Jr.
86.100.1a, b

A row of zigzag waves fills the open space between several vertical bars in the handle zone on either side of the vase. Concentric bands fill the middle area of the vase exterior and tall glazed rays rise from the foot on the lower portion. A glazed ring encircles the underside of the foot. A horizontal line decorates each handle. The interior of the vase is solid glaze. The lid, which does not belong to the kotyle, is decorated with thin concentric bands

around a thick one, all circling a knob decorated with more thin bands.

KK II

DIMENSIONS: H. of rim 7.4 cm.; Diam. of rim 9.3 cm.; Diam. with handles 13.6 cm.; Diam. of foot 3.1 cm.; Diam. of lid 10.1 cm.
CONDITION: Kotyle unbroken except for V-shaped restored fragment encompassing one handle. Lid restored from fragments.
SHAPE AND DECORATION: The shape appears in the Corinthian repertoire at the beginning of the Late Geometric period (e.g. kotyle in Vlasto Coll., and Athens 14476). The shape becomes slimmer and taller in time, reaching its most pointed form during Middle Protocorinthian (cf.

Johansen, p. 77, fig. 47). It is at this time that the base-rays first appear on this shape. As with the zigzag waves on the earlier pyxis above (Cat. No. 17), those on this kotyle are derived from the wire-bird motif which was popular on Early Protocorinthian kotylai.
BIBLIOGRAPHY: Unpublished.
LITERATURE: For the shape, decoration, and date, see Johansen, 77–79, there called "skyphos sans rebord"; C. Brokaw, "The Dating of the Protocorinthian Kotyle," in *Essays in Memory of Karl Lehmann*, ed. L. F. Sandler (New York 1964) 49–54; *GGP* 107–11; *CorVP* 428, 457–59. For the kotyle in the Vlasto Collection in Athens, see Brokaw, *op.cit.* fig. 1; for Athens 14476, see *GGP*, pl. 19, K-1.

13

**LATE PROTOCORINTHIAN
BLACK-POLYCHROME OLPE**
Related to the Chigi Group
Ca. 640–630 B.C.
Gift of Gilbert M. Denman, Jr.
86.134.176

A carefully drawn scale-pattern in the black-polychrome technique covers the upper half of the body. The design is created by compass-drawn, overlapping semicircles with red paint applied to alternating scales. A thick white dot fills the center of each scale. Beneath the scale-pattern are twelve purple bands, the top one overlaid with white paint, over the black glaze field. Black rays in a reserved field spring from the narrow foot-ring. A molded ring separates the body from the concave neck which is decorated with seven white dot-cluster rosettes over the black glaze. Traces of red paint, perhaps once in bands, are visible on the neck. A ribbed vertical handle was once covered with black glaze. A white dot-cluster rosette is placed on the body beneath the base of the handle and one each on the rotelles

where the handle joins the mouth of the vase. A black-glaze band circles the underside of the vase adjacent to the foot-ring.

The Chigi Group encompasses a number of finely decorated vases considered to be of "le style magnifique" by Johansen and in "the Macmillan Painter's workshop" by Dunbabin and Robertson. The most distinguished vase painter in this Group is the Chigi Painter, renowned for his magnificent black-figure olpe in Rome. Other artists in the Chigi Group favored the black-polychrome technique in decorating non-figured olpai and oinochoai. The application of rich polychromy and the carefully incised pattern of scales often with white dots are characteristic of vases in the Group. K K II

DIMENSIONS: H. of rim 25.4 cm.; H. to handle 27.1 cm.; Diam. of rim 12.5 cm.; Max. Diam. 18.2 cm.; Diam. of foot 10.1 cm.

CONDITION: Broken and repaired with small areas of restoration to left of handle and on front. Abrasion and glaze loss on

handle, neck, lip, and on lower body to the right of handle. Encrustation on handle.

SHAPE AND DECORATION: This olpe is one of the earliest of its type, which first appears in the Corinthian repertoire during the Late Protocorinthian period. Its origins are unclear, but the shape may derive from an Attic Late Geometric form, if not from East Greek prototypes which are still lacking from the period in question. Payne states (NC 272) that "the earliest Protocorinthian type is thick-set and bulky" (a description which fits this olpe well), becoming narrower with a taller neck in time. The profile of this olpe can be compared closely with those of early examples in Heraklion (NC pl. 8, 4) and in the Vatican (Johansen 103, fig. 56). Both of these olpai bear black-polychrome scale patterns and are in the Chigi Group. Payne (NC 19, n.2) suggested that the black-polychrome style (his term) in scale-patterns derived from textiles or embroideries (he compares the drapery patterns on the contemporary Auxerre Kore) which, in turn, were inspired perhaps by Assyrian glazed tiles. The shape is also close to a black-polychrome olpe, with similar polychrome banding over the lower part, by an artist near the Aegina Bellerophon Painter (CorVP pl. 10, 1a), a contemporary of the Chigi Group. Artists practicing the black-polychrome technique in the Chigi Group are more often inclined to provide the scales in their decorative patterns with double incised edges between which are placed the white dots. For the decoration of this olpe compare the Protocorinthian black-polychrome aryballos in Paris with single-edged scales, each with a thick dot in the center (Louvre E 308, CVA 13, pl. 44, 1 and 4).

BIBLIOGRAPHY: Unpublished.

LITERATURE: For the Chigi Group, see especially Johansen, 98–99; NC 94–97, 272; T. J. Dunbabin and M. Robertson, "Some Protocorinthian Vase-Painters," BSA 48 (1953) 178–80; J. L. Benson, Die Geschichte der korinthischen Vasen (Basel 1953) 16–19, lists 10–12, 15; CorVP 31–40, 302, and 334. For the black-polychrome technique, see NC 19–20; CorVP 370, 480, and 540. For the Protocorinthian olpe shape, see NC 272; CorVP 488.

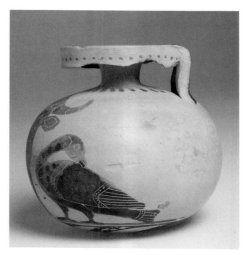

14

EARLY CORINTHIAN
BLACK-FIGURE ARYBALLOS
Attributed to
the Basel Ox-Head Painter
Ca. 600 B.C.
Gift of Gilbert M. Denman, Jr.
85.119.9
Frontal ox-head
between antithetical birds

A rectangular-shaped ox-head confronts the viewer with large staring eyes tipped with single incised lines and set within bulging eye sockets. Parallel arcs cut in from the eyes. Beneath these is a marked triangular area filled with curved bands and, at the bottom of the face, the flattened nostrils of the ox. On either side of the ox-head is a bird with folded wings and a long neck, the head turned backward to allow the beak to prune the wing feathers. The area beneath the vertical handle on the back side of the vase is blank and the entire figure zone is devoid of subsidiary ornamentation.

The Basel Ox-Head Painter is perhaps the most exacting of a number of Early Corinthian artists who decorated round aryballoi with frontal ox-heads. These vases belong to the Lion Group in which a number of subjects selected for decoration, like the frontal ox-head, duplicate those on the shield-blazons. This aryballos is an excellent example of the Group, with its choice of subjects, polychrome style, and fine subsidiary decoration on the mouthpiece, handle, and underside of the vase.

KK II

DIMENSIONS: H. 7.1 cm.; Diam. of rim 4.4 cm.; Max. Diam. 7.4 cm.
CONDITION: Broken and repaired. Fragment, including portion of the painted wing of bird to left of ox-head, restored. Minor chipping underneath lip. Figural decoration misfired.
SHAPE AND DECORATION: The round aryballos in Corinth was designed under Near Eastern influence during the late Protocorinthian period and rapidly reached its zenith in production during the Early Corinthian era. This aryballos is well made. Finely drawn tongues in black glaze between concentric bands are set around the vase mouth and, lacking bands, on the shoulder. There are fine black dots on the vase rim and thick black vertical bands on the handle edges. On the underside of the vase is a six-armed whirligig in black glaze, turning clockwise.
ADDED COLOR: Red paint is used on the ox-head and in dots on the birds' necks and upper wings. There are fine white dots in rows on the ox-head and on the birds' wings.
BIBLIOGRAPHY: Unpublished.
LITERATURE: For the Basel Ox-Head Painter, see J. L. Benson, "Some Notes on Corinthian Vase-Painters," *AJA* 60 (1956) 223; *CorVP* 119–20, pl. 50, 3. For the Lion Group, see *NC* 289, fig. 125; J.L. Benson, *Die Geschichte der korinthischen Vasen* (Basel 1953) 31–32, lists 38–39; *CorVP* 118 ff. and 377. For the shape of the Corinthian round aryballos, see *CorVP* 440–41.

15

**EARLY CORINTHIAN
BLACK-FIGURE KOTYLE-PYXIS**
Ca. 600 B.C.
Gift of Gilbert M. Denman, Jr.
86.134.26
Animal frieze

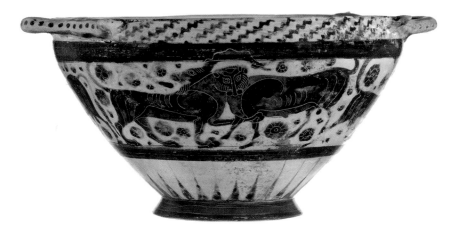

In the primary zone of decoration a
frieze of animals consists of a panther
opposite a bull, a panther with forepaw
raised and overlapping a goat, and a
lion opposite a stag. In the field are
many loosely placed star and petaled
rosettes.

The splendid decoration and excel-
lent draftsmanship exhibited on this
vase place it with other vases painted in
the fine style toward the end of the
Early Corinthian period. The individ-
ual style of the artist recalls that of the
Restauri Painter, a decorator of kotylai,
especially in the facial renderings of his
panthers. Other body markings, such as
the twisting haunch lines and rib lines
that touch the spine, on creatures of
this kotyle-pyxis are similar to those on
felines painted by the Anaploga Painter.

K K II

DIMENSIONS: H. 13.4 cm.; Diam. of rim
22.9 cm.; Diam. with handles 27.9 cm.;
Diam. of foot 10 cm.
CONDITION: Broken and repaired. Re-
stored area in region of hind-quarters of
stag and panther on Side B, and another
obliterating the front leg of lion under
B/A handle. Restored and repainted frag-
ment includes tail of panther on Side A.
SHAPE AND DECORATION: The kotyle-
pyxis is to be distinguished from the
kotyle in that the former is designed to
receive a lid and that it has reflex, spurred
handles as well as busy subsidiary decora-
tion like the concave-sided pyxis. Koty-
lai-pyxides emerge in the Late Geometric
period at Corinth, but are most popular
among vase decorators during the Transi-
tional and Early Corinthian periods. On
the San Antonio vase, polychrome bands
painted over thick black bands separate
the animal frieze from carefully drawn
zigzags on the rim and base-rays below.
More polychrome bands overlay the
black foot. A row of black dots embel-
lishes each handle. Two large glazed
bands decorate the vase interior. The un-
derside of the foot is reserved.
ADDED COLOR: Red paint is applied to
the haunch, ribs, belly, and neck of each
animal. A red band appears between in-
cised lines on the shoulder of the panther
confronting a bull.

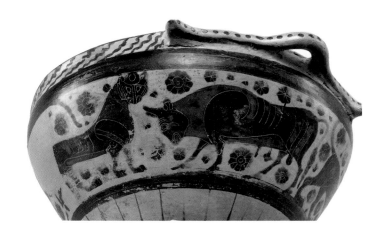

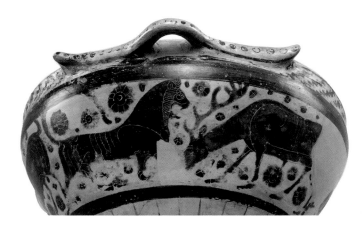

BIBLIOGRAPHY: Unpublished.
LITERATURE: For the Restauri and
Anaploga Painters, see *CorVP* 131–32,
and 139, pl. 54, 3; 55, 1–2. For the
kotyle-pyxis shape, see *GGP* 101;
CorVP 459–60.

16

**MIDDLE CORINTHIAN
BLACK-FIGURE ALABASTRON**
Attributed to the Erlenmeyer Painter
Ca. 590–580 B.C.
Gift of Gilbert M. Denman, Jr.
86.32.1
Spread-winged cock

A wide-eyed cock faces to the right
with both wings raised and spread,
nearly enveloping the entire vase. The
massive wings, which almost touch on
the back of the vase, are decorated with
broad, sweeping bands above parallel
incisions. The rich display of color on
the wings continues on the wattle and
earlobe, as well as the comb of the ma-
jestic bird. The claws and spurs of the
feet are clearly drawn in black glaze,
while the hackles on the neck and tail
coverts are rendered with long parallel
incisions.

A number of Middle Corinthian vase
painters were disposed to decorating al-
abastra with a large, single creature, es-
pecially with spread wings that encircle
the entire vase. The Erlenmeyer
Painter is one of the leading artists of

this period and a specialist in decorating
this shape; over thirty of his alabastra
are extant. All of his known subjects
are winged creatures, whether real or
hybrid. Of these, nearly one third are
cocks, all facing to the right, generally
with one or both wings spread.

The Erlenmeyer Painter, named after
the collector of two of the painter's
alabastra in Basel, was recognized by
Amyx and Benson. Extensive use of
polychromy, especially rows of white
dots, characterize his style and mark
him as a follower of other Early
Corinthian alabastra painters who lav-
ished color in similar ways, such as the
Vaccarella Painter and the Painter of
Delos 330. K K II

DIMENSIONS: H. 20.1 cm.; Diam. of rim
4.7 cm.; Max. Diam. 9.6 cm.
CONDITION: Unbroken. Minor chipping
on lip.
SHAPE AND DECORATION: The
Corinthian alabastron is probably derived
from Near Eastern prototypes and was
used to hold scented oils or perfume. The
size of this vase is typical of Middle
Corinthian alabastra, which are larger
than most Early Corinthian examples.
The handle is perforated and painted

black on the edge. The relatively large
figure zone on this alabastron and others
by the Erlenmeyer Painter are well suited
to the spreading creatures he selects for
the decoration. Surrounding the cock on
this vase are several different types of
floral ornaments including star, globular,
and petaled rosettes. A large ringed dot,
small dots, and "echo" ornaments de-
signed to correspond to the contour of
the bird's profile are also present. On the
mouth, neck, and bottom of the vase are
black-glaze tongues; black dots on the
vase rim.
ADDED COLOR: Red paint is applied to
the comb, wattle, and in thick bands on
the wings and tail of the cock. White is
applied to the cock's earlobe and white
dots appear in rows on its wings and on
the larger field ornaments.
BIBLIOGRAPHY: Unpublished.
LITERATURE: For the Erlenmeyer
Painter, see J. L. Benson, "The Erlen-
meyer Painter," *Antk* 7 (1964) 72–81, pl.
22–25; *CorVP* 160–62 (esp. nos. 25–31)
and 380, pl. 62.1. For the shape of the
Corinthian alabastron in general, see D.
A. Amyx, "The Attic Stelai, Part 3: Vases
and Other Containers," *Hesperia* 27
(1958) 213–17. For the origins of the
Corinthian alabastron, see *NC* 269–70.

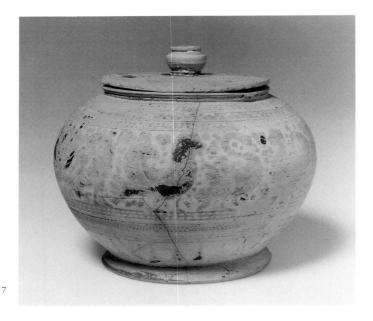

17

17

CORINTHIAN BLACK-FIGURE PYXIS WITH LID
Late Corinthian I, ca. 560–550 B.C.
Gift of Gilbert M. Denman, Jr.
86.134.27 a-b
Animal frieze

A swan flanked by raised-winged sirens is the only deviation from a series of folded and raised-winged birds in the main frieze. A row of raised-winged birds in silhouette (originally lacking incisions?) occupies the lid. K K II

DIMENSIONS: H. of rim 10.5 cm.; H. with lid 12.7 cm.; Diam. of rim 9.6 cm.; Max. Diam. 15.3 cm.; Diam. of foot 10.2 cm.; Diam. of lid 9.7 cm.
CONDITION: There was much repainting of the decoration in modern times, but the entire vase has been recently cleaned leaving only the few traces of ancient glaze in the figured scenes.
SHAPE AND DECORATION: The shape is that of the convex pyxis without handles and of the Type B variety (minimal neck). The lid, which can have a variety of knob designs, rests directly on the edge of the mouth. The shape has been traced back into the Protogeometric era at Corinth, but was primarily produced during the Middle and Late Corinthian periods. Subsidiary decoration on the lid consists of double concentric bands and a row of dots above, a single concentric band with a row of dots below the painted scene. Three sets of double row dicing motifs appear above and below the frieze course on the body. Base-rays appear above the foot.

ADDED COLOR: There are traces of added red paint on the animals decorating the vase.
BIBLIOGRAPHY: Unpublished.
LITERATURE: For the shape, see D. Callipolitis-Feytmans, "Origine de la pyxis convexe et sans anses à Corinthe," *ArchEph* (1973) 1–18; *CorVP* 448–49.

18 COLOR PLATE III

CARIAN (EAST GREEK) OINOCHOE
Ca. 625–600 B.C.
Gift of Gilbert M. Denman, Jr.
86.134.24
Shoulder: Water bird

In an irregularly shaped panel in the center of the shoulder a water bird walks to right, its body decorated with stripes in careless imitation of a feather pattern. As is common in the East Greek style, the figure is surrounded by a variety of geometric and floral filling ornaments.

The style and shape of such vases imitate contemporary East Greek vases which were produced in Ionian cities like Miletus. This, together with the likely provenance, suggests that the San Antonio example was produced by a provincial workshop likely located in a Carian city to the south of Miletus.
 GPS

DIMENSIONS: H. to rim 25.2 cm.; H. to top of handle 27 cm.; Diam. of body 20.3 cm.; Diam. of foot 10.8 cm.

CONDITION: Complete.
SHAPE AND DECORATION: The oinochoe has a low ring base, rounded body, low cylindrical neck, and trefoil lip. The two-reed handle rises from the lip and attaches at the lower shoulder. The exterior is slipped. Bands of paint are found on the lip, between thin lines on the body, and on the base. The shoulder is divided into three panels separated by vertical meander patterns. The central panel is decorated with a simple water bird surrounded by filling ornaments; the side panels by pendent rays. The handle has rows of blobs.
PROVENANCE: The three Carian vases Cat. Nos. 18, 19 and 20 belong to an unusual group of pots said to be from an ancient cemetery in Caria, a site near the coast of western Turkey.
BIBLIOGRAPHY: Unpublished.
LITERATURE: For the shape and fabric, see P. Gercke, *Funde aus der Antike, Sammlung Paul Dierichs, Kassel* (Kassel 1981) 28–75, nos. 1–35 (for the shape and decorative scheme, see esp. nos. 10 and 14); *Archaeologica Traiectina* 14 (1980) 74–79; R.M. Cook, "Antecedents of Fikellura," *Anadolu* 21 (1978–80) 71–74.

19

CARIAN (EAST GREEK) OINOCHOE
Ca. 575–550 B.C.
Gift of Gilbert M. Denman, Jr.
86.134.25

The oinochoe has a low flaring ring base, oval body, low broad neck, and trefoil lip. The three-reed handle rises from the lip and attaches at the mid shoulder. The shape of the vase and some of the motifs, for example the meander on the neck and the crescents on the body, can be compared closely with Fikellura style oinochoai, a style which at least in its figured work began at Miletus ca. 550 B.C. There is, however, no good parallel for the floral chain in true Fikellura. GPS

DIMENSIONS: H. to rim 23.2 cm.; H. to handle top 26 cm.; Diam. of body 18.5 cm.; Diam. of foot 10.2 cm.
CONDITION: Preserved complete. The exterior decoration is worn and flaked in places.
SHAPE AND DECORATION: The exterior is slipped. Bands of paint are found on the lip, lower wall and base. Ornament includes a band of broken meander on the neck, chevrons, crescents curving right, and crescents curving left on the

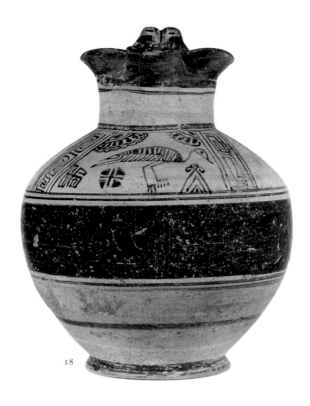

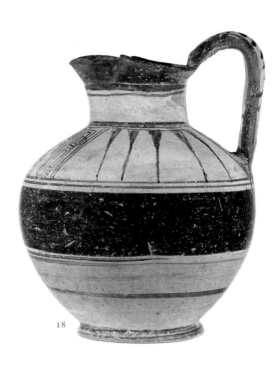

18

18

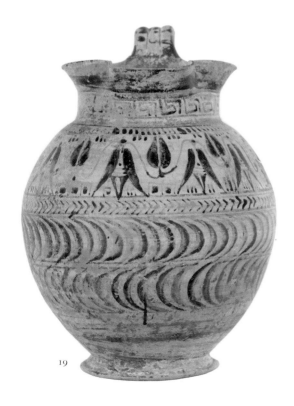

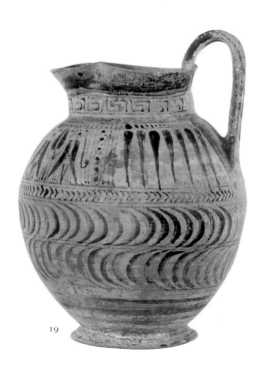

19

19

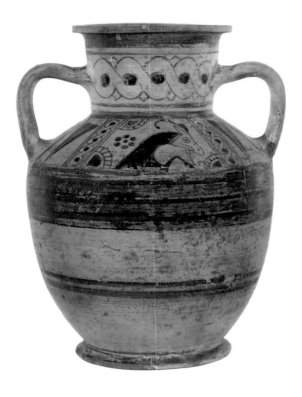
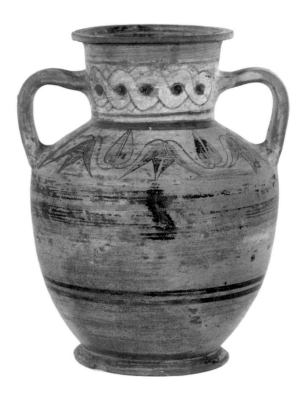

body. The shoulder zone is divided into three panels separated from each other by a vertical single cable pattern. The long central panel is filled with a floral chain of alternating buds and pendent lotuses. Groups of short stripes and framed squares fill spaces along the top and bottom edges of the panel. The side panels are filled with pendent rays. The handle has broad horizontal stripes across the three reeds.

ADDED COLOR: Red on the upright lotus buds and on occasional stripes and squares of the filling ornament.

PROVENANCE: See Cat. No. 18 above.

BIBLIOGRAPHY: Galerie Günter Puhze, *Kunst der Antike*, cat. 3 (Freiburg 1981) 12, no. 119.

LITERATURE: For the shape and decorative scheme, see *MidwesternColls* no. 18. For the floral chain on other vases of this group, see P. Gercke, *Funde aus der Antike, Sammlung Paul Dierichs, Kassel* (Kassel 1981) nos. 18 and 28; *Archaeologica Traiectina* 14 (1980) pl. 16a-b.

20

CARIAN (EAST GREEK) AMPHORA

Ca. 600 B.C.
Gift of Gilbert M. Denman, Jr.
86.33
A: Forepart of goat

The shoulder, neck, head and one foreleg of a goat are represented in a panel on the shoulder. Unlike the common grazing or walking goats seen in Wild Goat pottery, here part of the animal is depicted as though stretching up to pluck leaves off a bush or tree branch. Quarter rosettes fill three corners of the panel and a dot rosette fills space behind the goat's neck. GPS

DIMENSIONS: H. 22.5 cm.; Diam. of rim 10.4 cm.; Diam. of body 16.4 cm.; Diam. of foot 10.1 cm.

CONDITION: Preserved complete except chips in the base (one restored in plaster). Some repainting of the cable and lotus-bud chain on Side B.

SHAPE AND DECORATION: The amphora has a low, flaring ring base, oval body but flat shoulder, cylindrical neck, and flat outturned rim. Vertical strap handles are attached at mid-neck and lower shoulder. Bands of paint decorate the rim, neck, body and base. The broad band on the

body has three lines in added red. A single cable pattern fills the neck on both sides while the shoulder on Side A is divided into three panels by vertical cables. The large central panel has the forepart of a goat and several filling ornaments; the narrow side panels have single pendent rays. On Side B the shoulder is filled with an alternating bud and pendent lotus chain, very similar to that on Cat. No. 19. The appearance of only the forepart of the goat, as well as the cable pattern on the neck, the unusual lotuses and added red for only one half of the pendent rays, taken together are odd for the East Greek Wild Goat style. The use of a panel between pendent rays on Side A is normally found on oinochoai, not amphorae. These features suggest that the vase is another one produced in a Carian workshop but based on East Greek models.

ADDED COLOR: Red for one half of each of the pendent rays, the shoulder of the goat, the interior of one of the quarter rosettes, three lines on the body, and leaves of the upright lotus buds.

PROVENANCE: See Cat. No. 18 above. Ex. coll. Richard Hattatt.

BIBLIOGRAPHY: Unpublished.

LITERATURE: Charles Ede, *Collecting Antiquities* (London 1983) 12, fig. 26. Sotheby's London, 10–11 December 1984, lot 19 (Hattatt coll.)

21

ITALIC BLACK–FIGURE
AMPHORA
Mid-6th century B.C.
Gift of Gilbert M. Denman, Jr.
86.134.39
A: Vintaging
B: Two horsemen

On Side A, three men are engaged in
picking grapes. The vines grow in a
wild tangle up from a strange triangular
mound. The grape clusters are hastily
rendered as irregular blobs of glaze and
may have been highlighted in white,
traces of which remain on one cluster.
The vines themselves are indicated in
dilute glaze. The two men at right are
busy picking while the third, at left,
carries off a full basket, its contents
spilling over the top. The men on the
right and left wear red tunics, but that
of the basket-carrier is incompletely
drawn, leaving his shoulders and geni-
tals exposed. Behind the grape-pickers
grows a tree of a rather different type
from the vines: a tall, slender, essen-
tially straight trunk, spreading into a
network of branches bearing small, oval
fruit—most likely olives.

Two young horsemen on Side B gal-
lop to the right, the forelegs of their
horses raised high in the air. Each rider
wears a short red tunic, a fillet about
his long flowing hair, and holds a long,
leafy branch in his right hand as he
wields the reins in his left. The lively, if
oddly proportioned horses are boldly
differentiated from one another in the
use of added red, once for the mane,
once for the neck and belly. An eagle
flies behind the rear rider, carrying a
branch in its mouth.

Scenes of the harvesting and vintag-
ing of grapes occur regularly in Greek
vase-painting throughout the sixth cen-
tury and in the fifth as well, but ours
has no close parallels, especially in the
peculiar form of the vines. The tread-
ing of the grapes is a more popular sub-
ject than the picking, though some-
times the two activities are combined
in a single scene, suggesting that in
Greek practice the grapes went directly
from the vine to the press. The work-
ers in these scenes are often satyrs; also
common is the presence of Dionysos or
other indications of his realm which are
here completely lacking. A very fine
black-figure plaque dedicated on the
Akropolis shows a group of Athenian

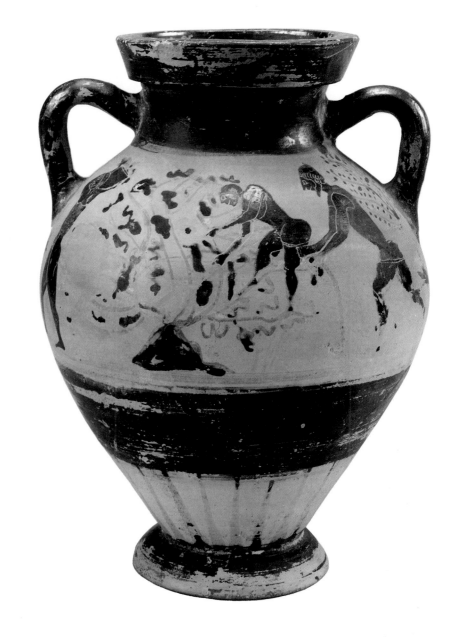

men harvesting grapes in a lush vine-
yard which has little resemblance,
however, to the wild vines depicted
here.

Pairs of riders are a popular motif in
both Attic and non-Attic black-figure
(cf. the Chalkidian amphora, Cat. No.
22), but ours are distinguished from
most by the branches they carry. These
suggest a festival as the setting, rather
than a military occasion, and might
even hint at a link with the grape har-
vesting on the obverse. The flying ea-
gle is a favorite device to emphasize the
swiftness of the horses.

The identification of the fabric or
workshop of our amphora is problem-
atical. The shape, with its somewhat
ovoid body and echinus foot, has good
parallels in Attic workshops of the sec-
ond quarter of the sixth century, for
example many horse-head amphoras
(cf. Cat. No. 31), yet other features are
distinctly non-Attic. In particular, a
standard element in Attic is the re-
served picture panels of belly amphoras,
the area around the handles always be-
ing glazed, whereas the San Antonio
amphora has one continuous reserved
surface all the way round. In non-Attic

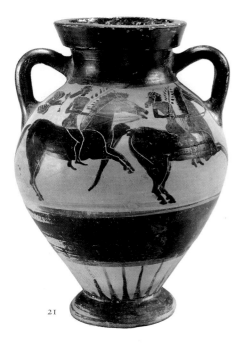

21

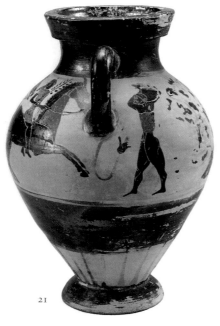

21

CHALKIDIAN
BLACK–FIGURE AMPHORA
Ca. 550–540 B.C.
Gift of Gilbert M. Denman, Jr.
86.134.30
A: Two galloping horsemen
B: Two confronted cocks

The two youthful riders on Side A, their overlapping horses completely filling the picture panel, look like an excerpt from a longer cavalcade. The horsemen are beardless, and their long wavy hair flowing over the shoulder recalls early Archaic kouroi. They wear short-sleeved red tunics. A single large rosette fills the only substantial free space, behind the rear rider.

Side B contrasts the vigorous movement of the front panel with a static, heraldic and symmetrical composition especially popular in this period. The two cocks are virtually twins, down to the patterns of incision and the use of added color. Three rosettes forming an equilateral triangle also add to the symmetry.

Many elements in the decoration of our vase derive from Attic traditions of the early sixth century, but details of shape and execution confirm that it belongs to the earliest phase of a non-Attic ware known conventionally as Chalkidian. Among the dozen known Chalkidian belly amphoras there is a surprising variety of shapes and proportions, but ours can be grouped with the most 'standard' type, borrowed from Attic amphoras of the mid-sixth century: the shoulder sharply angled to the body, the greatest diameter of the belly just below the roots of the handles, and a spreading echinus foot. Several of these have more ambitious compositions, including animal friezes on the broad shoulder. The simple band of rosettes on the shoulder of the San Antonio amphora is closest to that of an amphora in the Castellani Collection (Castellani 156; Rome, Villa Giulia), which shares so many other similarities that both vases should be by the same hand. On the Castellani amphora, the same young horsemen recur, now facing each other instead of galloping, each accompanied by an eagle. The confronted cocks on the reverse are virtually identical to ours, though the rosettes are replaced by lotus buds.

such a frieze-like effect occurs, for example, on the one belly-amphora of the East Greek 'Northampton Group,' in Munich, dated ca. 540 B.C. The figure style is, however, utterly different, very refined, with much use of incision. The very simplified renderings of eyes, hair, and beards on the San Antonio amphora recall early Attic vases of the Komast Group. One might speculate that a local workshop working in Etruria in the mid-sixth century could have produced such a vase bearing the influence of earlier Attic imports as well as contemporary Ionian practices by then familiar in North Italy. HAS

DIMENSIONS: H. 34 cm.; Diam. of mouth 14.6 cm.; Diam. of foot 11.8 cm.
CONDITION: Broken and repaired. Restored fragment to the right of left figure on Side A, and beneath A/B handle. Interior and exterior of mouth is abraded and pitted.
SHAPE AND DECORATION: Offset lip: round handles; ovoid body; small echinus foot. The only ornament is a single lotus on a long curving stem growing from the base of each handle. The inside of the mouth is glazed to ca. 5 cm.
ADDED COLOR: Red for the tunics of riders; mane of rear horse; neck and belly of front horse; eagle's wings; tunic and shirt of grape-pickers; hair of middle

grape-picker; stripes on top of mouth, inside mouth, under figured scenes, and above rays. White traces on one grape cluster.

BIBLIOGRAPHY: Galerie Günter Puhze, *Kunst der Antike*, cat. 4 (Freiburg 1982) 19, no. 197.
LITERATURE: On vintaging scenes, see B. A. Sparkes, "Treading the Grapes," *BABesch* 51 (1976) 47–64. On the significance of youthful riders on belly amphoras, see I. Scheibler, "Bild und Gefäss: zur ikonographischen und funktionalen Bedeutung der attischen Bildfeldamphoren," *JdI* 102 (1987) 57–118, esp. 77–86. The Acropolis plaque: no. 2560; *Graef-Langlotz* pl. 107. For the development of the belly amphora, see R. Lullies, "Eine Amphora aus dem Kreis des Exekias," *AntK* 7 (1964) 85–89. The shape of this vase is particularly close to Tübingen D4 (Painter of Akropolis 606); *ABV* 81, 5; *CVA* (Tübingen 2) pl. 31,1. On horse-head amphoras, see M.G. Picozzi, "Anfore attiche a protome equina," *StMisc* 18 (1971). One early horse-head amphora has a continuous picture field, as on the San Antonio amphora, instead of panels, see Boston 63.1611; *CVA* (Boston 1) pl. 1, 1–2. For the Northampton Group amphora, Munich 585, see *CVA* (Munich 6) pl. 299.

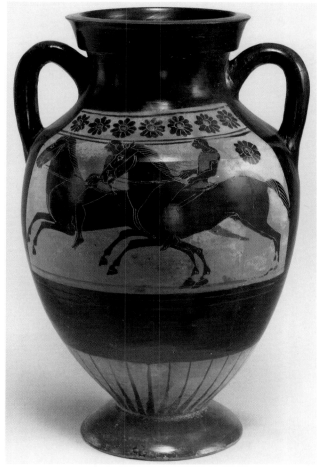

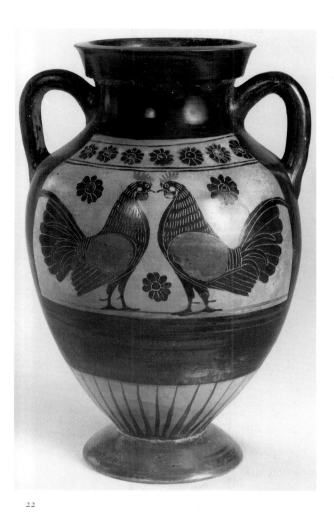

22

22

Both motifs, the riders and the cocks, may be traced back to Attic models as early as the workshop of the Gorgon Painter in the late first quarter of the sixth century. An amphora now in Bochum, for example, attributed to the Painter of Berlin 1659 (Circle of the Gorgon Painter), has the cocks and rosettes on one side, a single galloping rider on the other. The pair of riders on our vase is, however, more immediately indebted to Attic cavalcades of the second quarter of the century, especially popular on Siana cups.

The number of preserved Chalkidian vases was already near three hundred when Andreas Rumpf published his monumental study in 1927, and it has grown steadily since, yet the question of the true origin of this fine fabric is still debated. The name originally reflected the fact that when these vases carry inscriptions, they are written in the Chalkidian alphabet, though we now know that the same alphabet was used in many Euboean colonies in Magna Graecia. In recent scholarship, most weight has been attached to the fact that no Chalkidian vase has been found on Euboea. All come from Etruria or from South Italy, and the majority opinion would now localize the workshop in the South, possibly centered at Rhegion (Reggio di Calabria). HAS

DIMENSIONS: H. 28.5 cm.; Diam. of mouth 12.1 cm.; Diam. of foot 10.6 cm.
CONDITION: Broken and repaired. Hindquarters of right horse restored and repainted on Side A. Mid-section of left cock on Side B restored and repainted.
SHAPE AND DECORATION: Offset lip; round handles; narrow shoulder and relatively slender body; echinus foot. Shoulder ornament on each side consists of seven incised rosettes in a reserved band between a single line above and a double line below.
ADDED COLOR: Red for combs, necks and bellies of cocks; tunics of riders; tail of front horse (projecting under the belly of the rear horse); centers of rosettes.
BIBLIOGRAPHY: Unpublished.
LITERATURE: On Chalkidian vases, see A. Rumpf, *Chalkidische Vasen* (Berlin-Leipzig 1927); and most recently, J. Keck, *Studien zur Rezeption fremder Einflüsse in der chalkidischen Keramik* (Frankfurt 1988). On Chalkidian belly amphoras, see R. Lullies, "Bemerkungen zu den 'chalkidishen' Bauchamphoren," *RA* (1982) 45–56. For the Castellani amphora, Villa Giulia, Castellani 156, see Rumpf, pl. 18, 116. On the Attic amphora in Bochum, see B. Korzus, ed., *Griechische Vasen aus westfälischen Sammlungen* (Münster 1984) no. 26 (N. Kunisch). On the problem of the localization of Chalkidian workshops, see the discussion in Lullies, 53–56.

23

LACONIAN CUP
Ca. 550–530 B.C.
Gift of Gilbert M. Denman, Jr.
86.134.29

This vase belongs to a small group of
semi-decorated Laconian cups. Both
the bud chain and handle palmettes are
common motifs on Laconian black-
figure cups though both vary slightly
from other attested examples. The San
Antonio cup is similar in shape to the
Attic Lip cup. It finds close parallels in
other examples of Laconian decorated
and black-glaze cups. GPS

DIMENSIONS: Diam. of rim 20.3 cm.;
Diam. of bowl with handles 26.4 cm.
CONDITION: Broken and repaired, some
pieces from the bowl are missing, re-
stored in plaster and repainted. The foot
is a modern restoration.
SHAPE AND DECORATION: This cup has a
well rounded bowl and a tall straight lip

which is offset from the bowl and flares
outward. The horizontal round handles
are attached at the cul and curve slightly
upward. The interior of the bowl is black
except for narrow reserved lines on the
top and bottom edge of the lip. The ex-
terior is black also except for reserved lip
and handle zones and one line on the
lower wall. The handle zone is decorated
with a chain of small lotus buds between
black-figure broom palmettes. The lower
edge of the handle zone and the reserved
line on the lower wall are slipped.
BIBLIOGRAPHY: Unpublished.
LITERATURE: For Laconian black-glaze
cups, see *Tocra* I, 116–17, 125–29 nos.
1307–1318. For the shape of the San An-
tonio cup, cf. C.M. Stibbe, *Lakonische
Vasenmaler des sechsten Jahrhunderts v. Chr.*
(Amsterdam 1972) figs. 17 and 19; *Tocra*
I, 116–17 no. 1309, fig. 59. For decorated
cups of similar shape, see Stibbe, 24–36,
figs. 13–42. For the palmette, cf. Stibbe
61 type 17. For the bud chain, see Stibbe,
61 type 1.

24

**BOEOTIAN BLACK–FIGURE
LEKANE**
Attributed to the Protome Painter
Ca. 530 B.C.
Gift of Gilbert M. Denman, Jr.
86.134.28
Exterior: Animal frieze
Interior: Lion

The exterior carries two groups of
three animals each, dividing the frieze
course into halves which are roughly
separated by the handle alignment. A
spread-winged siren to right with head
turned backward is set between a pan-
ther and a lion in one group. The other
group consists of a ram to right be-
tween panther and lion. Incised rosettes
are loosely scattered over the field. A
lion to right fills the tondo of the vase
interior.

The Protome Painter is one of the
most prolific Boeotian vase painters
known to us and was a specialist in
decorating lekanai during the third
quarter of the sixth century B.C. He
favors the animal style, but decorates a
few tondos with human heads, whole
human figures, and hybrids (sirens,
satyrs, and centaurs). On a number of
lekanai he restricts decoration of the
vase exterior to repetitive floral designs.
The Protome Painter is a competent
craftsman who is equally adept with the
brush and the incising tool. He relies
heavily on added color for the total ef-
fect and, for most of his career, prefers
animal scenes congested with field or-
naments. The Protome Painter and a
close associate known as the Triton
Painter belong to Ure's first group of
lekanai and are at the center of a num-
ber of lekane painters working in
Boeotia during the latter half of the
sixth century B.C. KK II

DIMENSIONS: H. 7.2 cm.; Diam. of rim
27.6 cm., Diam. with handles 32.9 cm.;
Diam. of foot 9.2 cm.
CONDITION: Interior badly worn. Parts
of the faces of the panther and the lion
flanking the ram are repainted. Large
fragment of the vase rim and body lost.
SHAPE AND DECORATION: The open and
simple form of the lekane allowed it to
serve in diverse ways. It should be distin-
guished from the lekanis, which has a lid.
The lekane is a common shape in Boeot-
ian black-figure, making a hesitant ap-
pearance early in the second quarter of
the sixth century and then appearing reg-

ularly during the second half of that century. Good examples with silhouette decoration are known from the fifth and fourth centuries B.C. The ram on the exterior of this vase is very rare in Boeotian black-figure. It, like the other creatures in the animal frieze, is adapted from the Attic repertoire. The field ornament on this lekane is unusual in type and in compactness for the Protome Painter. His animal scenes are normally cluttered with a variety of field ornaments, many derived from East Greek types, and rendered without incision. The globular rosettes which are spaciously placed about the exterior scene on this vase are all, save one, incised with a cross. This form, lacking incision, appears sporadically among the other, more frequent field ornaments found on other works by the Protome Painter. It occurs more frequently, sometimes with incision, on later lekanai, many of which were assigned by Ure to her second group. This would tend to place the San Antonio lekane late in the Protome Painter's oeuvre. This particular incised globular rosette, like the unincised dot-cluster rosette used by the Protome Painter on other lekanai (e.g. Rijksmuseum van Oudheden, Inv. I 98/6.21), is common to Middle and Late Corinthian vases and entered the Boeotian black-figure repertoire by the end of the first quarter of the sixth century B.C. Other subsidiary decoration on the San Antonio lekane includes vertical bars tapering downward on the vase rim, a large dot within a thick circle under the foot, and black glaze on the handles, handle spurs, and on the inner and outer sides of the foot.

ADDED COLOR: Red is applied to animal manes and haunches, and in the form of one (or two?) band encircling the tondo and another pair halfway between the tondo and the vase rim.

BIBLIOGRAPHY: K. Kilinski II, *Boeotian Black-Figure Vase Painting of the Archaic Period* (Mainz 1990) Protome Painter no. 27, pl. 26, 5.

LITERATURE: For the Protome Painter, see Kilinski, "Boeotian Black-Figure Lekanai by the Protome and Triton Painters," *AJA* 81 (1977) 55–65. For the shape, see A. D. Ure, "Boeotian Orientalizing Lekanai," *MMS* 4 (1932) 18–20; *CorVP* 465–67. On the relation of Boeotian to Attic lekanai, see A. Lioutas, *Attisch schwarzfigurige Lekanai und Lekanides* (Würzburg 1987) 87–88. For the rosettes, see *NC* 157, fig. 69c-d. For the lekanai in the Rijksmuseum van Oudheden, Inv. I 98/6.21, see *AJA* 81 (1977) 57, fig. 6.

25

EUBOEAN BLACK-FIGURE
LEKANE
Ca. 530–520 B.C.
Gift of Gilbert M. Denman, Jr.
86.134.159
Exterior: Animal frieze
Interior: Octopus

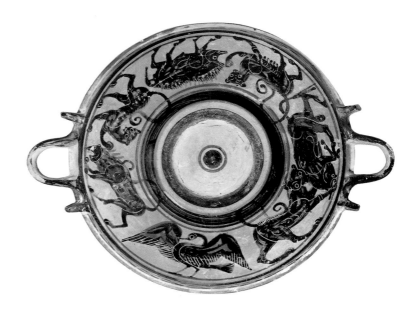

Six quadrupeds are grouped in pairs
along with a spread-winged swan on
the vase exterior. Starting from the
right of the swan, the pairs consist of a
panther downing a bull, a lioness con-
fronting a boar, and a lion facing a pan-
ther with its head turned backward.
The vase tondo is filled with an octo-
pus, displayed almost perpendicular to
the alignment of the handles. KK II

DIMENSIONS: H. of rim 8.7 cm.; Diam.
of rim 27.2 cm., Diam. with handles
34.6 cm.; Diam. of foot 10.4 cm.
SHAPE AND DECORATION: The lekane
was a frequently selected shape for deco-
ration among Euboean black-figure vase-
painters. Like Attic lekanai, the Euboean
type is usually less shallow than the Boeo-
tian models. The handles and flanking
spurs on Euboean lekanai are connected
by strips of clay which continue the
sweeping form of the handles through a
reverse curve and into the spurs. This is
unlike the Boeotian counterparts which
are attached separately to the vase rim.

The octopus is a rare subject in black-
figure vase-painting. Its appearance on a
few Corinthian aryballoi and on an occa-
sional Attic amphora are among the infre-
quent occurrences. That it should appear
here, painted on an island vase, is no sur-
prise, but a welcome addition. In depict-
ing this subject the artist has placed the
marine creature in an ideal area on the
vase, harmoniously filling the circular
frame of the tondo. Compare the starfish
placed in a similar fashion on the lid of a
Euboean cylindrical pyxis in Athens
(Athens NM 276). The animal frieze on
the vase exterior is somewhat rare for Eu-
boean black-figure. Water fowl and/or
floral motifs are more frequently found
on the exteriors of Euboean lekanai.
Quadrupeds do occur, but thus far in
fewer numbers. Comparative examples
include Euboean lekanai in Munich (Mu-
nich 6197) and in London (London BM
1913,12–18,2 and 1914,4–13,3). Perhaps
the best example for comparison is a small
Euboean black-figure lekane with pan-
thers and deer on the London art market.
For the spiny boar on the San Antonio
vase compare the hedgehog on another

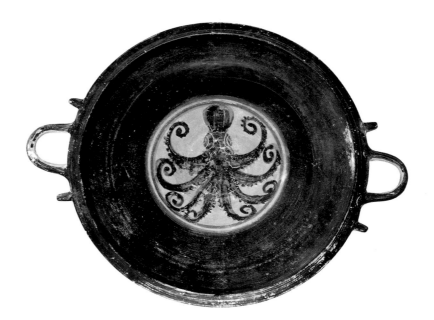

Euboean lekane in a German private collection. The row of three-barred sigmas in the handle zone is a very common motif on Euboean lekanai (e.g. Laon 37–993 and Nauplia 534). The San Antonio lekane has a red band serving as a ground-line for the animals in the exterior frieze; two red bands adjoining a wide black band circling the foot. The inner and outer sides of the foot are painted black. A red band encircles a large black dot under the foot. Two red bands border the tondo and two more red bands appear on the vase interior halfway between the tondo and the vase rim.

ADDED COLOR: Extensive use of red and white paint on the animals: red on the haunches and shoulders of the quadrupeds and on the wings of the swan; white dashes on the lion's neck and body, on face and neck of panther before lion, in a row of dots on this same panther and on the back of the boar alternating with red vertical dashes; red and white marks on the tentacles of the octopus.

BIBLIOGRAPHY: Unpublished.

LITERATURE: For Euboean black-figure lekanai, see A. D. Ure, "Euboean Leka-nai," *JHS* 80 (1960) 160–67; eadem, "An Eretrian Lekane in Reading," *BICS* 12 (1965) 22–26; eadem, "Lekanai in Laon and Tübingen," *BSA* 70 (1975) 203–05.

PARALLELS: Athens NM 276: *BSA* 52 (1957) pl. 4a; Munich 6197: *CVA* (Munich 3) pl. 146, 3 and 5–7; London BM 1913, 12–18, 2 and London BM 1914, 4–13, 3: *CVA* (London BM 2) pl. 7, 1–2 Attic); Laon 37–993 and Nauplia 534: *BSA* 70 (1975) pl. 28 a & d. The lekane on the London market is Charles Ede, Ltd., no. 5895. For the Euboean lekane in the German private collection, see *JHS* 80 (1960) pl. 15, 5.

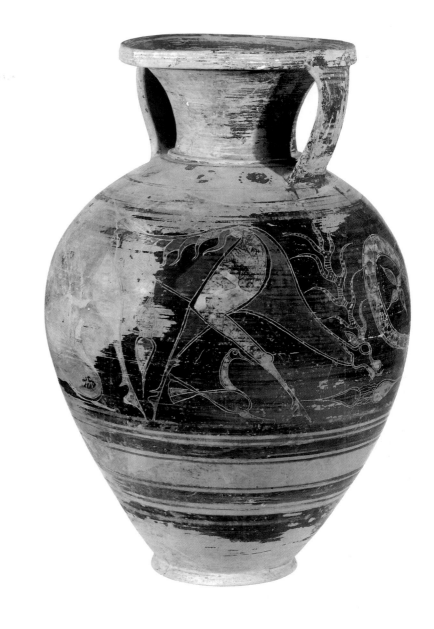

26 COLOR PLATE I

ETRUSCAN BLACK-FIGURE AMPHORA
Attributed to the Brown Painter, Monte Abatone Group [J.G. Szilágyi]
Ca. 620–600 B.C.
Gift of Gilbert M. Denman, Jr.
87.20.4
Animal frieze

The animals stretching around the body of the amphora include a winged feline, a hippocamp, a deer, a stag, and three waterfowl, all of which have a kind of fantastic character similar to that of animals on contemporary or slightly later Etruscan tomb paintings.

The *hippocamp*, half horse and half sea-creature with long scaly tail, is especially common in tombs. The great stag has a single wonderfully crooked antler and long flame-like strands of hair along its back. The deer (?), without antlers and missing its back legs for lack of room, has a very long tongue stretching toward the wing of the fe-line. An object above its back looks like a human leg (the mate to one in the feline's mouth?). Finally, the feline with wing curling above its back and piece of flesh hanging from its mouth is typical of Etrusco-Corinthian art. Wings are common additions to animals in this style; pieces of flesh are

sometimes found hanging from the mouths of panthers. The feline other-wise looks tame with only half-open maw and no teeth. Simple florals and rosettes together with water birds fill spaces between the animals.

The style of painting used here, in which figures are incised on a completely dark background and large areas are painted red and white, is called Polychrome. This is typical of the earliest phase of Etrusco-Corinthian vase painting. The animal frieze, the use of incised drawing, as well as added red and white paint, are taken from Corinthian painting, but the style of the animals and the incision against a totally

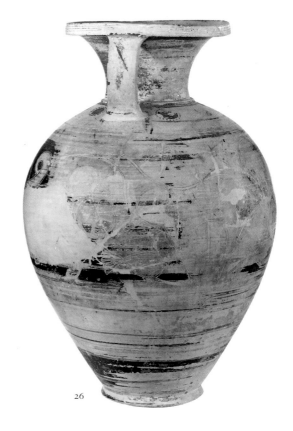

26

black background are Etruscan. Also typically Etruscan are the large masses of color (white and red) over the dark figures, giving a balance of black, red and white. The depiction of fantastic animals is frequent in a funerary context, whether on tomb paintings or, as here, on a vase, suggesting that the San Antonio amphora comes from an Etruscan tomb. GPS

DIMENSIONS: H. 53.2 cm.; Diam. of rim 22.3 cm.; Diam. of body 35.3 cm.; Diam. of foot 14.2 cm.

CONDITION: Broken and repaired, missing pieces restored in plaster, repainted and re-incised except for one large section on the body. The glaze and added colors have flaked badly over half the vase.

SHAPE AND DECORATION: Large amphora with low ring base, ovoid body, flaring neck with a sharp fillet at the join of neck to body, and a thickened rim with four grooves on the flat outside face. Vertical strap handles attach at the lower edge of the rim and the shoulder. A

winged feline, to left, with a chunk of human flesh (leg?) hanging from its mouth confronts a hippocamp facing right. Behind the feline is a deer (?), to left, missing its back legs, and a water bird to right between the deer's front legs. Behind the hippocamp is a stag to right with two water birds to right between its legs. Besides the animal frieze on the body there is a reserved zone on the shoulder which is decorated with a row of solid circles and dots.

ADDED COLOR: Red for three lines inside the mouth and bands around the outside of the rim, on the lower neck, on the shoulder, below the figure scene, and on the lower wall; in the figured frieze, for the shoulder and one foreleg, some scales and part of the tail of the hippocamp; for the neck, one foreleg, alternate locks of hair on the back, part of the shoulder and rear leg of the stag; for the body and some tail feathers of the water birds; for the eye, tongue, neck, one foreleg of the second deer; for the neck, back and one rear leg of the feline; and for half the

leaves of the floral filling ornaments. White for the row of dots on the lower neck, groups of three horizontal stripes on the handle, single lines on the shoulder, below the figure scene and on the lower wall; in the figured frieze, for one foreleg, the body, most of the scales and part of the tail of the hippocamp; for dots over the antler; for the ear and lowest prong of the antler, outline of the head, tongue, shoulder, one foreleg and alternate locks of hair of the stag; for the neck, leg and some tail feathers of at least one and probably all of the waterbirds; for the wing, back of the head and ear, and one back leg of the feline; for the piece of flesh hanging from the feline's mouth, and alternate leaves of the floral ornaments.

PROVENANCE: Ex. coll. Pomerance.

BIBLIOGRAPHY: *The Pomerance Collection of Ancient Art* (Exh. Cat. Brooklyn Museum 1966) no. 140; J. G. Szilágyi, *Etruszko-Korinthosi Vázafestészet* (Budapest 1975) 25–26 pl. 4, fig. 5; Sotheby's New York, 20 May 1987, lot 100.

27

THREE ETRUSCAN BUCCHERO VASES
Late 7th–first half
of the 6th century B.C.
86.134.93,165,166

The stamnos is an unusual shape in Etruscan bucchero ware. The decoration on the San Antonio example suggests that it dates to about the last quarter of the seventh century. Conversely, the kantharos is a very popular vase type, the most commonly found object exported from Etruria. The shape was probably produced from the late seventh century through the first half of the sixth. GPS

DIMENSIONS: Stamnos (86.134.93) H. 11.2 cm.; Diam. of rim 7.3 cm.; Diam. of body 11.9 cm.; Diam. of foot 5.1 cm. Kantharos (86.134.165) H. 7.3 cm.; H. to handles 11.4 cm.; Diam. of rim 12.2 cm.; Diam. of foot 5.7 cm. Kantharos (86.134.166) H. 6.8 cm.; H. to handles 11.3 cm.; Diam. of rim 12.3 cm.; Diam. of foot 5.4 cm.
CONDITION: All are preserved complete except the second kantharos (166), with one handle broken and repaired. On the stamnos much of the white paint which once filled the incised dots and lines on the body has now disappeared. Large areas of the exterior surface of the first kantharos (165) have flaked away.
SHAPE AND DECORATION: The stamnos is decorated with a row of upright closed fans impressed on the shoulder of each side and fine vertical reeding around the body (plain band above the base). Both designs were emphasized with white paint now mostly disappeared. The first kantharos (165) has diamond notches on the carination; the second has simple notes on the carination and a pair of horizontal incised lines below the rim. The kantharoi are similar to kantharos Type 3e.
BIBLIOGRAPHY: Unpublished.
LITERATURE: For Etruscan bucchero pottery, see N.H. Ramage, "Studies in Early Etruscan Bucchero," *BSR* 38 (1970) 1–61, pl. I–V; T. B. Rasmussen, *Bucchero Pottery from Southern Etruria* (Cambridge and New York 1979); J. W. Hayes, *Etruscan and Italic Pottery in the Royal Ontario Museum* (Toronto 1985) 62–130. For kantharos type 3e, see Rasmussen, 104–06, pl. 31–32; Hayes, 75, 77 nos. C22 and C23.

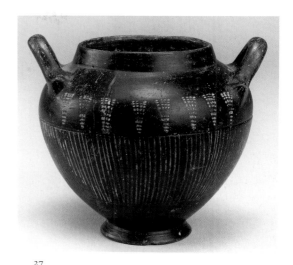

27

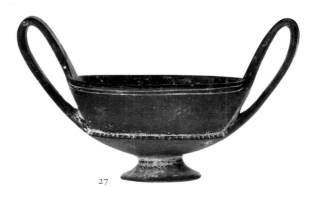

27

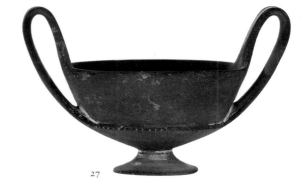

27

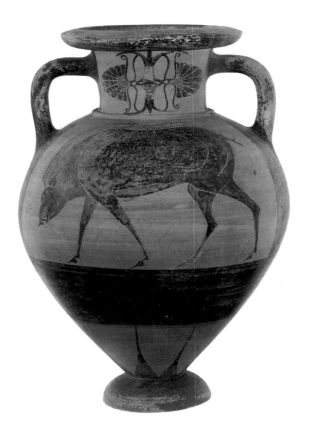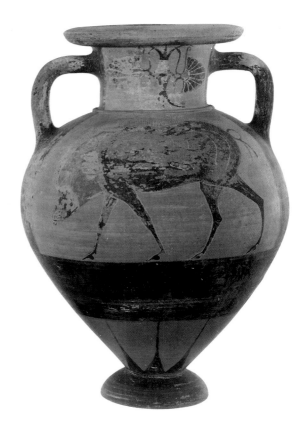

28

ETRUSCAN BLACK-FIGURE
NECK-AMPHORA
Attributed to
the La Tolfa Painter [M. Zilverberg]
Ca. 520–500 B.C.
Gift of Gilbert M. Denman, Jr.
86.134.161
A and B: Boar

The artist has depicted a large boar
walking to left in a panel on both sides
of his amphora. The animals are virtu-
ally identical.

J. D. Beazley suggested a division of
the La Tolfa group into two parts (α
and ß), and J. M. Hemelrijk proposed
the name Lotus Painter for the artist of
the α vases. Zilverberg, however, ob-
jected to Beazley's division and argued
instead that most of the vases are by
one hand, that of the La Tolfa Painter.

The subjects which this artist chose
for the large panels on his vases are typ-
ically Etruscan, but his work also shows
influence from East Greece and from
the Caeretan hydriae. He occasionally
depicted scenes of myth and departure
or home-coming from the hunt, but

more commonly he used one or two
large figures, either human or animal,
to fill the panel on each side of his vase.
On three vases, including the San An-
tonio amphora, he chose a wild boar.
Besides minor differences in the details
of the boars (they all, however, walk to
left, including the San Antonio animals,
pace Zilverberg), the London and Am-
sterdam vases differ from the San Anto-
nio amphora in having a short lotus and
palmette chain decorating the neck
rather than a lotus-palmette cross.

GPS

DIMENSIONS: H. to rim 32.5 cm.; Diam.
of rim 15.4 cm.; Diam. of body 22.9 cm.;
Diam. of foot 9.2 cm.
CONDITION: Preserved complete. The
glaze paint has flaked quite badly, espe-
cially on Side B.
SHAPE AND DECORATION: The amphora
has a thick echinus foot, piriform body,
conical neck joined to the body by a nar-
row fillet, and thick echinus rim with
slanting lip. Vertical round handles are at-
tached at the neck and shoulder and char-
acteristically bend at ninety degrees. The
neck on both sides is decorated with a lo-
tus-palmette cross. The lower wall is re-

served and decorated with rays. At least
three other vases in the La Tolfa group
have a similar neck ornament, Capitoline
Museum D 50, Louvre E 728, and Karl-
sruhe inv. 2592 (Zilverberg nos. 25, 29,
38).
ADDED COLOR: Red for the bottom half
of the lotuses and hearts of the palmettes,
the necks of the boars, two short stripes
on the flank of the boar on Side A (on
Side B it is too badly flaked to discern
color), and for two pairs of narrow encir-
cling lines in the zone between the fig-
ured panels and the rays.
BIBLIOGRAPHY: Galerie Günter Puhze,
Kunst der Antike, cat. 6 (Freiburg 1985)
no. 194; M. Zilverberg, "The La Tolfa
Painter. Fat or Thin?," in *Enthousiasmos*
59 no. 24, fig. 6.
LITERATURE: For the La Tolfa Group, see
T. Dohrn, *Die schwarzfigurigen etruskischen
Vasen aus der zweiten Hälfte des sechsten
Jahrhunderts* (Berlin 1937) 23–33, 144–45;
idem, "Die etruskischen schwarzfigurigen
Vasen," *StEtr* 12 (1938) 284; *EVP* 11;
J. M. Hemelrijk, *Caeretan Hydriae* (Mainz
1984) 190–91; Zilverberg, 49–60. The
other two vases by the painter, decorated
with boars, are London, BM D 43, and
Amsterdam, Allard Pierson Museum
9132; Zilverberg, nos. 22–23.

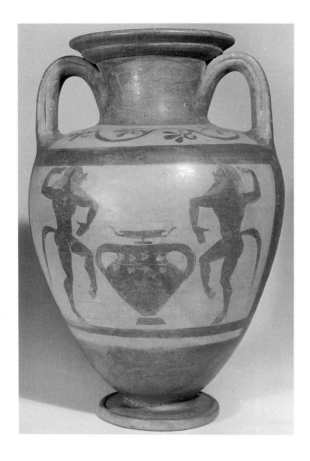
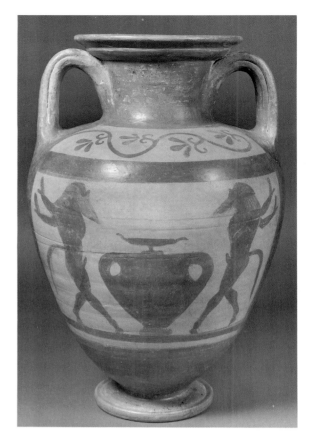

29

ETRUSCAN NECK AMPHORA
Early 5th century B.C.
Gift of Gilbert M. Denman, Jr.
85.119.8
A and B: Two satyrs dancing
around a krater

In the center of both scenes is a large
krater on the ground with a kylix rest-
ing on the krater rim. On Side A an
ivy wreath encircles the neck of the
krater. To either side of it is a bearded
satyr dancing in step facing his partner
opposite. On Side A the satyrs each
have their right arm and left leg raised.
On Side B, in a strongly torsional
movement, the satyrs have both arms
raised and stretched behind them and
one leg twisted sideways in front of the
other. The satyrs on Side B are balding
and ithyphallic. All four satyrs have pug
noses and horses' ears, tails and hooves.
Details and contour lines are not pro-
duced by incision as in true black fig-
ure but by lines in added white.

Satyrs are common subjects on am-
phoras, meant to hold wine, since they
are regular companions of Dionysos,
god of wine. They are often shown, as
here, performing and imbibing without
the god. Satyrs with horses' hooves are
normal in East Greek art to which
Etruscan art in the Archaic period was
often indebted. GPS

DIMENSIONS: H. 42.1 cm.; Diam.
27.1 cm.; Diam. of rim 17.4 cm.; Diam.
of foot 13.3 cm.
CONDITION: Broken, repaired and re-
stored in plaster, heavily overpainted.
Yellowish buff clay, fine with a little
mica. Red glaze paint. No incision.
SHAPE AND DECORATION: Tall neck am-
phora with spreading base, ovoid body,
unbroken transition to the concave neck,
wide-spreading rim in two parts. Two-
reed handles with support strap attached
at neck and shoulder. Tendrils with four
simple palmettes decorate each side of the
shoulder. The figured scenes fill the pan-
els on the body.
ADDED COLOR: Greyish yellow for the
hooves of the satyrs and the bases of the
two kraters; greyish white for the beard
and hair of the satyrs, details of the bod-
ies, contour lines, and ivy wreath.
BIBLIOGRAPHY: Galerie Günter Puhze,
Kunst der Antike, cat. 6 (Freiburg 1985)
19, no. 197.
LITERATURE: The shape and decoration
of this vase are close to, but not exactly
matched in a group of vases from Orvi-
eto: A. L. Calo, "Comunicazioni," *StEtr*
10 (1936) 429–39; T. Dohrn, *Die schwarz-
figurigen etruskischen Vasen aus der zweiten
Hälfte des sechsten Jahrhunderts* (Berlin
1937) 131–39; *EVP* 19–20; N. J. Spivey,
The Micali Painter and His Followers (Ox-
ford 1987) 84–85. For non-figured vases,
cf. S. Schwarz, "The Pattern Class Vases
. . .," *StEtr* 47 (1979) 65–84. The yel-
lowish-buff clay and glaze paint fired red
or reddish brown are distinctive and are
similar to the fabric of the Orvieto group.

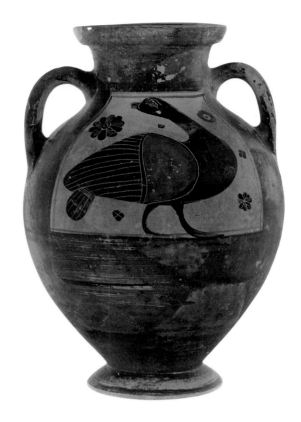

30

ATTIC BLACK-FIGURE
AMPHORA, TYPE B
Workshop of the Gorgon Painter
Ca. 580 B.C.
Gift of Gilbert M. Denman, Jr.
86.134.160
A and B: Bird

On A a bird moves right, looking back
over his shoulder to the left. The exact
species is not determinable, although a
duck or goose is the most likely. Geese
are common on early Attic black-fig-
ured vases. This, and the fact that their
bodies are often similarly conceived to
the bird on our vase, speak in favor of
a goose as the identification, while the
short neck and bill favor a duck. Many
birds by Attic vase-painters are not
species specific, but often have charac-
teristics of several; this is the case here.
The same bird is shown on B, but the
neck, head, front leg, and part of the
lower body, tail and the other foot are
lost. Rosettes decorated the fields on
both sides.

The vase was formerly attributed to
the Gorgon Painter, but a comparison
with his birds shows that this is incor-
rect; nor can the vase be said to be in

his manner. The style of drawing
comes closer to the Komast Group, al-
though it cannot be attributed to that
workshop (cf. the loutrophoros by the
KX Painter in the Kerameikos: *Para*
15). The Gorgon Painter is credited
with being the first to decorate the
panels of Type B amphorae with a sin-
gle moving animal, and the size, loca-
tion, and form of the panel is similar to
his, so the vase may have been pro-
duced in the Gorgon Painter's work-
shop, but by an artist other than the
master. None of the Gorgon Painter's
amphorae of this type have a bird,
rather they have a lion or ram (Emory
Univ. 1984.20). JHO

DIMENSIONS: H. 34.1–.4 cm.; Diam. of
mouth 13.9–14.1 cm.; Diam. of foot
12.4 cm.; Max. Diam. 23.9 cm.
CONDITION: Broken and recomposed
from fragments; several large fragments
from the back are lost; slight repainting
on some of the rosettes and bird of Side
A; glaze peeled off on much of Side B
and the handles. No preliminary drawing.
Incision for eye, bill, wing, and tail of the
birds and rosettes.
SHAPE AND DECORATION: Type B am-
phora. Echinus mouth glazed inside to a
depth of 2.3 cm.; rounded handle at ei-
ther side; flaring foot. The outside of the

vase is painted black, except for the pan-
els and the lower .4 cm. of the foot
which is, as the bottom, left in reserve.
A black line runs parallel to and slightly in
from each side of the border of the pan-
els. Two horizontal red lines run around
the vase beneath the picture panel.
ADDED COLOR: Red for bill, eye, and
wing of bird; some of the petals of the
rosettes; and the two lines running
around the vase.
BIBLIOGRAPHY: Galerie Günter Puhze,
Kunst der Antike, cat. 6 (1985) 19 no. 200.
LITERATURE: For the Gorgon Painter, see
Agora XXIII 75–77; D. Williams, "In the
Manner of the Gorgon Painter: the Deia-
neira Painter and Others," in *Enthousias-
mos* 61–68. Two new examples, probably
from the Gorgon Painter's workshop, are
in Florence (M. Cristofani, *Gli etruschi in
Maremma* [Turin 1981] 205, fig. 180) and
Cervetri 67730 (M. Cristofani, *Civiltà
degli etruschi* [Milan 1985] 196, no. 1 and
198). For the Type B amphorae, see
Agora XXIII, 4–7; I. Scheibler, "Bild und
Gefäss: zur ikonographischen und funk-
tionalen Bedeutung der attischen Bildfeld-
damphoren," *JdI* 102 (1987) 57–118; for
an interesting new example in Munich,
see B. Käser, *MüJb* 38 (1987) 228–31. For
the amphora at Emory University,
1984.20, see Christie's London, 2 July
1982, lot 251. Compare also the am-
phorae *ABV* 9,9 and *Para* 7,9*bis* and 9[5].

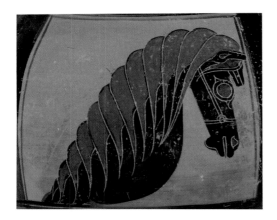

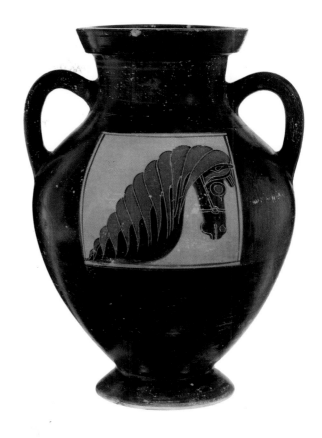

31

ATTIC BLACK-FIGURE
HORSE-HEAD AMPHORA
Attributed to Painter H
Ca. 575–550 B.C.
Gift of Gilbert M. Denman, Jr.
86.134.173
A and B: Horse-head

Over one-hundred examples are known of this special type of early black-figure vase called the "Horse-head amphora." The canonical decoration consists of a haltered horse protome in profile to the right within a reserved panel on each side of the vase. The series begins around 600 B.C. and continues for at least fifty years. Its invention has been variously attributed to prominent early black-figure painters, such as the Gorgon Painter and the Nessos Painter, but the horse type with its luxurious mane, large round eye and prominent chin can be traced back to Proto-attic vase-painting of the seventh century B.C. And it can be found as late as the third quarter of the sixth century B.C. on an amphora in Bonn attributed to the Amasis Painter.

The San Antonio specimen can be attributed to the same hand as two

horse-head amphorae in Paris (Cabinet des Medailles 204 and Louvre E 821). The distinctive features of this artist, known as Painter H, include the squared (as opposed to rectangular) panel, the way in which the head abuts the right side of the frame so that the right ear overlaps it, and the excessively large eye. Unusual aspects of the San Antonio vase are the incised chin line and the absence of an upper tear duct.

Since horse-head amphorae have been found in Attic as well as Etruscan cemeteries, and were also dedicated on the Athenian Acropolis, it is difficult to determine their precise original function. Some scholars have suggested that they were prize vases and so predecessors to the Panathenaics which begin ca. 570–560 B.C. Others maintain that their use was specifically funerary, and connect the image of the horse with the chthonic deities Poseidon Hippios and Athena Hippia. J N

DIMENSIONS: H. 35.6 cm.; Diam. of mouth 16 cm.; Diam. of foot 13 cm.
CONDITION: Broken and repaired. Large misfired area stretching from right half of

Side B to left half of Side A. Minor chipping on mouth exterior.
SHAPE AND DECORATION: Type B amphora with flaring mouth, round handles and echinus foot.
ADDED COLOR: Red for two horizontal lines below mouth, line above panels, frame of panels, two lines below panels, locks of manes, inner ears, pupils of eyes, nostrils, and mouths.
BIBLIOGRAPHY: Sotheby's London, 17–18 July 1985, lot 246.
LITERATURE: For horse-head amphorae, see ABV 15–17, and M. G. Picozzi, "Anfore attiche a protome equina," StMisc 18 (1970–71) 3–64; A. Birchall, "Attic Horse-Head Amphorae," JHS 92 (1972) 46–63; M. G. Picozzi, "Precisazioni sulla classificazione stilistica delle anfore attiche a protome equina," ArchCl 24 (1972) 378–85. For the Amasis Painter's horse-head amphora (Bonn 504), see ABV 151,20; A. Greifenhagen, AA 50 (1935) 422, fig. 10. Amphorae by Painter H include Louvre E 821 (ABV 16,21; CVA [Louvre 3] pl. 9, figs. 8, 9, and 11), and Cab. Méd. 204 (ABV 16, 20; Birchall, pl. 13a). For horses and the cult of Athena, see N. Yalouris, "Athena als Herrin der Pferde," MusHelv 7 (1950) 54–55.

ATTIC BLACK-FIGURE
SIANA CUP
Attributed to the Malibu Painter
Ca. 565–560 B.C.
Gift of Gilbert M. Denman, Jr.
86.134.34
Interior: Female head
A and B: Symposium with guests

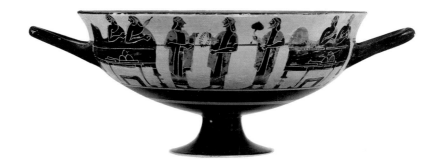

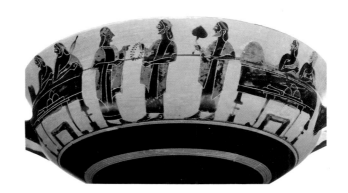

A large female head facing left is por-
trayed in the interior medallion, in-
cluding the shoulders and part of the
peplos. The hair is curly along the fore-
head and worn long, with one strand
falling in front of the shoulder and the
rest over the nape of the neck. Finely
incised lines indicate the eye and brow,
the details of the ear, the mouth (two
short parallel lines), and the necklace.

The friezes on both sides of the cup
depict a symposium scene. Side A
shows three couches; a man stands fac-
ing right between the left and middle
ones. Two men recline on each of the
couches to the right of him, while a
single man occupies the left couch. In
the middle of Side B there is a group of
three persons, a woman and two men,
flanked on either side by a couch with
two reclining symposiasts. All male
symposiasts are bearded, except for the
second one from the right on Side B.
They wear red fillets around their
heads and face left. Their legs are
drawn up, and the outline of both
knees of the man at the far left is indi-
cated on both sides of the cup. Each
wears a red or black mantle, and, except
for the two at the head of the middle
and right couches on Side A, their right
arms and shoulders are exposed. All
hands are clenched into fists. On the
table in front of each couch there is a
tray with three white buns, piled pyra-
midally, and two slices of meat; below
there is a rectangular footstool. The
two men in the middle of Side B are
apparently guests who bring a wreath
and a large ivy leaf as a present for the
lady of the house. The man standing
between the couches on Side A might
be the host (or perhaps another guest?).

The paintings on both sides of the
cup can easily be recognized as the
work of the Malibu Painter, a younger
colleague of the C-Painter, named after
a Siana cup from his hand in the J. Paul
Getty Museum (77.AE.46). The ar-
rangement of the couches, occupied by
two reclining figures, and the presence

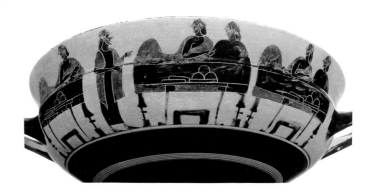

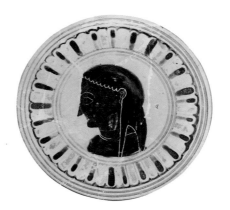

of guests standing between them are
characteristic of this painter. Men
bringing a wreath and a large ivy leaf
are also found on other cups by his

hand. The female head in the interior
tondo, however, is so far unique in
cups by the Malibu Painter and by his
colleagues from the C-Painter's work-

shop. Male heads are encountered in tondos of cups made by Lydos' workshop. The female head inside the San Antonio cup is turned about fifty degrees to the right of the handle axis. When painting a tondo figure the Malibu Painter usually held the cup with the left handle and foot resting on the his knees; as a result his tondo figures are tilted to the right. The name and role of the lady portrayed, girl or *hetaira*, remains uncertain (cf. the female heads in outline on lip-cups, who may be *hetairai*). The subject and style of painting and drawing of the symposium scenes are closely paralleled by some of the painter's middle-period cups, dated ca. 565–560 B.C. HAGB

DIMENSIONS: H. 13.3 cm.; Diam. of rim 26.5 cm.; Diam. of foot 9.7 cm.
CONDITION: Unbroken; repaired crack at bowl/foot join. The black paint in the medallion and on the exterior has been applied too thinly, causing a brownish dilute effect after firing; the same occurred on the other Siana cup, Cat. No. 33.
SHAPE AND DECORATION: The shape of the cup shows the characteristics of 'overlap' cups from the Malibu Painter's middle period: a low, flaring foot; a steeply rising body-wall with hardly rounded shoulders; a remarkably blunt offset, and very high lip. The border of the small tondo consists of a ring of alternating red and black tongues between two concentric circles. Bands along the lower edges of the klinai are solid red and dotted in red; there is also a dotted band along the upper edge of the right-hand kline on Side B. The reserved band in the solid black underside of the bowl is filled in with a series of four lines, as is usual on 'overlap' cups from the C-Painter's

workshop. A large blotch of spilled black paint protrudes from the back of the symposiast at the head of the left-hand couch on Side B. On Side A the painter incised an erroneous line on the left-hand tabletop.
ADDED COLOR: Added red on the mantles, fillets, and couches is rather well preserved; the added white of the buns and of the female skin is faded.
BIBLIOGRAPHY: Sotheby's London, 11 December 1984, lot 282 (illus. of side A reversed); Galerie Günter Puhze, *Kunst der Antike,* cat. 6 (Freiburg 1985), 20, no. 206 (illus. of side B reversed).
LITERATURE: For the Malibu Painter, see Brijder, *Siana Cups* I 169–81, esp. pl. 39 b-d, 40a-b. For cups by Lydos with a male head in the tondo, see Taranto 20273, *ABV* 112,69, *CVA* (Taranto 3) pl. 19, 3; Taranto I.G. 4492, *ABV* 113, 73, *CVA* (Taranto 3) pl. 19, 1.

33

ATTIC BLACK–FIGURE
SIANA CUP
(DOUBLE-DECKER)
Manner of the Heidelberg Painter
Ca. 550–545 B.C.
Gift of Gilbert M. Denman, Jr.
86.134.33
Interior: Two fighting warriors
A and B (Lip): Ivy
A (Bowl): Women welcoming youths
B (Bowl): Gathering of men, youths, and women

Two fighting warriors are represented in the tondo. Both are moving to the right. The left-hand warrior, running in the so-called *Knielauf* position, is much bigger than his opponent, whom, it appears, he is about to defeat. He holds his own sword horizontally in the lowered right hand, ready to thrust, after having apparently seized his opponent's sheathed sword, which he raises in his other hand as a sign of victory. Partially preserved lines seem to belong to the scabbard's baldric, even though the warrior on the right is seen wearing a baldric. The left lower leg of the attacking warrior is largely overlapped by his opponent's right leg; his left foot stands on a double volute ornament. The warrior at the right, deprived of his weapon, tries to flee while looking

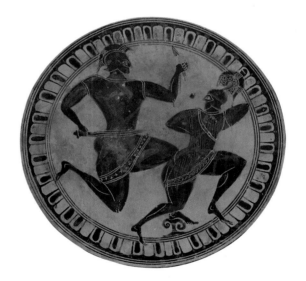

back at his attacker. His arms are bent sharply, as if tied behind his back. Both warriors wear Corinthian helmets and short chitons. The one on the left has a low crest and a chiton bordered at the hem by a band filled with a row of incised crosses; the other has a high crest and a wavy line in the chiton's border. The added white of the chitoniskos of the right-hand warrior, now faded, is incised with fine vertical lines. Crests and feet overlap the border of the medallion, which consists of a ring of alternating red and black tongues be-

tween two concentric circles.

The exterior is decorated according to the so-called "double-decker" system with high figured-frieze. The lip is adorned with an encircling ivy-branch. The leaves, growing from a wavy branch, are alternately red and black, with stalks that curve in a more or less S-curve. Bunches of berries depicted as dotted circles are painted between the leaves. Seven figures are present in each frieze on either side of the cup.

The painter of this cup obviously imitated one of the most important

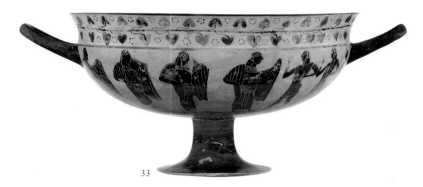

33

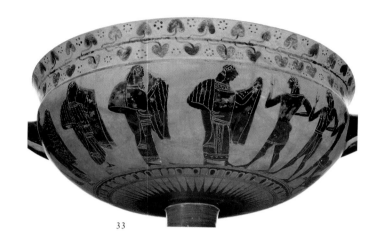

33

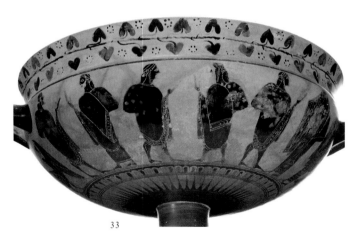

33

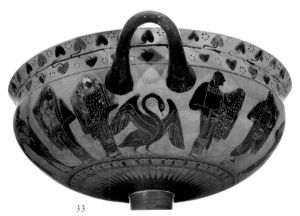

33

Siana cup painters, the Heidelberg Painter. The subject of both sides is related to that of the Heidelberg Painter's name-piece. On Side A four women are welcoming three youths. The four women are dressed in peploi and mantles. The two in the middle pull their mantles over their heads as a veil, and hold the edges away from their faces with their left hands in the so-called *aidos* (shame) gesture. The two other women wear the mantles over their shoulders, holding one corner up with the left hand. The three youths wear short chitons; the one in the middle has a belted *nebris*. They raise their right hands in a gesture of greeting. The subject of returning youths being welcomed by family, especially female members, is common in the work of another Siana cup painter, the Taras Painter. It may be interpreted as the homecoming of victorious athletes.

Side B shows a gathering of upper-class Athenian men, youths, and women; the scene may be connected with the theme of the welcoming party on the other side of the cup. On the left, two bearded men who gesticulate animatedly with one hand raised as if in discussion. Two youths stand at the center. To the right, a youth converses with two ladies, making a similar gesture. All three youths have long ringlets before their ears. All males wear wide mantles draped over their shoulders; the second man from the left also wears a white chiton. The women pull their mantles over their heads, like the two on the other side of the cup. The painter clearly borrowed these types of figures, their stance and garments, from the Heidelberg Painter. They also have the elongated fingers and garment patterns, such as wavy lines and crosses, that are characteristic of that painter. The swans below the handles are a common motif on the Heidelberg Painter's double-deckers. The style of painting and drawing, however is more clumsy than the Heidelberg Painter's.

The ornaments of an ivy-branch with bunches of berries in the shape of dotted circles and base-rays combined with a tongue band are similar to those on the lip and underside of a late cup by the Heidelberg Painter, Vienna 1672. As far is now known, this painter did not depict two fighting warriors in his cup tondos. Herakles' struggles, however, are the Heidelberg Painter's

most common subject for this part of the cup. The composition of the fighting figures shows some resemblance to that of the fight of Herakles and an Amazon inside one of his late cups, Würzburg L 452. Here, however, the figures are confronting and better proportioned, and the composition is much better balanced. Three elements in the San Antonio tondo are curious: the position of the arms of the right-hand warrior, the sword in the raised left hand of the left-hand warrior, and the double volute ornament under the latter's foot (such an ornament is also seen under the foot of the female warrior, or Amazon, in the tondo of Taranto I.G. 4442 by the C-Painter).

HAGB

DIMENSIONS: H. 13.7–14 cm.; Diam. of rim 24.6–25 cm.; Diam. of foot 9.8 cm.
CONDITION: Unbroken; repaired chip on interior of cup. As on Cat. No. 32, the black paint has been applied so dilutely that firing has caused it to turn brownish. The fact that the lower half of the bowl and the foot have discolored to a reddish-brown is interesting: it demonstrates that the cup was stacked in another cup when fired in the kiln.
SHAPE AND DECORATION: The shape and proportions of the cup are almost identical to those of Würzburg L 452, which belongs to the Heidelberg Painter's later period, ca. 550–545 B.C. A swan, standing to the right and spreading its wings, fills the area below each handle. Base-rays decorate the lowest part of the bowl around the top of the foot. A tongue band between pairs of lines, of the same type as the tondo border, is painted above the rays, and forms, as it were, the base for the figures in the friezes.
ADDED COLOR: Added red is preserved on parts of the garments (note the polka dots on the mantles of the youths in the middle of Side B); white, for the most part faded, is preserved on the head of the woman at the far right on Side B.
BIBLIOGRAPHY: Münzen und Medaillen, Basel, Auktion 63 (29 June 1983) no. 22, attributed to a companion of the Heidelberg Painter, ca. 550 B.C.; A. B. Brownlee, "Attic Black Figure from Corinth: I," *Hesperia* 56 (1987) 83; H. A. G. Brijder, *Siana Cups IIA*, no. 472, pl. 147d, 148a-b (forthcoming).
LITERATURE: For the Heidelberg Painter, see *Development²* 51 (his later period). For the cup Würzburg L452, see *ABV* 63, 6; E. Langlotz, *Griechische Vasen in Würzburg* (Munich 1932) pls. 117, 126, 128.

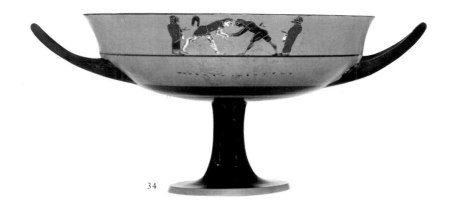

34

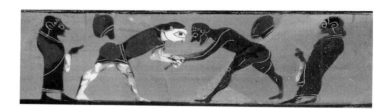

34

34

34

ATTIC BLACK-FIGURE LIP CUP
Ca. 550 B.C.
Gift of Gilbert M. Denman, Jr.
86.134.35
A and B: Wrestling match
of Peleus and Atalanta

The contest between Peleus and Atalanta is seen on both sides of the vase. The wrestling match is depicted in nearly identical fashion on each occasion with both contestants braced for the struggle. On Side A, Peleus is nude and bearded, standing at right with his left foot advanced, his outstretched hands in the grip of Atalanta's fists. She

faces right in a similar pose to that of Peleus, but with elbows bent. She is clad in a short tunic. Over the back of each contestant is a bundle of cloth hung in mid-air. Flanking this scene are two youths, each dressed in a chiton and a himation. On Side B, Peleus has only a few whiskers for a beard and, though nude, has a single incised line across his left upper arm as if he were wearing a short-sleeved garment. The two male spectators here are bearded. In the handle zone, beneath each scene is a nonsense inscription. This continues in the form of dots under one handle.

The wrestling match of Atalanta and Peleus was part of the funeral games in

honor of Pelias, king of Iolkos, whose death came about after the two contestants returned with the other Argonauts from Kolchis to Thessaly. Literary reference to the wrestling match of Peleus and Atalanta is quite late (esp. Apollodoros 3.9.2), yet its iconography in Greek art is established by the sixth century B.C. Its first appearance in Attic black-figure vase-painting occurs about 560 B.C., and by mid-century, as seen on the San Antonio lip cup, the positions of the antagonists are set in opposing stances with Atalanta on the left. In Attic black-figure examples, it is common to find two or more spectators to the event, and it is plausible to assume that these might be judges. A close parallel to the wrestling scene on the San Antonio lip cup is found on an Attic band cup in Oxford, where Atalanta wears a similar tunic and cloths are suspended in mid-air over the wrestlers' backs. K K I I

DIMENSIONS: H. of rim 9.2 cm.; Diam. of rim 14.7 cm.; Diam. with handles 19.7 cm.; Diam. of foot 6.1 cm.
CONDITION: Broken and repaired. Restored fragment on Side A encompasses right leg of Herakles.
SHAPE AND DECORATION: The lip cup is a product of the Little Master workshops of the mid-sixth century B.C. The figure decoration on the vase exterior is restricted to the offset lip; the space be-tween the handles often carries a signature, motto, or, as in the case of the San Antonio cup, a nonsense inscription. The number of characters painted on the lip of the San Antonio vase exceeds the normal amount (normally one to three) which generally does not allow for a mythological subject. Repetition of the subject from Side A to Side B is frequently the case. The painter responsible for this vase is a lesser artist with an unusual subject. He has deviated from the norm in omitting a figured tondo and the palmettes at the handles found on other lip cups. The vase interior is black save for a reserved tondo with two rings, the outer thick, the inner thin and of dilute glaze, around a black dot.
ADDED COLOR: White paint is used for Atalanta's flesh and the exposed edges of the spectators' draperies about the extended hands on Sides A and B. Red paint is applied to Peleus' beard on Side A and to that of the spectator at right on Side B.

BIBLIOGRAPHY: Unpublished.
LITERATURE: For the band cup Oxford 1978.49, see *LIMC* II 945, s.v. Atalante no. 67. For Atalanta and Peleus, see *LIMC* II 940, 945–46, and 949; *Vasenlisten*[3] 316–17. For Little Master cups, see J.D. Beazley, "Little-Master Cups," *JHS* 52 (1932) 167–204; *Development*[2] 53–56.

ATTIC BLACK-FIGURE
NECK-AMPHORA
Attributed to
the Castellani Painter [J.D. Beazley]
Ca. 550 B.C.
Gift of Gilbert M. Denman, Jr.
86.134.169
A: Chariot race
B: Symposium

The front of this Tyrrhenian amphora shows an excerpt from a chariot race, two quadrigas driven by charioteers in long white chitons. One horse in each team is white, a popular device on black-figure vases for adding a touch of variety. The rear chariot seems to be starting to gain on the front runner, as the horses' forelegs begin to overlap the front car. Two male spectators watch the race from the sidelines, and two dogs run alongside, as if trying to join the race. A nonsense inscription runs beside the front chariot.

The reverse depicts a symposium comprising three couches with tables bearing food alongside. The middle couch is occupied by a man and woman, while the other two are shared by bearded male couples. Such scenes had appeared on Attic vases even somewhat earlier than the Tyrrhenian Group, for example on a neck-amphora of ca. 570 in the Joslyn Art Museum, Omaha (1963.480). The Castellani Painter himself reverted to the theme at least one other time, on an amphora now at Stanford University (Stanford 90). But on the Stanford vase, all the symposiasts are pairs of a bearded man and beardless youth, as in the Athenian paederastic ideal, while on our vase none of the pairs is so constituted.

The Castellani Painter is one of the most prolific of the painters of Tyrrhenian vases, first identified by Dietrich von Bothmer in 1944. He belongs to the "dicers," that is, painters who separate the figured scene from the registers below it with a band of dots known as dicing. These vases are in general later than the Tyrrhenians by such painters as the Goltyr Painter (cf. Cat. No. 36) that lack the dicing. The figure style has deteriorated somewhat in the work of the Castellani Painter, though his animals are still carefully drawn. The upper animal frieze features goats,

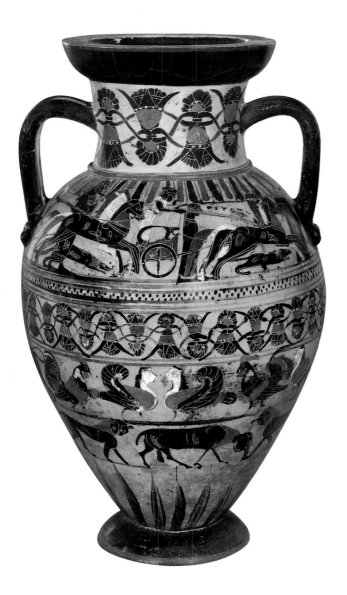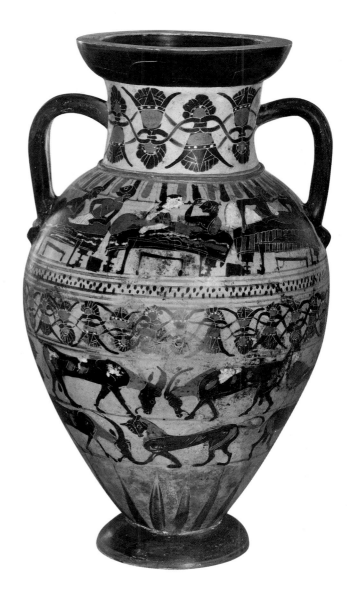

cocks and sirens; the lower, panthers, a goat and a ram.　**HAS**

DIMENSIONS: H. to rim 41.6 cm.; Diam. of mouth 16.7 cm.; Diam. of foot 12.2 cm.

CONDITION: Body broken and repaired. Restored portion in non-figural regions on Side A.

SHAPE AND DECORATION: Ovoid neck-amphora of standard Tyrrhenian type. Lotus chain of four elements on either side of the neck; tongue pattern above the figured scene, with ring separating neck from body; echinus foot with rays above.

ADDED COLOR: White for dots on lotuses and palmettes. On Side A, white used for chitons of charioteers, center horse in each team, rosettes on chiton of first spectator, necks of cocks, face, breasts and band on wings of sirens. On Side B, white used for himation of second male on left couch, flesh of female, himation of first male on right couch, wavy bands along first and second couches, stripe on under-belly of panther, hind-quarters, upper back and fore-quarters of goats, head, breast and stripe along wing of siren, mask of panther. Red for centers on palmettes and lotuses, alternating tongues on shoulder. On Side A, red for center of rosettes on chiton of first spectator, mane and tail of center horse in each team, details on hind-quarters and neck of frontal horse in each team, cart of second chariot, details on necks and bellies of dogs, comb, neck and wing of each cock, bodies of sirens, necks and areas of hind-quarters on panthers and goats. On Side B, red for neck and areas of hind-quarters of panthers and goats.

BIBLIOGRAPHY: *Para* 42, middle; Christie's London, 23 February 1965, lot 179. Christie's East, New York, 19 June, 1985, lot 159.

LITERATURE: On the Castellani Painter, see D. von Bothmer, "The Painters of 'Tyrrhenian' Vases," *AJA* 48 (1944) 165 (Castellani Painter as earliest of the 'dicers'), 168–69, (list of two vases by him); T.H. Carpenter, "On the Dating of the Tyrrhenian Group," *OJA* 2 (1983) 279–91. For the early amphora with symposium, name-vase of the Omaha Painter (Joslyn 1963.480), see *CVA* (Omaha 1) pl. 10. For the Stanford amphora with symposium (Stanford 90), *AJA* 69 (1965) pl. 17, 1–2.

36

ATTIC BLACK-FIGURE
NECK-AMPHORA
Attributed to the Goltyr Painter
[D. von Bothmer]
Mid-6th century B.C.
Gift of Gilbert M. Denman, Jr.
86.134.31
A: Amazonomachy
B: Man and woman courting

In this excerpt from an Amazono-
machy, two Greek hoplites wielding
spears attack a single Amazon from
either side. She too carries a spear, a
shield seen in profile, and wears a hel-
met of nearly standard Corinthian type,
except that the cheekpieces are rather
narrow. Her short tunic is decorated
above the waist with an incised star
pattern and, below, with a broad, ta-
pering stripe filled with white sirens on
rectangular panels. The two Greeks are
nicely differentiated, one carrying a
round shield seen from the inside, the
other an oval Boeotian shield with a
thunderbolt as its device. Both wear
Corinthian helmets, and the cuirass of
the Greek at left is richly decorated. A
pair of symmetrical cocks completes the
picture panel, seeming to watch the
combat intently, though impassively.

The reverse contrasts love with war.
A nude, middle-aged man with pot
belly and a fillet in his hair stands be-
fore a young woman and displays his
painfully erect penis. She wears a very
short tunic, with a star pattern on the
barely covered buttocks. The suitor
pulls back his foreskin ("praeputia
ducit," wrote Beazley) in an effort to
pique her interest. But the girl seems
unimpressed and with a dismissive ges-
ture of her outstretched hand suggests
that he might have better luck with the
sphinx perched beside the handle. A
second sphinx stands at the left, and a
pair of cocks edges rather close to the
would-be lover, as if eavesdropping on
this intimate moment.

Both subjects on the San Antonio
vase are quite popular on Tyrrhenian

neck-amphoras, especially in the reper-
toire of our artist, the Goltyr Painter.
While most Tyrrhenian Amazono-
machies specifically include Herakles,
on several vases our painter leaves the
interpretation open by portraying the
Greeks as standard hoplites and omit-
ting inscriptions. Two of his amphoras,
Paris E840 and Leiden PC36, have the
identical three-figure composition, and
the latter even matches our scene in
virtually all details of armor and dress.

On his reverses, the Goltyr Painter
sometimes places a single dancing ko-
mast between animals, but the more
interesting confrontation depicted on
our amphora also has parallels in his
work. The group may be expanded to
two couples, as on the amphora once
in Goluchow (Inv. 9; his name vase,
from 'Gol[uchow] Tyr[rhenian]'),
which also explains most clearly the
gesture of retracting the foreskin. Per-
haps closest to our couple is that on an
amphora formerly on the Lucerne mar-
ket, where, however, the girl displays
considerably more curiosity.

The Goltyr Painter, whose oeuvre
was first assembled by Beazley in 1932
and later expanded by Bothmer, repre-
sents within the larger workshop "per-
haps the most idiosyncratic 'Tyrrhen-
ian' artist" (Bothmer). Our vase
includes, in the two animal friezes, sev-
eral of the peculiar bulb-headed rams
which Bothmer singles out as charac-
teristic, as well as the rich use of inci-
sion (e.g. on the cuirass) and of added
red and white which, when well pre-
served, as here, combine to give a
rather pleasing effect. HAS

DIMENSIONS: H. 39 cm.; Diam. of
mouth 15.5 cm.; Diam. of foot 11.1 cm.
CONDITION: Body broken and repaired.
Restored segment between, and partially
encompassing, cock and male figure on
Side B, as well as head of ram in frieze
below. Bottom frieze on Side B misfired.
SHAPE AND DECORATION: Ovoid neck-
amphora of standard Tyrrhenian type.
Lotus chain with five elements on either

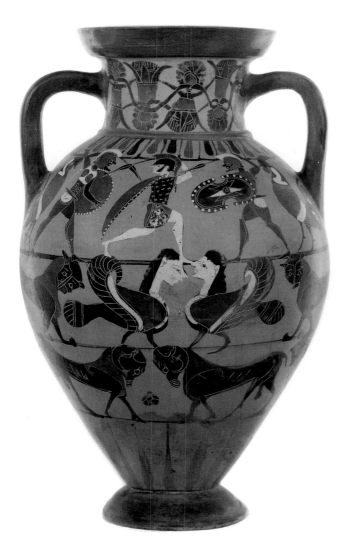

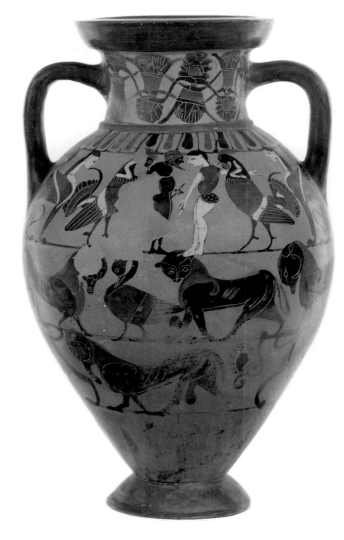

side of the neck; tongue pattern above the figured scenes, with plastic ring separating neck from body; echinus foot with rays above. The two animal friezes comprise sphinxes, panthers, rams, and a single swan.

ADDED COLOR: Red for helmets of warriors and Amazon; shield of one warrior and of Amazon, and dot in the center of the other shield; greaves of both warriors; shirt of Amazon; comb, neck, belly, and wings of cocks; necks and body markings of panthers; bellies of sphinxes; necks of rams; belly and wing of swan; hair and beard of male lover; tunic of woman; centers and dots on palmettes; molded ring at base of neck; alternate tongues below neck. White for flesh of woman and sphinxes; markings on cocks.

BIBLIOGRAPHY: *Palladion. Antike Kunst* (Basel 1976) 23, no. 23; Sotheby's London, 14–15 December 1981, lot 268a.

LITERATURE: For the Goltyr Painter, see D. von Bothmer, "The Painters of 'Tyrrhenian' Vases," *AJA* 48 (1944) 164, 167. For Amazonomachies by the Goltyr Painter, see idem, *Amazons in Greek Art* (Oxford 1957) 25, pl. 22; *CVA* (Leiden 1) pl. 2. For the gesture 'praeputia ducit,' cf. *ABV* 101,91; *CVA* (Goluchow 1) pl. 8. For the amphora on the Lucerne market, see *Para* 42; *Ars Antiqua Auktion* 2, Lucerne (14 May 1960) lot 132.

ATTIC BLACK-FIGURE
COLUMN-KRATER
Attributed to the Painter
of Louvre F6 [J.D. Beazley]
Ca. 560–550 B.C.
Gift of Gilbert M. Denman, Jr.
86.134.38
A: Frontal quadriga between spectators
B: Youth between lions regardant

A four-horse chariot confronts the
viewer with the pole horses looking in-
ward and the trace horses facing out.
Between each pair of pole and trace
horses is a cloth suspended in midair.
A beardless charioteer faces to the left.
Four men, one of them beardless, in
long robes flank the quadriga. The re-
verse scene (Side B) displays a single
youth clad similarly in a long robe, his
left hand reaching out from under its
folds. He is flanked by two pieces of
cloth which hang magically in space
and in turn by two heraldically placed
lions with flicking tails and reversed
heads. Under each handle, a great bird
in flight separates the two scenes.
Bearded male heads adorn the handle-
plates on the vase rim, itself decorated
with wavy lines which recall the rip-
pling action created by stirring the
vase's contents. In shape, subject mat-
ter, and subsidiary decoration, this vase,
as the style of the Painter in general, is
very Corinthianizing.

The Painter of Louvre F 6 was, in
Beazley's words, an "old-fashioned
companion of Lydos." His style copies
that of the master artist, especially in
the rendering of animals, but is far
more mechanical and drier, lacking the
robust vitality inherent in the mytho-
logical scenes painted by Lydos. The
scene of the frontal quadriga is not un-
common in his work and examples of
this subject can be found on nearly
every type of vase shape in his reper-
toire. It also appears on a column-
krater by Lydos at Harvard (Harvard
1925.30.125). Mythological scenes are
relatively rare, usually Dionysos with
his entourage or Herakles with an op-
ponent. More common to the Painter
of Louvre F 6, especially on his late
vases, are warriors on the move, stand-
ing male figures, and athletes. In all,
well over a hundred vases are credited
to his hand. KK II

DIMENSIONS: H. 43 cm.; Diam. of
mouth 42.9 cm.; Diam. with handles
53.1; Diam. of foot 20.5 cm.
CONDITION: Unbroken. Repaired crack
under B/A handle. Heavy encrustation
on interior; abrasion along top of rim and
on shoulder of Side B.
SHAPE AND DECORATION: The column-
krater, originally a Corinthian shape, ap-
pears in Attica during the early years of
the sixth century B.C. It receives its
name from the columnar supports under
the handle-plates. The shape develops to-
ward a narrower body and a taller neck.
With this in mind, the San Antonio vase
would be slightly later in date than an-
other column-krater by the Painter of
Louvre F6 in Oxford (Oxford 190) hav-
ing a nearly identical rendition of the
quadriga scene. Rows of zigzags appear
around the mouth, alternating red and
black tongues extend from the neck onto
the vase shoulder. Base-rays appear above
the echinus-shaped foot. A vertical row
of dots is set in front and in back of the
youth on the reverse and a single dot-
rosette appears under each lion.
ADDED COLOR: Red paint is applied to
the beards, head bands, and garments of
the men on Side A as well as to the chari-
oteer's robe and the pole horses' manes,
the bodies of all the horses, and parts of
their rigging. Red paint appears in dots
on the lions' manes, rib lines, and
haunches as well as on the garment of the
youth on Side B. Red also appears on the
wings of the birds under the handles and
on the beards of the heads on the handle-
plates. White marks were applied to the
garments of the men and charioteer, and
to the manes of the trace horses on Side
A. It also embellished the whiskers of the
lions and the garment of the youth on
Side B.
BIBLIOGRAPHY: ABV 124,17 (unpub-
lished).
LITERATURE: For Lydos and his compan-
ions, see ABV 107ff; Tiverios, Lydos; on
the Painter of the Louvre F6, see esp.
idem, Problemata tes melanomorphes attikes
Keramikes (Thessalonica 1981). For the
column-krater, see T. Bakir, Der Kolonet-
ten-Krater in Korinth und Attika zwischen
625 und 550 v. Chr. (Würzburg 1974). For
the column-krater by Lydos, Harvard
1925.30.125, see ABV 108,9; Tiverios,
Lydos, pl. 19–20a. For the column-krater
by the Painter of the Louvre F6, Oxford
190, ABV 124,16, see Tiverios, Prob-
lemata, pls. 20–24.

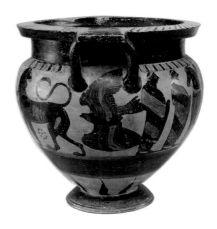

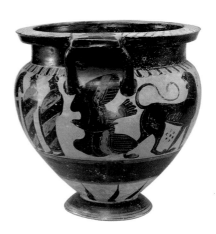

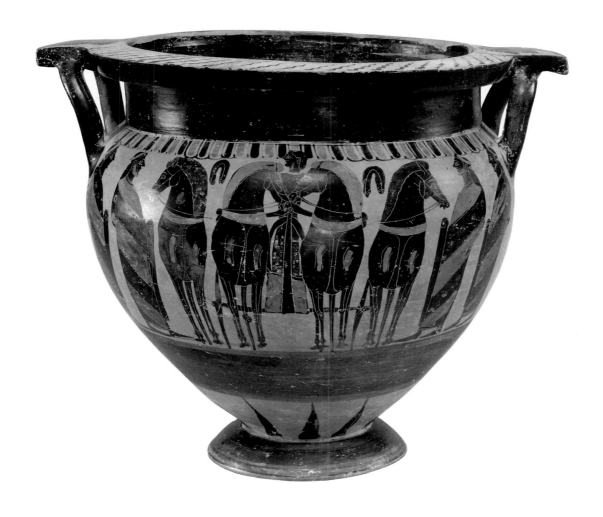

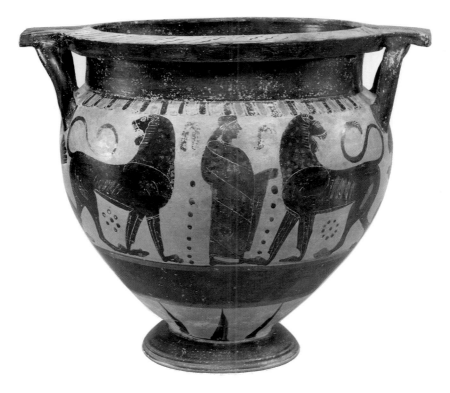

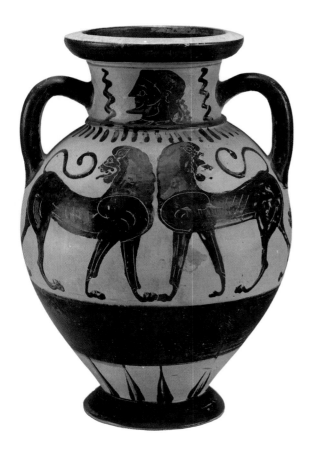
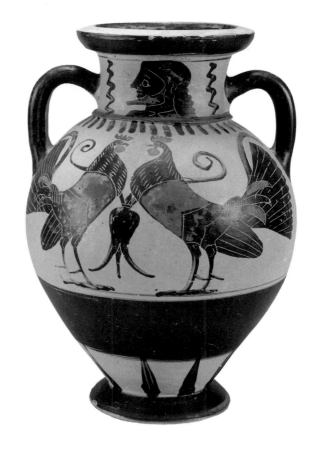

38

ATTIC BLACK–FIGURE OVOID NECK-AMPHORA

Attributed to the Painter of Vatican 309
Ca. 560–550 B.C.
Gift of Gilbert M. Denman, Jr.
86.134.37
A: Confronted lions regardant
B: Confronting cocks

Two snarling lions walk toward each other, their heads turned backward and their tails flicking over their backs. On the opposite side of the vase two cocks in a heraldic display confront one another. Positioned behind them is an inverted lotus bud from which two tendrils curl into spirals above the backs of the cocks. On the neck on both sides of the vase a bearded head with long wavy hair faces left between vertical, zigzagging lines.

The Painter of Vatican 309 is a close companion of Lydos. The workshop in which they decorated their vases was very prolific and included the last group of Attic artists who decorated large vases solely in the animal style.

The strong similarities in their treatment of animals in the painted scenes prevented Beazley from distinguishing among them on this basis alone. They are, as he states, Lydian. Details in the rendering of human figures vary. For the Painter of Vatican 309 the rendering of the human head, a common subject on the necks of his amphorae, displays a cheerful quality distinguishable from the more reserved characterizations by his colleagues. Of the large vase shapes, the preference of the Painter of Vatican 309 was the ovoid neck-Amphora. His inclination toward Corinthian subsidiary decorative motifs, like that of his companions, is exemplified by the tongue pattern under the neck and the base-rays above the foot of the San Antonio amphora.

KK II

DIMENSIONS: H. of rim 32.4 cm.; Diam. of mouth 14.5 cm.; Diam. of foot 11.6 cm.
CONDITION: The vase is intact except for chips in the lion at right.
SHAPE AND DECORATION: The neck-amphora of ovoid shape is prominent

during the first half of the sixth century B.C. It is seen here with standard cylindrical handles which attach shoulder to mid-neck and an echinus-shaped lip and foot. A molded ring separates the neck from the body. Beyond the subsidiary ornaments mentioned above, the figure zones are devoid of decoration except for an incised rosette on the body of the vase beneath each handle.

ADDED COLOR: Red paint was applied to the beards and headbands of the human heads, to the manes, ribs, and haunches of the lions, and to the combs, wattles, saddle feathers, and tail coverts of the cocks. Single red bands appear just inside and outside of the mouth, and on the edge of the foot of the vase. White paint was applied to the wing and middle tail covert of each cock.

BIBLIOGRAPHY: Unpublished.

LITERATURE: For the Painter of Vatican 309, see *ABV* 114,120–22; *Para* 49–50.

PARALLELS: For a companion piece see *Hesperia Art, Bulletin* XLII (Philadelphia ca. 1967–68) no. 8. For comparable works by the Painter of Vatican 309, see Florence 78784; *ABV* 121,13; A. Rumpf, *Sakonides* (Leipzig 1937); Louvre E810; *ABV* 121,14; E. Pottier, *Vases antiques du Louvre* II (Paris 1897) pl. 57B.

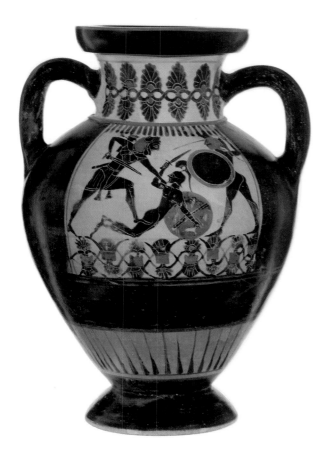
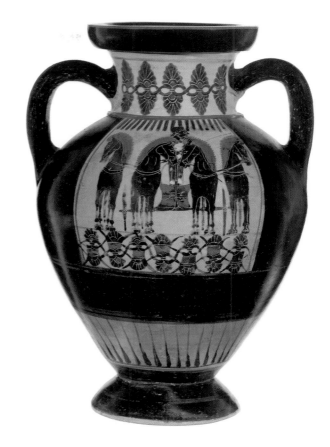

39 COLOR VERSION PAGE I

ATTIC OR ITALIC
BLACK-FIGURE
NECK-AMPHORA
Ca. 550–525 B.C.
Gift of Gilbert M. Denman, Jr.
86.134.32
A: Herakles and Kyknos
B: Frontal chariot

On Side A, Herakles is about to deliver the coup de grace to a fallen Kyknos, whose father Ares tries in vain to intervene. The hero wears a short pleated chiton and, over it, his lionskin, knotted over his chest, the paws hanging far down. He wields his sword against Kyknos, its scabbard slung across his back, and he also wears a quiver filled with arrows about his right shoulder, though there is no sign of a bow. Kyknos is, exceptionally, nude, but for a high-crested Corinthian helmet. The sword he holds up in his right hand is rendered useless by Herakles' gesture of grasping the limp upper arm, and the big round shield threatens to slip from his lowered left arm. Ares wears a red Corinthian helmet with a low crest and long tail and hefts a spear which is so thin as to look rather harmless. His greaves are distinct, in added red, but his body armor is hard to make out and the exposed buttocks look unprotected. Only two incised lines at the shoulder suggest a corselet which is mostly hidden behind the round, undecorated shield.

The reverse panel is filled with a frontal chariot in a symmetrical scheme popular in Archaic art, the two outside horses facing out, the two inner toward each other, nose to nose. In the simple car, shaped like an ingot in frontal view, stands a bearded charioteer in long white garment. He gathers the reins and holds a thin crop, visible over the horses' heads at the right.

Herakles' fight with the Thessalian brigand Kyknos is one of the hero's most often depicted deeds in Archaic vase-painting. One reason for its popularity was no doubt the fame of the two poems of the early sixth century which

each recounted the story in different versions, one by Stesichoros, the lyric poet from Himera in Sicily, the other the pseudo-Hesiodic short epic, the *Shield of Herakles*. In the Stesichorean version, now known only from references in later writers, Herakles at first

39

had to back away when confronted by both Kyknos and Ares at once, giving rise to a proverbial saying "Not even Herakles against two." He then slew Kyknos in single combat. Our scene could almost be inspired by the first episode, except that the hero seems unintimidated by the presence of Ares. The monomachy of Herakles and Kyknos is depicted sporadically through the sixth century and early fifth, but what makes the version on the San Antonio amphora unique (and problematical for the attribution to a workshop) is the absence of Athena. For the many vases, overwhelmingly Attic, which show Ares seconding his son invariably include Athena supporting her favorite protégé, as she does in the *Shield*.

This iconographical rarity, combined with several technical and stylistic peculiarities, cast some doubt on the Attic origin of our vase. Particularly noticeable are the narrow picture panels, with large areas around the handles glazed black. On the standard Attic ovoid neck-amphora, the reserved panels reach nearly to the handles. Such narrow panels are best paralleled on pseudo-Chalkidian neck-amphoras of the second half of the sixth century, which were probably made in Etruria in imitation of the Chalkidian vases of

South Italy (cf. Cat. No. 22). On the other hand, the bands of lotus and palmette beneath the picture panel on each side do not have any good parallel in that position, either in Attic or non-Attic. The figure style of the Kyknos scenes has many affinities with Tyrrhenian amphoras, made in Athens for export to Etruria, but so far the Kyknos story is unknown on Tyrrhenian vases, and the complete absence of animals would be surprising for a Tyrrhenian vase. The awkward, twisting/falling pose of Kyknos somewhat recalls that on a 'Chalkidian' amphora in Munich (Munich 592), where, however, he is shown as an armed hoplite. The artist of our vase was evidently well aware of the Stesichorean version of the Kyknos myth, and of Attic and 'Chalkidian' depictions of the story, but his slightly eccentric adaptation of all these sources suggests a local artist working in Etruria. H A S

DIMENSIONS: H. 31.8 cm.; Diam. of mouth 13.5 cm.; Diam. of foot 11.9 cm.
CONDITION: Broken and repaired; restored area beneath A/B handle.
SHAPE AND DECORATION: The amphora has a convex lip, round handles, and an echinus foot. Decoration consists of a palmette chain on the neck with five and one-half elements on Side A and five elements on Side B. A tongue pattern appears above each figural panel and lotus-palmette chain below. Below the figural panels is a reserved band decorated with rays, bracketed by double lines in red, above and below.
ADDED COLOR: Red for Herakles' lion-

skin, Ares' helmet, Kyknos' shield, horses' manes, chariot-car and double lines above and below reserved band. White for charioteer's chiton.

BIBLIOGRAPHY: H. A. Shapiro, "Two Black-figure Neck-amphorae in the J. Paul Getty Museum: Problems of Workshop and Iconography," *Greek Vases in the J. Paul Getty Museum* 4 (1989) 22, fig. 12 (Side A).
LITERATURE: For Herakles and Kyknos: F. Vian, "Le combat d' Héraklès et de Kyknos d'après les documents figurés du VIᶜ et du Vᶜ siècle," *REA* 47 (1945) 5–32; H.A. Shapiro, "Herakles and Kyknos," *AJA* 88 (1984) 523–29. On the literary sources, see R. Janko, "The Shield of Heracles and the Legend of Cycnus," *CQ* 36 (1986) 38–59. On the frontal quadriga, see G. Hafner, *Viergespanne in Vorderansicht* (Berlin 1938). On pseudo-Chalkidian vases, see F. Canciani, "Eine neue Amphora aus Vulci und das Problem der pseudochalkidischen Vasen," *JdI* 95 (1980) 140–62; on Chalkidian: cf. bibliography for Cat. No. 22. For the 'Chalkidian' Kyknos amphora in Munich (592), see *CVA* (Munich 6) pl. 285.

40

ATTIC BLACK–FIGURE AMPHORA (TYPE B)
Attributed to Group E
Ca. 550–540 B.C.
Gift of Gilbert M. Denman, Jr.
86.134.40
A: Herakles and the Nemean Lion
B: Lyre-player

On Side A, Herakles, erect and facing right, struggles with the lion between two columns. One of these supports an Ionic, the other a Doric capital, each surmounted by a seated sphinx. The combatants are posed in a manner reflective of actual wrestling form. The lion's body rises to the right behind that of Herakles, its head turning back to left and overlapping the hero's chest. The intense action of the conflict is heightened by the beast's lashing tail as he twists about in the grip of his adversary. Supported on the ground only by his left hind leg, the lion mauls Herakles' left shoulder with its left fore paw and rakes his left calf with the claws of its right hind leg. Wearing only a baldric and a sheath, Herakles holds open the mouth of the lion with his left hand while he attempts in vain to pierce the skin of the creature with a thrust of his

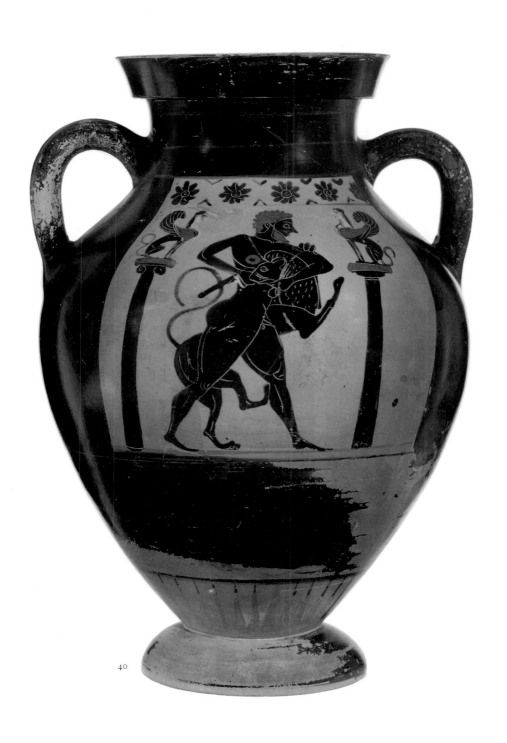

40

sword, held in his right hand. The white pommel of the sword's hilt can be seen protruding from the back of Herakles' right fist. The entire blade of the sword is concealed behind the lion's head.

The reverse side of the vase displays a youthful lyre-player in a long sleeveless chiton under a himation, facing to right. The beardless musician plays his light-framed instrument with both hands while positioned between two slender columns surmounted by Ionic capital(s?) with a cock perched on each. Beazley considered most of the vases (primarily Type B amphorae) in Group E to be earlier than those painted by Exekias, whose art emerges from and surpasses that of the group. The particular rendering of Herakles and the Lion as seen on the San Antonio vase is "a relatively rare configuration [which] appears earliest and almost exclusively on vases of this [E] group." (Bell, p. 80) The motif of Herakles and the Nemean Lion first appears in Greek art during the eighth century B.C. Its first certain appearance in Greek vase painting is on a Middle Corinthian kylix from Perachora of the early sixth century. This single occurrence in Corinthian vase painting is overshadowed by its popularity on Attic pottery where it appears more often than any other mythological theme. The emergence of this subject on Attic black-figure vases occurs

40

about 570 B.C. on works by the C-Painter and rapidly reaches its apogee during the mid-sixth century, to which the San Antonio vase belongs. The sudden popularity at this time of the contest between Herakles and the Nemean Lion may well be linked to the establishment of the Nemean Games, traditionally in 573 B.C., as a Panhellenic festival.

On vases in Group E the scene of Herakles and the Lion is more commonly flanked by two spectators, one male and one female, on occasion recognizable as Iolaus and Athena. Here, however, the mythical contest is set between two columns, one Doric and one Ionic, surmounted by sphinxes. The placement of the musician on Side B between two Ionic columns bearing cocks recalls poetic recitations and the Panathenaic festival in honor of Athena. Prizes for the contests took the form of specially designed and painted black-figure amphorae, with Athena depicted between two Doric columns crowned by confronted cocks on the obverse, and a scene reflective of the actual competition on the reverse. The scene of Herakles wrestling the Lion certainly expresses the essence of competition, and the image of flanking columns may have been adapted from Panathenaic vases on which cock columns were a novelty at this time. Herakles, also, is depicted in musical competitions on Attic black-figure vases, playing the lyre or *kithara*. The subject of Herakles and the Lion on vases in Group E is quite common, whereas the lyre-player and the presence of flanking columns in both scenes are hitherto completely alien to the group. It would then seem plausible to look outside of Group E for an external stimulus, and it is noteworthy that a Panathenaic amphora in London with cock columns and a *kitharoidos* stands on the periphery of the group. The mixing of Doric and Ionic capitals on the obverse side of the San Antonio vase perhaps was meant to invite comparison, since Ionic capitals were still a novelty in Athens at this time, being primarily associated with religious architecture in Ionia. Applied to small, votive monuments, their presence was perhaps encouraged by Peisistratos, who maintained strong ties with the Ionian tyrants. Artists imitating aspects of Panathenaic amphorae often substituted owls, lions, objects and even hu-

man figures for the traditional cocks atop the Doric columns on their vases. However, for the image of a seated sphinx perched on an Ionic column one cannot overlook the uniquely inspirational dedication of the Naxians at Delphi about 560 B.C. in the form of a single Ionic column over ten meters in height, supporting a colossal, seated sphinx, posed like those on our vase.

KK II

DIMENSIONS: H. 35.4 cm.; Diam. of rim 15.1 cm.; Diam. of foot 12.3 cm.
CONDITION: Restorations occur on the hind quarters and parts of the tail of the lion, and on both columns and part of the Doric capital on Side A. On Side B, restorations include most of the left column and its capital, body parts of the musician between his elbow and lower legs, part of the right column, head of right cock, and neck and part of tail feathers of left cock. The semicircular mark across the lion's mane and shoulder is the result of a pre-firing accident. A graffito under the foot of the vase may be an alpha or a stemless rho.
SHAPE AND DECORATION: The one-piece or belly amphora Type B exhibits a continuous curve over the body from the flaring lip to the inverted echinus foot. Its handles, connecting neck and shoulder, are cylindrical in section. Black-figure examples of this form appear in the late seventh century and develop into the fifth century B.C. Over the intervening decades the form of the vase becomes taller in its proportions with the neck more elongated. By these criteria, the San Antonio amphora is less fully evolved than other examples of the shape in Group E, a fact which contributes to its date near the mid-century mark. Recent studies by MacKay on amphorae in Group E and by Exekias have made progress in distinguishing different potters. Subsidiary decoration on the San Antonio vase consists of five petalled rosettes alternating with four pairs of opposing chevrons in a segregated band across the top of the figure scene on Side A and four such rosettes (with only a fraction of a fifth) without chevrons on Side B. Base-rays rise from the foot. Two thin red bands circle the neck while others frame the figure panel, and others still set off the base-rays from the rest of the body and edge the rim of the foot.
ADDED COLOR: Red is applied to the hair, beard and nipple of Herakles, the hair of the lyre-player, the abacuses of the capitals and wings of the cocks and sphinxes. White paint appears for the baldric and sword pommel of Herakles,

on the faces of the sphinxes, and on the exposed parts of the musician's chiton at the neck and feet.

BIBLIOGRAPHY: J. Neils, *Goddess and Polis: The Panathenaic Festival in Ancient Athens* (Hanover, New Hampshire, 1992) 156–57 no. 20 (Side A); K. Kilinski II, *Classical Myth in Western Art: Ancient through Modern* (Dallas exh. cat. 1985) 48, no. 11 (Side A).

LITERATURE: For Group E, see *ABV* 133–38; *Para* 54–57, 130; E. E. Bell, "An Exekian Puzzle in Portland: Further Light on the Relationship between Exekias and Group E," in *AGAI* 75–85. For Herakles and the Nemean Lion, see F. Brommer, *Heracles: The Twelve Labors of the Hero in Ancient Art and Literature*, trans. S. J. Schwarz (New Rochelle 1986) 7–11; *LIMC* V s.v. Herakles and the Nemean Lion, 1762–1989. For this particular pose, see *Vasenlisten³* 126–27. For the rarity of this subject in Corinthian vase painting, see T. J. Dunbabin, *Perachora* II (Oxford 1962) 262 no. 2542, pls. 106, 110, and 163; *CorVP* 628. For Herakles as a musician, see *LIMC* IV 810–17. For the Panathenaic in London (B 139), see *ABV* 139,12; *Para* 57,12. For the subject of Herakles and Peisistratos, see J. Boardman, "Herakles, Peisistratos and Sons," *RA* (1972) 57–72; idem, "Herakles, Peisistratos and Eleusis," *JHS* 95 (1975) 1–12. For the design of belly amphorae in Group E, see A. Mackay, "Amphorae by Exekias," in *Ancient Greek and Related Pottery*, ed. H. A. G. Brijder (Amsterdam 1984) 153. No close parallels exist for the graffito in A. W. Johnston, *Trademarks on Greek Vases* (Wiltshire 1979), but cf. type 9E, 47E, fig. 8g.

41

41

ATTIC BLACK–FIGURE
AMPHORA
Attributed to
Group E [D. von Bothmer]
Ca. 540–530 B.C.
Gift of Gilbert M. Denman, Jr.
75.59.15
A: Herakles slaying the centaur Nessos
B: Wheeling chariot

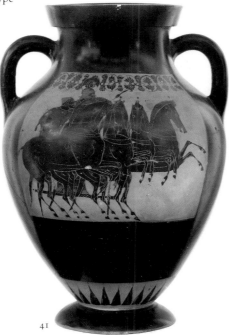

41

On the front of this amphora of Type B, Herakles rescues his wife from the centaur Nessos, who had tried to molest her as he ferried her across a swollen river. The hero strides to the right, menacing the centaur with his drawn sword. He wears a short, sleeveless tunic with embroidered hem and a fillet in his hair. The scabbard hangs from a baldric over his right shoulder. Nessos flees to the right, but turns back, brandishing a rock in each hand. Deianeira stands impassively between the two and faces her husband, her extended right hand the only sign of distress. She wears a belted peplos and a shawl draped over her shoulder.

On the reverse, a quadriga is shown wheeling around. The pole horse has a band tied around his belly. In the car are a charioteer and an armed warrior. The charioteer, visible only from the waist up, wears a short-sleeved chiton and a *nebris* over it, and a conical cap. Of the warrior, only the high-crested helmet and tip of the spear can be seen behind the pole horse.

The death of Nessos is a favorite subject in Attic black-figure, but disappears almost entirely from the repertoire of red-figure painters. It is one of the first clearly recognizeable mythological scenes depicted on a Greek vase, the great Protoattic amphora in New York of about 670 B.C., and was espe-

cially favored by the painters of Tyrrhenian vases in the second and third quarters of the sixth century. Our artist presents an unusually spare version, stripped of any indication of setting or landscape. He follows earlier vase-painters in making Herakles' weapon the sword (as, for example, on the great early amphora in Athens (Athens 1002), name-vase of the Nettos Painter). In the later literary tradition, best known to us from Sophokles (*Trachiniae* 567), the hero shoots Nessos with an arrow dipped in the deadly blood of the Hydra.

The attribution to Group E was made by Dietrich von Bothmer and accepted by Beazley, who first assembled this large but closely related group of vases and characterized it as, "the soil from which the art of Exekias springs, the tradition which on his way from craftsman to true artist he absorbs and transcends" (*ABV* 133). The death of Nessos appears on only one other vase of Group E, an unpublished amphora in Boulogne. The wheeling chariot is, however, a favorite motif on the reverse of Group E amphoras; a virtual replica of our Side B occurs on an amphora in Tarquinia (Tarquinia RC 7170). **HAS**

DIMENSIONS: H. 40 cm.; Diam. of mouth 17 cm.; Diam. of foot 14.2. cm.
CONDITION: Broken and repaired. Fragment restored to right of Nessos.
SHAPE AND DECORATION: Narrow mouth and handles set high; echinus foot. At the top of the picture panel on Side A, a chain of lotus buds pointing downward; on Side B, a palmette chain. Rays above the foot.
ADDED COLOR: White (mostly flaked off) for Deianeira's flesh, charioteer's chiton and animal hide. Red for hair and beard of Herakles and Nessos, fillet in Herakles' hair, and Deianeira's peplos.
PROVENANCE: Ex colls. Rogers; Sir Stephen Courtauld (La Rochelle, Imbeza Valley, Rhodesia).
BIBLIOGRAPHY: *Para* 56,38*bis*; Sotheby's (London) 9 December 1974, lot 227; *SouthernColls* no. 25; J. P. Uhlenbrock, *Herakles: Passage of the Hero through 1000 Years of Classical Art* (New Rochelle, NY 1986) cat. no. 2 (H. A. Shapiro).
LITERATURE: On Herakles and Nessos, see K. Fittschen, "Zur Herakles-Nessos-

Sage," *Gymnasium* 77 (1970) 161–71. For the Protoattic amphora in New York, see K. Schefold, *Frühgriechische Sagenbilder* (Munich 1964) 36, pl. 23. For Group E and Exekias, see E. A. Mackay, "Painters Near Exekias," in *Copenhagen Proceedings* 369–378. For the Group E amphora in Boulogne, see *ABV* 135,31; for the Group E amphora, Tarquinia RC 7170 (*ABV* 134,24) see *CVA* (Tarquinia 2) pl. 29.4.

42

ATTIC BLACK-FIGURE
AMPHORA (TYPE B)
Attributed to the
Taleides Painter [J. D. Beazley]
Ca. 540 B.C.
Museum Purchase:
Grace Fortner Rider Fund
86.119.1
A: Seated man and standing woman with a warrior and three youths
B: Youth and woman with two warriors and a man

The figure-scenes on the panels of this amphora, which have no inscriptions, cannot be interpreted with certainty. Both are simple lineups with virtually no overlapping. The six-figure panel belongs to Side A; its focal point is a bearded man (his face missing), with long hair bound by a fillet, seated on a campstool, facing toward the right. He wears a chiton, with incised crosses and borders of incised curls at neck and lower edge, topped by a himation. His right arm is bent at the elbow, with the hand extended parallel to the picture plane. In his left hand he holds a long slender object whose upper section is missing. A woman stands before the seated man. She gestures with both hands raised. Her hair is long, and she wears a belted peplos decorated with borders of incised circles at the neck and at the bottom edges of the overfall and skirt. Behind her stands a warrior facing left. He wears a Corinthian helmet with a low crest and carries a spear and a round shield (device: tripod), drawn with a compass. The ends of his chlamys hang down beneath the shield, which obscures his torso. The greaves protecting his legs are precisely detailed

with stylized anatomical markings. Behind the seated man stands a long-haired youth, in a chiton and a himation with incised borders, who holds an upright spear in his left hand. A pair of spear-bearing, nude youths occupy the far left and right.

At the center of the five-figure composition on Side B, a woman, wearing a belted peplos with incised borders, has pulled her himation over her head. Two incised lines indicate her necklace. She faces a spear-bearing youth at the left. He has long hair and wears a himation tightly wrapped over his chiton (incised borders on both). Flanking the couple at left and right are two armed warriors. The warrior at the far left, facing right, wears a Corinthian helmet with a low crest, which overlaps the upper border of the panel. He carries a spear and a shield (device: leaf?), shown in profile view. His greaves are plain. He wears a short chiton with borders of incised curls. The armed warrior on the right differs in detail. He faces left, with spear in right hand and shield (device: tripod) on left arm—his upper torso is in back view. His Corinthian helmet differs only in the decoration of its low crest (incised circles). His greaves, like those of the warrior on Side A, have stylized anatomical markings. His short chiton is decorated with incised borders of circles and curls. Neither warrior on the reverse wears a cuirass. At the far right stands a bearded man with short hair who holds an upright spear. He wears a himation wrapped over a chiton (borders of incised circles).

Full-sized pots, such as the amphora in San Antonio, are exceptional for the Taleides Painter. Although he started out decorating large hydriae in the workshop of the potter Timagoras, in his surviving oeuvre of less than thirty vessels, small vases predominate. Eight of his works, a small amphora, an oinochoe, a loutrophoros, a lekythos and four lip-cups, bear the signature of the potter Taleides, after whom the painter is named. Taleides the potter and the Taleides Painter could have, but need not have been, the same man. Significantly one of the painter's late lekythoi, in Malibu (Getty 76.AE.48), was potted by Amasis. This great contemporary

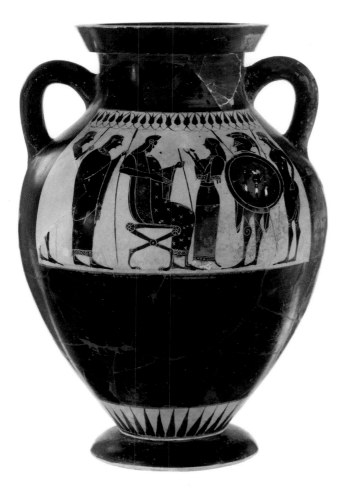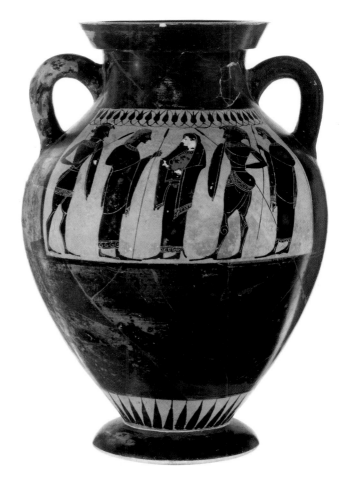

potter and the Amasis Painter are the closest kin of the potter Taleides and the Taleides Painter. Whether they were two, three or four individuals in reality, these craftsmen must have been associates. Even on the full-sized San Antonio amphora the Taleides painter's black-figure sensibility was that of a miniaturist. Great attention has been paid to the balance of incised detail and added-color (now poorly preserved). The figures are slender and elegant, albeit stiff and perhaps a bit mannered. The Taleides Painter's love of spear-bearing onlookers recalls the Amasis Painter, as does his predilection for surmounting black-figure pictures with upright lotus buds. Another unusual trait, shared with the Amasis Painter, appears on most of the Taleides Painter's mature works—female flesh is left black, and the eye is incised in the male manner. On the San Antonio am-

phora, however, female flesh, as is standard in black-figure, is covered with white added over the black—a feature which links this pot with this painter's earliest works, three hydriae in the Louvre (Louvre F38, F39, Louvre Camp. 10655).

That the Taleides Painter's representations often defy easy interpretation perhaps also is Amasean. While he favored variety in subject matter, only two identifiable myths by his hand are preserved: Herakles and Triton, and Theseus and the Minotaur. Sometimes he clearly depicted genre: the weighing of goods, boxing, foot-racing, homosexual courting. Schefold believed the reverse of the San Antonio amphora to represent Menelaos courting his wife-to-be Helen, but the beardless youth could hardly be the Spartan king. Alternatively, one might see the Trojan Prince Paris and Helen; however, this

is no abduction—the male figure does not lead the woman away. The equally enigmatic compositional type of the obverse recurs two other times in the Taleides Painter's oeuvre: on the shoulder of the Louvre hydria, F 38, and on the body of the Getty lekythos. On the former the male figure seated on a campstool holds a scepter, on the latter a spear. On the San Antonio amphora only the shaft of the corresponding object is preserved, and one cannot determine whether the seated man here was meant to be a king or perhaps a god. Beazley termed the Louvre scene "warrior leaving home?" But no one apparently readies to leave on the obverse of this amphora. The difficulty in assigning specific meanings to both of the centralized gatherings of simple black-figures in San Antonio counts as part of the appeal of the Taleides Painter.

BC

DIMENSIONS: H. 41.9 cm.; Diam. of mouth 18 cm.; Diam. of foot 15.7 cm.

CONDITION: Broken and repaired; restored fragment on Side A to the right of B/A handle (includes torso of first youth), and another including face of seated man.

SHAPE AND DECORATION: Flaring mouth, outside glazed black; top surface flat and reserved; inside glazed black. Round handles, glazed black. Panels surmounted by friezes of upright lotus buds, bounded above and below by lines of dilute glaze. On each side a line of dilute glaze serves as the ground line for the figures. Vertical line of dilute glaze at right edge of panel on Side B. Above foot, thirty-six black rays. Echinus foot, glazed black; underside reserved.

ADDED COLOR: Red for line on neck and for two lines on body below panels. On Side A, himation of seated man and fillet on his head, peplos of female figure, lower part of helmet crest, rim of shield and greaves of warrior on right, hair of youth in himation on left, hair of youths on far left and right. On Side B, red for peplos and pupil of eye of female figure, in her hair traces of a fillet(?), hair of youth in himation on left, lower part of helmet crest and rim of shield of warrior on the left, upper part of helmet crest and band across upper part of short chiton of warrior on the right, hair and beard of man at right. On Side A, white for flesh of female figure, shield device of warrior, dot rosettes on chiton of youth on left. On Side B, white for flesh of female figure, dot rosettes on her himation, upper part of helmet crest and shield device of warrior on left, shield device of warrior on right, dot rosette on chiton of man on right.

BIBLIOGRAPHY: *Para* 73,1*bis*; *Beazley Addenda²*, 49; Münzen und Medaillen, Basel, Auktion 26 (5 October 1963) lot 101; Sonderliste G (November 1964) no. 3; K. Schefold, *GuH* 189; Sotheby's New York, 17 February 1978, lot 77; *Apollo* 107 (January 1978) 74; B. Legakis, "A Lekythos Signed by Amasis," *AntK* 26 (1983) 75, pl. 20, 2; Sotheby's New York, 21–22 November 1985, lot 33.

LITERATURE: For the Malibu lekythos, 76.AE.48, and the association of the Taleides Painter with the workshop of Amasis, see Legakis, 73–76, pl. 19. For the Taleides Painter, see *ABV* 174–77; D. von Bothmer and M. J. Milne, "The Taleides Amphora," *BMMA* n.s. 5 (1946–47) 221–28. For Amasis and the Amasis Painter, see von Bothmer, *The Amasis Painter and his World* (New York 1985) esp. 86–87, 102–03.

43

ATTIC BLACK-FIGURE
AMPHORA (TYPE B)
Attributed to
the Painter of Berlin 1686
[H. A. Shapiro, G. Puhze]
Ca. 540 B.C.
Gift of Gilbert M. Denman, Jr.
86.134.44
A: Men courting youths
B: Birth of Athena (?)

Five bearded men compete for the attentions of three youths in the boisterous and crowded composition on the front of the vase. The eight figures are, however, somewhat symmetrically arranged in groups of three, two, and three, illustrating different aspects and phases of the courtship. In the group at left, the youth has just received a large white cock as a love gift from the suitor to whom he looks back, who waits expectantly for some gesture of appreciation. But another man, hand to his head as if in a dance, has come alongside and threatens to distract the youth's attention. At the the right, another threesome approaches a more intimate encounter. The youth stands rather impassive, holding up a wreath in one hand. It appears that between him and his wooer another man, aroused and unable to contain himself, has suddenly intervened. In the very center, unperturbed by the activity around him, a successful lover, distinguished from the others by the fillet in his hair, embraces his prize as he pushes his erect penis between the boy's thighs. This last activity is watched intently by a dog that has wandered through the forest of legs from the right, perhaps drawn by the smells. The festive atmosphere is further enhanced by white wreaths, two held by the couple in the center, one hanging in the background.

The scene on Side B is uncertain and is made more difficult to interpret by the large missing section, which obscures much of the male and female figures in the center. A kingly figure sits on a *diphros*, beneath which crouches a hare. He is surrounded by a woman and four men and youths. Three incised lines across the seated figure's garment just below the break could belong to a thunderbolt, confirming what we might have suspected from the familiar schema, that he is

Zeus. The woman wears a belted chiton with white dot patterns and another garment in red, but her upper garment is lost. Of the four male figures, the only identifiable one is Hermes, second from the right, in his winged boots, short chiton, patterned shawl, and cap. The youth behind him wears a long striped mantle, and the pair at the left likewise alternate short and long costumes. The hare would seem more at home in the courting scenes on the obverse, as a love gift, but otherwise there seems no apparent connection between the two sides.

The key to the reverse scene's interpretation perhaps lay in the now lost portion of the female figure. Eileithyia, the birth goddess, with hands outstretched, would indicate Zeus in labor, about to give birth to Athena. It seems very unlikely that the newborn goddess was shown, for there is no trace of her on Zeus' lap, and had she emerged from his head, she would reach up onto the shoulder of the vase. Alternatively, we may well have here a vaguely defined gathering of gods on Olympos, a motif not uncommon on vases of this period. Indeed, even in better preserved versions, as on two amphoras by the Princeton Painter and many by the Affecter, it is difficult to either confirm or deny an allusion to the impending birth of Athena in the absence of a clinching figure, such as Hephaistos wielding his axe.

The courtship on Side A neatly illustrates in one scene all the stock motifs and different degrees of intimacy which Beazley first distinguished in 1949: his Type Alpha (*erastes*, or the lover, approaching *eromenos*, the beloved, with hands in the 'up-and-down' position) at the far right; Type Beta (giving or receiving gifts) at the left; and Type Gamma (*intercrural* intercourse) in the center.

The Painter of Berlin 1686, so named by Beazley after his amphora with a remarkable and—for him—unusually ambitious scene of a sacrificial procession for Athena, now in East Berlin, was active in the first and perhaps second decade after the middle of the sixth century, a contemporary of Group E (cf. Cat. No. 41) and the Princeton Painter. Our amphora should

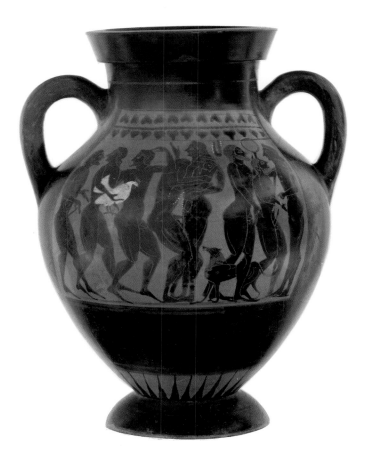

be one of his later works, when more sketchily drawn figures and sparing use of ornament and incision replace his ornate and painstaking early style. To the same phase belongs an amphora in London (London W39) with courtship scenes sharing many of the same elements on our vase, spread over both obverse and reverse. HAS

DIMENSIONS: H. 35.1 cm.; Diam. of mouth 16.2 cm.; Diam. 13.6 cm.

CONDITION: Broken and repaired. Large restored area in upper portion of figural scene on Side B. Side A misfired.

SHAPE AND DECORATION: Amphora Type B of standard shape, with offset lip, round handles, echinus foot, pictures set in broad panels. The shoulder ornament, two rows of ivy leaves growing from a horizontal band, is unusually simple and hastily executed. Rays above the foot.

ADDED COLOR: Red for hair and beard of all figures on Side A; fillet in center man's hair; penis of men at left and in the center; neck of dog; comb and neck of cock; wreath held by youth at right; parts of garments of all figures on Side B; hair and beard of man at left; wings on Hermes' boots. White for cock on Side A and necklaces held by youth in center and worn by one man diagonally over his chest, by three others over the forearm; dots on red wreath. Red stripes on neck of vase, below panels, above rays, and on foot.

BIBLIOGRAPHY: Galerie Günter Puhze, *Kunst der Antike*, cat. 4 (Freiburg 1982) 18, no. 185.

LITERATURE: On the Painter of Berlin 1686, see *ABV* 296–97; *Para* 128–29; J. Maxim, "A New Amphora by the Painter of Berlin 1686," in *Studien zur Mythologie und Vasenmalerei. Festschrift K. Schauenburg* (Mainz 1986) 35–40. For the London amphora with courting scenes, London W 39, *ABV* 297,16, see K. Schauenburg, "Erastes und Eromenos auf einer Schale des Sokles," *AA* (1965) 862–63. For the iconography of the Birth of Athena, see F. Brommer, "Die Geburt der Athena," *JRGZM* 8 (1961) 66–83. On the problems of recognizing the birth of Athena on two amphorae by the Princeton Painter, cf. D. von Bothmer, "A Panathenaic Amphora," *BMMA* 12 (1953) 56. On the subject and the Affecter, see H. Mommsen, *Der Affecter* (Mainz 1975) 64–68. On the typology of courtship scenes, see J. D. Beazley, *Some Attic Vases in the Cyprus Museum* (London 1948) 7–31.

44 COLOR PLATE IV

ATTIC BLACK-FIGURE NECK-AMPHORA
Attributed to
the BMN Painter [J. R. Guy]
Ca. 540 B.C.
Museum Purchase: Museum Antiquities
Acquisition Fund, with funds provided
by Mr. and Mrs. Robert Willson
87.58
A and B: Masturbating satyr

The Greek satyr's famed preoccupation with sexual gratification and uninhibited exhibitionism are vividly portrayed on this sadly fragmentary neck-amphora. On each side, a satyr clutches his enormously swollen phallus and, we may assume, masturbates. The two creatures are virtually twins, and the breaks are such that we can almost complete each figure by supplying missing parts from his twin. Thus, the frontal face and big staring eyes of the headless satyr can be imagined by looking at the other's well-preserved head, while the well-preserved penis of the headless satyr allows us to fill in details missing from the other: the head, testicles and vein running down the shaft, and the triangular patch of pubic hair, indicated by carefully incised dots. The only minor difference is that the headless satyr grasps his penis somewhat higher on the shaft, just below the head. The demonic look of the mask-like face, with teeth clenched, expresses the tension of the moment before release.

The side of the neck that is partially preserved is decorated with at least five sporting dolphins in a diagonal pattern. Dolphins are not uncommon on vases of the Nikosthenic workshop, in which the San Antonio amphora was probably made, but do not otherwise occur in this position.

The motif of the masturbating satyr reaches back a full generation to the painter Nearchos, whose crouching frontal satyr on the back of an oinochoe handle is very similar in pose to ours, except that he uses both hands. More generally, the San Antonio amphora illustrates an important change in satyr iconography in the mid-century: the hair covering the whole body of Nearchos' satyr and his two companions is now gone.

The San Antonio vase is attributed to the BMN Painter, whose name, as Beazley explained, is short for "the painter of the neck-amphora with the signature of Nikosthenes, number B295 in the British Museum." Of the large number of vases signed by the potter Nikosthenes (well over 100), only one other has been assigned to this painter, whom Beazley considered superior to other painters with whom the potter

 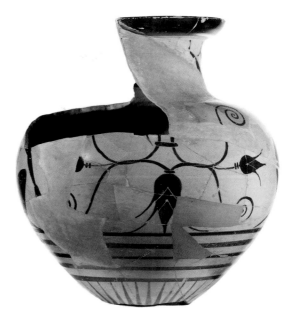

Nikosthenes collaborated. But Beazley did recognize his hand on about twenty other vases of various shapes, large and small. The largest single group among these consists of neck-amphorae of a special type, to which the San Antonio vase also belongs, designated by Beazley as the Bellerophon Class. Among this group, one, in Berlin, comes very close to the San Antonio amphora in subject matter as well, but adds a further touch of humor: while one satyr holds his huge, erect penis, the other's droops to the side: "Before and After" seems to be the message. HAS

DIMENSIONS: Preserved H. 23.1 cm.; Max Diam. of body 20.9 cm.
CONDITION: Mended from fragments with many gaps. The foot and upper body of the one side are entirely missing.
SHAPE AND DECORATION: Neck-amphora of the Bellerophon Class, charac-

terized by a round, globular body, broad, concave neck, and echinus mouth. The remains of one handle show that it was thin, rather than the wide triple-ribbed handle on a rotella-like root shared by other members of the class. Rays project above the (now lost) foot, and above these are five broad concentric rings, the top one serving as a ground line for the satyrs. The ornament, originating under the handles, swings outward to encroach on much of the picture field. It consists of interlocking vines supporting a very large bud in a double calyx that hangs straight down, as well as two smaller buds projecting to the sides.
ADDED COLOR: Red for the body of alternate dolphins, buds of florals, alternate tongues on shoulder, alternate rings below figural scene. On the figures, red is used for the testicles, the head and vein on the phallus, and for the satyrs' hair and tails.

BIBLIOGRAPHY: Unpublished.
LITERATURE: For the BMN Painter see *ABV* 226–27; *Para* 106–07; *Development²* 67. For the Bellerophon Class, See *ABV* 228. For the BMN Painter's neck-amphora with masturbating satyrs, Berlin 1671, see *ABV* 226,2; C. Johns, *Sex or Symbol* (London 1982) 92, fig. 72. For the aryballos by Nearchos, New York 26.49, see *ABV* 83,4; *AJA* 36 (1932) pl. 11. For dolphin friezes and their origin in East Greek vase-painting, see R. Stupperich, *Die Antiken der Sammlung Werner Peek* (= *Boreas Beih.* 6, Münster 1990) no. 29, with further references. For dolphins on Nikosthenic vases, see e.g. *ABV* 217–18, 10–12; 221, 40. For a dolphin on the neck of a much earlier vase, see the horse-head neck-amphora, Bloomington 74.10.1, *MidwesternColls*, no. 29.

ATTIC BLACK-FIGURE
COLUMN-KRATER
Manner of the Lysippides Painter
Ca. 530–520 B.C.
Gift of Gilbert M. Denman, Jr.
86.134.46
A: Harnessing of a chariot
B: Departure of a warrior

The broad panels of this exceptionally large krater depict in rich detail the preparation of a heroic warrior's departure for battle. The actual subject of the principal side is the harnessing of a chariot, but this mundane activity is ennobled by the presence of other members of the warrior's household who have gathered to bid him farewell. Amidst the crowd and the activity, the ostensible protagonist, the departing warrior, could almost be overlooked. He is probably to be identified with the fully armed hoplite, third from the left, who waits beside the chariot car, his face obscured by the Corinthian helmet that leaves only the eye visible. He carries a round shield and a pair of spears. He watches as a bearded man mounts the car, wearing not the long garment more characteristic of charioteers, but a chitoniskos, engraved cuirass, and sword.

Three more men are engaged in the actual business of harnessing the chariot. A bearded Scythian, dressed in patterned body suit and tall pointed cap, leads a third horse to join the two who stand ready and quietly at ease. The newcomer prances, with one leg in the air, rearing back slightly, his mouth muzzled. Behind the two harnessed horses, their activity obscured from view, a bearded man in long mantle and a nude youth (we cannot see if he is bearded or not, but the nudity suggests he is not) probably prepare a set of ropes like that hanging from the horse in the front plane. One horse is still missing from the quadriga, so that the departure is not imminent. Nevertheless, three of the warrior's family have come to say farewell: his elderly, bald father, tightly wrapped in a long garment and standing behind the car; and his wife, with their small son perched on her shoulder, at the right.

The five figures on the reverse comprise a different kind of farewell scene, quieter and more intimate. The principal pair is a fully armed hoplite warrior and his wife, who draws aside her veil, a standard, almost ritualized gesture in

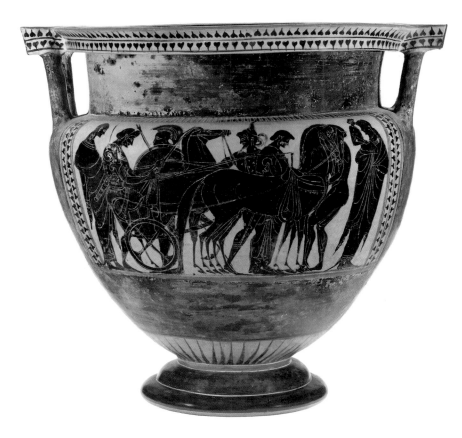

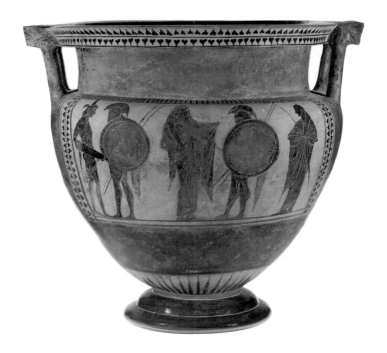

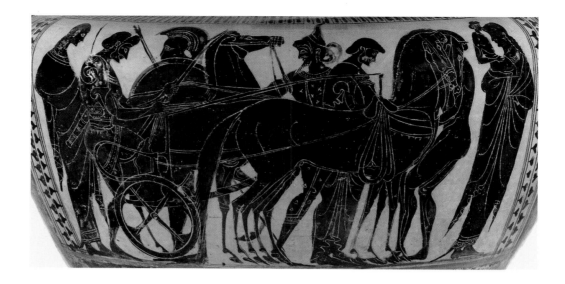

this context. At the left, an identical hoplite stands together with a Scythian archer. In contrast to his countryman on the obverse, this Scythian is young and beardless and carries a token of his expertise, the quiver. Finally, a woman stands alone at the right, quietly observing the others; her precise status (sister or mother of the departing warrior?) is left vague.

The top of the krater's mouth is decorated with a frieze of animals, arranged in six pairs of confronted leopard and boar. Each handle plate bears a floral pattern.

The departure of a hoplite warrior is a favorite subject of Attic black-figure in the last third of the sixth century. The stock figures on the reverse of our krater find parallels on many other vases, but the scene on the obverse is unique in combining elements from two different schemata which, though related, were conventionally kept rather distinct. The family members—the aged father and wife with small child—do not, strictly speaking, belong to the scene of harnessing the chariot, but rather to a later moment, the actual departure. It is as if the artist had to borrow these extras from another scene in order to fill his unusually broad panel, though they in no way disturb the logic or harmony of the composition. Indeed, they have the pleasing effect of framing the central action with two solid, vertical members and of enhancing a feeling of overall symmetry.

It has often been pointed out that such scenes of departure, though beloved and endlessly repeated in Archaic

vase-painting, occupy a curious realm between myth and genre. For on the one hand, they cannot represent actual hoplite warriors of the period of the vases, who had not used war chariots for centuries, while on the other hand, none of the figures is readily identifiable with familiar mythological heroes, such as those from the Trojan Cycle. Even the Scythian archer, who might at first seem to hint at Troy, is such a ubiquitous stock figure in these years that we cannot use him to localize the scene. One motif on our krater —the mother and child—does seem to be a direct borrowing from a mythological context favored in early black-figure, the Departure of Amphiaraos, one of the Seven Against Thebes. There they are of course integral to the narrative, representing the hero's treacherous wife Eriphyle and the future matricide Alkmaion, whereas by the period of our vase the same figures have become conventional and nameless members of the departing warrior's family.

Through a comparison of the figure style, but especially of the shape and subsidiary ornament, our krater may be placed with several which Beazley assigned to the Manner of the Lysippides Painter. All of these have the double row of ivy framing the picture panels as well as running along the mouth, the tongue pattern on the shoulder, and undecorated neck. One of these in London, has a similar but more orthodox scene of a warrior's departure, slightly heroized by the presence of Hermes. The two hoplites, their frontal

eye staring from the massive Corinthian helmet, are very close to those on the San Antonio krater, and the bald, egg-headed old man, though seated before the chariot instead of standing, matches ours as well. The animal frieze around the top of the mouth of our krater is, however, not paralleled on other kraters of this group. It derives ultimately from Corinthian column-kraters of the early sixth century and had been used last by Lydos, on his great krater in New York. HAS

DIMENSIONS: H. 53.8 cm.; Diam. at rim 50.3 cm.; Diam. with handles 58.2 cm.; Diam. of foot 26 cm.
CONDITION: Broken and repaired. Mouth on Side A misfired.
BIBLIOGRAPHY: Unpublished.
LITERATURE: On the harnessing of the chariot and departure of the warrior, see W. Wrede, "Kriegers Ausfahrt in der archaisch griechischen Kunst," *AM* 41 (1916) 221–374; A. Spiess-Dietrich, *Darstellungen des Kriegersabschied in der attischen Vasenmalerei* (Diss. Munich 1988). On Scythian archers, see W. Raeck, *Zum Barbarenbild in der Kunst Athens im 6. und 5. Jh. v. Chr.* (Bonn 1981) 47–54. On the departure of Amphiaraos, see I. Krauskopf, "Die Ausfahrt des Amphiaraos auf Amphoren der tyrrhenischen Gruppe," in *Tainia: Festschrift R. Hampe* (Mainz 1980) 105–16. For the Lysippides Painter and his workshop, see *ABV* 253–65; *Para* 113–17; B. Cohen, *Attic Bilingual Vases and their Painters* (New York 1978) 9–104. For column-kraters in the Manner of the Lysippides Painter, see *ABV* 261–62, 42–44; London B360 illus. by Wrede, pl. 20. For Lydos' New York krater, *ABV* 108,5, see Tiverios, *Lydos* pl. 55a.

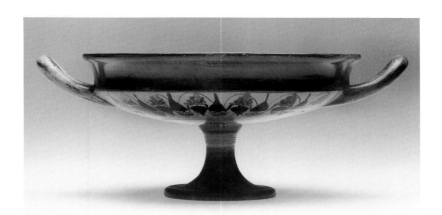

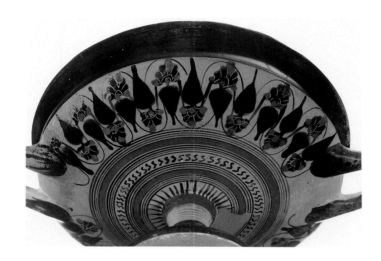

ATTIC DROOP CUP
Attributed to
the Painter of Athens NM 21028
Ca. 530 B.C.
Gift of Gilbert M. Denman, Jr.
86.134.175
Droop cup, Ure Type IIC
Interior: Reserved medallion
with a concentric circle and a dot
A and B (Lip): Black
A and B (Handle-zone): Chain of large
lotus-buds above palmettes alternating
with palmettes above large lotus-buds;
thin curved tendrils connect the lotus-
buds and thick ones the palmettes
A and B (Lower part of body): Two
red bands with groups of four lines on
both sides frame a band with "S's";
base-rays encircle the top of the foot

The San Antonio cup may be attrib-
uted to the painter of Athens NM
21028. He decorated the band in the
lower part of the body of the Athens
cup with a chain of black and white
dots instead of the "S's" that appear on
the San Antonio example. H A G B

DIMENSIONS: H. 10.7 cm.; Diam. of rim
19.9 cm.; Diam. of foot 8.1 cm.
CONDITION: Broken and repaired; re-
stored portions on tondo and on Side B
rim. Interior, handles, and rim on A/B
handle-side, misfired.
SHAPE AND DECORATION: Droop cups
were named after the first scholar who
studied them, J. P. Droop. The lips of
Droop cups are concave and black; the
reserved upper part of their feet is usually
channelled, the lower part and edge are
black. There is a black band on the verti-
cal interior surface of the feet.
BIBLIOGRAPHY: Sotheby's London, 17–
18 July 1985, lot 572.
LITERATURE: For the classification of
Droop cups, see P. N. Ure, "Droop
Cups," *JHS* 52 (1932) 55–71; eadem,
"Droop Cups, Black and Figured," in
Studies Robinson II 45–54. For Athens
NM 21028, see *CVA* (Athens 3) pl. 45,
1–2.

47

ATTIC BLACK–FIGURE
BAND CUP
Attributed to the Circle of the
Antimenes Painter [J. Haldenstein]
Ca. 530 B.C.
Gift of Gilbert M. Denman, Jr.
86.134.36
A: Zeus in labor
B: Achilles and Memnon

On Side A Zeus is seated to the right on a campstool with lion paw feet. He is bearded, clad in a chiton and himation, and holds a scepter and thunderbolts in his hands. Zeus is flanked by two women wearing peploi, the Eileithyiai, goddesses of childbirth, who face him with gesticulating hands. On either side of this trio is a departed charioteer, bearded and wearing a *petasos* on his head and a Boeotian shield strapped to his back. Each charioteer steps into a quadriga which is attended by a standing groom in a long gown, holding a whip or goad. At the far left is a male figure with a staff. Like Zeus he is bearded, wears a chiton and himation, and is seated on a campstool with lion paw feet.

On Side B two armed hoplites, Achilles and Memnon, engage in battle. Each warrior wears a high-plumed Corinthian helmet, a cuirass, greaves, and a short chiton. They engage each other with shields and spears, their swords still in their sheaths. The figure at right, presumably Memnon, turns to withdraw while still fighting and holds his shield in a manner to protect his retreat. Two female figures, Thetis and Eos, wearing peploi, flank these warriors and gesticulate wildly. The female at left with her arms raised seems to be cheering on the warrior in front of her. These would be Thetis and Achilles. The downward pose of the arms of the woman at right appears to indicate a distraught attitude in response to the impending fate of the fleeing warrior, Memnon. She would then be Eos. Flanking this central scene of combat are two outward bound quadrigae with charioteers and grooms, nearly exact parallels to those on the obverse side of the vase.

There is much in common here with the style of the Antimenes Painter, but the brush work and sometimes careless incisions are distinct from his. The mounting charioteers, horses and atten-

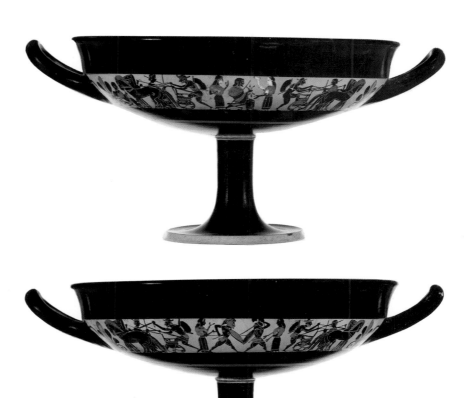

dant grooms display the closest parallels. The vase shape is also not Antimenean; the artists in his circle decorated large vessels.

The Birth of Athena appears early in Greek literature with references in Homer (*Iliad* 5.875ff), Hesiod (*Theogony* 886ff), and the Homeric *Hymn to Athena* (28). In Greek art the subject of Zeus delivering the war goddess from his head occurs from the seventh century B.C. Scenes of the "pre-birth," or Zeus in labor, appear on Attic black figure vases from ca. 575 B.C. Vases of the mid-century, such as a hydria in

Rhodes, display Zeus seated on a campstool and flanked by gesticulating Eileithyiai. The myth of Athena's birth remains in Attic vase painting until the mid-fifth century B.C., when it last appears on the east pediment of the Parthenon.

The combat between Achilles and Memnon occurs in the *Aethiopis* by Arctinos of Miletos. Memnon, the son of Eos, goddess of the dawn, joins the Trojan War against the Greeks and takes the life of Antilochos, Nestor's son, in battle. Despite his armor made by Hephaistos, Memnon is himself de-

feated by the gifted Achilles, son of the sea-nymph Thetis, who takes revenge for Antilochos' death. The subject appears in Greek vase-painting during the first decades of the sixth century B.C. A close parallel in the arrangement of the combatants with flanking chariots on the band cup is seen on an Attic dinos in Vienna by the Painter of the Vatican Mourner (Vienna 3619), an artist late among those near Group E.

KK II

DIMENSIONS: H. of rim 18.4 cm.; Diam. of rim 29.3 cm.; Diam. with handles 37.1 cm.; Diam. of foot 12.8 cm.
CONDITION: Broken and repaired. Small area of repainting on Zeus' shoulder (Side A). Restored fragment to right of B/A handle; part of foot is restored.
SHAPE AND DECORATION: This band cup is an excellent example of the Little Master cups which flourished around the mid-sixth century B.C. and slightly later. The interior is glazed with a reserved tondo bearing a black dot within a black circle.
ADDED COLOR: White paint is applied to the flesh of females and shield straps of the charioteers. Red paint is applied to clothing, human hair, shields (either in large masses or in dots), horses' manes, helmet plumes, and chariot parts. A five-petaled palmette with the center petal painted red emerges on a tendril from the vase handles in the corners of the figured scenes. A reserved band occurs one third the way down the bowl from the figured scene. A red molding encircles the stem where it bonds to the bowl.
BIBLIOGRAPHY: Galerie Günter Puhze, *Kunst der Antike,* cat. 5 (Freiburg 1983) 20, no. 180.
LITERATURE: For the birth of Athena, see *LIMC* II 985–86; F. Brommer, "Die Geburt der Athena," *JRGZM* 8 (1961) 66–83; hydria, Rhodes 10593: *LIMC* II 986, no. 336. For Achilles and Memnon, see *LIMC* I 175–81; *Vasenlisten³* 348–52; black-figure dinos, Vienna 3619; *LIMC* I 176, no. 820. For the Antimenes Painter and his Circle, see *ABV* 266–291; *Para* 117–24; J. Burow, *Der Antimenes Maler* (Mainz 1990). For Little Master cups, see J. D. Beazley, "Little Master Cups," *JHS* 52 (1932) 167–204; idem, *Dev. rev. edn.* 53–56.

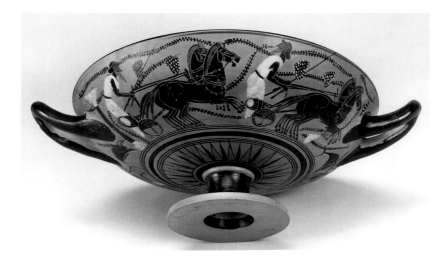

48

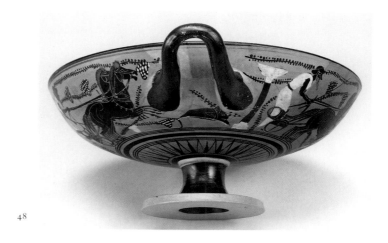

48

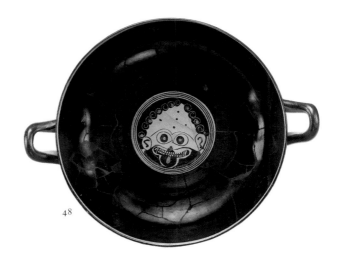

48

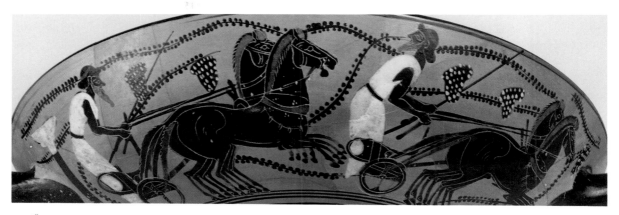

48

48

ATTIC BLACK-FIGURE CUP
Related to the Painter
of the Quadrigas [J. Neils]
Ca. 520 B.C.
Gift of Gilbert M. Denman, Jr.
86.134.49
Interior: Gorgoneion
A and B: Pairs of racing chariots

Cups of this shape are normally deco-
rated with pairs of eyes on the exterior
interspersed with single figures. How-
ever, this artist has opted for a continu-
ous frieze of racing chariots, a motif
more often encountered on amphora
lids or the shoulders of hydriae. Four
quadrigas, two on each side, are de-
picted coursing to the right, interrupted
only by the handles. On Side A the
charioteer in the lead looks back at his
opponent, who has just passed the
turning post, a Doric column. On Side
B, the charioteer at the left looks back
as if at the opposition on the other side
of the handle. All the charioteers are
bearded, wear long white, belted
gowns, and hold long goads, along
with the reins, in their hands. The
background is filled with dotted vines
and large clusters of grapes, and dol-
phins sport underneath the handles.

The interior of the cup shows the
ever-popular gorgon-head rendered in
outline drawing and framed by three
concentric black lines. The gorgoneion
has a tall forehead decorated with five
black dots, close-set eyes, a double row

of pearly white teeth along with two
pairs of fangs, a pendent tongue and a
heavy black beard. Her ears are notice-
ably off-kilter, her right one being con-
siderably lower than her left, and her
curls extend much farther on her right
side. J N

DIMENSIONS: H. 10.4 cm.; Diam.
25.5 cm.; Diam. with handles 32.4 cm.;
Diam. of foot 10.2 cm.
CONDITION: Broken and repaired. Re-
stored and repainted area to the right of
the left charioteer on Side A, and on un-
derbelly of foremost horse. Head of right
charioteer on Side B is restored and re-
painted.
SHAPE AND DECORATION: Type A kylix.
At base of exterior, black band framed by
triple black lines; alternating outline and
black rays. Reserved torus at juncture of
bowl and stem. Outer edge and bottom
of foot reserved.
ADDED COLOR: White for charioteers'
robes, column base and capital, grapes,
dots along horses' reins, belly line of dol-
phins, gorgoneion's teeth; red for chario-
teers' beards, horses' manes, neck bands
and some tails, gorgoneion's curls, pupils
and pendent tongue.
PROVENANCE: Ex colls. Ticted & Co.,
Geneva; Earl Morse, New York.
BIBLIOGRAPHY: Sotheby's New York,
17 February 1978, lot 78; Christie's New
York, 20 May 1980, lot 25; Sotheby's
New York, 22 May 1981, lot 125.
LITERATURE: For the Painter of the
Quadrigas, see *CVA* (Louvre 10) pl. 108,
7 and 109, 1 (F134).

49

ATTIC BLACK–FIGURE CUP
The Group of
the Camiros Palmettes
Ca. 520 B.C.
Gift of Gilbert M. Denman, Jr.
86.119.2

DIMENSIONS: H. 8 cm.; Diam. of rim
18.6 cm.; Diam. of foot 8.2 cm..
CONDITION: Broken and repaired with
large area along rim restored on Side B,
and to the left of B/A handle.
SHAPE AND DECORATION: The cup is
stemless with a Type C torus foot; the
bowl is low and broad; there is a fillet be-
tween the base of the bowl and the top of
the foot; the handles curve upward. The
outside and vertical interior surface of the
foot are black; there is a black circle with
central dot in the ceiling of the foot. In-
terior decoration consists of a reserved
disk with a black circle and central dot.
The body is decorated with a continuous
composition of four palmettes with fine
tendrils and volute. The petals of the pal-
mettes are free-standing; there are dots in
palmette hearts and at the ends of the
tendrils and volutes. The base-fillet is re-
served.
BIBLIOGRAPHY: B. Freyer-Schauenburg,
in *Copenhagen Proceedings* 157, fig. 5.
LITERATURE: This cup belongs to Beaz-
ley's 'Group of the Camiros Palmettes,':
ABV 215; *Para* 104. B. Freyer-Schauen-
burg has recently discussed the group and
added seven more pieces to Beazley's list.
She recognizes Ionian influence in the
palmette decoration: "Die Gruppe der
Kamiros-Palmetten," in *Copenhagen Pro-
ceedings* 153–60. HAGB

50

ATTIC BLACK-FIGURE
EYE-CUP
Signed by Nikosthenes as potter
Ca. 520–510 B.C.
Gift of Gilbert M. Denman, Jr.
86.134.56
Interior: Gorgoneion
A: Dionysos between eyes and vines
B: Female figure (Ariadne?)
between eyes and vines

Large eyes and handle-vines form a
symmetrical decorative framework for
this cup's exterior. Each of the four
eyes and brows is drawn in outline.
The oculus of each large eye, drawn
with a compass, exhibits the standard
black, white and red rings of fairly
equal width surrounding a large black
pupil, with a dot of red concealing the
compass point. Significantly, on Side A
most of the letters of the potter-signa-
ture of Nikosthenes can still be made
out, written between each brow and
eye: ΝΙΚΟΣΘΕΝΕΣ and ΕΠΟΕΣΕΝ.

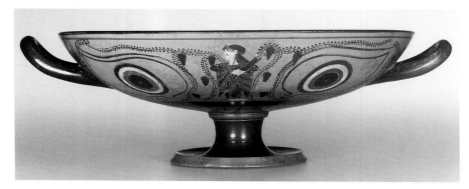

Vines grow upward from between the
roots of each of the cup's two handles,
their stems intertwined. Their leafy
tendrils, which fill the space between
each handle and large eye, are laden
with ten bunches of grapes arranged in
similar configurations of five on either
side. The B/A handle zone is drawn
somewhat more neatly than the A/B.
The conceit of symmetrically grouped
bunches of grapes is carried over to the
decoration of the spaces between the
pairs of large eyes. Here the little black
figure on each side of the cup holds
grape vines laden with eight bunches,
arranged in identical configurations of
four to left and right. Whereas the han-
dle vines sprout full-fledged grape

leaves, these vines simply have dots.
On Side A, Dionysos stands in profile
view, facing right. In his raised left
hand, he grasps a rhyton, with a border
of incised dots at its mouth, in addition
to the grape vines. The god's beard is
long and full, with hair along its lower
edge indicated by incision. Borders of
incised circles at the top and bottom
edges of Dionysos' chiton match the
one on his rhyton. The himation
draped over his shoulders is decorated
with incised crosses. The female figure
between the eyes on Side B stands with
her legs in profile to the right, but she
turns her head around to the left as if to
face Dionysos around the surface of the
cup. Her upper body is in frontal view,

with her arms bent across her chest.
She, too, holds a rhyton along with
vines in her left hand. Further, she also
wears a chiton and himation. Since the
female figure is shown in isolation, vi-
sually balancing the god of wine, she
may well be Dionysos' consort Ari-
adne, rather than simply a maenad—
despite an apparent lack of inscriptional
evidence for the latter's presence in ar-
chaic vase-painting.

The small medallion inside the eye-
cup's bowl bears a gorgoneion, ren-
dered in a combination of outline and
black-figure technique. Although stan-
dard in this location, individual gor-
goneia differ, and describing a few
telling details helps classify this exam-
ple. Incised corkscrew (rather than

50

tongue-like) curls extend across her forehead, reversing direction from the center toward each ear. Four black dots mark her reserved forehead. Her monstrous female eyes, drawn in outline, are pear-shaped and especially large— both brows and eyes extend from nose to ears. The nose, a triangular blob of black glaze, is defined by three upward-curving incised lines—an imitation of a nose-type with carefully drawn separate tiers. An incised line runs across the black interior of her hideously grinning mouth. The lower contour of her face is incised through her beard, and separately incised strands form her beard's lower, and her hair's upper, contour.

The Attic eye-cup appears to have been invented by the great black-figure painter Exekias, ca. 530 B.C. On his impressive model in Munich (Munich 2044), Dionysos sails inside the bowl, and the masts of the god's ship sprout vines and bunches of grapes. Since the Greek kylix was used for drinking wine, such Dionysiac imagery made especially appropriate decoration. Simplified versions of the eye-cup format were popular for cups of Type A in both black-figure and red-figure during the last decades of the sixth century B.C. In black-figure, a gorgoneion, as is found here, became standard for the interior tondo, but a variety of subjects, not necessarily Dionysiac in nature, could appear between the large eyes in the bipartite decorative scheme of the exterior. Although a slight product of

Nikosthenes' workshop, the San Antonio eye-cup is particularly appealing due to its balanced network of grape-vines and bunches, which, along with its two figures, evoke the vessel's intimate association with wine.

More signatures of Nikosthenes are preserved than of any other potter or vase-painter. On eye-cups this potter's signature can be found in a variety of locations: e. g. on the foot-profile, on the fillet between bowl and stem, centered above both brows and eyes, above one of the eyebrows, above one of the eyes. The balanced decoration of the San Antonio cup's exterior is enhanced by the precise placement of Nikosthenes' signature on Side A: the potter's name is written neatly between the eye and brow at the left, and the verb in same location over the right eye. A signed cup in Paris (Louvre F 121) is closest kin; here *Nikosthenes* is written over the left eye and *epoiesen* ("made this") within the right eye. Aspects of the San Antonio cup's painted decoration, especially the gorgoneion with extraordinarily large pear-shaped eyes as well as curls in her hair, and an exterior laden with both dotted and leafy grape vines, also resemble a finer, especially elaborate unsigned eye-cup in Munich. In shape, Bloesch related the Munich cup (Munich 2084) to his Andokides Group; in decoration, these eye-cups have a notable Dionysiac flavor and bring to mind the Krokatos Workshop and its Group of Walters 48.42. The signed San Antonio cup

further documents the broad role played by Nikosthenes' workshop in the Attic pottery industry of the late sixth century B.C. B C

DIMENSIONS: H. to rim 11.7 cm.; Diam. of rim 30.9 cm.; Diam. with handles 37.6 cm.; Diam. of tondo 8.5 cm.; Diam. of foot 12 cm.

CONDITION: Broken and repaired with minor restoration. Repainting on the lower portion of Dionysos' himation, and on grape-vines.

SHAPE AND DECORATION: Interior of bowl glazed black save for the tondo and a reserved line near inner edge of lip. Handles black outside, reserved inside. Beneath vines, eyes and figures, is a black groundline and a broad black band. Above the foot, alternating outlined rays (15) and black rays (16) bounded above by a black line. Beneath right root of B/A handle two adjacent black rays. Fillet at juncture of bowl and stem, set off above and below by incision. Stem and foot glazed black to upper edge of foot-plate. Underside of foot reserved. Band of black glaze on interior of stem.

ADDED COLOR: Red for the fillet, interior, dot at center of each curl and tongue of gorgoneion; A and B, innermost ring of each oculus, dot at center of each large pupil; Side A, beard, front of hair and alternate folds of himation of Dionysos; Side B, fillet around head, pupil of eye and alternate folds of garments of female figure. White for interior, smaller dot atop red dot within each curl, teeth and tusks of gorgoneion. A and B, central ring of each oculus. Side A, chiton of Dionysos. Side B, flesh of female figure, dots on her himation and dots along upper edge of her rhyton.

BIBLIOGRAPHY: Unpublished, but recently discussed and illustrated by J. Jordan, *Attic Black-figured Eye Cups* (Diss., New York University 1988) 83–84, pl. 31, 2–3.

LITERATURE: For Nikosthenes' eye-cups, see *ABV* 230–32; *Para* 108–109; for the Krokotos Workshop and the Group of Walters 48.42, see *ABV* 205–08; *Para* 93–97. See also, D. J. R. Williams, "The Late Archaic Class of Eye-Cups," in *Copenhagen Proceedings* 674–83. For the signed cup in Paris, Louvre F121, see *ABV* 231,7; *Para* 97,108; *Beazley Addenda²* 59–50; *CVA* (Louvre 10) pl. 106, 4–7. See also, Jordan, 64–78, 85–86, 102–03, pl. 20–22, 32, 37.2–3 (Munich 2084). For the Exekias eye-cup, Munich 2044, see *ABV* 146,21; *Para* 60; *Beazley Addenda²* 41; P. E. Arias and M. Hirmer, *Greek Vase Painting* (New York 1961) pls.

XVI and 59. For the shape, see
H. Bloesch, *Formen attischer Schalen* (Bern
1940) Exekias, 2, Nikosthenes, 9–12
(Louvre F 121: 10, no. 12), Andokides
Group, 12–16 (Munich 2084: 16, no. 10).
For the location of potter-signatures, see
T. Seki, *Untersuchungen zum Verhältnis von
Gefässform und Malerei attischer Schalen*
(Berlin 1985) 112–14, 139. On Dionysos
and his female companions (not Ariadne),
see Carpenter, *Dionysian Imagery* 22–25.

51

ATTIC BLACK-FIGURE
EYE-CUP
Class of the Top-Band Stemlesses
Ca. 520–500 B.C.
Gift of Gilbert M. Denman, Jr.
87.20.5
A: Seated Dionysos
between palmettes and eyes
B: Maenad between palmettes and eyes

At first glance this drinking vessel, with
its black lip and reserved foot, resem-
bles a stemless version of the older band
cup. However, it utilizes a newer, red-
figure scheme of decoration: palmettes
sprouting from the handles and a pair
of eyes flanking a central figure, albeit
rendered in black. In fact, it belongs to
a special class of late black-figure cups
which Beazley called the "top-band
stemlesses," the name deriving from
the broad black band above the handle
zone.

Side A shows a bearded male figure
seated on a *diphros* and holding out a
kantharos, one of the drinking vessels
that is an attribute of the wine-god
Dionysos. On Side B, a female figure
wearing a dotted chiton and a *nebris*
hastens, gesticulating, to the right as she
looks back to the left. Dotted vines fill
the void behind each figure. Although
very simply executed, the Dionysiac
subject is nonetheless appropriate to the
function of this wine cup. J N

51

51

DIMENSIONS: H. 7.4 cm.; Diam.
19.2 cm.; Diam. of foot 7.7 cm.
CONDITION: Unbroken. Minor abrasion
on the top band of the vase's exterior.
SHAPE AND DECORATION: Type C kylix
"of conservative trend," i.e. shallow
stemless cup without lip, with broad fillet
at the base and a torus foot. Below the
handle zone, black with a reserved band.

Interior decoration consists of a reserved
medallion with two concentric circles
and a dot.
ADDED COLOR: White for bands around
pupils and outer eyes, Dionysos' chiton,
maenad's skin; red for inner eye circles,
Dionysos' hair, beard and mantle stripes,
maenad's *sakkos* and chiton decoration.
PROVENANCE: Ex colls. Angelo Sig-
norelli, Rome; Richard Hattatt, Oxford,
1984.

BIBLIOGRAPHY: Christie's London, 14
June 1978, lot 355; Sotheby's London,
10–11 December 1984, lot 35; *Art of the
Ancient World* 4 (Royal Athena Galleries,
New York 1985) 24, no. 61; Sotheby's
New York, 29 May 1987, lot 135.
LITERATURE: For Top-Band Stemlesses,
see *Para* 100–02; *ABFV* 109. A close par-
allel in terms of decoration is Villa Giulia
865; *CVA* (3) pl. 40.

ATTIC BLACK-FIGURE NECK-AMPHORA

Manner of the Lysippides Painter
Ca. 525–515 B.C.
Gift of Gilbert M. Denman, Jr.
86.134.41
A: Dionysos
between Hermes and a woman
B: Frontal chariot

The god of wine, Dionysos, holding a kantharos by its foot in his left hand and vines of ivy in his right, stands at the center of Side A. He is regally attired in a long chiton covered by a himation edged with borders of incised curls and decorated with incised swastikas and crosses (some with small angles at their interstices). The flap on the right shoulder of his chiton bears an incised cross. A wreath of ivy surrounds his head. His hair and beard are both long and full; the latter has separately incised strands at its lower contour. He faces a female figure at the right. She is dressed similarly—tightly wrapped in a long chiton, decorated with crosses, and a bordered himation, with swastikas—but she is not so precisely identifiable. Her self-composed posture, quietly standing in profile facing left, suggests she may be Dionysos' consort Ariadne, rather than one of his cavorting female followers, the maenads. On this vase there are no helpful inscriptions giving the names. Hermes, at the left, completes the simple three-figure composition. He is clearly identified by his traveller's dress: a short chiton topped by a chlamys with incised crosses and boots with long tongues (glaze missing), but no wings. His traveller's cap also is wingless, but it probably originally had the *petasos'* typical wide brim (glaze now missing). His long beard, like Dionysos', has incised lines for hair at the lower contour. Although Hermes stands with left leg before right in profile, his upper torso is in front view and his arms, raised elbows out, meet across his chest. In his right hand he holds a short staff, not distinguished as his usual attribute, the *kerykeion* (perhaps its top is cut off by the border of tongues above the picture).

Both sides of this vase are decorated with centralized tripartite compositions; that of Side B consists of a single four-horse chariot drawn in frontal view, according to the standard convention. The two pole horses overlap the chariot's car to form the main compositional mass. The middle is marked by the chariot pole and the profile heads of the frontal pole horses, which overlap each other, left upon right. Just above the pole horses appear the heads of the charioteer and a warrior, the latter wearing a Corinthian helmet with a low crest, who ride in the chariot's box; these human heads also are shown in profile view, but facing outward toward left and right. The presence of an armed warrior suggests a festival or an heroic context, since chariots were not employed in contemporary Archaic Greek warfare. The warrior's paired spears and the charioteer's paired goads form diagonals leading away from the center. The wheels of the chariot, drawn in profile view, appear between the pole horses and the trace horses. At far left and right, the heads of the frontal trace horses, likewise shown in

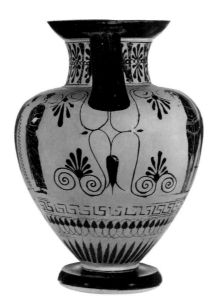 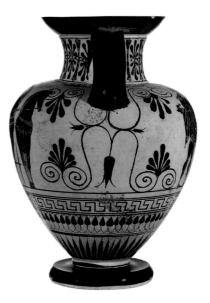

profile view, face outward, while the horses' reins lead back to the center of the composition. The decorative pattern formed by the chariot is enlivened by carefully drawn details of the horses and their harnesses. All have red manes with incised hair along the upper contours, tails incised in a herringbone pattern and broad red breast bands, each with a narrow, decoratively studded band hanging below.

Simple depictions of Dionysos with satyrs, maenads and, occasionally, Ariadne were popular in Archaic vase-painting. In both techniques during the first generation of red-figure, the kantharos, as here, often is preferred to the rhyton for the drinking vessel of the god of wine. The San Antonio neck-amphora, as a very typical product of Attic black-figure from the last quarter of the sixth century B.C., presented an attribution puzzle in its modern history. The vase appeared on the New York antiquities market in 1964 with no attribution. Although known in Beazley's day, it is not included in *Paralipomena*. Hoffmann associated this neck-amphora with the circle of the Antimenes Painter. Subsequently it was assigned to the Lysippides Painter [D. von Bothmer and M. Moore]. This painter was the major follower of Exekias. Confirmation of a Lysippidean association comes from the painter's neck-amphora in Oxford, Ashmolean Museum 208, where a Dionysiac scene also is paired with decorative frontal chariot. On both the Oxford and San Antonio neck-amphorae, moreover, Hermes attends Dionysos. While this messenger god may well have had a close association with the god of wine—in later Greek art the infant Dionysos often is shown entrusted to Hermes' care—Hermes also happens to be a particular favorite of the Lysippides Painter and his followers, who introduce him in

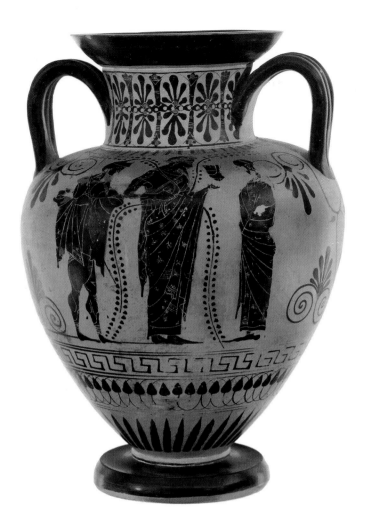
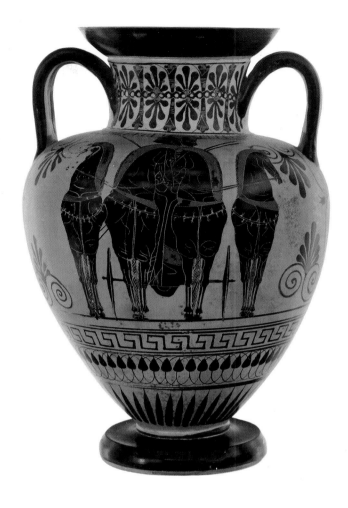

their work whenever possible. Even more distinctly Lysippidean are the fancy trappings of the chariot horses on the reverse of both neck-amphorae: bright red breast bands with studded ornamental bands below. Several other details, however, such as Hermes' knees described by separately incised strokes rather than curving caps, round eyes with straight strokes for tear glands and outer corners, herringbone incision on the horses' tails and two pairs of biconvex arcs on their shoulders, suggest that the San Antonio neck-amphora should be attributed to the Lysippides Painter's manner rather than to the master himself. B C

DIMENSIONS: H. 42.5 cm.; Diam. of mouth 19.2 cm.; Diam. of foot 15.8 cm. CONDITION: Broken and repaired. Heavy abrasion and glaze loss on left trace-horse on Side B, and on faces and figures of Hermes, woman and Dionysos on Side A.

SHAPE AND DECORATION: Echinus mouth glazed black, its upper surface reserved. Inside of mouth glazed black, set off from glazed inside of neck by a reserved line. A palmette-lotus chain decorates each side of the neck. Raised ridge at the juncture of neck and body. On each side of the shoulder, tongues. Triple handles glazed black outside, reserved inside. Beneath each handle, in black glaze, the following configuration: above, a pair of downward palmettes grow on long tendrils from each handle-root; below, a pair of upward palmettes grow from a large hanging lotus bud; two small horizontal lotus buds spring from the interstices of the tendrils. Beneath the figures, a line of black glaze; a leftward meander, bordered above and below by two black lines; a row of upright lotus buds; two black lines. Above the foot, rays. Fillet partially glazed black at juncture of body and foot; bottom edge of fillet incised. Torus foot, glazed black; lower edge and underside reserved.

ADDED COLOR: Red on neck, dots on cuffs and central petals of lotuses and on hearts of palmettes; on shoulder, alternate tongues; Side A, alternate leaves on Dionysos' wreath, his beard (traces), Hermes' beard, alternate folds of his chiton; Side B, charioteer's fillet, edge of warrior's helmet crest, heads of his spears, manes and breastbands of horses, part of chariot box. White on Side A, dots at interstices of cross ornament on Dionysos' shoulder (traces), flesh of female figure (flaked off along with black glaze).

BIBLIOGRAPHY: *Masterpieces of Greek Vase Painting* (André Emmerich Gallery, New York 1964) no. 18; H. Hoffmann, *Ten Centuries that Shaped the West* (Exh. Cat., Institute for the Arts, Rice University, Houston 1970) 374–77, no. 174. *The San Antonio Museum of Art: The First Ten Years* (San Antonio 1990), 64 (Side B). LITERATURE: For Dionysos, his kantharos, and the god with Hermes and female companions, see Carpenter, *Dionysian Imagery* 23–25, 114, 117–19.

For Hermes and the infant Dionysos, see K. Schefold, *Die Göttersage in der klassischen und hellenistischen Kunst* (Munich 1981) 32–40. For the Lysippides Painter and his manner, see *ABV* 254–63; *Para* 113–16. For the neck-amphora Oxford, Ashmolean Museum 208, *ABV* 256,15, see *CVA* (Oxford 2) pl. 10, 3–4 and pl. 7, 1–5. For the style of the Lysippides Painter, see B. Cohen, *Attic Bilingual Vases and their Painters* (New York 1978) 9–104, esp. 11–12, 91–94. For conventions of Lysippidean horses and frontal chariots, see M. B. Moore, "Horses on Black-figured Greek Vases of the Archaic Period" (Diss. New York University 1971) esp. 73–79, 236–37, 272–74, 306, 345–46, 393–94, 411–14. See also, eadem, "A Neck-amphora in the collection of Walter Bareiss, I. The Painter," *AJA* 76 (1972) 1–9.

53

ATTIC BLACK-FIGURE SHOULDER-HYDRIA
Attributed to the Antimenes Painter
Ca. 520–510 B.C.
Gift of Gilbert M. Denman, Jr.
86.134.42
Panel: Wedded pair in chariot
Predella: Lions and boars
Shoulder: Herakles and the Lion

A chariot, moving toward the right and carrying a youth and his bride, forms the central focus of the hydria's main panel. Both figures are wrapped in himations, worn over chitons. An edge of the maiden's himation has been drawn over her head like a veil. Her hand, wrapped in her drapery, rests on the breastwork atop the chariot's box.

The youth drives, holding the horses' reins in both hands, and in his right, a goad as well. His hair is short with individual strands incised at the neck and in a fringe above the forehead. The young couple's chariot is accompanied by a divine host. Dionysos stands behind the car at the left. The imposing god wears an himation over a long chiton, with incised borders at neck and lower edge. His hair and beard are long. Two individual locks fall over his chest, and hairs along the lower edge of his beard are separately incised. An ivy wreath encircles Dionysos' head, and he holds vines of ivy in both his right and left hands—even though the latter is wrapped in drapery. Apollo, overlapped by the horses at the center, plays the *kithara*. The strings of his instrument are incised against the reserved ground and over the splayed fingers of the god's left hand. Apollo, facing right, is flanked by a pair of female figures who turn toward him. All three wear chitons with incised lower borders covered by himations decorated with incised crosses. The two females, who have no attributes, probably are Apollo's twin sister, Artemis, and mother, Leto. This peaceful group in the background marks the solemnity of the procession. The chariot horses themselves are fine-legged creatures, with tails and manes incised at the upper contours. The team is enlivened by the bent head of the far trace horse; the creature's face is (excessively) elongated to enable its muzzle to show beneath that of the near trace horse. Hermes, on the right, leads the procession, walking at the head of the horses. He is identified by his *petasos*, a traveller's hat

with a broad brim, his boots with long tongues, and the *kerykeion* held in his right hand. A mature, bearded man, he wears a chlamys over a short chiton with an incised border at the neck. The front of his left foot, his left hand, *kerykeion* and his hat's brim all overlap the panel's right vertical border, suggesting forward movement. An animal predella, a standard feature in hydria-decoration, forms a horizontal border beneath the main panel. Here a pair of lions, with left front paws raised, facing right, menace a pair of boars, facing left. The rump and tail of the left-most lion are cut off by the edge of the predella. An incised mane and a tuft on the end of its tail are preserved on the right boar.

On the shoulder of the San Antonio hydria the hero Herakles is engaged in his first labor: wrestling the Nemean lion. Herakles, striding vigorously to the right, forces the lion's jaws open, his left arm locked around the beast's neck. The bearded hero wears a short chiton with stacked folds at its lower edge, decorated with incised crosses, and a sword. The central lion-fight, shown in the old-fashioned standing-wrestling scheme, is flanked on the left by the bearded Iolaos, holding Herakles' club and bow, and on the right by the goddess Athena, who walks right, but turns around, gesturing toward the hero with her right arm. She wears a chiton decorated with incised crosses topped by a snake-edged aegis (summarily described) and an Attic helmet with cheekpieces and tall crest. She carries a shield on her left arm and a spear in her left hand. Next on the right stands Hermes, facing left, and dressed much like the larger version of himself in the main panel. The remainder of the long shoulder-panel is filled by conventional onlookers: on the right a woman, wearing chiton and himation; on the left, a youth in a chlamys, walking left, turning around; and finally a woman in chiton and himation facing right.

Named by Beazley after a *kalos* name on a hydria in Leiden, the Antimenes Painter, although contemporary with the early red-figure period, apparently worked only in black-figure. This prolific artist is a fine representative of late sixth-century tradition in the old technique. The San Antonio vase is one of more than forty preserved

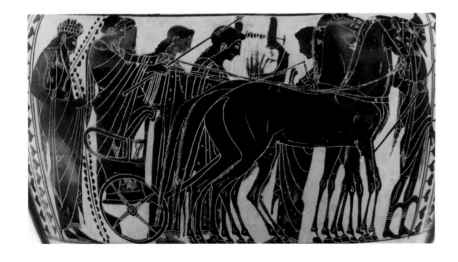

shoulder-hydriae by the Antimenes Painter, who also decorated more than twice that number of extant neck-amphorae. Horses and chariots often decorated the bodies of these large vase-shapes; they are found not only on pots by the Antimenes Painter, but on pots by, for example, Psiax and the Lysippides and Priam Painters. Chariots are shown being harnessed, bearing warriors, transporting Herakles to Olympos, or, as on the San Antonio vase, carrying a bride and groom in a wedding procession.

Here the couple's names are not inscribed, and their identity is not revealed by attributes. Could the presence of deities be a special intrusion at a marriage of ordinary mortals? Wedded couples in similar chariot-processions on Lysippidean hydriae in Florence and New York have been identified by inscriptions as either Peleus and Thetis or Herakles and Hebe. Herakles' adventures are popular subjects for shoulder panels of hydriae, and since in this location on the San Antonio hydria the hero fights the Nemean lion, one might argue that this vase's main panel should also represent Herakles—in his union with Hebe. The subsidiary scene, however, need not be thematically related to the body-panel: on another hydria by the Antimenes Painter (East Berlin, Staatliche Museen 1891), Theseus fights the Minotaur above another wedding procession, and on the Lysippidean hydria in Florence, Herakles fights Kyknos above the bridal chariot of Peleus and Thetis. In sixth-century black-figure vase-painting, moreover, Herakles probably would not have been shown as a beardless youth like the San Antonio bridegroom, and at his wedding Athena probably would have been found among the attending deities. But one aspect of the San Antonio hydria is absolutely clear: like its lion-fight or its lion-and-boar predella, its wedding procession belongs to an established decorative repertory employed by the Antimenes Painter for the black-figured hydria. B C

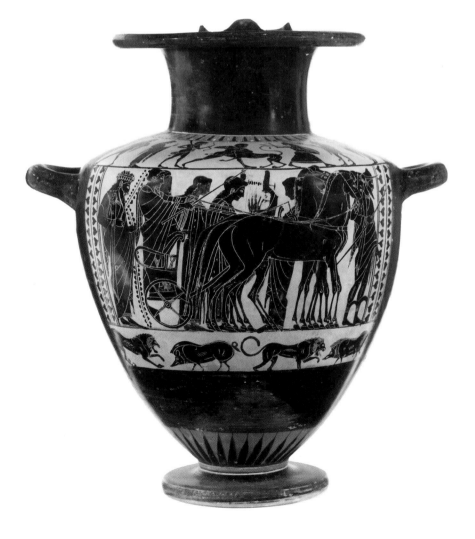

DIMENSIONS: H. 44.3 cm.; Diam. of mouth 24.2 cm.; Diam. of foot 15.7 cm. CONDITION: Broken and repaired. Minor abrasion on figural panel. Chipping and glaze loss on reverse side and on handles. SHAPE AND DECORATION: Overhanging torus lip, with upper edge raised. Lip glazed black outside and in; inside of neck glazed. Round vertical handle, glazed black; rotellae at upper outer edges. Round horizontal handles, glazed black outside, reserved inside; reserved patch on body between handle roots. Upper border of shoulder panel consists of tongues; groundline of black glaze marks the division between shoulder and main panel on body. Ivy in vertical borders of main panel. Groundline of black glaze below figures. Animal predella.

Black rays above foot. Fillet at juncture of body and foot. Upper surface of foot glazed black; underside reserved.

ADDED COLOR: Red for alternate tongues on shoulder; fillet; on the body panel: traces on all himations, beard of Dionysos and some leaves in his ivy wreath, tails, manes and harnesses of chariot horses; on the predella: dots on mane and tongue of lion on right, neck of boar on right. White on the body panel: flesh of female figures, brim of Hermes' *petasos*; on the shoulder: flesh of female figures.

BIBLIOGRAPHY: Unpublished.

LITERATURE: On the Antimenes Painter, see J. D. Beazley, "The Antimenes Painter," *JHS* 47 (1927) 63–92; *ABV* 266–75; *Para* 117–21; J. Burow, *Der Antimenes Maler* (Mainz 1990). For the painter's name-piece, Leiden PC 63, see *CVA* (Leiden 1) pl. 13–16.3 For a good summary of the shoulder-hydria's standard decoration, including a general bibliography on the shape, see *Agora* XXIII

53

35–37. Other chariot themes: harnessing, Psiax, Berlin, Staatliche Museen 1897 (lost), *ABV* 293,8; *Development² pl.* 36,2; Herakles' introduction to Olympos: Priam Painter, Madison, Elvehjem Museum of Art 68.14.1, *Para* 146–47,26*bis*; *MidwesternColls* 116–17, no. 66. For Herakles and Hebe, see *Vasenlisten³* 67 and F. Brommer, *Herakles II, Die Unkanonischen Taten des Helden* (Darmstadt 1984) 123–24. For the inscribed wedding hydriae in the manner of the Lysippides Painter, New York, Metropolitan Museum 14.105.10, Herakles and Hebe, *ABV* 261,37, in *MMS* 10 (1915) 122 and 123, fig. 2, and Florence 3790, Peleus and Thetis, *ABV* 260,30 in *CVA* (Florence 5) pl. 28.2 (Herakles and Kyknos on the shoulder, pl. 28.1); see also *Vasenlisten³* 318–19. The Antimenes Painter's hydria, Berlin 1891 (unpublished): *ABV* 267,10. For compositional types of Herakles' fight with the Nemean lion, see H. Marwitz, "Zur Einheit des Andokidesmalers," *ÖJh* 46 (1961–63) 73–82.

54

ATTIC BLACK–FIGURE
NECK–AMPHORA
Leagros Group
Ca. 510–500 B.C.
Gift of Gilbert M. Denman, Jr.
86.134.47
A: Aeneas and Anchises fleeing Troy
B: Fight

Trojan themes were a favorite subject of the late black-figure vase-painters of the Leagros Group, so-called after a *kalos* name found on five of its hydriae. The story of Aeneas fleeing the burning city with his father Anchises on his back, and his son Ascanius in hand, was particularly popular, and was painted on at least a dozen Leagran vases. As many of these were found in Etruscan tombs, and given the relevance of the Trojan hero to the founding of Rome, it has been suggested that they were made specifically for the Italian market. However, since the majority of Leagran vases were exported to this part of the Mediterranean, the point cannot be pressed.

The San Antonio vase shows Aeneas, fully armed with Corinthian helmet, cuirass, greaves and two spears, stooped under the weight of his aged father whose legs he clutches in his right

hand. He is preceded by a woman in chiton and mantle fleeing to the right but looking back; she is presumably Kreusa, Aeneas' wife, who did not survive the fall of Troy. Behind, in the position usually occupied by the young Ascanius, crouches a Scythian archer, identifiable by his leather cap. This figure's appearance here and in other examples serves to set the scene at Troy, just as the palm tree does in other contexts (cf. Cat. No. 64).

The reverse of the vase shows two warriors dueling over a third who has fallen to the ground. The one advancing to the right, who is given precedence because of his position and his high-crested Corinthian helmet, carries a Boeotian shield and a spear, while his opponent protects himself with a large round shield whose device is a now-faded white leg. The fallen warrior resembles the latter in his military garb, and as he was presumably marching to the left, the two should be allies. Who they might be is impossible to state without inscriptions, but it is tempting to see a Trojan War battle, perhaps Aeneas fighting Ajax for the body of Patroklos, as represented on a contemporary, inscribed cup by Oltos (Berlin F 2264). JN

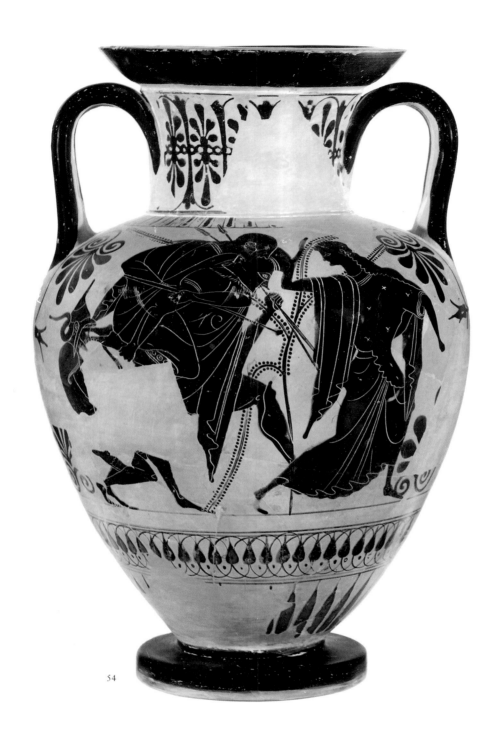

54

DIMENSIONS: H. 44.6 cm; Diam. of lip 20.5 cm.; Diam. of foot 15.5 cm.

CONDITION: Broken and repaired. Restored areas on Side A: on neck and shoulder, lower region of the figure of Aeneas, part of crouched archer, and below both handles. Restored areas on Side B: upper neck region, and in right and lower left areas of figural group. Foot is modern.

SHAPE AND DECORATION: Neck-amphora with echinus mouth, torus foot (modern), and triple handles. On the neck, palmette-lotus chain. Tongue pattern on the shoulder. Below each handle, a configuration of four palmettes and three buds with a cross in the center. Below the figures, groundline, two lines, a frieze of upright lotus buds, dotted, and rays at the base.

ADDED COLOR: White (now lost) for Anchises' hair, female flesh and shield device; red for Scythian's hair and beard, baldric, dots on shield rims and mantles.

BIBLIOGRAPHY: Unpublished.

LITERATURE: For the Leagros Group, see *ABV* 360–91; *ABFV* 110–11. Compare also the unattributed black-figure amphora, Turin 4102, *CVA* (Turin 2) pl. 9–11. For the Oltos cup, Berlin F 2264, *ARV*² 60,64, see A. Bruhn, *Oltos* (Copenhagen 1943) fig. 6. For Aeneas and Anchises, see S. Woodford and M. Loudon, "Two Trojan Themes: The Iconography of Ajax Carrying the Body of Achilles and of Aeneas Carrying Anchises in Black Figure Vase Painting," *AJA* 84 (1980) 25–40; *LIMC* I (1981) s.v. Aineias, 386–87, pls. 300–02, nos. 59–87 (F. Caniciani).

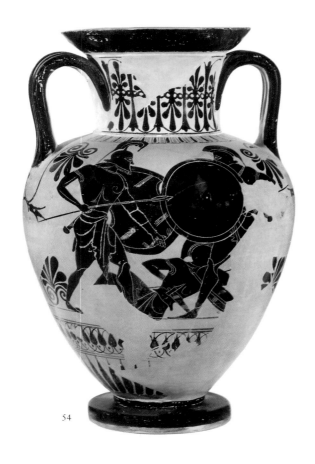

54

55

ATTIC BLACK-FIGURE
NECK-AMPHORA WITH LID
Attributed to
the Nikoxenos Painter [J.R. Guy]
Ca. 500 B.C.
Gift of Gilbert M. Denman, Jr.
86.134.43a,b
A: Herakles battling two Amazons
B: Two mounted Amazons

Both sides of this amphora are drawn from Herakles' adventure to the land of the Amazons. On Side A, the hero has just mortally wounded one Amazon and now turns to face her comrade in single combat. They both fight with long spears, while Herakles uses a sword, more effective in close combat. He has laid his club aside, and his quiver hangs behind him. His only

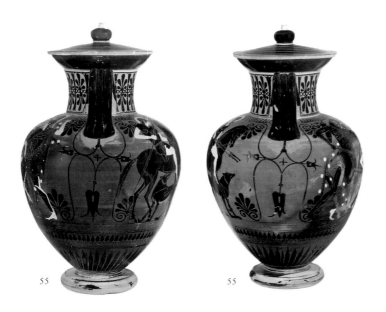

55 55

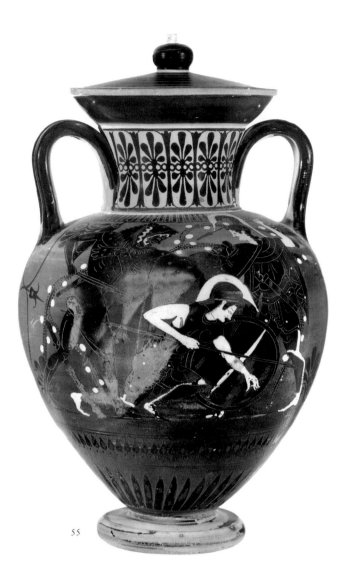

55

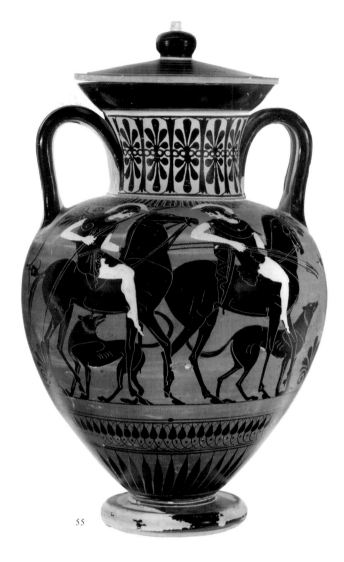

55

protective armor is a large lionskin, knotted high on the chest, with most of the pelt draped over his extended left arm as a shield. The falling Amazon is armed in cuirass and greaves as well as low-crested helmet. Blood pours from a wound near her right shoulder. The second Amazon wears a different helmet, a high-crested Attic one, and a short cloak over her shoulders. The device of her round shield is a bearded satyr's head molded in high relief that seems to stare directly at Herakles. Vines with large white blobs spiral through the background.

The scene on Side B might be interpreted as Amazon reinforcements, except that they do not show any awareness of the battle taking place or the dire situation of their comrades. Rather, the horses walk at a gentle pace, accompanied by yapping dogs, and the forward Amazon turns to speak

to her companion. They are dressed alike, save that again only one has a short mantle over her shoulders, and she carries a pair of spears while her friend has only one. The motifs on both sides of our vase are popular in black-figure of the late sixth century. The fallen warrior on Side A should be Andromache, the Amazon queen.

The Nikoxenos Painter's work in black-figure, mostly on neck-amphoras like this one, places him in the Leagros Group. He also has a red-figure side (Cat. No. 68), like his pupil the Eucharides Painter (Cat. No. 72). H A S

DIMENSIONS: H. 43 cm.; Diam. of mouth 18.7 cm.; Diam of lid 19.4 cm.
CONDITION: Misfiring on Side A continuing around to A/B handle side; loss of glaze on foot.
SHAPE AND DECORATION: Standard neck-amphora with torus foot glazed to

the lowest ring; triple handle; and echinus mouth. Fillet between foot and body. On the neck, palmette-lotus chain; tongue pattern on shoulder. Ornament at each handle: a configuration of four palmettes and three buds with a small cross at the center. Below the figured scenes, a frieze of upright lotus buds between pairs of lines, and rays. Concentric glaze-bands on the lid.
ADDED COLOR: White for blobs along vines, flesh of the Amazons, Amazons' helmet crests, details on greaves, shields and chitioniskos; details on Herakles' lion pelt.
BIBLIOGRAPHY: Sotheby's London, 11–12 July 1983, lot 316.
LITERATURE: For the Nikoxenos Painter, see *ABV* 392–93. On Herakles' Amazonomachy, see D. von Bothmer, *Amazons in Greek Art* (Oxford 1957) esp. 48–51; and, for Amazons on horseback, *ibid* 100–05.

56

ATTIC BLACK-FIGURE PELIKE
Attributed to
the Theseus Painter [J.D. Beazley]
Ca. 500 B.C.
Gift of Gilbert M. Denman, Jr.
86.134.157
A and B: Pyrrhic dancer and flutist

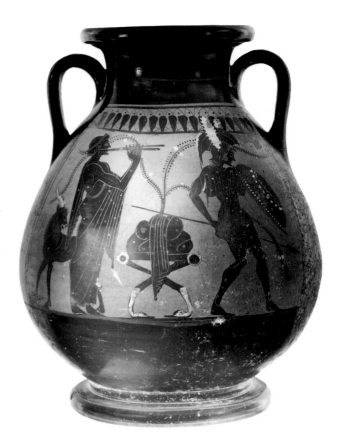

Each side depicts a variant of the same subject: a pyrrhic, or armed dancer, practices in the palestra to the music of a flute-player. The musician, wearing a mantle draped loosely over the left shoulder to leave his arms free, stands stiffly erect. He wears the *phorbeia*, the leather strap around his mouth, to keep the instrument firmly in place. The pyrrhic wears a full set of armor—helmet, greaves, shield, and spear, as well as a short belted chitoniskos. The only variations in equipment between the dancers on Sides A and B are in the shield device and helmet. On Side A, the tall crest of the Attic helmet rises into the lotus band ornament, while on Side B the lower crest stops short of it. The shield on Side A has a white tripod as insigne, one of the most popular on vases of this period, that on Side B, a circular pattern of white dots. Side B is most noticeably distinguished from Side A in the presence of a large goat beside the flutist. Precisely in the middle of each picture stands a *diphros*, or stool, carrying a bundled-up garment. Vines with fruit rendered in white blobs spiral through both scenes, but these do not grow organically from any tree, and should not be thought of as indicating an outdoor setting. They are simply filler decoration, originally associated with Dionysos and his circle, but nearly ubiquitous on later black-figure vases. The setting is indicated rather by the stool, as the palestra.

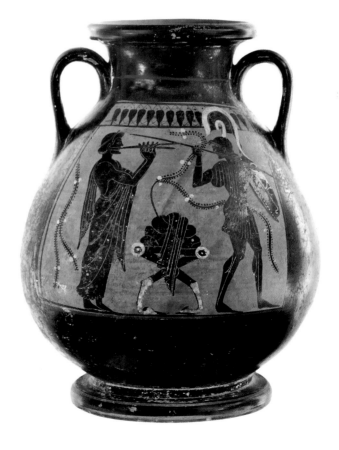

At the Panathenaic festival, celebrated with especial splendor every four years in honor of the city goddess Athena, the athletic competitions included the so-called *pyrrhich*, or armed dance. The contestants represented their respective *phyle*, or tribe, and were financed by a *choregos* (sponsor of a theatrical performance), just like the theatrical companies that performed at the festival of Dionysos (Isaios 5.36). Prizes were awarded on the basis both of how well the pyrrhics were equipped and how they executed the prescribed movements. From the ora-

tor Lysias (21.4–5) we even learn how much it cost the *choregos* to sponsor a team in the *pyrrhich* in the late fifth century: 800 drachmai at the Greater Panathenaia, 700 at the Lesser Panathenaia, the smaller festival held in each of the intervening three years.

Though it is likely that the *pyrrhich* was introduced as early as 566 B.C., with the major reorganization of the Panathenaia, the earliest depictions of pyrrhic dancers in vase-painting are in the period of our pelike, near the end of the sixth century. Sometimes several members of a team are depicted in formation, but more often only one or two are shown in training, always accompanied by the flutist. Most often the pyrrhics are entirely nude, apart from their armor, presumably an accurate reflection of how the contest was actually performed, but occasionally, as on our vase, they are shown wearing the chitoniskos. Whether nude or clothed, the motif of the folded garment on the stool occurs frequently in such scenes. Of particular interest on the San Antonio pelike is the repetition of the same dancer in both scenes but in different poses. Each is paralleled on the vases, that with the head turned back the most common. But the juxtaposition of the two on opposite sides of our vase is not simply a matter of *variatio*, but must illustrate two of the prescribed positions in this highly stylized performance.

The slender physique of our dancers, their beardlessness and longish hair emerging from beneath the helmet, could raise doubts as to gender. Female pyrrhic dancers, who performed not at the Panathenaia, but mostly at private banquets and symposia, are indeed well attested on red-figure vases, but only from the mid-fifth century on. A comparison with the many black-figure versions shows that our pyrrhic is certainly a youth. By Lysias' time, the *pyrrhich* at the Panathenaia was divided into contests for men, "beardless youths," and boys, and there is no reason this should not have been true a century earlier. Thus, our dancer belongs to the middle category.

The Theseus Painter, to whom Beazley attributed our vase, was, together with his companion the Athena Painter (cf. Cat. No. 62), the last major artist to decorate only black-figure vases. He is best known for his fine, large skyphoi, often decorated with imaginative subjects, and for his lekythoi, one of which has two nude pyrrhics surrounding a flute-player. HAS

DIMENSIONS: H. 33.4 cm.; Max. Diam. 25.9 cm.; Diam. of rim 15.2 cm.; Diam. of foot 17.5 cm.
CONDITION: Unbroken. Cracks around handle-joins. Minor abrasion on handles and on mouth. Some loss of applied white paint on helmet of dancer on Side A.
SHAPE AND DECORATION: The pelike was one of the last shapes to be introduced to Attic black-figure, in the last quarter of the sixth century. Ours has heavy proportions, with the standard torus mouth, segmented handles, and spreading foot. The lip is glazed, but the inside of the mouth reserved to a depth of 1.3 cm., then glazed to a depth of 3.5 cm. Lotus band above the figured scene on both sides, as often on black-figure pelikai.
ADDED COLOR: Red for dots on all garments; fillets in hair of all four figures; bracelet of dancer on A; shield rims; goat's mane. White for goat's horn and underbelly; legs and ends of *diphroi*; helmet crests; shield devices; fruit on vines.
BIBLIOGRAPHY: J. Neils, *Goddess and Polis: The Panathenaic Festival in Ancient Athens* (Hanover, New Hampshire, 1992), 177 no. 48 (Side A, 56; Side B, 95); Para 257, top; Sotheby's London, 11 April 1960, lot 156; Sotheby's New York, 8–9 February 1985, lot 66.
LITERATURE: On the pyrrhic contest at the Panathenaia, see L. Ziehen, *RE* 18 pt. 3 (1949) 483–84, s.v. Panathenaia. On depictions of pyrrhics on Attic vases (with an excellent selection of illustrations), see J.-C. Poursat, "Les représentations de danse armée dans la céramique attique," *BCH* 92 (1968) 550–615; and cf. now G. Camporeale, "La danza armata in Etruria," *MEFRA* 99 (1987) 11–42. For the Theseus Painter, see *ABV* 518–21; *Para* 255–59; *ABL* 141–47 and 249–52; M. Reho-Bumbalova, "Un vaso inedito del pittore di Theseus," *BABesch* 58 (1983) 53–60. For the lekythos by the Theseus Painter with pyrrhics, Bonn 307, see *ABL* pl. 44, 3. For black-figure pelikai, see D. von Bothmer, "Attic Black-Figured Pelikai," *JHS* 71 (1951) 40–47; for the pelikai by the Theseus Painter, see D. D. Feaver, "Musical Scenes on a Greek Vase," *Muse* 2 (1968) 14–20.

57

ATTIC BLACK-FIGURE KYATHOS

Ca. 520–510 B.C.
Gift of Gilbert M. Denman, Jr.
86.134.55
Between eyes: Dionysos reclining
At the handle: Maenad and satyr

Dionysos reclines leaning against a cushion, directly on the groundline, at the center front of the kyathos. The god faces left; his beard and hair are long. He wears a chiton with elbow-length sleeves, painted bright white and incised with wavy lines to indicate folds in the fine fabric. Dionysos holds a rhyton—his characteristic rustic drinking-vessel—in his extended right hand. His left forearm and hand bend in toward his waist. The god's himation is wrapped around the lower part of his body. His draped right leg is drawn up and bends down sharply at the knee. This reclining black figure is flanked by a pair of large, decorative black eyes with long, heavy tear glands. Their oculi, drawn with a compass, consist of white and red rings surrounding a large black pupil with a red dot at the center covering the compass point. Grape vines grow up from beneath the eyes and virtually encircle them, filling much of the background. These vines are laden with bunches of grapes, alternately black and white, and their leaves are simply black dots. Another row of black dots beneath the left large brow indicates that the painter mistakenly started to turn it into a vine. Between each large eye and the kyathos' handle a little black figure dances. At the left a sprightly maenad bends at the knees and extends both arms and hands before her. She is wrapped in a himation decorated with white dots and incised crosses, which conceals most of her chiton. There is a wreath in her hair (a streak of black glaze at the back could be a drip rather than a feather). At the right a satyr kicks up his left leg as he dances. His chest is shown in front view. He extends his left hand and arm before him; his right arm is drawn back and bent at the elbow, with the hand pointing downward. No fingers other than the thumb are indicated on the elongated hands of either satyr or maenad. A single arc defines each of the satyr's upper arms and another his fat, round cheek. Satyr and maenad both

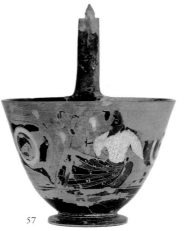

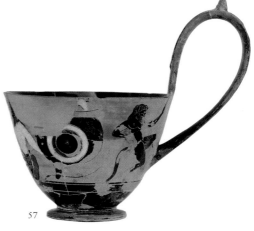

57 57 57

face toward the handle and appear to dance around it together.

A peculiar-looking vessel with a single, tall looped strap handle, the ancient kyathos somewhat resembles the modern tea cup in its thin-walled, bell-shaped bowl. It was, however, designed for ladling wine from large kraters. Significantly, it belonged to the furniture of the drinking party in Etruria, and was not used in Attica or elsewhere in Greece. Its high handle makes this delicate dipper top-heavy; since an empty kyathos cannot stand securely, it must have hung when not in use. Later models of ladles preserved in metal have tall hooked handles which must have allowed suspension directly from a krater's rim. The Attic kyathos, patterned after a local Etruscan vase-shape, evidently was manufactured solely by the workshop of the potter Nikosthenes and intended exclusively for the export market.

Given the association of kyathoi with wine, it is not surprising that they often bear Dionysiac imagery. Furthermore, a decorative scheme characteristic of wine-cups from the late sixth century B.C.—large eyes and vines—commonly came to be applied to these wine-dippers. It is as if a section of an eye-cup's bowl with only one set of eyes were contoured to form a smaller, deeper vessel punctuated by only one (vertical rather than horizontal) handle. The San Antonio eye-kyathos, with its strap handle embellished with plastic twisted cone and palmette, its central rhyton-carrying Dionysos reclining beneath heavy-laden grape vines and its satyr and maenad dancing at the handle, is as typical an example of this

genre of Nikosthenic merchandise as one could imagine.

While most kyathoi are run-of-the-mill workshop products, one major artist, the bilingual vase-painter Psiax, decorated fine black-figured examples of the shape with eyes, vines and/or Dionysiac imagery, e.g. Würzburg 436 (white-ground) and Milan, Poldi-Pezzoli, 482. On the San Antonio kyathos, a sleeved chiton of finely creased fabric, recalling the garment of Psiax' maenads, is worn by Dionysos. Beazley's Group of Vatican G 57, where a reclining Dionysos inserted between the kyathos' eyes is a popular motif, is patterned directly after Psiax's kyathoi. The San Antonio kyathos, work of a minor master, yet not without charm, somewhat more distantly echoes the Psiacian realm. B C

DIMENSIONS: H. to rim 8.2 cm.; H. with handle 14.6 cm.; Diam. of rim 11.4 cm.; Diam. of foot 5.3 cm.

CONDITION: Glaze flaked off in places; lower portion of profile repainted. A large missing section, extending back to right eye of kyathos, includes most of top and back of Dionysos' head, which probably was wreathed.

SHAPE AND DECORATION: The tall strap handle, flat on outer surface and convex inside, is glazed black and decorated with a spiral cone-shaped finial at the top. A raised rib runs downward from the cone, terminating, at the front, in a plastic palmette. Interior of bowl is glazed black. Below main zone on exterior a thick line of black glaze forms the groundline for the figures. Beneath this is a band of black glaze, bordered above and below by a narrow reserved stripe. The lower portion of the bowl's exterior is glazed

entirely black. Black fillet at juncture of body and foot. Disk-shaped foot with double torus profile; black glaze extends over top surface and upper part of profile. Lower rim of foot's profile and stand-surface of foot reserved. Bottom of bowl and vertical inner edge of foot glazed black.

ADDED COLOR: Red for inner ring of oculus and dot over compass point at center of pupil of each large eye; hair and beard of Dionysos, alternate folds of his himation, the cushion, maenad's chiton and leaves of her wreath, tail, beard and hair of satyr. White for outer ring of oculus of each large eye, alternate bunches of grapes, Dionysos' chiton, dots on his himation, flesh of maenad, dots on her himation, stem of her wreath.

BIBLIOGRAPHY: Unpublished.

LITERATURE: On kyathoi, see *ABV* 609–14; *Para* 304–05; M. M. Eisman, "Attic Kyathos Painters" (Diss. University of Pennsylvania 1971) esp. 1–7, 11–22, 31–35, 42, 46–48, 193–99, 234–37, 253–58 and pls. 11b–14, 20–21; idem, "Attic Kyathos Production," *Archaeology* 28 (1975) 76–83; and cf. an unusual kyathos on which a satyr and maenad are located between the eyes and flank of the reclining Dionysos rather than on the handle, collection of Dr. Warren Gilson, Madison, Wisconsin; *MidwesternColls* 122–23, no. 69. For the shape, see M. G. Kanowski, *Containers of Classical Greece, A Handbook of Shapes* (St. Lucia 1984) 72–75, with bibliography. On Dionysos' rhyton, see Carpenter, *Dionysian Imagery* 117–18. G.M.A. Richter first attributed Psiax's Milan kyathos: "A kyathos by Psiax in the Museo Poldi-Pezzoli," *AJA* 45 (1941) 587–92; *ABV* 293,15. For Würzburg 436 (and the Group of Vatican G 57), see *ABV* 294,16 and Mertens, *AWG* 36–38, pl. 3.4.

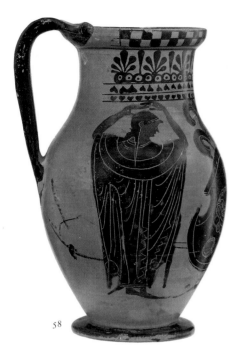
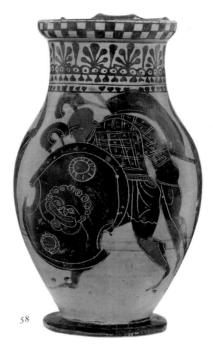

58

58

58

58

ATTIC BLACK-FIGURE OLPE
Ca. 510–500 B.C.
Gift of Gilbert M. Denman, Jr.
86.134.48
Ajax carrying the body of Achilles
between two female mourners

At the center front a warrior lumbers
toward the left, bent by the weight of
a fully armed body he carries over his
shoulder. The drawing is awkward: his
back is hunched, overlapping rather
than supporting the form of the heavy
corpse. The warrior wears a Corinthian
helmet with a high crest; his beard pro-
trudes beneath its lower edge. His
cuirass is decorated with an incised grid
pattern. A greave protects his left leg;
none is indicated on the lower part of
his right leg, which extends beneath his
shield. His large shield, carried parallel
to the picture plane, is of the elongated
arced-shape known as Boeotian, which
often belongs to heroes in Greek art. It
is emblazoned with a gorgoneion be-
tween rosettes, above and below. The
body being rescued from the battlefield
is similarly armed. His head—save for
the tall crest of its helmet—is hidden
behind the first warrior's shield. The
body also has a grid-patterned cuirass, a
short chiton and a greave only on the
left leg. A Boeotian shield, slung over

the corpse's back, is seen in profile
view. This central group is flanked on
each side by a woman wearing a chiton
and flowing himation who raises her
hands above her head in a gesture of
despair and mourning. The garment of
the woman on the right is embellished
with incised crosses. The head of each
woman is bound by an incised fillet.
Careless streaks of black glaze appear
on the left side of the olpe and across
the lower front.

After Achilles' death in the Trojan
war, Ajax saved the hero's fully armed
body in the ensuing fight and carried it
from the battlefield. When his fellow
Greeks voted to award Achilles' arms
to Odysseus, Ajax went mad and com-
mitted suicide. This tragic story was
told in the now lost epic the *Aithiopis*.
Although the heroes' names are gener-
ally not given on later black-figure ex-
amples, such as this olpe, the distinctive
carrying-motive is well known from
earlier vase-paintings (e.g. Kleitias' in-
scribed depictions on the François vase
of ca. 570 B.C.). The San Antonio
olpe's representation of the theme de-
pends on Exekias' re-interpretation of
the theme (ca. 530–520 B.C.). This
may be seen in such elements as the
potent inclusion of armor on Achilles'
body (earlier often unarmed) and in the
unusual, even ominous, right to left di-

rection of Ajax' movement. This rever-
sal allows depiction of the exterior of
the hero's impressive shield, borne on
the left arm. In vase-painting a woman
often is shown running away, mourn-
ing or receiving the body. She should
be Achilles' anguished mother Thetis; a
less likely identification is his slave-girl
Briseis. Here, there happens to be a du-
plication of the mourning female-type,
but this doubling probably was in-
tended to create a symmetrical, central-
ized composition rather than to mean-
ingfully enrich the iconography.

The special compositional framing,
in fact, may have been prompted by an
unusual handling of the shape's decora-
tion, that is, the black-figures are not
confined to a panel. The olpe's clay
ground is entirely reserved; hence the
vessel is termed red-bodied. This light-
coloration is a phenomenon of black-
figure olpai from the late sixth century
B.C.; it is associated especially with the
Leagros Group and favored by the
Painter of the Louvre F 161. A
checkerboard mouth in conjunction
with a red-body occurs in the Leagros
Group as well, e.g. the olpe in Küs-
nacht, Hirschmann Collection (Chiusi
Painter), and the checkerboard was
even transferred to contemporary red-
figured examples of the shape, such as
two olpai in Warsaw attributed to the

Goluchow Painter (Warsaw 142463 and 142308). Six drill-holes low on the San Antonio olpe's body once were fitted with metal clamps to mend breaks; ancient repair suggests that this strikingly decorated wine pitcher must have been prized by its owner.　BC

DIMENSIONS: H. to rim 23.4 cm.; Diam. of mouth 10.2 cm.; Diam. of foot 9.1 cm.
CONDITION: Body broken and repaired; small restored area to the left of the handle-join. Minor chipping along rim and handle.
SHAPE AND DECORATION: Offset mouth decorated with two rows of checkerboard. On the neck: upright palmette and lotus chain, ivy. Interior of mouth and neck glazed black. Concave strap handle with projecting spurs at top corners, glazed black on outer and inner surfaces. Red-bodied. Foot glazed black on upper surface, flat, reserved underside.
ADDED COLOR: Red for helmet and greave of Ajax, tongue of gorgoneion device on his shield, dots on garments of woman on right. White for dots on cuirasses of Ajax and Achilles, dots on short chiton of Ajax, dots on rim, the rosettes, teeth and tusks of gorgoneion on Ajax's shield, dots on shield of Achilles, flesh of female figures, dots on garments of woman on right.
BIBLIOGRAPHY: Sotheby's London, 10–11 December 1984, lot 316.
LITERATURE: The shape and ornament of oinochoai are treated in a dissertation by A. Clark, *Attic Black-Figured Oinochoai* (New York University 1992). For the red-bodied olpai and the Painter of Louvre F 161, see *ABV* 450–51, e.g. Adolphseck, Schloss Fasanerie 14, *CVA* (Adolphseck 1) pl. 14, 2 and 5. For the Hirshmann olpe, see H. Bloesch, ed., *Greek Vases from the Hirschmann Collection* (Zurich 1982) 54–55 (A. Lezzi-Hafter). For the red-figure olpai by the Goluchow Painter, Warsaw 142463 and 142308, see *ARV²* 10,1–2; *CVA* (Goluchow 1) pls. 17, 2a and 1a. For the subject, see S. Woodford and M. Loudon, "Two Trojan Themes," *AJA* 84 (1980) 25–40; M. B. Moore, "Exekias and Telamonian Ajax," *AJA* 84 (1980) 417–34; *LIMC* I, s.v. "Achilleus" (A. Kossatz-Deissmann) 185–93 pls. 141–43; for the François vase see *ibid.* pl. 141, no. 873, and for the Exekias amphora, Munich 1470, see *ibid.* pl. 141, no. 876.

59

ATTIC BLACK-FIGURE LEKYTHOS (WHITE-GROUND)
Attributed to the Class of Athens 581
Ca. 500 B.C.
Gift of Gilbert M. Denman, Jr.
86.134.53
Herakles and the Hydra

The scene is carefully balanced, with the Hydra flanked by Herakles and Iolaos. Herakles charges to the right, wearing his lionskin over a short chiton or tunic. His sword sheath is held fast to his left side by a baldric, but his sword is drawn and clenched tightly in his right hand as he lunges at the Hydra. The hero's outstreched left fist clutches one of four tendrils with a dotted leaf pattern that curve about from behind him. The body of the Hydra occupies the central portion of the scene opposite the vase handle. The monster has ten bearded heads attached to serpent-like necks plus one other neck, at the lower right, which passes between two adjacent necks before disappearing behind the creature's body. There is no indication that the head has been severed from this neck. The Hydra has been positioned diagonally from left to right across the scene so that the majority of its head confronts Iolaos, not Herakles. The monster's tail trails behind it to the left and Herakles steps on it with his left foot to halt its retreat. At the same time he plunges the blade of his sword deeply into the creature's body just beneath the closest head, which responds by attacking the hero's hand. From the right side of the scene, Iolaos approaches with his arms flailing wildly at the Hydra's open jaws. He is bearded and wears a low-crested helmet, greaves, a belted animal skin over a short tunic, and a sheathed sword slung from a baldric.

The Class of Athens 581 is a large group of early fifth-century lekythoi of which the Marathon Painter is the most visible artist. His extensive use of white-ground lekythoi, inherited from the Edinburgh Painter, and his strong

sense of color patterns influenced several artists decorating lekythoi of this class, and are evident in the painted scene on the San Antonio vase. The painter responsible for this vase, however, is a better draftsman than the Marathon Painter and is far more careful in his rendering of human figures than most of the artists decorating lekythoi in this class. We can find his work on a slightly later white-ground lekythos of the same class in Baltimore (Walters Art Gallery 48.227), also with the subject of Herakles and the Hydra. Here the shoulder pattern of connecting lotus-buds on the San Antonio vase has given way to the simple arrangment of leaves. The coiled body of the Hydra on the Baltimore vase is more in keeping with other Attic black-figure renditions of the monster. The globular body of the Hydra on the San Antonio lekythos is unusual and we might question the purpose of the single incised line across its width, since it does not appear to define the monster's shape other than to present some semblance of a three-dimensional form. Perhaps the painter became momentarily confused while applying the incised detail to the creature's trunk. This possibility gains credence when we compare the body of another hydra on an Attic Band cup in Berlin (Berlin F 1801) which would have appeared equally globular were it not for the large circular incision on its trunk creating the effect of an overlapping coil.

The mythical theme of Herakles and the Hydra first occurs in Greek art on bronze fibulae of the eighth century B.C. In literature the account is told first by Hesiod (*Theogony* 313–18). Its earliest appearance in Greek vase-painting is on Corinthian pottery, where it enjoys a full and varied exposure, perhaps due to the close proximity of Lerna to Corinth. On Attic black-figure vases the subject begins about the time of its last known occurrence in Corinthian, ca. 570 B.C. In Corinthian vase-painting the number of heads depicted on the Hydra reaches ten, on Attic vases the count is more often nine or fewer.　KKII

DIMENSIONS: H. of rim 18.4 cm.; Max. Diam. 7 cm.; Diam. of foot 4.8 cm.
CONDITION: Unbroken. Portions of the figure of Iolaos and Herakles misfired.
SHAPE AND DECORATION: This is a shoulder lekythos in the Class of Athens 581. The nearly cylindrical form tapers rapidly over the lower portion of the body toward the foot, which has a flanged edge and is reserved underneath. The lip and outer side of the handle are glazed, as is the lower portion of the body (except for two reserved bands) and the top of the foot. The figure scene has a white ground. At the top of this is a double row of black dots which merge into a single row over the Hydra and Iolaos. On the reserved shoulder is a dotted lotus-bud pattern with connecting tendrils and tongues above.

ADDED COLOR: Extensive use of added red paint creates a colorful display with the black forms and white background. The necks, body, and tail of the Hydra are speckled with red dots. So too the lionskin worn by Herakles, and there are red lines on the lion's mane and jaws. Io-laos' helmet is outlined in red and bears a row of red dots at the base of the crest. Red is also applied to his beard, baldric, and in dots on his tunic.
BIBLIOGRAPHY: Unpublished.
LITERATURE: For the Class of Athens 581, see *ABV* 489–506. For the white-ground lekythos in Baltimore, Walters Art Gallery 48.227, see *ABV* 499,33; *Vasenlisten*³ 80, 26. For Herakles and the Lernian Hydra, see F. Brommer, *Heracles: The Twelve Labors of the Hero in Ancient*

Art and Literature, trans., S. J. Schwarz (New Rochelle 1986) 12–18. The Band cup Berlin F 1801 is pl. 13, Brommer *Vasenlisten*³ 79–82; *LIMC* V, 34–43 (G. Kokkorou-Alewras). For the Hydra see also Brommer, "Herakles und Hydra auf attischen Vasenbildern," *Marburger Winck-elmann-Programm* (1949) 3–8; K. Schauen-burg, "Herakles und die Hydra auf attis-chen Schalenfuss," *AA* (1971) 162–78. For the theme in Corinthian vase paint-ing, see P. Amandry and D. A. Amyx, "Héraclès et l'Hydre de Lerne dans la céramique corinthienne," *Antk* 25 (1982) 102–16; D. A. Amyx, "Archaic Vase-painting vis-à-vis Free Painting at Corinth," in *AGAI* 45–52.

60

ATTIC BLACK-FIGURE
LEKYTHOS (WHITE-GROUND)
Attributed to
the Edinburgh Painter [J.R. Guy]
Ca. 500 B.C.
Gift of Gilbert M. Denman, Jr.
86.134.152
Herakles and Apollo: The Struggle
for the Tripod

Five figures form a frieze running all
round the body of the vase, with only
the area under the handle left undeco-
rated. Herakles has taken the Delphic
Tripod, cradling it in his left arm, and
has drawn his sword to fend off
Apollo's attack. The hero wears a short
chitoniskos and an animal pelt belted at
the waist, but not his traditional lion-
skin. His quiver hangs from his right
shoulder, the sheath at his waist. Be-
hind him, Athena stands somewhat
stiffly, showing her support for Herak-
les only by a discreet gesture of the left
hand. She is fully armed, the high crest
of her Attic helmet cut off by the rim
of the vase's shoulder. The shield, in
side view propped upon the ground, is
hers rather than Herakles'. Apollo
rushes in from the right, reaching out
for the Tripod with his right hand,
which disappears behind the central
figure. He holds his bow in the left
hand, but there is no sign of quiver or
arrows. A male figure, Zeus or Her-
mes, intervenes between the two an-
tagonists, moving toward Apollo but
looking back at Herakles. He wears a
short chitoniskos, a kind of shawl
draped over both shoulders, and a
broad fillet in his hair. Finally, Artemis
runs up from the right behind her
brother, gesturing with upraised right
hand. She wears a patterned chiton and
a mantle, and carries a scepter which
echoes Athena's spear on the other
side.

The Struggle for the Tripod is one of
the most popular mythological subjects
on black- and red-figure vases of the
late Archaic period, with over two
hundred examples known. In the most
canonical type, Athena and Artemis are
both present to lend support to their
protégé and brother, respectively, as on
our vase. But the San Antonio lekythos
belongs to an extremely small group of
no more than four or five vases which
add the figure of a god between Her-
akles and Apollo, seemingly trying to
mediate between them. The ultimate
source of this figure is the East Pedi-
ment of the Siphnian Treasury at Del-
phi (ca. 525 B.C.), where Zeus inter-
venes between his two sons. Though
most of the vases which depict this
myth show some degree of dependence
on the sculptural model, only two bor-
row the central figure of Zeus. On an
amphora in London (London B 316),
the god looks and gestures to Herakles,
as on our vase, but the movement of
figures is in the opposite direction. On
a fragment of a hydria in Cleveland
(Cleveland 15.533A), Zeus faces to-
ward Apollo. In addition, Hermes re-
places the central Zeus on two vases, an
unpublished hydria in Dijon and a
neck-amphora by the Amasis Painter in
Boston (Boston 01.8027). It is not clear
in these instances whether Hermes is
actually trying to separate the combat-
ants or is simply running past, perhaps
on his way to inform Zeus. The figure
on the San Antonio vase does not have
any specific attributes which would en-
able us to identify him as Zeus or Her-
mes, and his beardlessness is equally un-
usual for both (Herakles is also,
exceptionally, unbearded). But the lack
of winged boots makes it somewhat
more likely that he is meant to be
Zeus. The motif of Herakles and
Apollo moving toward each other is
also unusual, since most often they
move in the same direction, as Apollo
pursues the fleeing Herakles. The com-
position here makes the presence of
Zeus more meaningful, since he clearly
intervenes to stop the impending fight
signalled by Herakles' drawn sword.
We know that the myth ended with a
compromise, Herakles returning the
Tripod but receiving the oracle he had
been refused.

The Edinburgh Painter, whose ori-
gins lie in the Leagros Group in the late
sixth century, was a prolific painter of
lekythoi on a white-ground decorated
with mythological subjects (cf. Cat.
No. 61). In fact, he introduced the use
of a white slip on the body of a leky-
thos, though he also painted a smaller
number of this shape on red-ground.

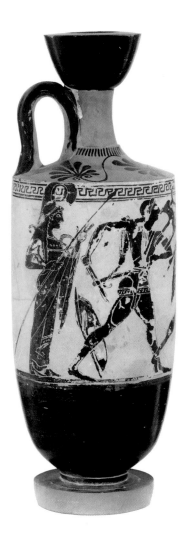
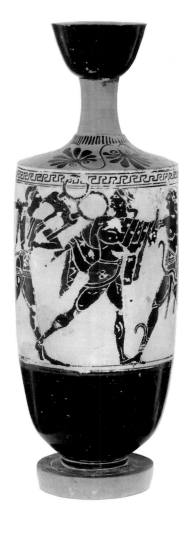
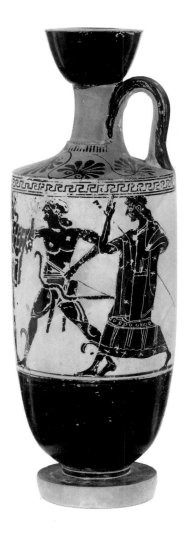

This is his first known version of the Struggle for the Tripod, though the story is especially popular on later black-figure lekythoi. HAS

DIMENSIONS: H. 34.7 cm.; Max. Diam. 11.8 cm.; Diam. of foot 8 cm.
CONDITION: Broken and repaired. Flaking of black glaze on figures.
SHAPE AND DECORATION: The body a straight cylinder; fillet on the base; plain, thick torus foot, reserved on the outside. Shoulder, neck, and inside of handle reserved, the shoulder decorated with five palmettes of nine fronds each.

ADDED COLOR: Purple for fillet on the base of Athena's helmet, Apollo's, Herakles' and Zeus' fillets and chitoniskoi; two stripes directly under the figured scene. Women's flesh is left black.
BIBLIOGRAPHY: Sotheby's London, 10–11 December 1984, lot 292.
LITERATURE: On the struggle for the tripod, see *Vasenlisten*³ 38–46; D. von Bothmer, "The Struggle for the Tripod," in *Festschrift für Frank Brommer* (Mainz 1977) 51–63 (adds to and corrects Brommer's lists and organizes them according to iconographical types). On the Siphnian

Treasury Pediment and the central figure of Zeus, see B. S. Ridgway, "The East Pediment of the Siphnian Treasury: A Reinterpretation," *AJA* 69 (1965) 1–5. Two vases with the central Zeus are London B316 = *ABV* 268,24; *CVA* (British Museum 6) pl. 79, 4 and Cleveland 15.533A = *ABV* 715; *CVA* (Cleveland 1) pl. 9, 1. For the Amasis Painter's neck-amphora with Hermes in the middle, Boston 01.8027, *ABV* 152,27, see *CVA* (Boston 1) pl. 27. For the Edinburgh Painter, see *ABV* 476–80; *ABL* 86–89; 215–21; Kurtz, *AWL* 13–14, fig. 8a (shoulder pattern).

61

ATTIC BLACK-FIGURE
LEKYTHOS (WHITE-GROUND)
Attributed to the
Edinburgh Painter [H. A. Cahn]
Ca. 500 B.C.
Gift of Gilbert M. Denman, Jr.
86.134.52
Introduction of Herakles
to Mount Olympos

The little procession makes its way on
foot around the tall body of the leky-
thos. At center front, Herakles strides
eagerly toward the right, following the
goddess Athena, who looks back and
gestures reassuringly with her right
hand. The bearded hero, having left
behind his lionskin, wears only a short
chiton. His sheathed sword is suspen-
ded from a baldric over his right shoul-
der, and a quiver of arrows hangs at his
back. Herakles carries a bow in his left
hand and his club in his right. His head
is bound by a fillet. Athena wears an
Attic helmet with a high crest, which
overlaps the upper border of the leky-
thos and extends onto its shoulder. The
spear held in her left hand also overlaps
the border. She wears the snake-edged
aegis over a long chiton (its skirt, now
overpainted, once had incised crosses).
Goddess and hero are led to the gates
of Olympos by the messenger-god
Hermes. The bearded Hermes wears a
short chiton topped by a chlamys and,
on his head, a wide-brimmed *petasos*.
His long hair is bound behind. He ges-
tures, showing the way with his left
hand, and carries his *kerykeion* in his
right. On his feet are boots with long
tongues. The composition is framed at
far right and left by a pair of Doric
columns. A bearded man in a cap is the
last figure on the left. He wears short
chiton and chlamys and carries a pair of
spears in his right hand. He visually
echoes Hermes, thereby setting off the
central group of Herakles and Athena.
An onlooker inserted for compositional
balance, he might be Herakles' mortal
nephew Iolaos and will have to stay be-
hind when the others arrive at Mount
Olympos, dwelling-place of the gods.

This cylinder-shaped lekythos is a
typical product of the Edinburgh
Painter, a late Archaic black-figure
artist named after a similar vessel in the
Royal Scottish Museum. He appears to
have been the first painter to use com-
monly a white-ground (cream-colored
slip) for the lekythos. The San Antonio
vase is marked as one of the Edinburgh
Painter's earlier works by a second,
whiter white applied to female flesh (cf.
the Athena on his lekythos in Athens,
National Museum 550). He soon omit-
ted this white, which does not show
off against the special ground; female
flesh is black not only later in his oeu-
vre (cf. Cat. No. 60) but in the work
of subsequent lekythos-painters. The
distinctive shoulder ornament is his in-
novation as well: two black palmettes
facing the handle flank a central group
of three. That the Edinburgh painter
also favored a centralized grouping
with flanking forms for figural compo-
sitions is especially apparent on this
lekythos, as is his fondness for onlook-
ers in "Robin Hood caps." His figures
are distinguished by round eyes, inner
markings described by thick incised
lines, stiff gestures and erect postures.
The pair of columns may mark the en-
trance to Olympos here, as they suggest
the hero Achilles' tent on the painter's
name vase in Edinburgh (Edinburgh
L224.379). In any event, they provide
a decorative framework for the four-
figure composition and seem to support
the upper portion of the vessel. This
depiction of Herakles' apotheosis sub-
scribes to an early archaic version in
which the hero walks to Mount Olym-
pos, rather than being driven by
Athena in a chariot. A similarly retar-
dataire iconographic formula occurs on
the Edinburgh Painter's white-ground
lekythos in Basel (Antikenmuseum BS
1921.337), where the hero awkwardly
wrestles the Nemean lion standing up,
rather than fighting on the ground.
Although the Edinburgh Painter grew
out of the Leagros Group, both his
figural style and iconography remained
particularly old-fashioned—characteris-
tics which probably enhanced boldness
and simplicity in the design of his leky-
thoi. BC

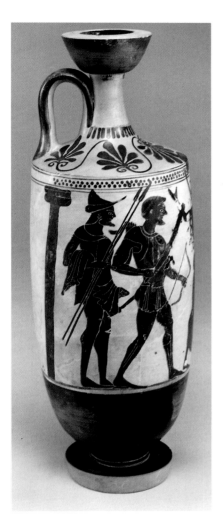
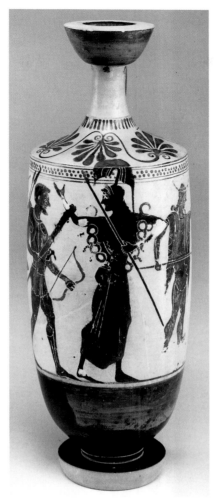
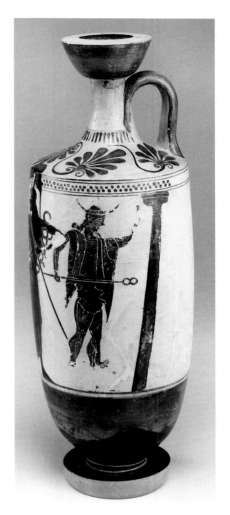

DIMENSIONS: H. 31.6 cm.; Max. Diam. of body 11.1 cm.; Diam. of foot 9.1 cm.

CONDITION: Body broken and restored; small restored area to the left of Hermes. Black glaze misfired under figural scene and on mouth.

SHAPE AND DECORATION: Mouth glazed black outside and in, top surface reserved. Vertical handle glazed black outside, reserved inside. Neck and shoulder reserved ground. Ridge defined by line of black glaze at base of neck; below this, black tongues. On shoulder, five black palmettes: two separate palmettes facing handle flank a central palmette-configuration; two downward, one upward.

White-ground; around top of body double row of dots, bordered above and below by two black lines, beneath the figures a line of black glaze. Lower portion of body glazed black. Black fillet set off by incised lines at juncture of body and foot. Torus foot, glazed black on top surface, edge and underside reserved.

ADDED COLOR: Red for fillet around Herakles' head, visor of Athena's helmet, Hermes' beard. White for Herakles' sword hilt and baldric, flesh of Athena, dots on her helmet crest and on skirt of her chiton, border of dots at neck of Hermes' short chiton, dot rosettes on short chiton of man (Iolaos?) on left.

BIBLIOGRAPHY: *Art of the Ancients: Greeks, Etruscans and Romans* (New York, André Emmerich Gallery exh. cat., 1968) 18, no. 10 (H. A. Cahn); *SouthernColls* 70–71, no. 26 (H. A. Shapiro).

LITERATURE: The work of the Edinburgh Painter, *ABV* 476–80 and *Para* 217–19, was best defined by Haspels, *ABL* 86–89, 215–20. For the lekythos Athens National Museum 550, see *ABL* pl. 28. For Edinburgh L224.379, see *ABL* 147, figs. 241.1, 2; Kurtz, *AWL* 13–14. For Basel, Antikenmuseum BS 1921.337 see *CVA* (Basel 1) pl. 55.1, 4. On the introduction to Olympos, see F. Brommer, *Herakles II, Die unkanonischen Taten des Helden* (Darmstadt 1984) 95–97.

ATTIC BLACK–FIGURE
LEKYTHOS
Attributed to the
Athena Painter [W. Hornbostel]
Ca. 500–490 B.C.
Gift of Gilbert M. Denman, Jr.
86.134.54
Men and siren playing the lyre

In the very center of the scene, directly opposite the handle, a siren is perched on a tall craggy rock, playing a six-stringed lyre. With her left hand (sirens only have human hands on such occasions when they need them), she fingers the strings, and in her right she holds the *plectron*, or pick. A long cloth hangs down from the instrument. On either side of her, identical bearded men, in loosely draped mantle, lean on long staffs, their heads gently lowered as they listen enraptured to the music. A tree grows up between the siren and the man at left, its long vines trailing off in all directions, even as far back as the second listener. A goat stands before the tree, turning to look back.

Ernst Buschor, in a celebrated monograph of 1944, nicknamed the sirens "Die Musen des Jenseits," and the encounter of Odysseus and his men with these irresistible creatures best illustrates the two sides of their nature, music and death (*Odyssey* 12. 39–46). Their song is one of magic beauty and promises limitless knowledge, but the man once seduced by the music never comes away alive. In the period of our lekythos, Odysseus and the sirens are depicted on a handful of vases. The craggy rock on the San Antonio lekythos recalls Homer's reference to the sirens' island perch (*Odyssey* 12. 167), but here landscape, goat, and listeners transform the setting from the seashore to one on land. Perhaps these two men are destined to join the heap of bones, the sirens' victims which surrounded them, but now they simply enjoy the music, and their relaxed pose recalls that of audiences in many concert scenes on vases of this period featuring human performers.

The Athena Painter decorated several other lekythoi with similar scenes, though always varying the number of sirens, their instruments (some play the double flutes), and the audience. He painted lekythoi in both white-ground and red-ground technique, like his predecessor the Edinburgh Painter (cf. Cat. Nos. 60 and 61). But unlike the latter, he decorated only small vessels, lekythoi and oinochoai. His contemporary and stylistic companion is the Theseus Painter, who, however, did not specialize in lekythoi (cf. Cat. No. 56). The red-figure artist known as the Bowdoin Painter is probably to be identified with the Athena Painter.

HAS

DIMENSIONS: H. 31.2 cm.; Max. Diam. 11.4 cm.; Diam. of mouth 7.7 cm.; Diam. of foot 8.1 cm.
CONDITION: Body unbroken; repaired neck break. Minor chipping on mouth.
SHAPE AND DECORATION: Tall, cylindrical body, with a slight inward curve near the top; widely flaring mouth. On the shoulder, below a red band and tongue pattern, five palmettes with dots in the field between them. Just below the shoulder, a narrow frieze with two-tiered dot pattern between double stripes of dilute glaze. Lower body and foot all glazed, except the underside of the foot.
ADDED COLOR: Red for belly of siren and dots on her wings; fillets in men's hair; outline of rock. White for flesh and tail of siren, front side of rock; horn and underbelly markings of goat.
PROVENANCE: Ex coll. W. Kropatschek, Helgoland.
BIBLIOGRAPHY: H. Telmer, *Kunst der Antike. Schätze aus norddeutschem Privatbesitz* (Hamburg Museum exh. cat. 1977) 292–

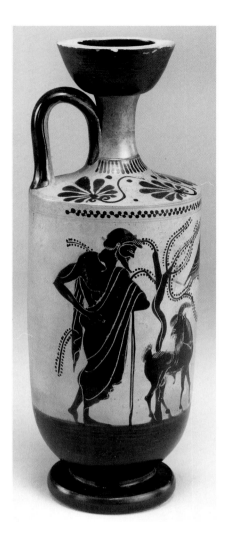 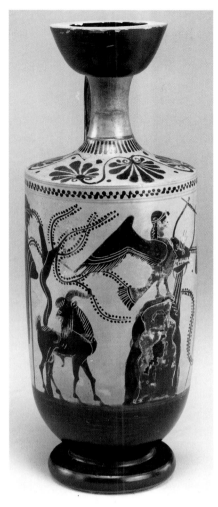 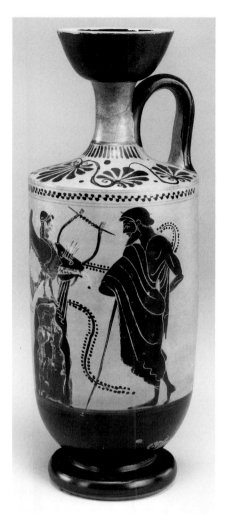

93, no. 254 (W. Hornbostel); W. Horn-bostel, *Aus Gräbern und Heiligtümern. Die Antikensammlung Walter Kropatschek* (Hamburg Museum exh. cat. 1980) 107–09 no. 64; A. Griefenhagen, *AA* (1978) 529, n. 32; Münzen und Medaillen *Kunstwerke der Antike*, Basel, Auktion 63 (29 June 1983) lot 36.

LITERATURE: For scenes of Odysseus and the sirens, see F. Brommer, *Odysseus* (Darmstadt 1983) 83–86 (including a fine

example published for the first time, pl. 34). For musical sirens from antiquity to modern times, see W. Salmen, "Mu-sizierende Sirenen," in *Forschungen und Funde, Festschrift B. Neutsch* (Innsbruck 1980) 393–400. For representations of the lyre in Archaic vase-painting, see M. Maas and J. M. Snyder, *Stringed Instru-ments of Ancient Greece* (New Haven 1989) 27–39. For scenes of musicians and audi-ence on late Archaic vases, see K. Schau-

enburg, "Herakles Mousikos," *JdI* 94 (1979) 49–76. On the Athena Painter, see *ABV* 522–24; *ABL* 147–53, 254–60. For his depictions of sirens, see *ABL* pl. 45, 5 and 48, 2; and the lekythos Münzen und Medaillen, Basel, Sonderliste G (1964) no. 42. On the Athena Painter's shapes and ornament, and for the relationship of the Athena and the Bowdoin Painters, see Kurtz, *AWL* 15–16.

63

ATTIC BLACK-FIGURE
LEKYTHOS
Attributed to
the Gela Painter [J.R. Guy]
Ca. 500–490 B.C.
Gift of Gilbert M. Denman, Jr.
91.80.1
Hades, Herakles
and Kerberos, Sisyphos

The Doric column at the left side of
the figural frieze on the lekythos' nar-
row, cylindrical body, which appears to
support the upper portion of the vase,
serves to set the scene in the Under-
world. The column represents a gate-
way to the house of Hades, and the
age-old god himself, dressed in a chiton
and himation, stands nearby. Hades
originally had long white hair (painted
over the short hair indicated in black
glaze), bound with a fillet, a white
mustache and a white beard; he carries
a staff. A group of man and dog filling
two-thirds of the foreground consists of
the great Greek hero Herakles leading
Kerberos, the guardian hound of hell,
away on a chain. Kerberos, here a gi-
gantic two-headed beast, sprouting
tufts of hair along his spine, glares at
Herakles with his teeth bared. The
hound's long tail curls around the back
of the vase. The hero is outfitted with
his major attributes. He wears the skin
of the Nemean lion over a short chi-
ton. Two paws of the lionskin are tied
around his neck, another dangles be-
tween his legs, and its head is set upon
his own like a helmet. The quiver of
arrows, awkwardly positioned behind
his back, seems to be suspended in the
air. As Herakles walks towards the
right, wielding his club in his left hand,
he glances back at the fearsome dog.
The purely decorative branches that
spring from behind the hero's body
emphasize his compositional impor-
tance. Finally, at the far right, the sin-
ner Sisyphos is engaged in his endless
task of pushing a rock, which will only
roll back down again, up a hill. A
naked, mature bearded man, with his
knees bent for leverage, he has just
managed to boost his rock atop a tall
mound, which stands for the hill; in-
cised slashes and strokes of white paint
of the composition balance the column
at the left.

The figural frieze on the San Anto-
nio lekythos particularly recalls a por-
tion of the Nekyia in Homer's *Odyssey*
(11.593–626) where the doomed
Sisyphos struggling with his eternal
mindless task is described just before
the apparition of Herakles. The hero
mentions his difficult labor of fetching
the hound of Hades—one of the final
steps on his path toward immortality.
Herakles in the Underworld, either ap-
proaching Kerberos or leading the
hound away, normally accompanied by
Athena and/or Hermes, is a popular
theme in Archaic Attic vase-painting.
Often not only the gateway, but
Hades' consort Persephone appears; the
god himself is represented only rarely.
Sisyphos, also a rarity in Attic vase-
painting, occurs only on a small group
of vases depicting the Underworld, pri-
marily black-figured neck-amphorae,
which date to the late Archaic Period.
The Homeric juxtapostion of Sisyphos
along with Herakles and Kerberos on
the San Antonio lekythos is unusual;
these characters also appear on either
side of the neck-amphora by the Bucci
Painter in Munich (Staatliche Antiken-
sammlungen 1493). A rare red-figure
Sisyphos, on a cup-tondo by Epiktetos
(Louvre G16), and the earliest pre-
served Sisyphos, on a metope from the
Heraion at Foce de Sele (354), are both
more powerful embodiments of this
sinner, straining to push a heavy rock
up a steep hill, than the Gela Painter's
ungainly depiction.

The Gela Painter was named, after
the Sicilian findspot of many of his
vases, by Emilie Haspels, who also has
given a memorable characterization of
this artist's black figures. "His people
are easily recognisable, with their long
nose and skipper-beards. They stand on
short legs, wooden and motionless, and
are stiff in the joints." The angular pose
of the lionskin-bedecked Herakles on
the San Antonio lekythos—walking to-
ward the right, but looking back, with
his left arm bent upward at the elbow,
wielding a club, and his right arm bent
downward—is familiar from the Gela
Painter's depiction of his hero in the
struggle with Apollo. On a lekythos in
Vienna (Vienna 198), for example, the
Delphic tripod, stolen from the god, is
tucked under the downward bent right
arm belonging to the twin of the San
Antonio Herakles. The vase in San An-
tonio may be dated to the early fifth
century B.C. by the downward-taper-
ing shape of its body and characteristic
ornament. Its artist is noteworthy both
as one of the most prolific and most
mediocre of the painters of black-
figured lekythoi. B C

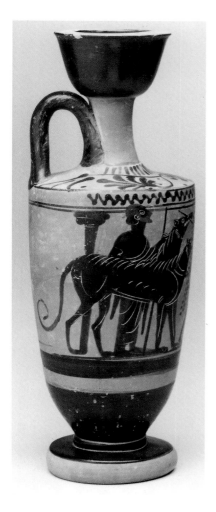
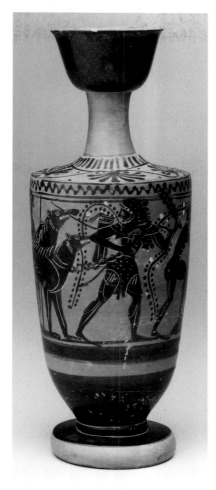
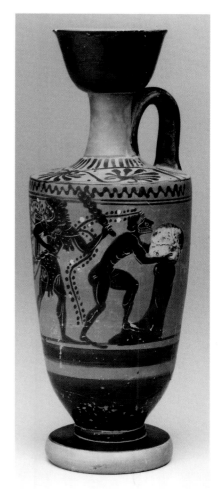

DIMENSIONS: H. 24 cm.

CONDITION: Black glaze pock-marked, particularly on lower portion of body; some added color has flaked off.

SHAPE AND DECORATION: Mouth glazed black outside and in, top surface reserved. Vertical handle glazed black; sloppy application of glaze on interior surface. Neck reserved. Ridge at base of neck, beneath this black tongues bordered below by a black line. On shoulder a configuration of three black palmettes and two lotus buds, surrounded by six dots. Around top of body net pattern, bordered below by two black lines; beneath the figures a black line. Lower portion of body glazed black save for a reserved band. Black fillet set off by incised lines at juncture of body and foot. Foot glazed black on top surface, convex vertical profile and concave underside reserved.

ADDED COLOR: Red for line around base of vessel's neck, fillet around Hades' head, flap of quiver, dots on central vertical band of quiver, knot of lionskin's tied paws, belt of lionskin, dots on skirt of

Herakles' short chiton, forelock and beard of Sisyphos, two lines on band of black glaze beneath figure zone, on line on lower black-glazed portion of vessel's body. White for Hades' hair, mustache and beard, dots on fold of himation across Hades' chest, alternate tufts of Kerberos' mane, Kerberos' teeth, fruit on vines, tails of arrows, teeth in mouth and claws on paws of lionskin, double strap (of quiver?) across Herakles' chest, dots on Herakles' short chiton, strokes on hill, Sisyphos' rock.

BIBLIOGRAPHY: Galerie Günter Puhze, cat. 8 (Freiburg 1989) 21, no. 208. *The Odyssey and Ancient Art: An Epic in Word and Image* (Bard College exh. cat. Annandale-on-Hudson, N.Y., 1992) 100–01, 105, no. 31 (B.Cohen).

LITERATURE: On Herakles and Kerberos see *LIMC* V, 85–92, pls. 93–99 s.v. Herakles, (V. Smallwood) and V,2, pls. 93–99; F. Brommer, *Herakles, The Twelve Labors of the Hero in Ancient Art and Literature*, trans. S.J. Schwarz (New Rochelle 1986) 45–48, 93 (bibliography), figs. 40–

41; *Vasenlisten³* 91–97; and T. Carpenter, *Art and Myth in Ancient Greece* (London 1991) 129–30, figs. 214–16 and 79; figs. 129, 131 for Sisyphos. On Sisyphos, see *EAA* VII, 354–55, s.v. Sisifo (P. Zancani-Montuoro). For the metope from Foce del Sele see *ibid.* 354, fig. 443. For vase-paintings of the Underworld, see P. Zancani-Montuoro, "Heraion alla Foce del Sele," *Atti e Memorie della Società Magna Grecia* ns V (1964) 60–70, pls. XII–XIV. For Paris, Louvre G 16 by Epiktetos, see *ibid.* pl. XIV, fig. a; *ARV²* 71,13 and *Beazley Addenda²* 167. For Munich, Staatliche Antikensammlungen 1493, by the Bucci Painter, see *ABV* 316,7; *Beazley Addenda²* 85; Side A, *EAA* II, 211; Side B, *ABFV*, fig. 198. See also *Vasenlisten³* 549–50; W. Felten, *Attische Unterwelts Darstellungen des VI. und V. Jh. v. Chr.* (Munich 1975) 26–39. On the Gela Painter see *ABL*, 78–86, 205–15 (208, shoulder-decoration, division IIIa), pls. 23–27 (Vienna 198: pl. 24, fig. 1); *ABV* 473–75, 699–700; *Para* 214–16; *ABFV*, 114,147, figs. 234–36.

64

ATTIC BLACK-FIGURE CUP
Attributed to the Leafless Group
Ca. 500 B.C.
Gift of Gilbert M. Denman, Jr.
86.134.50
Interior: Warrior
A and B: Achilles and Ajax gaming

The symmetrical image of two warriors crouching before a gaming table is a popular one in Athenian black-figure, appearing over one hundred times on vases ranging in shape from large neck-amphoras to small lekythoi and sky-phoi. The players can be identified as the most famous Greek heroes involved in the Trojan War, Achilles and his friend Ajax, because their names are inscribed on a number of vases. The most famous example, and probably the earliest, is the well-known painting by Exekias on his signed amphora in the Vatican (Vatican 344). Thus, the scheme was invented around 540 B.C. and remained popular to the end of the sixth century, appearing also in Attic red-figure and on bronze shield bands found at Olympia and Aegina. It may also have been represented in a sculptural group dedicated on the Athenian Acropolis ca. 500 B.C. Surprisingly, given the popularity of this theme in art, there is no extant literary reference to Achilles and Ajax playing a game.

The painter of this cup, although a slapdash artist, has shown more of an interest in character and context than other painters who depict this scene. On Side A, the right-hand opponent has a beard whereas the left-hand one is beardless; the latter must be Achilles since he was the younger hero. On Side B, the right-hand warrior has his right heel raised slightly off the ground, a subtle detail, known first in the painting of Exekias, and which perhaps indicates the impetuous nature of Ajax. A palm tree, which appears beyond the low gaming board, serves both to fill an awkward void and to indicate a foreign setting, i.e. Troy. In addition, the cen-

tral scene is flanked on both sides of the cup by pairs of helmeted warriors marching to the right and pairs of draped men, three of whom are seated on *diphroi*. It is certainly the wide format of the cup exterior that has prompted the multi-figured scene in contrast to the simple two-figure format of Exekias' panel-amphora. But the painter has included yet another warrior, a helmeted figure carrying a spear and a Boeotian shield, in the tondo. Fellow "Leafless Cup" painters tend to include extraneous women in this scene, and so their cups lack the military flavor and overall unity of this example. J N

DIMENSIONS: H. 11.7 cm.; Diam. of lip 29.3 cm.; Diam. with handles 37.2 cm.; Diam. of foot 11.3 cm.

CONDITION: Broken and repaired.

SHAPE AND DECORATION: Type B kylix with foot in two degrees. Tondo and base of exterior framed by dotted band flanked by three concentric circles. Background of exterior filled with grapevine; single leaf under each handle.

ADDED COLOR: White for shield devices (thunderbolts on Boeotian shields; dots on *peltas*), helmet crests and dots on crestholders and drapery, fruit of palm tree, beard and hair of older men.

BIBLIOGRAPHY: Sotheby's London, 6–7 May 1982, lot 432; *JHS* 102 (1982) 183, no.7*bis*.

LITERATURE: For the Leafless Group, see *ABV* 632–53. For the "Brettspieler," see *Vasenlisten*³ 334–39; S. Woodford, "Achilles and Ajax playing a Game on an Olpe in Oxford," *JHS* 102 (1982) 173–85; and *LIMC* I s.v. Achilleus nos. 391–427 (A. Kossatz-Deissmann). For Exekias, see J. Boardman, "Exekias," *AJA* 82 (1978) 11–24; M. B. Moore, "Exekias and Telamonian Ajax," *AJA* 84 (1980) 417–21; for the Exekias amphora, Vatican 344, *ABV* 145,13, see Moore pl. 149, 1.

PARALLELS: A close parallel for our cup is a black-figure cup in Paris (Cab. Méd. 328) attributed to the Caylus Painter: *ABV* 646, no. 199; *CVA* (Bibl. Nat. 2) pl. 55, 8–9.

65

ATTIC WHITE-GROUND
ALABASTRON
Attributed to the
Group of the Negro Alabastra
Ca. 490–480 B.C.
Gift of Gilbert M. Denman, Jr.
86.134.174
A: Negro warrior
B: Stool and palm tree

The alabastron, as its name implies, derives its shape from perfume containers made of white alabaster and originally produced in Egypt. The shape was incorporated into the Attic repertoire in the mid-sixth century, possibly by the potter Amasis whose name is in fact Egyptian. The first white-ground examples, which clearly imitate their stone prototypes, were produced in the last quarter of the sixth century. From the very beginning the white-ground alabastra feature white and exotic figures such as maenads, satyrs and Amazons. No doubt because of their close association with Amazons as allies of the Trojans, the black warriors of Memnon are introduced onto these alabastra ca. 500 B.C. in the workshop of the Syriskos Painter. Thereafter a long series of both Negro and Amazon alabastra is produced, of which over sixty examples are extant today.

The San Antonio alabastron is typical of the group in depicting a frontal Negro with head in profile to the left. He is dressed in trousers and sleeved jacket, the Asiatic *anaxyrides* traditionally worn by "barbarians" such as Scythians and Persians. His armor consists of a cuirass, large *gorytos* or quiver worn at the waist, battle axe in his extended right hand, and curved bow in the left. Before him is a simple rectangular stool, and on the reverse of the vase a single palm tree. The warrior is recognizable as a Negro by the snub nose, thick lips, woolly hair rendered in outline by a series of small black dots. The style of the painting, on this and most other Negro alabastra, seems to be deliberately crude.

A number of diverse explanations for the popularity and wide dispersal (from the Black Sea to Spain) of this unique class of pottery have been advanced. Some scholars believe that the Negro acts as a trade advertisement for a special Egyptian perfume bottled in these alabastra, but this theory cannot account for his appearance on a few white-ground plates and a head-vase. Some feel that the Negro warrior may have been inspired by the arrival of

Ethiopian mercenaries in Xerxes' army in 480 B.C., as described by Herodotus (7, 69), although the series begins well before this date. Given the use of such vases by women, others believe that the imagery relates to a ritual or funerary purpose. However, since one of the earliest alabastra to depict a Negro shows him paired with an Amazon (Berlin 3382), it is surely their mythological association that accounts for the presence of the Negro. And since the palm tree is often depicted in a Trojan context, this element supports the mythological interpretation. On other Negro alabastra the stool, here empty, supports a helmet, and so the scene, originally one of arming, has become abbreviated in the process of mass production. J N

DIMENSIONS: H. 14.6 cm.; Diam. of rim 3.7 cm.; Max. Diam. 5 cm.
CONDITION: Broken and repaired.
SHAPE AND DECORATION: The shape is one of the later examples from this group: it is more ovoid and no longer has lugs. The subsidiary decoration is reduced to simple black stripes which have moved up closer to the neck. Base, neck and underside of lip slipped; surface of lip reserved.
BIBLIOGRAPHY: Sotheby's London, 20 May 1985, lot 380; Sotheby's London, 17–18 July 1985, lot 312.
LITERATURE: On the Group of the Negro Alabastra, see *ARV² 267–69; Para 352*; J. Neils, "The Group of the Negro Alabastra: A Study in Motif Transferal," *AntK* 23 (1980) 13–23, pls. 3–7; W. Raeck, *Zum Barbarenbild in der Kunst Athens im 6. und 5. Jht. v. Chr.* (Bonn 1981) 188–99; I. Wehgartner, *Attisch weissgrundige Keramik* (Mainz 1983) 118, 129–31. On the ancient view of blacks, see F. M. Snowden, *Blacks in Antiquity* (Cambridge, Mass. 1970); idem, *Before Color Prejudice: The Ancient View of Blacks* (Cambridge, Mass. 1983). On palm trees, see C. Sourvinou-Inwood, "Altars with Palm-trees, Palm-trees and Parthenoi," *BICS* 32 (1985) 125–46.

66

ATTIC ALABASTRON
IN SIX'S TECHNIQUE
Attributed to the Diosphos Painter
Ca. 500–490 B.C.
Gift of Gilbert M. Denman, Jr.
86.25.1
Youth leaning on walking stick, seated woman embracing standing youth, boy leading dog

A continuous frieze of sprightly little figures encircles the alabastron. Here the viewer, treated to a slice of life, is invited to interweave the figures thematically. There are three major compositional elements. At the left (1) a youth leans upon a walking stick, supported by his left hand and arm, which, along with his body, are wrapped in his himation. His legs are crossed; his right arm is bent at the elbow and the hand placed on his side. A long fillet hangs from this wrist and another fillet (or wreath) crowns his head. He pauses to watch (2) an amorous couple who form the focal point of the frieze. At the center a female figures sits on a *klismos*. Her hair appears to be bound up (rather than short), and she is dressed in a himation and long chiton. She gazes intently into the eyes of a youth, who approaches her from the right, and extends her arms up around his neck to draw him closer. The youth, who is nude save for a chlamys thrown over his left shoulder, advances eagerly, right leg before left, trailing behind the walking stick held in his left hand. His head is crowned by a wreath. Behind the youth, a fillet hangs at the upper border of the frieze, and down below (3) a dog facing right, but looking round, pauses as if his attention has been caught by the activity of the couple. A small boy advancing to the right, but looking round, tugs on the animal's leash with his right hand to urge his pet to move on. Might this boy shortly be of interest to (1) the alabastron's idle, young onlooker, the next figure around the vessel's cylindrical surface?

This charming genre scene is particularly striking because it is not painted in black-or red-figure, but in a third odd technique, named after Jan Six, the Dutch scholar who first studied it thoroughly a century ago. Six's technique,

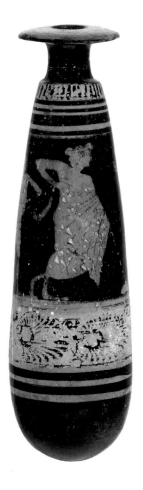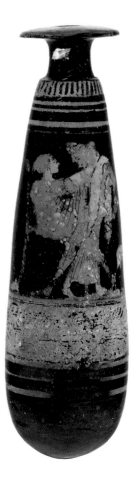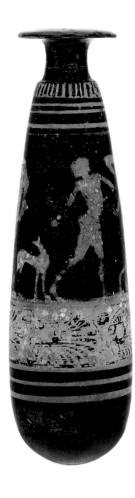

which appeared around the same time as red-figure, ca. 530–525 B.C., employs added color with incised details (both of which derive from black-figure) to create light images on a dark glazed ground, cleverly avoiding reserve. At first an avant garde experiment, Six's technique soon was relegated to minor masters who specialized in small vase-shapes. Foremost among its practitioners are the Diosphos and Sappho Painters, who also employed black-figure on a white ground and semi-outline in their work (primarily decorating lekythoi for the same workshop, now known as the Diosphos workshop).

The alabastron in San Antonio combines in one unique product individual features which are found elsewhere in the oeuvre of the Diosphos Painter (so named after an inscription on a small black-figure neck-amphora in Paris, Cabinet des Médailles 219). The Six's technique of this alabastron belongs to a rare type, in which all of the forms are added in different colors rather than some simply incised directly into the black ground. Lekythoi decorated with both variants of Six's technique have been preserved, e.g. Athens, National Museum 2262 and Columbia (Missouri), University of Missouri, Museum of Art and Archaeology 58.12. On the San Antonio alabastron, in addition to a deep tan, approximating fleshtone (or reserve), used for male figures and most other elements of the composition, a creamy white slip (resembling white-ground), applied over the tan, was introduced primarily for the flesh of the female figure and for the dog. Several things, such as the male lover's walking stick, were added in an even whiter white (now flaked and faded). Inner details are incised upon the added colors, and a few contours are defined by a reddish dilute glaze. The unusual occurrence of Six's technique on an alabastron brings to mind the fine, early example by Psiax in London, British Museum 1900.6–11.1. On Psiax' alabastron the band of Six's technique is juxtaposed with ornament in black

glaze on white-ground. The same juxtaposition occurs on the Diosphos Painter's alabastron, but here there are also stripes of plain reserve. By contrast, normally, late Archaic alabastra, including the other extant examples by the Diosphos Painter, are entirely white-ground. On white-ground alabastra of the Paidikos Group circumscribed black palmettes form the sole decoration. The Diosphos Painter also was fond of such florals, and on the San Antonio alabastron there is a row of horizontal, circumscribed black palmettes beneath the figural frieze. The hearts of these palmettes appear to have been reserved (glaze very worn in this register) and probably once were embellished with added red as is characteristic of this painter. Since the profile of the San Antonio alabastron is especially slender, this vase should date close to the beginning of the fifth century B.C.

Representations in Greek art reveal that alabastra belonged to women whereas round aryballoi were used by males, particularly athletes. While both vase-shapes were intended to hold (perfumed) oil, the alabastron followed earlier, undoubtedly expensive, models carved from alabaster. The San Antonio alabastron suggests that ceramic versions also were luxury items—specially decorated with delicate, fugitive colors. On a white-ground alabastron by the Diosphos Painter in Adolphseck, Schloss Fasanerie 16, a female figure carries another alabastron—as its round bottom dictates—suspended by strings (or leather thongs) tied around its narrow neck. Here a seated female figure holds a mirror while being handed an alabastron by another woman. This seated woman at her toilette brings to mind the amorous seated woman in San Antonio and leads one to question whether the Adolphseck alabastron simply depicts a quiet moment in the women's quarters of an Athenian home. While many such oil containers bear exotic imagery, others depict

genre scenes—often of titillating nature. The Diosphos Painter's repertory, for example, not only included Amazons, but also women (shown by themselves or in the company of men) and male homosexual encounters—replete with cock, hare and dog. The clearly suggestive figural frieze of the San Antonio alabastron requires one to ask both who the seated woman here was meant to be, and who the flask's female owner would have been. Given the secluded existence of respectable girls and wives in Ancient Athens, it is likely that, in this case, the answer to each question should be a prostitute (*hetaira*).

B C

DIMENSIONS: H. 17.5 cm.; Diam. of mouth 3.8 cm.; Max. Diam. 4.6 cm.
CONDITION: Lip, neck and body intact; bottom restored. Entire surface pitted.
SHAPE AND DECORATION: Broad, flaring mouth reserved on the upper surface; underside of mouth glazed black and decorated with a tan line. Tall cylindrical neck glazed black, inside and out. Neck set off from the long, slender body by a chamfer. At top of body, black tongues on (creamy) white-ground. The figural zone in Six's technique is bounded above by a line of (creamy) white glaze, and then by one thick and two thin bands of reserve. Another cream-colored line forms the groundline for the figures. Below the main zone a frieze of circumscribed, horizontal black palmettes on (creamy) white-ground bounded above and below by a line of black glaze and a reserved band. Below this two reserved bands. Bottom (partly restored) glazed entirely black.
ADDED COLOR: Tan for line on underside of mouth, all male figures, chitons and himations, staff of male onlooker, the chair. Creamy white for ground for tongues and palmettes, flesh of female figure, chlamys of male lover, the dog. White (now mostly flaked and faded) for line above figural zone, staff of male lover and the fillet hanging above it, tail and leash of dog. Red (dilute) for front locks of woman's hair, lower edge of her chiton's sleeve, outline of male lover's chlamys.

BIBLIOGRAPHY: Galerie Günter Puhze, *Kunst der Antike*, cat. 5 (Freiburg 1983) 22 no. 203.
LITERATURE: For Six's technique, see J. Six, "Vases polychromes sur fond noir de la period archaique," *GazArch* 13 (1888) 193–210, 281–90; and, most recently, J.B. Grossman, "Six's Technique at the Getty," *Greek Vases in the J. Paul Getty Museum* 5 (1991) 13–26; for its use on lekythoi and alabastra, see *ABL* 106–07, 235–36; for the Athens lekythos by the Sappho Painter, see *ABL* pl. 36.3. For the Diosphos Painter's Missouri lekythos, see C.H.E. Haspels, "A Lekythos in Six's Technique," *Muse* 3 (1969) 24–28; and see also *MidwesternColls* 146, no. 83, color pl. v. For Psiax's alabastron in London, see Kurtz, *AWL* 12, 116–20, pl. 1. 3a-c and *ARV²* 8,13. For the Diosphos Painter and white-ground alabastra, see Mertens, *AWG* 95–100. For the alabastron in Schloss Fasanerie, see *CVA* (Adolphseck 1) pl. 15 and *ABV* 703,24*bis*. On the Diosphos Painter, see also *ABL* 96–107, 232–41, and C. H. E. Haspels, "Le Peintre de Diosphos," *RA* 1972, 103–09; *ABV* 508–11,702–03, 716; *ARV²* 300, 303–04, 973; *Para* 60–61. On representations of alabastra and aryballoi, see H. Gericke, *Gefässdarstellungen auf Griechischen Vasen* (Berlin 1970) 72–77, 107–08, 112–14. For the depiction of respectable women versus hetairai, see D. Williams, "Women on Athenian Vases: Problems of Interpretation," in A. Cameron and A. Kuhrt eds., *Images of Women in Antiquity* (Detroit 1983) 92–106; and on the erotic connotations of the alabastron for both hetairai and wives, see E. Keuls, *The Reign of the Phallus* (New York 1985) esp. 119–22, 170–73, 256–57, and, 188–91 for the depiction of prostitutes.

67

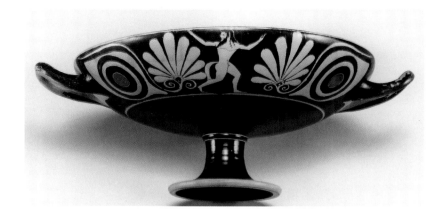

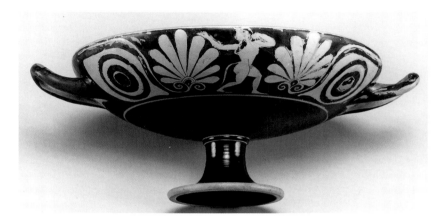

ATTIC RED-FIGURE CUP
Attributed to Oltos [H.A. Cahn]
Ca. 510 B.C.
Gift of Gilbert M. Denman, Jr.
86.134.57
Interior: Satyr
A and B: Dancing satyr
between palmettes and eyes

In early red-figure the vast majority of vases produced for export were drinking cups. They were frequently decorated on the exterior with large eyes, or palmettes, or a combination of the two. This cup, known by the name "palmette-eye," is one that transposes the motifs by placing the floral ornament between the eyes rather than at the handles, thus obscuring the mask-like effect of normal eye-cups. Oltos, in his repertoire of over one hundred cups, painted six other palmette-eye cups early in his career, but the San Antonio kylix is thus far the only extant late example.

The figural decoration consists of dancing satyrs. The one in the tondo, framed by a reserved circle, moves to the left with his arms raised to shoulder level, and possibly carries a *krotalon* (castanets) in his left hand. The two on the exterior cavort to the right, but look back to the left. Typical of Oltos are the poses (frontal upper body with profile head and legs), the mannered gestures, the sparsity of anatomical details, the elongated feet, and the uneven palmettes. J N

DIMENSIONS: H. 11.8 cm.; Diam. of lip 27 cm.; Diam. with handles 33.7 cm.; Diam. of foot 9.7 cm.
CONDITION: Broken and repaired. Abrasion on satyr in tondo, and on Side B of exterior.
SHAPE AND DECORATION: Type A kylix with torus molding between two reserved grooves at juncture of stem and bowl, and torus foot. Stem of palmettes attached to eyebrow line. Reserved tondo circle, ground-line on exterior, area between handles, edge of lip, outer edge of foot, and interior of stem. Incision for hair contour of satyrs and four concentric circles of eyes. Traces of the letter sigma behind the head of the satyr on Side A.
ADDED COLOR: Red for pupils of eyes.
BIBLIOGRAPHY: Münzen und Medaillen, Basel, Sonderliste R, 1977, no. 46;

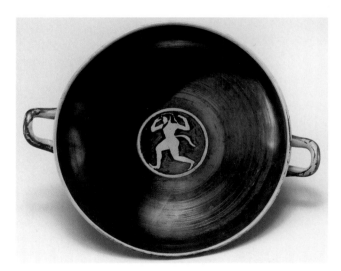

Sotheby's London, 12–13 December 1983, lot 364.
LITERATURE: For palmette-eye cups, see *ARV²* 49–50; *Para* 326; *ARFV* 55. For Oltos, see *ARV²* 53–67; *Para* 326–28.
PARALLELS: The satyrs on the San Antonio cup find close parallels on an Oltan cup in Berlin: F 4220; *ARV²* 61,76; A. Bruhn, *Oltos* (Copenhagen 1943) fig. 25.

ATTIC RED-FIGURE PELIKE
Attributed to the
Nikoxenos Painter [I. Scheibler]
Ca. 500–490 B.C.
Gift of Gilbert M. Denman, Jr.
86.134.71
A: Peleus and Thetis
B: Young warrior

Peleus wrestles with his future bride, the sea-nymph Thetis, as she tries to flee toward the right. The nude, bearded hero, his thick hair crowned with a wreath, has locked the goddess firmly about the waist with his left arm and holds her tightly with his right hand. The goddess barely resists and, in the Archaic manner, looks unperturbed. The signs of her metamorphosis into lion or snake or flame which are often depicted on other vases are here absent. A solitary palm tree witnesses the struggle, two long vines with red fruit descending from below the fronds. A similar vine spirals behind Thetis. The goddess wears a wreath like Peleus' and a long chiton with one end hanging from her left shoulder.

On Side B, a youthful warrior runs off to the right while turning to look back, as if pursued by an enemy. His low-crested helmet has a peak across the forehead, a thin curving cheekpiece, and leaves the ear exposed. The rest of his armor consists of an undecorated cuirass, short skirt, greaves with a spiralling 'eye'-motif, and a spear. His round shield has as its device a dancing satyr in silhouette. Yet another vine winds above and below the shield. A thin Doric column with abacus across the capital stands at the right.

The wrestling match of Peleus and Thetis is one of the few mythological subjects which remained consistently popular in Attica, from black-figure of the early sixth century to red-figure of the fourth. Naturally there were periods when it was especially favored and inspired the finest painters to imaginative reinterpretations. Red-figure of the late Archaic was one such period, and though Beazley and his disciples wrote rather disparagingly of our painter, his simple two-figure version has a crude vigor and monumentality. Peleus' nudity and his beard are both unusual, the combination of the two even more so, but they emphasize the aspect of the struggle as a wrestling

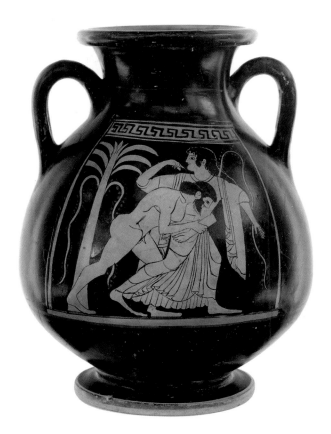

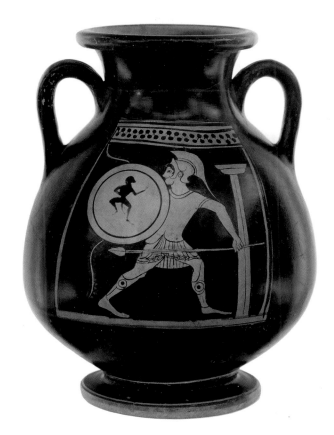

match, without any hint of the eroticism which will enter some later versions. That Thetis' metamorphoses are nowhere indicated is also unusual, but is especially characteristic of painters contemporary with or slightly later than ours, such as the Göttingen Painter and Berlin Painter. The palm tree, more often in combination with an altar but occasionally alone, as here, occurs especially on black-figure vases contemporary with ours, to indicate the setting as a sanctuary of Thetis near the seashore.

The isolated running warrior on the reverse of our vase gives the impression of an excerpt from a battle scene of a type popular on vases of this period. The dancing satyr seems at first an unlikely shield insigne, but it occurs on several contemporary vases, including a famous white-ground plaque from the Akropolis, where it and the shield are shown foreshortened in three-quarter view.

The distinctive heads of the figures on the San Antonio pelike, especially the heavy jaws, large profile eyes and lumpy features, suggest an attribution to the Nikoxenos Painter. He was trained and worked extensively in black-figure, and Beazley considered his red-figure work distinctly inferior to the black. Yet he worked on a variety of shapes in red-figure and, in Beazley's view, was the master of a far more refined artist, the Eucharides Painter. Of two pelikai assigned by Beazley to the Nikoxenos Painter, one in Amsterdam (Amsterdam inv. 1313) is similar in shape to ours and has the same pattern of connected dots which we find above the panel on Side B framing the other three sides of the panel. The meander above the scene on Side A of the San Antonio pelike occurs in this position on both sides of a pelike in Athens (Athens 1425) described by Beazley as akin to the Nikoxenos Painter. The unmotivated vine, as on Side B of our vase, also accompanies a warrior on the Athens pelike. HAS

DIMENSIONS: H. 27.3 cm.; Diam. of mouth 13.1 cm.; Max. Diam. of body 21 cm.; Diam. of foot 12.9 cm.
CONDITION: Broken and repaired. Area below A/B handle restored.
SHAPE AND DECORATION: Flaring mouth with rounded lip; round handles glazed inside and out; spreading torus

foot, the outside unglazed, with a red stripe covering the top half. The panel on each side is framed by plain reserved bands on three sides and only above bears ornament, dots connected by thin lines, between black bands, on Side B, a meander between black lines on Side A. Red bands frame the main composition on each side, and appear across the neck and below the reserved band under each panel.
ADDED COLOR: In addition to the ornament, red is also used for the wreaths of Peleus and Thetis and the fruit on the vines.
BIBLIOGRAPHY: Galerie Günter Puhze, *Kunst der Antike* cat. 4 (Freiburg 1982) 20, no. 209.
LITERATURE: On the struggle of Peleus and Thetis, see X. Krieger, *Der Kampf zwischen Peleus und Thetis in der griechischen Vasenmalerei* (Münster 1975) esp. 55–56 (iconography of Peleus), 73–74 (scenes with no indication of metamorphosis), 78–79 (palm tree). For the plaque with a satyr as shield device, Akr. 1037 (*ARV²* 1598), see *Graef-Langlotz* II pl. 80. For the Nikoxenos Painter, see *ARV²* 220–24; M. Robertson, "A Fragment by the Nikoxenos Painter," *AJA* (1962) 311–12; W. Hornbostel, *Aus Gräbern und Heiligtümern. Die Antikensammlung Walter Kropatschek* (Hamburg Museum exh. cat. 1980) 113–15, no. 67. For the pelike in Amsterdam, inv. 1313 (*ARV²* 221,12), see *CVA* (The Hague, Scheurleer) pl. 3, 3–4. For the pelike Athens 1425 (*ARV²* 223,6), see *CVA* (Athens 2) pl. 8, 2 and 4.

69

ATTIC RED-FIGURED
OINOCHOE
Attributed to the Harrow Painter
[D. Kurtz, M. Robertson]
Ca. 480–470 B.C.
Gift of Gilbert M. Denman, Jr.
86.134.58
Young warrior

This beardless youth has paused amidst arming in preparation for battle. His head, with its thick black hair bound up in a fillet, is turned toward the left. A cloak is draped over his upper right arm. He grasps his helmet in his right hand, by the bottom of the cheekpieces, just beneath the nose guard and extends the casque outward in the direction he is looking. This unusual and elaborate model of a Corinthian helmet has an ear-opening as well as linear decoration on the cheekpiece and vo-

lutes on its crown. Separate strands in the horsehair crest are suggested by strokes of dilute glaze along the outer edge. The youthful warrior grips a spear in his left hand. This weapon, held vertically, overlaps his left arm, which is bent up sharply at the elbow; (the point of the spear interrupts the ornamental tongue pattern at the base of the vessel's neck). He wears a composite corselet, over a short chiton. The corselet is decorated with a row of dots along the neckline, starbursts at top center and on the right shoulderpiece, a pattern of triple dots on its midsection and a horizontal band of zigzags above the protective double tier of leather flaps in its skirt. The left shoulder-piece (its tip is preserved above a restored missing section of the vase), which has not yet been fastened in place, stands up straight. His sheathed sword, of which the hilt alone can be seen behind his left hip, is supported by a pair of baldric straps slung diagonally across his corselet.

This youth is outfitted with the lightened body armor current in hoplite panoplies of the early fifth century B.C. Among the active scenes of warriors arming popular in vase-painting, a cup by Douris in Vienna (Kunsthistorisches Mus. 3694) provides well-preserved examples of still-unfastened shoulder-pieces on a composite corselet and of a helmet with ear-openings held by its cheekpieces. The warrior on the San Antonio oinochoe, a lone figure standing quietly, silhouetted directly against the vessel's black-glazed ground rather than set within a panel, ascribes to a common decorative convention found particularly on amphorae as well as on small vases during the Late Archaic Period. A relevant early example is a bearded red-figure warrior, identified by inscription as the hero Achilles, on a black-glazed amphora in London (BM E 258) by Oltos of ca. 515–510 B.C. While the youthful warrior of the San Antonio oinochoe might have been intended simply as a contemporary hoplite, his idealized, beardless beauty, quiet mood and fine armor have undeniably heroic associations, anticipating the handsome beardless Achilles, outfitted with composite corselet, short chiton, cloak and spear, on the name-piece of the Achilles Painter, a Classical black-ground amphora in the Vatican (Vatican 16571) of ca. 460–450 B.C.

The Achilles Painter is a pupil of the
Berlin Painter—the supreme master at
silhouetting red figures on black-
ground vessels. The artist of the San
Antonio oinochoe, the Harrow
Painter, also is related to the Berlin
Painter, but as contemporary imitator
rather than pupil. This shape of oino-
choe, with trefoil mouth and high
ribbed handle, happens to have been
employed by the Berlin Painter him-
self. Although large pots such as col-
umn-kraters have been attributed to
the Harrow Painter, he is at his best on
small black-ground vases, for which he
prefers single figures in open poses ac-
companied by space-filling props. The
boy on the painter's name-piece, the
oinochoe at Harrow School, holds a
hoop and a stick in outstretched hands.
Pehaps the goddess Athena, on an
oinochoe in Copenhagen, armed with
a spear and holding her Attic helmet in
her extended left hand, is the single red
figure by the Harrow Painter most
comparable to this young warrior on
the wine pitcher in San Antonio. The
youth of this small vessel is delicately
painted, with a characteristically exten-
sive use of dilute glaze, not merely on
his corselet, fine folds on his short chi-
ton, and inner anatomical markings on
his neck. He is one of the Harrow
Painter's finest creations. B C

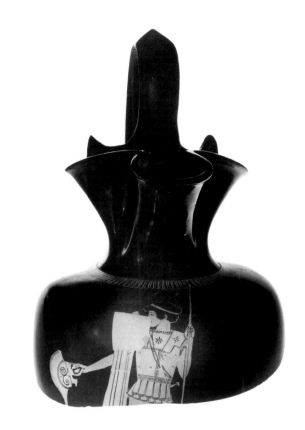

DIMENSIONS: Preserved H. 11.8 cm.;
Diam. at shoulder 12.1 cm.
CONDITION: Lower part of profile of
warrior's face, his right shoulder and an
adjacent section of black ground missing;
lower portion of oinochoe missing.
SHAPE AND DECORATION: Shape 1; tre-
foil mouth glazed black outside and in.
High, ribbed vertical handle glazed black.
Ridge at base of neck, beneath the black
tongues. Body glazed black.
ADDED COLOR: Red for baldric straps.
BIBLIOGRAPHY: *Palladion. Antike Kunst*
(Basel 1976) 34, no. 31.
LITERATURE: On armor see A. Snodgrass,
Arms and Armor of the Greeks (Ithaca, NY,
1967) 90–91, 93–94. For the Douris cup
Vienna, Kunsthistorisches Museum 3694,
see *ARV²* 427,3, 1652; *Para* 374; *Beazley
Addenda²* 235; *ARFV* fig. 281. For the
Oltos amphora, London, British Museum
E 258, see *ARV²* 54,4; 1622; *Beazley Ad-
denda²* 163; *GuH* 202, fig. 275. For the
Achilles Painter amphora Vatican 16571,
see *ARV²* 987,1, 1676; *Para* 437; *BA²*
311; J. Boardman, *Athenian Red Figure
Vases, the Classical Period, a Handbook*
(London 1989) 61 and fig. 109. On the

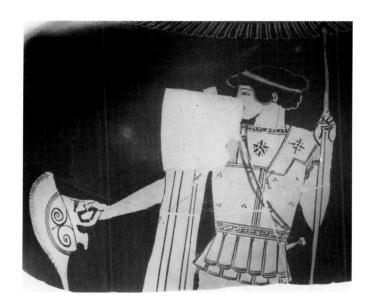

Berlin Painter, see the San Antonio
oinochoe, Cat. No. 70. On the Harrow
Painter and his name-piece, Harrow on
the Hill, Harrow School Museum 56, see
J. D. Beazley, "Two vases in Harrow,"
JHS 36 (1916) 128–29, 132–33, fig. 6 and
pl. VII, fig. 2; *ARV²* 272–78; *Para*
353–54; *Beazley Addenda²* 206–07. For

the Copenhagen oinochoe, see *ARV²*
276,78; T. Melander, *Thorvaldsens græske
vaser* (Copenhagen 1984) 19, fig. 8. On
the Harrow Painter see also *ARFV* 112
and figs. 173–75; M. Robertson, "Beazley
and After," *MüJb* (1976) 38–39 and
33–34, figs. 5–7.

ATTIC RED-FIGURE OINOCHOE
Attributed to
the Berlin Painter [J.D. Beazley]
Ca. 490–480 B.C.
Gift of Gilbert M. Denman, Jr.
86.134.59
Youth and woman

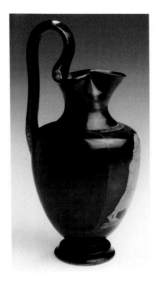 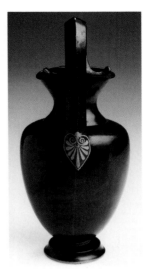

A young wreathed man, whose cheeks barely show the beginnings of a beard, stands in the manner of an Athenian suitor in front of a seated *hetaira*. He leans on a knotty stick, in one hand a red flower, in the other a purse. To show the anatomy of his chest marked in dilute paint, the painter has turned his upper body slightly to the onlooker. The woman's short-sleeved chiton—much in fashion during these years—is shown over her high-set breasts in brown dilute glaze, whereas the pleats covering her ankles are indicated with black relief lines. Her mantle is neatly wrapped around her shoulders and left elbow. She must have checked her looks in the mirror, now put back on the wall, shortly before the youth's arrival. She also has put on jewelry and tied up her hair with a fillet. In her right hand she might have held a sprig or another flower. As attractive as her own appearance is that of the cushioned chair, a *klismos*. The eyes of the two persons meet indirectly at the flower.

With this picture the Berlin Painter for once departs from his usual imagery, although the subject is rather popular with his colleagues who, like Makron, adorned the friezes of several cups with two or three pairs of *hetairai* and their customers. Purse in hand, our young man is on the brink of buying or negotiating the favors of a courtesan. He tries to ease the situation by offering her a fragrant flower first.

The San Antonio oinochoe, unpretentious as it may appear, shows the Berlin Painter, one of the dozen outstanding vase-painters of the first quarter of the fifth century B.C., in the best years of his career. AL-H

DIMENSIONS: H. with handle 28.9 cm.; H. to lip 23.2 cm.; Diam. of mouth 8.9 cm.; Diam. of body 12.9 cm.; Diam. of foot 7.4 cm.
CONDITION: Put together from fragments, minor pieces missing. Little relief-contour for the uncovered parts of the figures. Clear distinction in the glazing between the front and the back. *Miltos* underfoot.
SHAPE AND DECORATION: Oinochoe Type I with three-edge handle and rotelles. The San Antonio vase is one of four known oinochoai of Type I painted by the Berlin Painter. Closest to ours is Berlin 1965.5; the two form a pair in shape and size, in decoration-schemes, ornamental and figurative, and in the complementary subjects. The potter's work is still the same in a later amphora and is clearly different from the potter's work of the San Antonio oinochoe by the Harrow Painter (Cat. No. 69). Under the collar between neck and shoulder, restricted to the front, is the Berlin Painter's typical egg-pattern. As a base for the figures, a meander to right. On the lower handle-attachment, a circumscribed pointed palmette with relief-contour.
ADDED COLOR: Red for wreath and *tainia*, for flower and the object in the woman's hand, as well as for her jewelry.
BIBLIOGRAPHY: *Para* 345; *Beazley Addenda²* 196. *SouthernColls* 160–61, no. 63 and frontispiece (J. Neils). *The San Antonio Museum of Art: The First Ten Years* (San Antonio 1990) 65 (reversed).
LITERATURE: The London oinochoe E 513 quoted in *Para* is now fully figured in Kurtz (see below) pl. 59.a (68); mentioned in *JdI* 103 (1988) 103; 124, H1 (M. Meyer, see below). For the Berlin Painter, see C.M. Cardon, "The Gorgos Cup," *AJA* 83 (1979) 169–73; G. F. Pinney, "The Nonage of the Berlin Painter," *AJA* 85 (1981) 145–58; D.C. Kurtz, "Gorgos' cup: an Essay in Connoisseurship," *JHS* 103 (1983) 68–86. For other vases by the painter not in Beazley's lists, see R. Lullies, in E. Berger and R. Lullies eds., *Antike Kunstwerke aus der Sammlung Ludwig* (Basel 1979) 108–11, 115, 212–28; C.M. Cardon, *GettyMusJ* 6–7 (1978–79) 131–38; H. Bloesch ed., *Griechische Vasen der Sammlung Hirschmann* (Zurich 1982) 58–59 (C. Isler-Kerényi); M. Robertson, "The Berlin Painter at the Getty Museum and Some Others," in *Greek Vases in the J. Paul Getty Museum* 1 (1983) 55–72; see also *GettyMusJ* 13 (1985) 169, nos. 21–22; M. Kotansky et al., "A Fragmentary Hydria by the Berlin Painter," in *Greek Vases in the J. Paul Getty Museum* 2 (1985) 75–78; D.C. Kurtz, *The Berlin Painter* (Oxford 1983). On the potter for the Berlin Painter, see J. R. Green, "Five Potters. Some Classes of Oinochoe of the First Half of the Fifth Century B. C.," *AA* (1978) 263. For the oinochoe Berlin 1965. 5, see *Para* 345,184*bis; Beazley Addenda²* 196; H. Hoffmann, *Collecting Greek Antiquities* (New York 1971) 125; W. Heilmeyer et al., eds., *Antikenmuseum Berlin* (Berlin 1988) 107 no. 7. For the potter's work in later vases by the Berlin Painter, cf. C. Isler-Kerényi, "Ein Spätwerk des Berliner Malers," *AntK* 14 (1971) 25–26. For the subject, see M. Meyer, "Männer mit Geld," *JdI* 103 (1988) 87–125, with earlier references. An example of Makron's cups is Toledo 72. 55, not in *ARV²*; *CVA* (Toledo 1) pl. 54; the pair on A, at left, is quite comparable to the one by the Berlin Painter; also the *hetaira's* chiton is drawn in a similar way. For the flower-offering cf. G. Koch-Harnack, *Erotische Symbole* (Berlin 1989) 72–83, 177–84.

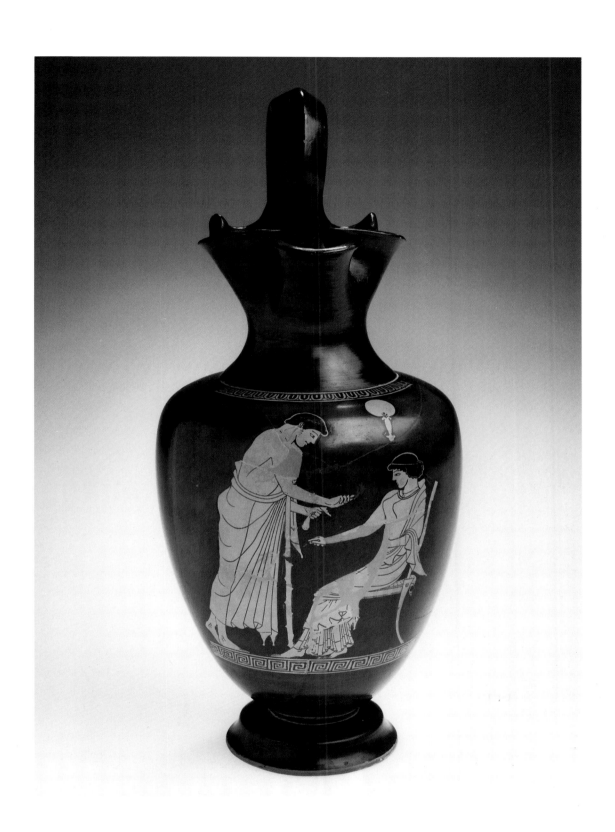

AN INTRODUCTION TO THE LATER
ATTIC RED-FIGURE VASES

Traditionally the Attic red-figure vases from the Late Archaic period (ca. 530–480 B.C.) have received more attention than those produced in the Early Classical and Classical periods (480–400 B.C.). This is due in part to the fact that the quality of drawing is generally better on the earlier vases and because in the early years great strides were made in the perfection of the technique and there were many important artists in whose traditions the later artists worked. There are, however, later masterpieces which rival anything produced earlier, and the wide variety of types of scenes found on the later vases is a fertile field for scholar and connoisseur alike that has not yet been fully explored. The years ca. 490–480 B.C. have long been recognized as a watershed for iconography, since it is then that many new scenes start to appear in the vase-painters' repertoire, some probably as a result of Athens' success in the Persian Wars. It is only after 480 B.C., for example, that a wide variety of wedding scenes appears on red-figure vases.

The collection in the San Antonio Museum of Art includes a wide and generous selection of these later vases which, although not yet representative of every major stylistic school, shape, and iconographic scene, nevertheless presents an important body of material. It should be no surprise that some areas are not represented, since the diversity and scale of this material allow only the largest and most important collections, such as those in the Metropolitan Museum of Art in New York, the Louvre in Paris, or the British Museum in London, to approach being representative.

In general the later red-figure painters tended to specialize in pots or cups, and the vast majority of the fifth-century painters can be connected in some fashion with one of several stylistic schools. One of the most important was that of the Berlin Painter (Cat. No. 70), an artist who started his career in the Late Archaic (ca. 500 B.C.) and continued well into the Early Classical (ca. 460 B.C.). He had three important students, the Providence Painter, Hermonax, and the Achilles Painter, the last of whom continued this workshop tradition along with his student, the Phiale Painter, until ca. 425 B.C. Representative of this master's school is an interesting Nolan amphora in his Late Manner, a small lekythos attributed to 'Near the Providence Painter', and a full-sized lekythos from the workshop of the Achilles Painter and Phiale Painter (Cat. Nos. 76, 78, and 89). Nolan amphorae, which take their name from the site not far from Pompeii where many of them were found, and lekythoi were the two most popular shapes in this workshop tradition. Earlier Nolan amphorae typically have a single figure on either side, a scheme the Berlin Painter loved, and which is found on the San Antonio Nolan in his Manner (Cat. No. 76) with a Thracian woman pursuing Orpheus.

Another tradition which continued throughout the fifth century drew its impetus from the Archaic style, traits of which, such as stacked folds, its painters continued to use. They are known

as the Mannerists, and the best of the first generation is the Pan Painter. There is no vase from this tradition in San Antonio, but a column-krater with dancing komasts (Cat. No. 71) by Myson represents its start, for the Mannerists are thought to derive from Myson, a Late Archaic pot painter.

Several other traditions have their origin in the Early Classical period. Most important is that of the Niobid Painter, who was succeeded in the next generation by Polygnotos and his many followers. This school preferred large vases, and a number of their scenes are influenced by monumental wall painting. The scale of the figures on a fragmentary volute-krater by the Painter of the Woolly Satyrs (Cat. No. 80), an artist related to the Niobid Painter, gives a good sense of the monumentality of the figures and the vases, as does a calyx-krater by the Curti Painter (Cat. No. 91), one of the followers of Polygnotos.

Some of the pot painters specialized in decorating a particular shape, and there are several good examples. The Bowdoin Painter, an Early Classical artist, specialized in lekythoi, and two with Nike (Cat. Nos. 82 and 83) are typical. The Naples Painter, a Classical artist, preferred column-kraters, and his vase of this shape (Cat. No. 88) with a marvellous scene of Orestes at Delphi is one of the most interesting vases in the collection.

The cup had its greatest popularity in the Late Archaic period, and the great names associated with it are Oltos (Cat. No. 67), Epiktetos, Douris, Makron (Cat. No. 73), Onesimos, and the Brygos Painter (Appendix B, No. 12). Some of the later artists continued in their traditions, such as the Euaion Painter who was a follower of Douris (Appendix B, Nos. 2, 3 and 13) and the Briseis Painter (Cat. No. 74) who was a Brygan. The most important school of Early Classical and Classical cup painters, however, was that of the Penthesilea Painter (Cat. Nos. 85 and 87) and his followers. Their production of cups often approached an assembly line mentality, for often more than one painter worked on the same vase. This is the case with Cat. No. 87 on which the tondo (center of the inside of the cup) is by the Penthesilea Painter and the outside is by the Painter of Brussels R 330.

The Eretria Painter, although mainly known for his exquisite drawing on small vases, such as oinochoai and squat lekythoi, was primarily a cup painter, and his fine kylix in San Antonio with scenes of the palaestra and music (Cat. No. 94) is one of the better examples of his stock work. He, along with the Meidias Painter, heralded in a new style which centered on a rich, ornate, carefree world of women and Aphrodite. This style has often been thought to represent escapism from the horrors of the Peleponnesian War in which Athens was involved against Sparta and her allies. No good example of this style, which greatly influenced one of the major movements of late fifth and early fourth-century red-figure painters, is found in San Antonio, although the multi-leveled composition of a calyx-krater in the Manner of the Kadmos Painter (Cat. No. 95) gives an idea of how many of their scenes were arranged. The painters of the other main trend retained the simpler, traditional style of figures. A bell-krater by the Nikias Painter with athletes (Cat. No. 96) is a good example.

The latest Attic red-figure vase, a bell-krater by the Painter of London F 64 (Cat. No. 97) of ca. 380 B.C., shows how added colors, such as white and gilt relief detail, played a major decorative role on the latest red-figure. It also demonstrates with its interesting scene of a centauromachy that, although the quality of drawing and range of subject matter drop off substantially in

the fourth century, vases of interest and quality are still produced until ca. 320 B.C., when Athens no longer made red-figure vases in any quantity.

But style is only one area in which a colleciton should seek to be representative. Subject matter is another, and one in which the San Antonio collection excels for the later Attic red-figure. Not only are many of the standard scenes of the Early Classical and Classical periods represented, such as symposium (Cat. No. 130), Dionysiac (Cat. No. 86), pursuit (Cat. No. 93), libation (Cat. No. 89), and athletic (Cat. No. 96), but there is a good range of mythological subject matter, including both some of the frequently depicted myths, such as the Mission of Triptolemos on a lovely hydria by the Painter of the Yale Oinochoe (Cat. No. 84) and the struggle of Peleus and Thetis on a pelike by the Nikoxenos Painter (Cat. No. 68) as well as rare and unusual subjects such as Iris being surprised by satyrs on a cup by the Penthesilea Painter (Cat. No. 85) and Athena pursuing the daughters of King Kekrops on a splendid column-krater by the Orchard Painter (Cat. No. 77). Add to these rare versions of other well known scenes, such as the dead Minotaur on a fragmentary cup by the Briseis Painter (Cat. No. 74).

Many of the most important shapes are also represented. For example, there are the four major types of kraters—column, volute, calyx, and bell (Cat. Nos. 71, 80, 91, 97 respectively)—and various types of cups, including the stemless cup (Cat. No. 85) which was primarily an Early Classical and Classical shape. Several of the vases represent rare shapes for red-figure: the plate with a man's head in the tondo (Cat. No. 90) and the oinochoe of Type V-A by the Florence Painter (Cat. No. 86). The dainty alabastron by the Stieglitz Painter (Cat. No. 79) would be a welcome example of this shape to any collection, and the janiform kantharos with back-to-back heads of a negro and Herakles (Cat. No. 130) is a good example of the type of plastic vase known as 'Head Vases'. This is not to say that every shape is represented, for the collection lacks one of the wedding vases, an Attic loutrophoros or lebes gamikos for example, but overall there is a good selection.

The later red-figure vases, then, form an important body of material that well represents the variety of styles, scenes, and forms used in the final three-quarters of the fifth century B.C. It is one of the strong points of the collection in San Antonio, and a look at this material will be rewarding for student, scholar, and layman alike.

JOHN H. OAKLEY
College of William and Mary in Virginia
Williamsburg, Virginia

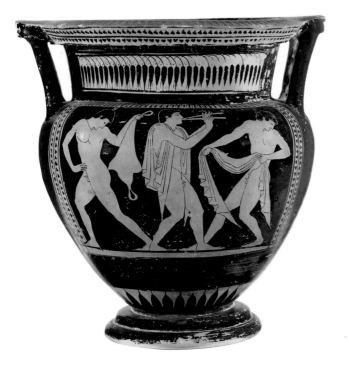

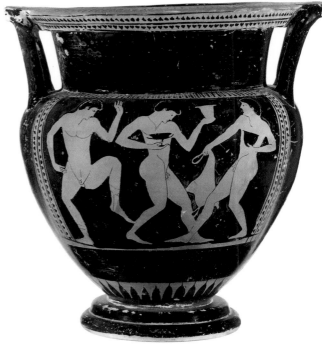

71

ATTIC RED-FIGURE
COLUMN-KRATER
Attributed to Myson
Ca. 490–480 B.C.
Gift of Gilbert M. Denman, Jr.
86.134.61
A and B: Komos

The painter Myson specialized in larger
pots, in particular the column-krater,
and one of his favorite subjects was the
komos. This vase shows the common
scheme of three revelers per side. On
Side A the first is nude and moves to
the left clutching a wineskin in his left
hand, the second, a draped aulist, walks
to the right with his double pipes raised
to his lips, and the third is posed hold-
ing his mantle in front of his body. On
the reverse the nude komasts are more
clearly concerned with drinking. The
first, wearing boots, is dancing with his
left arm and leg raised, the second
holds aloft two cups, a black kylix and
a reserved skyphos, while the third car-
ries both a wineskin and a black sky-
phos. Such scenes of male revelry are
naturally appropriate to a vase used for
the mixing and serving of wine. J N

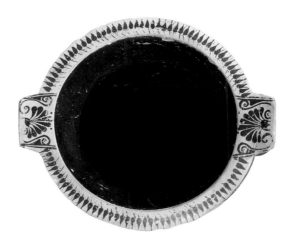

DIMENSIONS: H. 39.5 cm.; Diam. of rim
31.9 cm.; W. with handles 36.3 cm.;
Diam. of foot 18.3 cm..
CONDITION: Body unbroken; neck bro-
ken and repaired. Abrasion on foot, neck
and mouth. Two holes indicating an an-
cient repair are visible on the thighs of
the left-hand reveler on Side A. In firing,
the vase has settled to one side.
SHAPE AND DECORATION: Foot in two
degrees. The accessory ornament is all in
silhouette: on the upper surface of the
rim a dotted chain of lotus-buds like that

which appears on the neck of Side A;
palmettes framed by scrolls on the handle
plates, a row of ivy leaves on the sides of
the rim and the sides of the pictures,
tongues above the pictures, and rays at
the base.
BIBLIOGRAPHY: Sotheby's New York,
10–11 June 1983, lot 61a; Sotheby's New
York, 8 June 1984, lot 22.
LITERATURE: For Myson, see *ARV²*
237–42; *Para* 349; *ARFV* 112. A mono-
graph on Myson and Mannerist painters
by L. Berge is forthcoming.

ATTIC RED-FIGURE CUP
Attributed to
the Eucharides Painter [J.R. Guy]
Ca. 490–480 B.C.
Gift of Gilbert M. Denman, Jr.
86.134.60
Interior: Iris at an altar

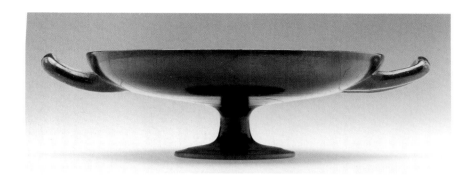

The goddess Iris, messenger of the
gods, stands beside a flaming altar,
looking back over her right shoulder.
She is dressed in a long pleated chiton
with a mantle draped over the right
shoulder and has her hair bound up in
a fillet. Her broad wings, decorated
with dots above the feathers, spread out
to fill the cup tondo. Her long *kery-
keion*, the token of office that she shares
with the other divine messenger, Her-
mes, virtually bisects the tondo from
left to right. Usually in such scenes, Iris
holds out a phiale or oinochoe to pour
a libation on the altar, but here the ves-
sel has been replaced by another of her
attributes, the folded writing tablet.
The practise of sending messages in
such a folded wooden *pinax* is attested
as early as Homer (*Iliad* 6.169), in the
tale of Bellerophon.

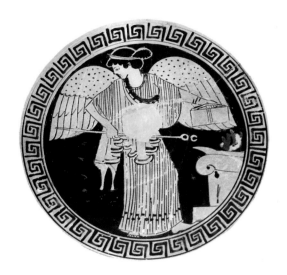

 In the field below Iris' right wing
runs the word *kalos*, but there does not
seem to have been a proper name to go
with it. The exterior of the cup is
undecorated.

 The Eucharides Painter was a versa-
tile artist of the late Archaic period
who, like his teacher the Nikoxenos
Painter (cf. Cat. Nos. 55 and 68), used
both black- and red-figure to decorate
a variety of shapes. Most of his cups
are, like this one, decorated inside only.

 HAS

DIMENSIONS: H. 7.7 cm.; Diam. of rim
21.1 cm.
CONDITION: Broken and mended from
fragments. A circular area in the middle
of the tondo is missing.
SHAPE AND DECORATION: Kylix with
horizontal handles even with the rim.
There is a continuous curve from rim to
foot, with a slight step in the foot.
ADDED COLOR: Red for *kalos* inscription,
flames above the altar, and streaks
(blood?) on the altar.
BIBLIOGRAPHY: Sotheby's London, 13–
14 July 1981, lot 275; *LIMC* V 745, s.v.
Iris, no. 22 and pl. 486.

LITERATURE: On the iconography of Iris
see *LIMC* V 741–60 (A. Kossatz-Deiss-
mann). For other representations of Iris
holding a writing tablet cf. the vases listed
there as nos. 16, 29, 34, and 35, all of the
late Archaic and early Classical periods.
On the Eucharides Painter, see *ARV²*
226–32; *ABV* 395–98; *Para* 347–48. The
name Eucharides occurs in a second kalos-
inscription on a hydria, Malibu
86.AE.227; *ARV²* 1637,43*bis*; *Para*
343,43*bis*; *Beazley Addenda²* 199.

73

ATTIC RED-FIGURE CUP
Attributed to Makron [H.A. Cahn]
Ca. 480–470 B.C.
Gift of Gilbert M. Denman, Jr.
86.134.172
Interior: Boy
A and B: Boy seated and youths

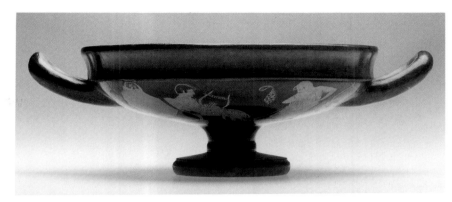

All three pictures revolve around the
courting of boys. While on the outside
each boy is admired by two youths
who rest longingly upon their staffs, the
boy in the tondo is portrayed alone.
Muffled in his coat, he stands in front
of a stool covered with a colorful cush-
ion. The stool is very similar to the one
which decorates, in place of an orna-
ment, the space under one handle.

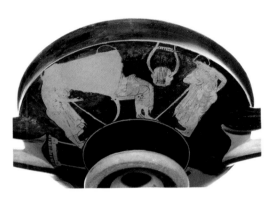

On Side A, a seated boy, whose back
does not touch the *klismos*, has just
passed the *plectron* through the cords of
the lyre. The lines hanging from the
plectron might indicate some spare
strings for the lyre. A second lyre hangs
behind the listening youth, and a net-
bag filled with marbles or dice hints at
the youthful age of the *eromenos* (be-
loved youth). Black dots similar to
those representing the marbles are re-
peated on the cushion under the lyre-
player. A third and fourth lyre are sus-
pended on the wall on Side B and in
the interior. Typical instruments of
young boys (see the San Antonio cup
by the Eretria Painter, Cat. No. 94),
the lyres are seen from the flat side,
where the seven strings are discernible
in their total length.

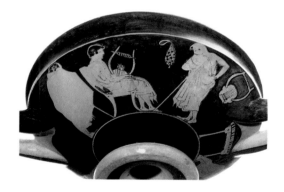

The San Antonio cup belongs to a
group of small and mostly late cups, of
type B or type C, which Makron
painted with one figure inside and
three on each frieze. He often chose as
a subject boys courted by youths or
men, who more or less openly display
their wishes. Depictions range from a
quiet talk to music-listening, from an
agitated run to the offering and ex-
changing of hares, flowers or other
gifts. A L–H

DIMENSIONS: H. 9.5 cm.; Diam. of rim
21.3 cm.; Diam. of foot 8.4 cm.
CONDITION: Put together from frag-
ments. Parts in A and B missing. Worn
surface. All figures contoured by relief-
line, except for the hair.
SHAPE AND DECORATION: Kylix of type
C with a relatively small black band of
1.2 cm. underfoot. In his cup-lists, Beaz-
ley does not usually make a distinction of

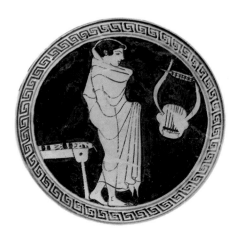

types. For the three-hundred odd cups he
assigns to Makron only two are lipped
cups: ARV^2 465,94–95. Other type C-
cups are: ARV^2 467,127 & 129 and
ARV^2 472,211; 1654; *Para* 378; *Beazley
Addenda²* 120 = H. Bloesch, *Formen attis-
cher Schalen* (Berlin 1940) 132, nos. 17–19.
Also of type C: ARV^2 463,51.1654 and
463,52. D. von Bothmer "Notes on
Makron," in: D.C. Kurtz and B.A.
Sparkes, eds., *The Eye of Greece. Studies in
the Art of Athens* (Cambridge 1982) adds
one more: 35,95B (compare 34,68B and
95,95A). Only cups of type B are signed
by the potter Hieron, with whom
Makron had had a life-long partnership:
ARV^2 481–82, 1654. There is possibly a
signature on a handle of a type C-cup:
von Bothmer 45, 47–48. I would opt for
Hieron as the potter also of type C cups
for another reason: the position of the
handles, seen from above (i.e. left handle
"higher" up than the right one) is a hall-
mark of Hieron's potting and is repeated
in this characteristic way on both types
(compare our cup with Type B cups, e.g.
in T. Seki, *Untersuchungen zum Verhältnis
von Gefässform und Malerei attischer Schalen*
[Berlin 1985] pls. 21–23). Around the
medallion is a slanting meander running
left, typical for Makron's tondos: see von
Bothmer 44.
ADDED COLOR: Red for the *tainiai* and
the strings of the *plectron*.
BIBLIOGRAPHY: Christie's London, 16
July 1985, lot 422.
LITERATURE: For the painter, see ARV^2
458–82, 1654, 1701, 1706; *Para* 377–79,
521, *Beazley Addenda²* 243–47. See also,
D. von Bothmer, *op.cit.*; N. Kunisch in
G. Boehm et al., eds., *Modernität und Tra-
dition, Festschrift für Max Imdahl* (Munich
1985) 179 = Bochum S 1101; M. Stadler,
*Hefte des Archäologischen Seminars der Uni-
versität Bern* 7 (1981) 29–35; N. Leipen,
ed., *Glimpses of Excellence* (Toronto 1984)
13–14 (J. R. Guy) with further refer-
ences. See also G. Nachbauer, "Un-
bekanntes aus der Werkstatt des Hieron,"
ÖJh 54 (1983) 33–45; *GettyMusJ* 12
(1984) 247, no. 81. N. Kunisch is prepar-
ing a monograph on Makron for the se-
ries "Kerameus." He presents two more
cups in Bochum: M. Schmidt ed., *Kanon.
Festschrift für Ernst Berger* (1988) 305–09,
and *Jahrbuch 1984 der Ruhr-Universität
Bochum* 22, 24–25. See also Galerie Nefer
(Zurich 1989), cat. no. 7, 1989, 17 no.
15. For the chronology of the painter see
C. Isler-Kerényi, "Hermonax in Zurich
III: der Schalenmaler," *AntK* 27 (1984)
156–69. For the erotic stance of the ad-
mirers, cf. the San Antonio oinochoe by
the Berlin Painter (Cat. No. 70) and the
San Antonio cup (exterior) by the Painter
of Brussels R 330 (Cat. No. 87).

74

ATTIC RED–FIGURE
CUP FRAGMENT
Attributed to the
Briseis Painter [D. von Bothmer]
Ca. 470 B.C.
Gift of Gilbert M. Denman, Jr.
86.134.62
Interior: Male head
A: Dead Minotaur

The dead, as opposed to wounded,
Minotaur is a rare subject in Greek art
and the San Antonio fragment is
among the earliest examples and the
only one on the exterior of a cup.

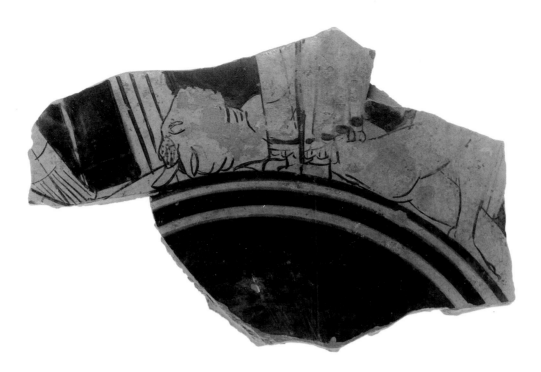

About contemporary with this fragment are two stamnoi, one by the Copenhagen Painter from the Acropolis (Acropolis 780) and the other by Hermonax in Leningrad (Leningrad 804), which depict the monster stretched out to the right, his right arm raised overhead, surrounded by standing figures. The cup fragment differs from these in the pose of the Minotaur (head at left with arms presumably over its chest), and the element of setting (a fluted column). The upper torso of the monster is obscured by the drapery of a figure who stands before it, presumably male, given the shoes. Another draped figure with a staff stands to the left beyond the column, while there is possibly a third behind the legs of the Minotaur at the right. None of these figures is likely to be Theseus, who always wears a chitoniskos, and so one presumes they are King Minos and other Cretans. In other fifth century depictions Theseus is occasionally shown dragging the dead Minotaur from the porch of the labyrinth. One peculiarity of this painting is the fact that the artist has mistakenly drawn a left foot on the bent right leg of the Minotaur. JN

DIMENSIONS: H. 7.5 cm.; W. 5.1 cm.
CONDITION: Heavy abrasion on reverse side.
SHAPE AND DECORATION: Stopt meander border around tondo. Two reserved bands below figure zone on exterior.
BIBLIOGRAPHY: Unpublished.
LITERATURE: For the Briseis Painter, see *ARV²* 406–10; *Para* 371–372; *ARFV* 137. For Theseus and the Minotaur, see F. Brommer, *Theseus* (Darmstadt 1982) 35–64. For the Copenhagen Painter stamnos, Akropolis 780 (*ARV²* 258,28), see *Graef-Langlotz* II pl. 69; for the stamnos by Hermonax, Leningrad 804 (*ARV²* 484, 16), see *AJA* 51 (1947) pl. 56.

75

ATTIC RED–FIGURE
NOLAN AMPHORA
Attributed to the
Nikon Painter [D. von Bothmer]
Ca. 470–460 B.C.
Gift of Gilbert M. Denman, Jr.
86.134.66
A: Woman and youth
B: Nike

On Side A, a matronly woman holds
out a wreath to a young victor. She is
dressed in a mantle over a long chiton
and wears a cloth *sakkos* over her head,
from which emerges a row of curls
over the forehead and ear. This modest
outfit is slightly enlivened by a spiral-
ling bracelet on each forearm. The
youth stands quietly facing her, only his
outstretched left hand signalling antici-
pation at the proffered gift. His hair is
rendered as a simple mass, crowned
with a wreath, and he wears a short
chiton with overfold and a light mantle
draped over the arms. Head and right
leg are shown in profile, torso and left
leg frontal, the frontal left foot and its
toes not very successfully foreshort-
ened. In his right hand he holds upright
a spear, which bisects the scene from
the base of the amphora's neck to the
meander border on which the figures
stand.

From the reverse hurries Nike, hold-
ing out a torch and gently lifting the
hem of her long garment to facilitate
her rapid gait. Her elaborate costume
consists of a belted chiton with long
overfold and billowing sleeves. Dot
patterns decorate the lower part of the
chiton, alternating with the folds, as
well as her wings, and the *sakkos*,
which otherwise resembles that of the
woman on the front.

Nike is a favorite figure on vases of
the Early Classical period, whether
flying, hovering at an altar, running, as
here, or standing still. The torch is of-
ten her attribute. Though she need not
have any relationship to the other fig-
ures on the vase, the San Antonio am-
phora may reasonably be read as a co-
herent whole. The youthful hero has
perhaps returned home, to be wel-
comed with victor's wreath, and Nike
herself hastens to join in the welcome.
The *kalos* inscription on Side A, which
extends from the woman's forehead,
past the spear, almost to the youth's
nose, then along the spear below the
youth's arm, may also help link the two
sides, for on the reverse the word *kalos*
alone spills from the mouth of Nike.
The longer inscription praises Kallias,
whose name is familiar from many
vases by this and related painters.
Though the name was a common one
in Athens, there is a good chance that
he belonged to a family widely consid-
ered the wealthiest in the city in the
years after the Persian Wars. An earlier
member of the family had been named
on vases of the late sixth century, and
yet another Kallias is *kalos* a generation
after ours. We cannot go so far as to as-
sume that the victorious youth on our
vase is a "portrait" of the handsome
Kallias, for such inscriptions often oc-
cur with no demonstrable relation to
the figures depicted. But the possibility
should not be excluded. Even then,
however, we cannot speculate on the
occasion for his victory, since beyond a
hypothetical family association, this
Kallias is attested only in *kalos*-inscrip-
tions and is not easily identified, on
chronological grounds, with a known
member of the family.

The Nikon Painter, to whom our
vase has been attributed, was a contem-
porary of the Oionokles Painter, both
followers of the more talented and pro-
lific Providence Painter. All three spe-

cialized in the then popular form of neck-amphora known as the Nolan, with sharply offset lip and broad triple handles. The Nikon Painter seldom depicts a mythological narrative, though a variety of divinities appears in his work, among whom Nike is the most often repeated. He is particularly fond of adding *kalos*-inscriptions to his scenes, but, unlike some painters, was not loyal to a single youth. Rather, half a dozen other names occur in his small oeuvre, and Kallias is named on only one other vase by the painter and one related to him. **HAS**

DIMENSIONS: H. 34.5 cm.; Diam. of mouth 16.2 cm.; Diam. of foot 9 cm.
CONDITION: Broken and repaired; small restored fragments in non-figural areas.
INSCRIPTIONS: Side A: ΚΑΛΛΑΣ; ΚΑΛΟΣ Side B: .ΑΛΟΣ
SHAPE AND DECORATION: The only ornament is the meander band on each side, just long enough to accommodate the figures, like a platform.
ADDED COLOR: Red for woman's and Nike's bracelets, and for wreath held by woman.

BIBLIOGRAPHY: Münzen und Medaillen, Basel, Auktion 63 (29 June 1983) no. 44; Summa Galleries, cat. 6 (Beverly Hills 1984) no. 7.
LITERATURE: For the Nikon Painter, see *ARV²* 650–52, 1581, 1663–64, 1699; *Para* 402–03. On the relation of the Nikon Painter to the Providence Painter, see E. Papoutsaki-Serbeti, *O Zographos tis Providence* (Athens 1983) 225–26. On Kallias kalos, see *ARV²* 1587–88. On the family of Kallias, see J. K. Davies, *Athenian Propertied Families* (Oxford 1971) 254–70.

76

ATTIC RED-FIGURE
NOLAN AMPHORA
Ca. 470–460 B.C.
Gift of Gilbert M. Denman, Jr.
86.134.65
A: Orpheus fleeing
B: Thracian woman

Orpheus sprints to the right while
looking back over his shoulder to left.
His rapid pace is accentuated by his
great stride, his outstretched left arm in
front of him, and his right trailing arm
and the hand-held lyre behind him.
The youthful Orpheus has a long lock
of hair spiraling down from behind his
ear over his chest. He wears a himation
which hangs over his left shoulder.
Chasing Orpheus on the opposite side
of the vase is a lone female clad in a
long pleated chiton which swirls about
in response to her swift pursuit. A
mantle is draped over her extended left
arm and hand and a long-handled dou-
ble axe is held fast in her trailing right
hand. Around her hair is a *sakkos*.

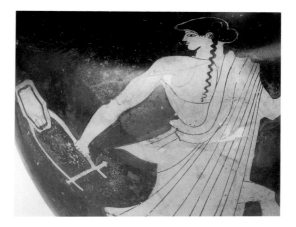

The painted style of this vase has
many aspects reminiscent of the late
manner of the Berlin Painter. The iso-
lated figures on either side of the vase,
the striding poses, gestures, and sub-
sidiary decoration are all dependent on
the master painter. Several of his Nolan
amphorae are decorated on one side of
the vase with a single mythological
character (Zeus, Apollo, Menelaos)
pursuing another figure on the opposite
side. Yet many elements of style on the
Orpheus amphora are distinct from that
of the Berlin Painter: the pronounced
chin of both figures, the left thumb of
Orpheus completely set off from the
hand, and the irregular numbers of
pleats in the woman's chiton, to name
only a few. The image of a striding
woman in a long chiton and wielding a
double axe is reminiscent of scenes de-
picting Clytemnestra or Electra taking
revenge, which do occur among the
repertoire of the Berlin Painter, the
Brygos Painter, and other contempo-
raries. Returning to the Thracian
myth, an excellent parallel to the San
Antonio vase is a Nolan amphora in
Oxford (Oxford 1966.500) by Her-
manax. Here the poses and attires of
Orpheus and the Thracian woman are
nearly identical to those on our vase,
even the detail that the cloak of the
pursuing female conceals her extended
left hand.

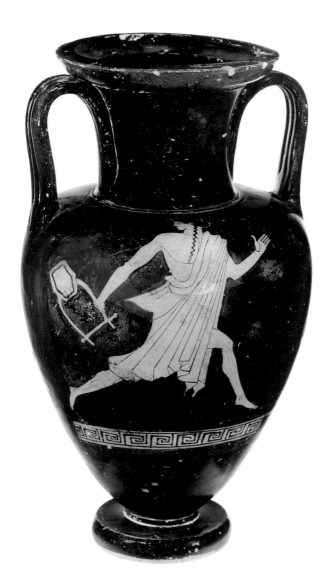
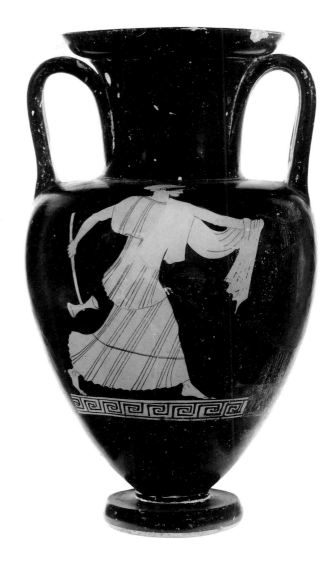

There are various separate episodes in the Orpheus legend, yet depictions of Orpheus in Greek art focus almost exclusively on the Thracian saga. Over seventy red-figure vases bear representations of the Orpheus myth, and the vast majority of these are Attic of the fifth century B.C. Tranquil scenes depicting Orpheus singing and playing his lyre before the Thracian men or violent episodes with the hero being chased or butchered by Thracian women occur for the first time about 490–480 B.C. The San Antonio amphora belongs to the latter category, usually entitled the "Death of Orpheus," and skillfully separates the startled and frightened musician from his enraged antagonist.　　KK II

DIMENSIONS: H. of rim 34.7 cm.; Diam. of rim 15.1.; Diam. of foot 9.4 cm.
CONDITION: Parts of Orpheus' himation, his right forearm, and much of the sound box on the lyre are lost. Also missing are the woman's upper left arm, left shoulder and waist areas, and parts of her cloak.
SHAPE AND DECORATION: The Nolan amphora (named after a find spot in Nola, South Italy) was favored by the Berlin Painter, especially during his later years. It was also frequently employed by the painters in his sphere of influence. The San Antonio vase has an echinus lip, triple handles, and a disk foot offset by a molded ring where it joins the body. A base line consisting of a meander pattern with eight and a half squares stretches under Orpheus on Side A, with another having seven and a half squares beneath the Thracian woman on Side B.

BIBLIOGRAPHY: Unpublished.
LITERATURE: For Orpheus on Greek vases, see *Vasenlisten*³ 504–08; H. Hoffman, "Orpheus unter den Thrakern," *Jahrbuch der Hamburger Kunstsammlungen* 14–15 (1970), 31–44; M. Schmidt, "Die Tod des Orpheus in Vasendarstellungen aus Schweizer Sammlungen," *Zur griechischen Kunst* (*AntK Beiheft* 9, 1973) 95–105. D. A. Amyx, "The Orpheus Legend in Art," *ArchNews* 5:2 (1976) esp. 25–30. For the Berlin Painter and his school, see J. D. Beazley, *The Berlin Painter* (Mainz 1974); D. Kurtz, *The Berlin Painter* (Oxford 1983). For the Nolan amphora by Hermonax in Oxford (1966.500, *ARV*² 487,66) see *Select Exhibition of Sir John and Lady Beazley's Gifts* (Exh. Cat., Ashmolean Museum, Oxford 1967) pl. 28.

ATTIC RED-FIGURE
COLUMN-KRATER
Attributed to the
Orchard Painter [D. von Bothmer]
Ca. 470–460 B.C.
Gift of Gilbert M. Denman, Jr.
86.134.63
A: Athena and the Daughters
of Kekrops
B: Youth and women

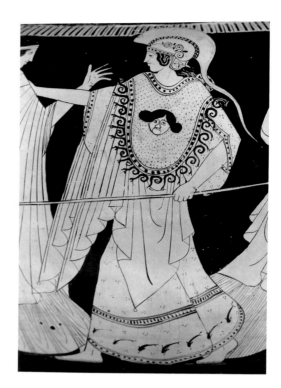

In the center Athena moves left catch-
ing hold with her left hand of one of
the daughters of Kekrops (also called
Aglaurids), who flees to the left, while
looking back at her pursuer. Athena is
richly dressed, wearing a chiton deco-
rated on the bottom with a frieze of
jumping dolphins, a short mantle, an
aegis, and an ornate Attic helmet. She
holds a spear horizontally in her left
hand by her side, and the end of her
hair is wrapped in a small cloth at back.
The girl holds a black sprig in the right
hand and wears chiton, mantle, and
headband. On either side her sisters
flee. The one on the left holds up a red
sprig in her right hand and wears a chi-
ton, mantle, and *sakkos*; the one on the
right wears a chiton, mantle, and ear-
ring; the mantle hides her arms and is
drawn up around the neck. Her hair is
held in place by red strings.

On the back is another scene of pur-
suit. In the center a mantled youth
with a red wreath runs to the right; he
holds out a staff in his right hand. His
downwardly turned mouth indicates
displeasure. To the right is a fleeing
woman who is posed and dressed simi-
larly to the Aglaurid on the right hand
side of the front. On the left another
woman in chiton and mantle flees left,
while looking back over her shoulder.
Her torso is shown in a three-quarters
back view. The hair of both is held in
place by strings in added red.

The Discovery of Erichthonios and
the punishment of the Daughters of
Kekrops is a myth rarely depicted in
Greek art, and only seven other exam-
ples on Attic vases are known, ranging
in date between 480 and 410 B.C. The
composition on each is different.
Athena in pursuit, as here, is found on
three and probably five others, and the
sister she grabs is usually identified as
Aglauros, the one who is most often
mentioned as responsible for opening
the basket, the forbidden act which was

the reason for their punishment. The
central Aglaurid on our vase, therefore,
is probably Aglauros, while the other
two are Herse and Pandrosos, which is
which is impossible to tell. Unique is
the fact that the basket with the baby
Erichthonios is not shown, since it is
the cause for all the excitement. All
three sisters are only found in two
other depictions.

Column-kraters were the Orchard
Painter's favorite shape. Only rarely, as
here, and as on his name-piece with a
scene of women picking fruit in an or-
chard (New York 07.286.74), did he

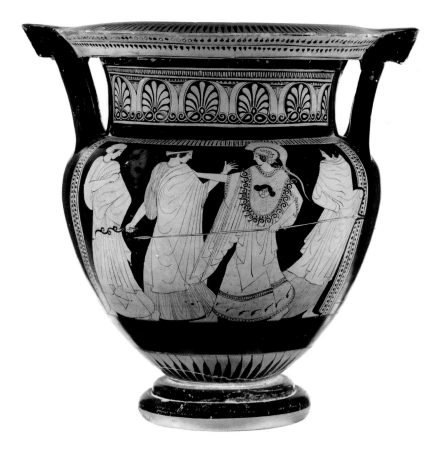

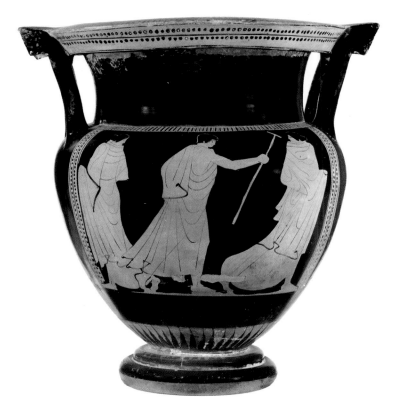

decorate the neck of the obverse with red-figure ornament; a black lotus chain is the norm. In general he was not a very careful painter, and the San Antonio krater is one of the finest vases we have from the hand of this mediocre artist. Pursuits and fights are common subjects in his repertoire, as are youths and women for the backs of his vases. Only occasionally does a youth chase a woman. Figures with mantles pulled up around their necks and with arms hidden beneath drapery are a type he preferred. JHO

DIMENSIONS: H. 44.1 cm.; Diam. of mouth 34.8 cm.; Diam. of foot 17.7 cm.

CONDITION: Recomposed from two large fragments; complete, except for a few lost chips from the rim and from the lower back of the reverse. Slight misfiring on the left side. Preliminary drawing for A and B. Much relief contour for Side A only. Dark dilute glaze, Side A: sprig of Aglauros snakes and hair of Gorgon on aegis, dolphins and dots and lines in decorative bands on Athena's chiton, and the leaves of volutes and dots on Athena's helmet; Side B: hems of mantles and outline of youth's right foot. Golden dilute, Side A: interior details of left woman's chiton, interior anatomical details, coloring of aegis, and dots on interior of Athena's chiton; Side B: interior of chitons.

SHAPE AND DECORATION: Rim rounded on top and sloping down with concave outside profile; two columnar handles on each side; ogee foot in two degrees; black lotus chain on the rim interrupted by a black palmette with scrolls and ivy leaves on top of each handle panel; debased black ivy vine on the outside of the rim; red-figure lotus and palmette frieze beneath an egg pattern on the neck of the obverse; surrounding the picture field on each side: a tongue pattern above, ivy vines on the sides, and a red line running around the vase below; black rays above the foot. Matt black wash on the inner body.

BIBLIOGRAPHY: Galerie Günter Puhze, *Kunst der Antike* cat. 3 (Freiburg 1981) 17, no. 158; *SouthernColls* 20–23, no. 4; *LIMC* IV 933, s.v. Erechtheus, no. 29.

LITERATURE: For the Orchard Painter, see *Richter and Hall* 117–21 and *EAA* III 749–50. For the myth, see J. H. Oakley, "A Louvre Fragment Reconsidered: Perseus Becomes Erichthonios," *JHS* 102 (1982) 220–22 with earlier bibliography; *LIMC* IV 932–33 and 946, s.v. Erechtheus (U. Kron). For New York 07.286.74 see *ARV²* 523,1.

78

ATTIC RED-FIGURE LEKYTHOS
Near the Providence
Painter [J.D. Beazley]
Ca. 470–460 B.C.
Gift of Gilbert M. Denman, Jr.
86.134.67
Dancing satyr

A satyr, his torso in nearly frontal view, lower legs in profile, dances to right. His left hand is extended up, overlapping the ornament above; in the downwardly angled right hand he holds a kantharos. He tilts his head slightly down, as he looks back; his right heel is raised off the ground.

Dancing satyrs are numerous on Attic vases, but not a common subject at this time on secondary lekythoi. There are contemporary examples by the Aischines Painter (*ARV² 714,167–69*),

an artist who exerted an influence on the Providence Painter, late in the latter's career. The Providence Painter was a student of the Berlin Painter and primarily a painter of Nolan amphorae and lekythoi; he preferred single figures on his lekythoi, both those of secondary and standard shape. Beazley placed this vase near to the secondary lekythoi of the Providence Painter (*Para* 402). Papoutsake-Servete thinks that it and three others (*ARV² 645,2,3 and 7*) are all by one artist whose style is near to that of the Providence Painter. J H O

DIMENSIONS: H. 19.9 cm.; Diam. of mouth 4.05 cm.; Diam. of foot 4.3 cm.; Diam. of shoulder 6.9 cm.
CONDITION: Complete; glaze flaked off in places, especially on the exterior of the mouth and the upper left of the satyr; slight misfiring in places. Preliminary drawing. Relief contours. Dilute glaze for lesser interior anatomical details and edges of hair and beard.
SHAPE AND DECORATION: Lekythos of Class ATL: calyx mouth, reserved on top; neck in reserve; ribbon handle, glazed only on the outside and sides; disk foot with sloping top and a deep groove at the top of the outside; reserved shoulder with five black palmettes below a debased tongue pattern, the middle three palmettes connected by tendrils. Above the satyr is a pattern band with running and stopt meanders, below a reserve band which runs around the vase; a thick, black band runs around the outside of the foot below the groove. For lekythoi of Class ATL: *ARV²* 675 and 709; Kurtz *AWL* 82–83; *BCH* 95 (1971) 610–12; cf. *ARV²* 642,105 and Amsterdam 6252 (Papoutsake-Serbete *infra* pl. 37). Palmettes of the Bowdoin Painter's type are not usual for shoulders of lekythoi of this class, rather a debased ray pattern is. The same decorative scheme is found on a number of other lekythoi either by the Providence Painter or in his Manner (cf. *ARV²* 642,104–06), and Beazley saw that these form a group (*ARV²* 642 and 645).
BIBLIOGRAPHY: *Para* 402, top; Auctiones A.G., Basel. *Kunst und Handwerk der Antike*, Auktion 14 (2 December 1983) lot 52.
LITERATURE: E. Papoutsaki-Serbeti, *O Zographos tis Providence* (Athens 1983) 231, no. T 15 and 235, *passim* for the painter and his associates.

79

ATTIC RED-FIGURE
ALABASTRON
Attributed to
the Stieglitz Painter [J.R. Guy]
Ca. 460 B.C.
Gift of Gilbert M. Denman, Jr.
86.134.74
A and B: Draped woman
holding wool basket

The long, narrow alabastron shape (cf. also Cat. No. 65) is best suited for two, at most three figures, and given its function as a perfume flask, women and their activities are the preferred subject. Both standing women on this vase are modestly enveloped in their black-bordered mantles, with only head, one hand and feet exposed. That they wear thinner chitons underneath is indicated by the tight pleats visible at their ankles. In addition the woman on Side A wears a snood (*sakkos*) decorated with a row of dots, while her counterpart on Side B is bare-headed, with only a fillet to tie up her long hair in a style known as the *krobylos*. Each woman holds a full wool basket (*kalathos*) in her hand, and they are posed in such a way on the vase that they seem to be facing each other, as if meeting. The expression of the woman on Side B with her muffled hand to her face suggests surprise or anxiety.

The setting is indicated on Side A by the accoutrements hanging on the wall: a pair of sandals shown frontally at the upper left, and an alabastron suspended by strings at the upper right. It is the *gynaikonitis* or women's quarters where one would expect to find ladies with their wool baskets since textile-making was one of the principal occupations of Greek women. More extended versions of such domestic scenes can be found on contemporary red-figure pyxides from the Penthesilea Painter's workshop. On these vases, sandals, wool baskets, perfume flasks, mirrors, *sakkoi*, as well as more suggestive architectural elements like doorways and columns, show, even though men may be present, that we are dealing with the restricted, indoor world of women.

The question of what kind of women Attic vase-painters were representing in such domestic scenes has recently occupied the attention of scholars. Are these wool-workers aristocratic

Athenian matrons, household slaves, or professional courtesans who have taken on the trappings of respectable women? The painters of the Kerameikos worked in the vicinity of the "red light district," and thus were more likely to see such women than the Attic matrons who were secluded. An oft-mentioned vase now in the Tampa Musuem of Art shows a mantle-clad woman demurely seated within a portico, an alabastron hanging on the wall. If it were not for the man lounging outside with his money pouch ready, one might identify the woman as a faithful wife at home rather than the *hetaira* that she is. Even closer in tone to the San Antonio vase is another red-figure alabastron in the Rhode Island School of Design (28.088): on Side A a woman with two children stands near a wool basket and looks apprehensively, hand to chin, toward the other side where a seated youth is making advances to another standing woman, almost certainly a prostitute. Thus we might have a deliberate juxtaposition of 'the *hetaira* and the housewife.' A similar juxtaposition may help explain the expression of the woman on Side B of the San Antonio vase. That the woman on Side A could be a prostitute is possibly indicated by the sandals, which often appear in erotic contexts in archaic vase-paintings, as well as the alabastron, the sexual connotations of which are obvious. As mentioned earlier the alabastron is an ideal shape for two figures, and so lends itself to a deliberate contrasting of types, a design opportunity realized by the first red-figure painter of alabastra, Psiax.

This alabastron is attributed to a mid-fifth century cup-painter, the Stieglitz Painter, whose name-vase, now in Leningrad but formerly in the Stieglitz collection, shows a tall, draped woman with a *kalathos* standing before a man in its tondo. This alabastron, the only one known to date by this artist, is unusual in the simplicity of its subsidiary ornament. Black tongues encircle the shoulder, and simple reserved lines, rather than the more traditional meander borders, frame the figural zone. Extending vertically below each lug is a single row of dotted net pattern.　　J N

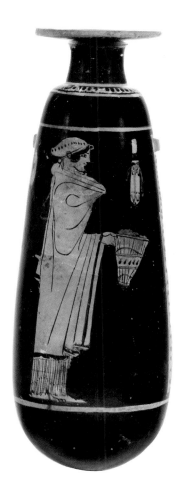
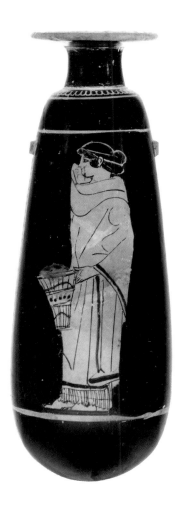

DIMENSIONS: H. 17.5 cm.; Diam. of mouth 4.5 cm.; Max. Diam. 5.9 cm.
CONDITION: Broken and repaired. Lip chipped and worn. Most of wool basket and part of mantle on Side A restored. Possibly burned(?).
SHAPE AND DECORATION: Reserved upper surface of lip; square reserved lugs.
ADDED COLOR: Red for wool in baskets, alabastron strings and sandal thongs.
BIBLIOGRAPHY: Sotheby's London, 9–10 July 1984, lot 228.
LITERATURE: On the Stieglitz Painter, see *ARV²* 827–30; *Para* 422. On *kalathoi*, see E. Abetel, *Aspects de l'artisanat attique: la vannerie, un exemple de comptage* (Lausanne 1982). On alabastra represented on other vases, see H. Gericke, *Gefässdarstellungen auf griechischen Vasen* (Berlin 1970) 72–74. On Attic pyxides, see S.R. Roberts, *The Attic Pyxis* (Chicago 1978) esp. pls. 27,

28, 30,1. On the hetaira vs. wife, see E. Keuls, "Attic Vase-Painting and the Home Textile Industry," in *AGAI* 209–30; eadem, "'The Hetaera and the Housewife' The Splitting of the Female Psyche in Greek Art," *Mededelingen van het Nederlandisch Historisch Instituut te Rome* 44–45, N.S. 9–10 (1983) 23–40; D. Williams, "Women on Athenian Vases: Problems of Interpretation," in A. Cameron and A. Kuhrt, eds., *Images of Women in Antiquity* (Detroit 1983) 92–106. For the hydria by the Harrow Painter in Tampa, see S. P. Murray, *The Joseph Veach Noble Collection* (Tampa 1985) 26 no. 63; *ARFV*, fig. 175. For the alabastron in Rhode Island, see D. M. Buitron, *Attic Vase Painting in New England Collections* (Cambridge, Mass. 1972) 122–23 no. 67. For the expression of hand to chin, see I. Wehgartner, *Attisch weissgrundige Keramik* (Mainz 1983) 40, pl. 6.

ATTIC RED-FIGURE VOLUTE-KRATER

Attributed to the Painter of the Woolly
Satyrs [D. von Bothmer, J.R. Guy]
Ca. 460–450 B.C.
Gift of Gilbert M. Denman, Jr.
86.134.76
A: Athena, Nike in chariot and
two warriors (the Dioskouroi?)
B: Nike at altar with queen and
king (Leda and Tyndareos?)

The illusionistically painted red-figure
pictures have no inscriptions, and their
specific subjects cannot be identified
with certainty. As we shall see, since
the human figures on the reverse recall
representations of the king and queen
of Sparta, Tyndareos and Leda, at the
birth of Helen, the warriors on the ob-
verse could well be two of Leda's other
famous offspring, Kastor and Poly-
deukes, the Dioskouroi.

A quadriga fills the center fore-
ground of the obverse. The charioteer
is a winged Nike, who stands quietly
erect in the car holding the reigns in
both hands. Her wings have three tiers
of primary and secondary feathers. Her
long black hair hangs down her back.
The Nike wears a tall diadem with a
volute pattern and a peplos with a
black-bordered overfall. Its skirt drapes
over the rear of the chariot's car. Vo-
lutes decorate the base and side rail of
the car, and each rail has a criss-crossed
thong for a mounting grip. The char-
iot's round wheel was drawn freehand,
with each spoke reinforced by a pair of
arcs inside the rim. The fine trappings
of the chariot's team include a dotted
cheekpiece for the bit and a harness
with downward-pointing scallops ter-
minating in ornament: dots, pomegran-
ates or florals.

The team itself is energetically char-
acterized, with contouring suggesting
the impressive animals' volume and
muscularity. Each trace horse lifts a
foreleg, and the far one tosses his head

forward and down. Notable features
include the horses' rounded eyes with a
straight line for the tear duct, chestnuts
on upper forelegs and separate hairs in
manes, forelocks and tails. Kerykeion-
shaped brands, indicating divine own-
ership, appear on the rumps of the near
trace and pole horses.

The Nike-driven chariot must be-
long to the goddess Athena, who stands
at the far left. Her Corinthian helmet
with low crest is pushed up atop her
head and worn over a Persian cap.
Athena's disk-shaped earring is visible
between the cap's hanging flaps and her
long black hair. The goddess's aegis,
here flung over her back, is covered by
scales with central ribs and edged by
snakes. The snakes overlap the sleeve of
her chiton, worn underneath the aegis,
and the aegis itself curves around her
body, reappearing on the far side. In
her left hand Athena grasps a long shaft
(spear?) by its criss-crossed thong
grip—holding it, remarkably, both near
the bottom and at waist height. It ex-
tends up vertically before her face,
overlaps the tongue pattern and is cut
off at the top by the vase's neck. Her
right hand is extended with the fingers
curving upward. Athena's gestures, as
well as the intense glance of her eye,
are directed toward the young warrior
on the far side of the chariot horses.

Although the upper portion of this
warrior is visible above the quadriga's
team, his legs and feet, which should
appear behind the sixteen horselegs, are
omitted. The handsome young warrior
meets the goddess's gaze. He has long
lashes and thick sideburns, but is as yet
beardless. His Corinthian helmet has an
elaborately patterned low crest, and the
casque, like Athena's, is worn pushed
up over a Persian cap. His shield, partly
visible behind the chariot's reins, is
foreshortened in three-quarter view
and embellished by a laurel wreath.
The unfastened shoulder flap of his
corselet projects from behind his right
shoulder. His extended right hand is

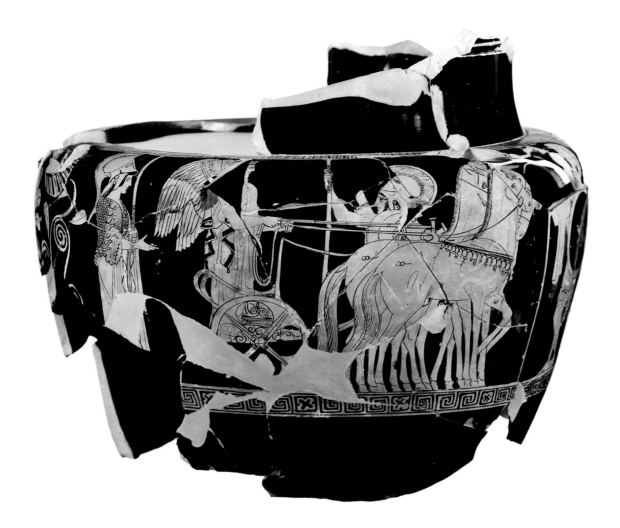

wrapped around a shaft (spear?) similar to Athena's, but held with its cross-hatched thong grip up.

On the far right a second warrior stands at the head of the chariot horses, but faces left. He too wears a low-crested Corinthian helmet pushed up. His round shield, drawn without a compass, is held parallel to the picture plane. Black save for a reserved border, it is emblazoned with a flying eagle. Although mostly hidden by his shield, this warrior evidently wears a composite corselet with a skirt of leather flaps over a short chiton, and a cloak draped over his shouldrs. He stands in contra-posto with his right knee bent. Like the central warrior, his right arm was ex-

tended to grasp a shaft (spear?). Extensive impressed preliminary sketch lines occur on both sides of the vase.

A simpler, three-figure composition appears on the reverse. The comely woman at the left, who wears a spiked crown and holds a scepter vertically before her, must be a queen. A curly lock hangs down her back. She wears a himation over a garment decorated with groups of three black dots and edged with a dotted border. The woman's himation must be pulled back by her left arm, resting with its hand on her hip.

At the center, a winged Nike stands before an altar, which has a low rectangular base, a central element with a frieze at the top and an upper element

in volute form. Two streaks of blood run down the altar's front surface. The Nike's black hair is bound up under a broad reserved headband. She wears a round earring and a peplos with black bands at the lower edges of its skirt and overfall. The Nike holds a long tendril (top missing) in one hand and gestures with the other toward the man at the right, to whom her intense glance is directed.

The man returns the Nike's gaze. His extended right hand held a striped scepter. The man's pose is a virtual mirror image of the woman's, but his feet and scepter are overlapped by the altar. His white hair and missing beard denote venerable age.

Representations of the birth of He-
len are popular on Attic vases during
the second half of the fifth century
B.C. and continue on South Italian
vases. The basic composition includes
Leda, wearing a diadem or crown,
Tyndareos, usually carrying a scepter
and sometimes white-haired, and a
blood-stained altar with a large egg on
top. Occasionally, the eagle of Zeus at-
tends the birth, as do the Dioskouroi.
In later examples Helen is shown
hatching from the egg fathered by Zeus
in the form of a swan. Although the
San Antonio krater lacks the egg, its re-
verse recalls the birth scene sufficiently
to suggest that this vase must refer to
another moment in the history of the
same family.

Here the Dioskouroi do not appear
beside the altar, but are probably the
pair of armed warriors on the obverse,
at least one of whom is shown as a
youth. The presence of Athena and
Nike suggests that the seemingly enig-
matic moment depicted on this vase
might well have had some special
significance for the city of Athens itself.
In Classical art the twin youths nor-
mally are nude save for cloaks and carry
(paired) spears. In one story, however,
it is appropriate for the Dioskouroi to
be fully armed: their invasion of Attica
to rescue Helen after her abduction by
the Athenian hero Theseus. According
to Plutarch [*Theseus* 31–33], upon the
successful completion of this mission
the Spartan heroes were honored as
Anakes (Lords) in Athens. The obverse
of the San Antonio volute-krater may
well show the Dioskouroi either just
before their departure for this battle or
after their victorious campaign, receiv-
ing the local commemoration directly
from the city's patron goddess. Perhaps
the central warrior, who is closest to

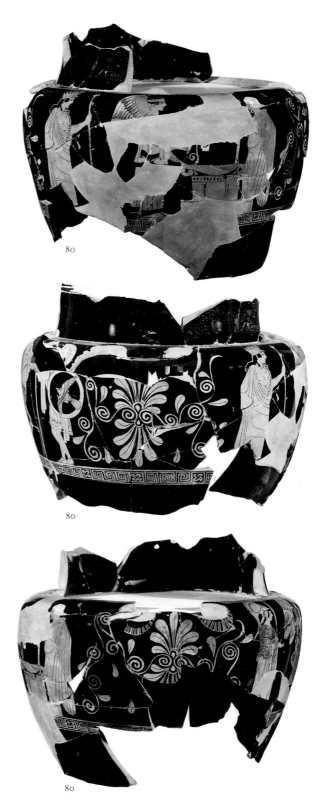

80

80

80

Athena, is Polydeukes, normally considered the immortal twin, rather than Kastor, the son of Leda and Tyndareos. Perhaps the arrestingly illusionistic eagle device on the shield of the right-hand warrior (Kastor?) implies the protective proximity of Zeus, divine father of Athena and Polydeukes. The chariot composition itself recalls earlier Attic representations of the apotheosis of the hero Herakles, another of Zeus' famous progeny. On the reverse Nike either instructs the royal couple to make suitable libations for the departing warriors or conveys the good news about "their" offspring to Leda and Tyndareos.

By the Classical Period the Dioskouroi were worshipped at a sanctuary in Athens known as the Anakeion, which, according to Pausanias [1.18.1], contained wall paintings by Polygnotos and Mikon (fl. 475–450 B.C.) depicting the Argonauts and the marriage of the daughters of Leukippos. Both of these subjects have been identified on Classical red-figured vases. Perhaps the remarkable vase paintings by the Painter of the Woolly Satyrs were inspired by another, now unknown monumental painting in the Early Classical Athenian sanctuary of the Dioskouroi.

The artist of the San Antonio volute-krater was named by Beazley after the exceptionally hairy satyrs on a bell-krater in Syracuse. An eccentric individualist with a small known oeuvre, the Painter of the Woolly Satyrs specializes in big red-figure pictures on kraters. His unusual compositions, such as the death of Aktaion or Herakles after the death of the Nemean Lion, are richly painted with much detail in relief line, black and dilute glaze as well as added-white, and have figures drawn in spatially complex poses with eyes in correct profile view. He is a follower of the Niobid Painter, whose name-piece, a calyx-krater in the Louvre, apparently reflects advances in compositional space of lost monumental paintings. The masterpiece by the Painter of the Woolly Satyrs, a volute-krater in the Metropolitan Museum, has also been associated with lost monumental paintings—the Amazonomachy and Centauromachy attributed to Mikon in another Athenian hero sanctuary, the Theseion [Pausanias 1.17.2–3]. B C

DIMENSIONS: Preserved H. 25 cm.; Max. Diam. 33.5 cm.

CONDITION: Fragmentary. Partially mended from numerous fragments. Lower portion of body and handles missing.

SHAPE AND DECORATION: At the top edge: scant remains of overhang and upper neck-element, glazed black with narrow reserved stripe. Preserved part of lower neck-element glazed black outside and in. Around base of neck, on shoulder, black tongues. A meander pattern, interrupted by saltire squares every three units, (after two units beneath right-hand figure on A) and bordered by narrow reserved stripes above and below, runs around the vase, serving as a groundline. Interior of body glazed black (streaky), save for underside of shoulder. Tongues surrounding roots of (missing) handles on B/A side; traces on A/B side. Beneath (missing) handles on each side, in reserve, the following configuration: a pair of addorsed palmettes (upward and downward) with ribbed fronds spring from volutes terminating in tendrils with spirals surrounded by leaves. A non-joining foot-fragment is glazed black outside and in, save for a reserved band with two black lines at the top and a reserved underside.

ADDED COLOR: Red for B, fillet on head of male figure. White for B, thick impasto for hair and beard (missing) of male figure.

DILUTE GLAZE: A, feathers on shoulders of Nike's wings, shading beneath tips of feathers; interior of chariot car; dots on cheekpiece of bit; manes, forelocks, tails and inner markings of horses, iris of horses' eyes, nostril of trace horse; interior of aegis, folds in sleeve of Athena's chiton; iris of central warrior's eye, shading on his sideburns and forehead hair, folds in warrior's cap, shading on his helmet's eyehole; lines on helmet crest of right-hand warrior; body, wings and tail of eagle. B, dots on shoulder of Nike's wing; blood on altar.

BIBLIOGRAPHY: Unpublished.

LITERATURE: On the birth of Helen and the Dioskouroi see T.H. Carpenter, *Art and Myth in Ancient Greece* (London 1991) 198–99, fig. 295; *LIMC* iv 498, 503, s.v. Helene; *LIMC* III 567–68, 581–82, 591, s.v. Dioskouroi; III,2 469, 471. On the cult of the Dioskouroi see H.A. Shapiro, *Art and Cult under the Tyrants in Athens* (Mainz, 1989) 149–54; the Dioskouroi armed appear earlier on the Aegina pyxis by the Amasis Painter, H.A. Shapiro 153 and pl. 68a. For Persian caps beneath helmets see E. Knauer, "Still More Light on Old Walls? Eine ikonographische Nachlese," in E. Böhr and W. Martini, eds., *Studien zur Mythologie und Vasenmalerei. Konrad Schauenburg zum 65. Geburtstag am 16. April 1986* (Mainz 1987) 121–26. For Louvre G 341 by the Niobid Painter see *ARV²* 601,22; *Para* 395; *Beazley Addenda²* 266. For the Painter of the Woolly Satyrs see *ARV²* 613–14; *Para* 397; *Beazley Addenda²* 268–69; J. Boardman, *Athenian Red Figure Vases, the Classical Period* (London 1989) 14; Louvre G 341, figs. 4.1–2; 12–14. For Metropolitan Museum 07.286.84 and monumental painting see B. Cohen, "Paragone: Sculpture versus Painting, Kaineus and the Kleophrades Painter," *AGAI* 174, fig. 12.3; 185, figs. 12.9a-b; 175, 180–86. Compare A, for a kerykeion brand and for spears with thong grips.

ATTIC RED–FIGURE STAMNOS
Attributed to
the Chicago Painter [B. Shefton]
Ca. 450 B.C.
Gift of Gilbert M. Denman, Jr.
86.134.64
A: Two women
at the image of Dionysos
B: Three women moving right

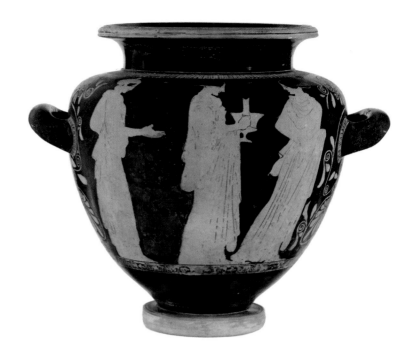

Because A and B belong together, let
us begin with the reverse and move
with the figures there to the front
scene. The woman in the center, clad
in a chiton and full himation, carries a
kantharos, the sacred vessel of Diony-
sos. It is shown from the handle side, a
convention which was inherited from
Attic black-figure vases. The woman
herself appears in strict profile, whereas
her two companions are depicted in
three-quarter view, the right from the
front, the left from the back. Their
heads are all in profile with the full hair
gathered up, the left woman with a
sakkos. She wears also chiton and hima-
tion, and her right hand is stretched out
in a gesture of speaking, perhaps pray-
ing. The woman at right looks back to
the center. Her himation covers both
hands; her chiton appears only just
above the feet.

On the front Dionysos is present in
the form of an idol, a bearded mask fas-
tened to a Doric column; the capital is
visible above. From the mask ivy-twigs
grow in the shape of a palm tree's
crown, thus converting the column
into a tree. Two big cakes (*plakountes*)
serve as shoulder-fasteners for the god's
garment, which covers the column. In
front stands a table. Two of its three
legs appear in different views, thus in-
dicating perspective drawing. On the
table two stamnoi frame the image,
showing the use of the vessel on which
they are depicted. They are a bit more
slender and their handles are more up-
right. It is a pity that we do not know
the ancient name of this shape, which
is called a stamnos by modern scholars.
It surely did not serve as a krater, that is
a vessel, for mixing wine with water,
but contained undiluted wine.

Round breads are heaped between
the stamnoi, and two long pieces of
meat hang from the table. The woman
at the left side dips a ladle into the
stamnos; she may be about to fill the
kantharos which is brought by the

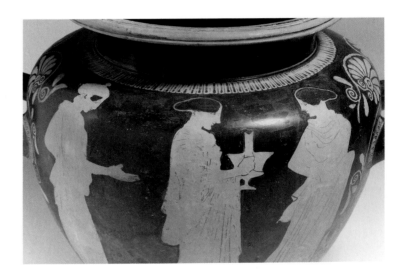

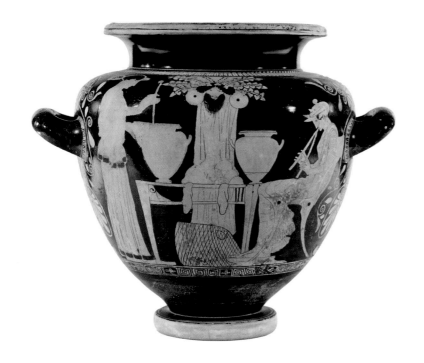

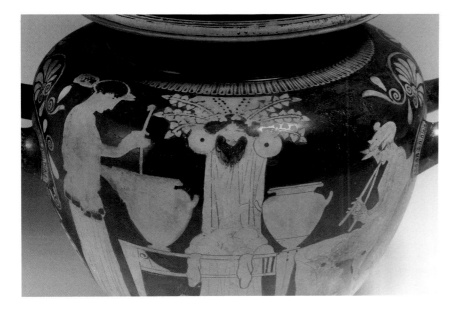

woman on the reverse. Because of her peplos and her young girl's hair-style, she is the youngest of the five women on the stamnos, perhaps still unmarried. The peplos is girdled and has fine black ornaments at the borders. Her companion is seated on a *klismos* and plays the double flute. Her head is covered by a *sakkos* and crowned with ivy leaves, which appear like 'horns' at her temples. The girl with the ladle has a similar crown, but most of it has faded. The slim flute-player wears a chiton and a himation which falls from the left shoulder and covers her legs. Her feet are resting on a small flat stool. Behind it ends the strange object which is placed beneath the table. Its high, flat end, and the lozenge pattern which appears on it, would suggest that it is a basket. I think Barbara Philippaki is right in calling it a *liknon*. Though quite a number of other red-figure Athenian vases, especially stamnoi, show the idol of Dionysos and the women serving it, none other depicts this object.

Liddell and Scott define the *liknon* with the following words: "Winnowing-fan, i.e. a broad basket, in which the corn was placed after threshing, and then thrown against the wind so as to winnow the grain from chaff." In the farmer's household it was also used as a cradle. Dionysos, originally an agrarian god, had the epithet Liknites, because his cradle had been a *liknon*. The same was told of Hermes, whose mother was an Arcadian nymph. In the fourth *Homeric Hymn*, which is devoted to Hermes, the newborn god's baby basket is called a "holy *liknon*" (21). The Brygos Painter has represented this on a cup in the Vatican (*ARV²* 369.6). Though that *liknon* is flatter, more like a shoe, its overall shape may be compared with the bigger basket on our stamnos. There are also the lozenges and an eye-shaped hole in the upper part of it, by which it could be handled for winnowing.

The Eretria Painter, on a chous in a private collection in Athens, has placed the mask of Dionysos into a *liknon*. It is the same type of bearded mask as in our picture, only seen in profile. There are also ivy twigs and some pieces of textile in the basket set on a table. Two women and a small girl are serving the god; only the column is lacking, and instead of stamnoi there is a krater. In the Dionysiac mysteries another symbol

of the god, the phallos, was placed among fruits into the *liknon*.

Because the farmers used it for separating the grain from the chaff it became a symbol of lustration, a prerequisite for fertility. In initiations it was carried on the head; its solemn revelation belonged to the ceremonies of mystery cults. But we remember that already in the *Homeric Hymn* it is called *hieron*, that is, consecrated or holy.

The Eretria Painter's *chous* can show us how the women on our stamnos used the *liknon*. In it they had carried the mask, ivy twigs and garment to the holy place where the god's column stood. It must have been a sanctuary of Dionysos in Athens. When it came time for the festival, the image was 'created' by the women in charge. It must have been a well-known festival, because many of the vases with this theme were found in Italy, both in Etruria and in Magna Graecia. Perhaps the festival was not limited to Athens.

In 1932 Martin P. Nilsson published a black-figure cup of the Haimon

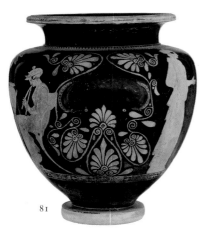

81

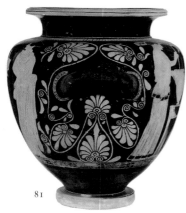

81

Group which is today in the Gustavianum of Uppsala. It shows on Sides A and B maenads dancing round the 'pillar god' and a *liknon* in front of both images. The *liknon* on the San Antonio stamnos, therefore, is not the first in this context, as Philippaki thought, because the Uppsala cup is about a generation earlier. Nilsson tried to associate the scenes on the cup with the Choes, the second day of a Dionysiac festival in early spring. Because jugs in the shape of the Eretria Painter's *chous* discussed above were used on that day, Nilsson had a strong argument. His interpretation was adopted by Walter Burkert and other historians of religion, but not by H.W. Parke, who rightly follows August Frickenhaus. The latter, as early as 1912, had associated the vases showing the 'pillar-god' with the Lenaia, an Athenian and Panhellenic winter festival of Dionysos. Lenai was a Greek name for maenads, and Dionysos Lenaios was their god. He, as well as his festival, was imported from Boeotia to Athens, where he was venerated in pillar shape on the Lenaia and on the Dionysia. These were the festivals around which the theater developed. The actors played with masks inspired by the main attribute of the 'pillar-god,' whereas at the Anthesteria Dionysos had other attributes and was not associated with the theater.

The Eretria Painter's *chous*, then, has led scholars in the wrong direction, all the more because its theme stands alone within the Choes iconography. Let us end this discussuion with a statement by Parke: "The best identification is that proposed originally by Frickenhaus and adopted by Deubner, that these are scenes from the Lenaia. If so, we would have to suppose that part of the festival was a midnight revel of women devoted to Dionysos. By the fifth century this continued, but was overshadowed by the procession and the plays so that it found no place in our literary tradition."

The painter of our stamnos was named by J.D. Beazley after a stamnos showing the same theme in Chicago. The Chicago Painter was a pupil of the Villa Giulia Painter, who himself loved this theme. E S

DIMENSIONS: H. 37.7 cm.; Diam. with handles 42.5 cm.
CONDITION: The vessel is complete, but its surface abraded and faded away in

many areas. Deeply incised on the underside of the foot, a graffito.

SHAPE AND DECORATION: Philippaki has attributed the shape to her "Class of the Stamnoi of the Chicago Painter." They have a thick disk foot with a reserved profile. Body and foot are divided only by a tooled line. Beneath the figures a meander pattern encircles the vase (three stopt meanders and cross-squares); above them, round the narrow neck, are tongues. On the shoulder, at the base of the neck is an egg pattern, but much is lost. The thickset handles are round, fully glazed, with egg pattern (three quarters) round the attachment. The carefully reserved handle ornament is symmetrical: a lyroid palmette below, two circumscribed palmettes on each side of the handle, between them small volutes and single or double leaves. The handle panel is glazed. Like most stamnoi by the Villa Giulia Painter and the Chicago Painter, the San Antonio stamnos is carelessly glazed in the inside. It is possible that there was a lid, such as that preserved on the stamnos by the Villa Giulia Painter in Würzburg (HA 126). Preliminary drawing visible, A: some relief contour, relief lines; B: no relief contour, some relief lines preserved. Dilute glaze, A: borders of peplos, dowels of table and *klismos*, black center of round cakes on each side of the mask, stripe ornament on the table; B: edge of himation of woman on right.

ADDED COLOR: Red for Side A, hair strings on left woman; Side B, hair strings on central and right women.

BIBLIOGRAPHY: *ARV²* 628,6; B. Philippaki, *The Attic Stamnos* (Oxford 1967) 114.

LITERATURE: For the cup by the Brygos Painter in the Vatican, see *ARV²* 369,6. For Dionysos Liknites, see *RE* XIII 1 (1926) 536–38. s.v. Liknites (Kruse); the liknon, *ibid*. 538–41 (Kroll). For the *chous* by the Eretria Painter with liknon, see *ARV²* 1249,13; A. Lezzi-Hafter, *Der Eretria-Maler* (Mainz 1988) 339, no. 215, pl. 137. For the black-figure cup in Uppsala, see M.P. Nilsson, *Geschichte der griechischen Religion* I (Munich 1955) 572, pl. 37, 3; E. Simon, *Die Götter der Griechen³* (Munich 1985) 274 fig. 263. Nilsson is followed by W. Burkert, *Griechische Religion der archaischen und klassischen Epoche* (Stuttgart 1977) 362. On the Lenaia, see A. Frickenhaus, *Lenäenvasen* (Berlin 1912); L. Deuber, *Attische Feste* (Berlin 1932) 123–34; H.W. Parke, *Festivals of the Athenians* (London 1977) 105; E. Simon, *Festivals of Attica* (Madison 1983) 100. For the stamnos with lid by the Villa Giulia Painter, see *CVA* (Würzburg 2) pl. 22.

82

ATTIC RED-FIGURE LEKYTHOS
Bowdoin Painter
Ca. 450 B.C.
Gift of Gilbert M. Denman, Jr.
86.134.68
Nike at an altar

Nike, holding a phiale in her extended right hand, stands in the center in profile to the right before an altar. Her left arm is extended at a higher level than the right arm, the palm opened up holding a circular object in white (fruit?). She wears a chiton, headband, earring, and a bracelet on the right wrist. A curved row of white dots imitating an inscription runs from the right of her head around the outside of her hands. The molding of the altar is decorated with a row of black dots. The liquid being poured from the phiale onto the altar and the fire on the altar are indicated in a mixture of white and red paint. On the left, emerging from the ground line, is a floral tendril with small volute and large bud.

The Bowdoin Painter worked in both the red-figure and the white-ground techniques and was a prolific artist; there are over 300 known vases by him. Active from the late Archaic period into the third quarter of the fifth century B.C., he takes his name from two lekythoi at Bowdoin College (Bowdoin 20.1 nd 13.5). Although the Bowdoin Painter decorated primarily lekythoi, we have oinochoai, loutrophoroi, and a hydria from his hand. Beazley and other scholars were unsure whether he was the same as a black-figure artist, the Athena Painter, and the problem remains unresolved today. Many of the scenes and figure types the Bowdoin Painter used were highly repetitive, and Nikai were a very popular subject with him. In fact, Nikai are common figures in many scenes on red-figured vases and are often shown libating.

This vase is a late work of the painter, at a time when he showed an interest in hems of thick, dark, dilute glaze like those on the sleeves of Nike's chiton. Other details of his drawing also changed, as for example his method of depicting the interior divisions of the wings with thick, waved strips of dilute glaze. Others remain the same: the altar, bracelet, and manner of rendering the face and head. A floral

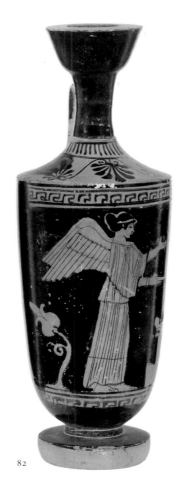

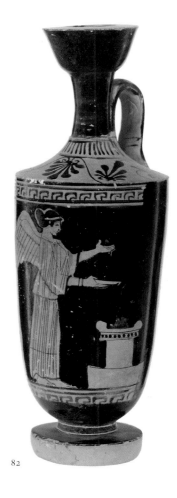

82

82

element as part of his figured scene is not unique (cf. Leningrad 674).

JHO

DIMENSIONS: H. 20.7 cm.; Diam. of mouth 4.95 cm.; Diam. of foot 4.65 cm.; Diam. of shoulder 7.1 cm.
CONDITION: Intact; glaze thinly applied in places. No preliminary drawing. Relief contour for face, neck, feet and top of the right arm. Dark dilute for interior of wings, hems of chiton, and bracelet.
SHAPE AND DECORATION: Lekythos of Class BL (*ARV²* 675; Kurtz *AWL* 79): calyx mouth, reserved on top; handle ovate in section, glazed on the outside and sides only; disk foot attached to the body by pad with a ridge in the middle, the exterior and bottom left in reserve. The ornament on the reserved shoulder consists of five black palmettes with enclosed bars above at the join of the neck; the middle three palmettes are connected by tendrils. This scheme is typical of the Bowdoin Painter, after whom the class is named. There is also a large oval-shaped spill of glaze on the left of the shoulder. Meander pattern bands border the picture

field above and below (cf. *ARV²* 679,30).
BIBLIOGRAPHY: Sotheby's London, 14–15 December 1981, lot 242.
LITERATURE: For the Bowdoin Painter, see S. Lasona, "Due lekythoi inedite da Leontini e il problema del pittore di Bowdoin," *Cronache di archeologia e di storia dell'arte* 8 (1969) 53–63; K. Schauenburg, "Athenabüsten des Bowdoin-malers," *AA* 89 (1974) 149–57; Kurtz, *AWL* 16; E. Zwierlein-Diehl, in W. Hornbostel et al., *Kunst der Antike. Schätze aus norddeutschem Privatbesitz* (Hamburg Museum exh. cat. 1977) 314–15, no. 268. On Nikai, see F. W. Hamdorf, *Griechische Kultpersonifikationen der vorhellenistischen Zeit* (Mainz 1964) 58–64; H. B. Walters, *History of Ancient Pottery* II (London 1905) 85–89; C. Isler-Kerényi, *Nike. Der Typus der laufenden Flügelfrau in archaischer Zeit* (Erlenbach 1969). For similar scenes, see *ARV²* 679,46–55; cf. the figure and drapery on *ARV²* 681,82 and the drapery on *ARV²* 680,70. Bowdoin 13.5: *ARV²* 684,143; Bowdoin 20.1: *ARV²* 685,170; Leningrad 674: *ARV²* 679,45.4.

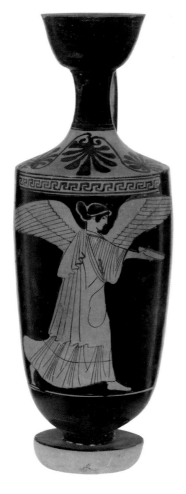
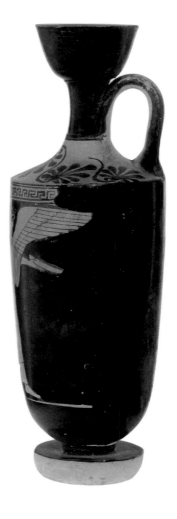

83

ATTIC RED-FIGURE LEKYTHOS
Bowdoin Painter
Ca. 450 B.C.
Gift of Gilbert M. Denman, Jr.
86.134.69
Nike with phiale

Nike in profile moves rapidly to the
right. She holds out a phiale in her
right hand; her wings are extended out
to either side. She wears a chiton, man-
tle, earring, and headband. Like Cat.
No. 82., this is a late work of the Bow-
doin Painter. JHO

DIMENSIONS: H. 25.5 cm.; Diam. of
mouth 5.6 cm.; Diam. of foot 4.9 cm.;
Diam. of shoulder 8.3 cm.
CONDITION: Complete; neck reattached;
glaze lightly applied on back with some
misfiring; glaze peeled off the handle in
places; top of mouth abraded. Preliminary
drawing. Relief contour for face, neck,
headband, and top of right arm. Dark di-
lute for hems of mantle and chiton and
interior of wings.
SHAPE AND DECORATION: Lekythos of
Class BL (see Cat. No. 82): calyx mouth,
reserved on top; handle ovate in section,
glazed only on the outside and sides; disk
foot attached to the body by a pad with a
ridge in the middle, the exterior and bot-
tom left in reserve. Five black palmettes
decorate a reserve shoulder; the middle
three are connected by tendrils; pattern
band with a running meander to the right
marks the upper border of the picture
field, a reserve line the lower.
BIBLIOGRAPHY: Sotheby's London,
14–15 December 1981, lot 241.
LITERATURE: For the artist and subject,
see the San Antonio lekythos Cat No. 82.
PARALLEL: For similar drapery and figure
type, cf. *ARV²* 679,43–44; for the drap-
ery and the rendering of the head, cf.
ARV² 681,93 and 1665,48*bis*; for the ren-
dering of the lower chiton, cf. *ARV²*
687.226.

84

ATTIC RED–FIGURE
HYDRIA (KALPIS)
Attributed to
the Painter of the Yale Oinochoe
[J.R. Guy, K. Kilinski]
Ca. 450 B.C.
Gift of Gilbert M. Denman, Jr.
86.134.70
Departure of Triptolemos

In the center of the scene Triptolemos
faces right and is seated in the winged
cart of Demeter. He is clad in a chiton
with an overall pattern and a himation.
The long chiton nearly conceals his
feet, which rest on the baseboard of the
specially designed chariot. The young
hero grasps the Eleusinian scepter in his
left hand and holds out a phiale in his
right. The scepter has sets of double
markings on its long staff which rests
on the baseboard of the cart beyond
the hero's feet. In front of him stands a
female clad in similar attire with a dia-
dem in her hair. With her left hand she
clutches four shafts of wheat that curve
downward in front of her. These are
rendered in dilute glaze on her reserved
clothing and continue with rough inci-
sions on the black-glazed area before
her. With her right hand she extends
an oinochoe toward Triptolemos in or-
der to fill his phiale, from which he
will make a libation before his depar-
ture. Behind Triptolemos stands a sec-
ond female, clad like the first, but with
a headband around her hair, and hold-
ing an oinochoe in front of her. Proper
identification of the goddesses in the
Mission scene is often uncertain since
representations of this subject with
identifying inscriptions vary in regard
to the positions of the two divinities.
On the San Antonio vase the figure at
left is probably Persephone, that in
front of Triptolemos, Demeter, since
they are indistinguishable from one an-
other except for the diadem worn by
the figure at right, a trait more often
associated with Demeter.

 The Painter of the Yale Oinochoe is
a contemporary of the Altamura, Nio-
bid, Villa Guilia, and Oreithyia Painters,
all of whom painted scenes of Triptole-
mos' departure. His style, however, is
considerably less refined than theirs.
His characters possess gaping eyes,
puckered lips, heavy chins, and large
feet. He prefers to decorate medium-

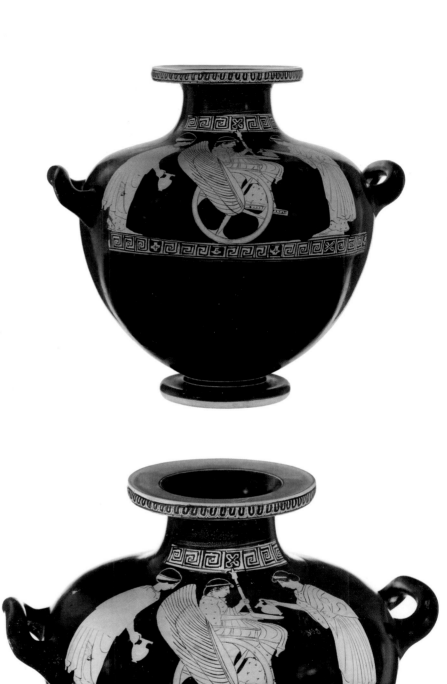

size vases, especially stamnoi and hydriae, with small groups of figures evenly spread out over the picture zone. Generally, his figures occupy a balanced composition of standing, bending, and/or seated poses. He has a preference for women in his scenes, which tend toward genre subjects. Mythological themes do occur but the lack of attributes and other means of identification in some scenes leaves them questionable, if not indistinguishable from scenes of daily life. The suggestion of Fracchia (p. 109) that the Painter abandoned with time the application of mythological subjects on his hydriae is not substantiated by the San Antonio example, which belongs to his late phase. A quick comparison of this hydria with the Painter's bell-krater in Paris (Louvre G 368) demonstrates the changes in his work. The Louvre krater displays Triptolemos in his winged cart before Demeter whose dress in this scene is far more carefully rendered. There Triptolemos' cart is more elaborately wrought with a bench with separate legs fastened to his seat by what appear to be pegs, eight spokes in place of four on the wheel, and a clearly discernible and more decorative pair of wings instead of the simple, single wing depicted on the San Antonio hydria. On the Louvre krater, Demeter offers Triptolemos a decorated phiale; on the hydria, he is already holding one while the goddess pours from an oinochoe into his vase. Both of these are rendered in a plain reserved manner. The Painter of the Yale Oinochoe depicted the subject of the Eleusinian goddesses on another vase, a stamnos in Oxford (Oxford 292), with the presence of a man who may be Triptolemos (contested, but included by Dugas, p. 134, no. 40). Yet another example, a fragment probably of a hydria, in Athens, was tentatively assigned to the painter by Beazley. The visible remains show parts of two females, one holding a scepter. These may be Demeter and Persephone with or without Triptolemos. On neither the Louvre krater nor the San Antonio hydria is the magical cart endowed with serpents, as seen on other red-figure depictions of the Mission scene, an attribute first mentioned by Apollodoros (*Bibl.* 1.5.2), who states that Demeter made the cart for the young missionary. In conjunction with

this means for transportation is an interesting Argive tradition related by Pausanias (1.14.2) in which Triptolemos' father is said to be one Trochilos, "he of the wheel."

Triptolemos was a legendary priest at Eleusis, initiated by Demeter into the Mysteries and given the knowledge of agriculture with instructions to spread this knowledge over the world. The name Triptolemos, meaning thrice warring, was taken to mean thrice ploughed (tripolos) in connection with the hero's agricultural interests (Cook, pp. 224–25). Representations of Triptolemos' departure on his mission in a magical cart begin on Attic black-figure vases during the third quarter of the sixth century B.C. among the works of the Swing Painter (*ABV* 308–09, 82–83). A substantial increase in popularity of this theme among Attic red-figure vase-painters occurs during the second quarter of the fifth century, during the career of our painter, and has been linked to the production of Sophokles' *Triptolemos*, dated to 468 B.C. (Pliny, *NH* 18.65). Although certain iconographical elements of the vase scenes correspond with fragmentary passages from the play, these elements were established in the paintings prior to the theatrical performance. The popularity of Triptolemos among Attic painters and playwrights is understandable. The young hero was considered the emissary of the Eleusinian goddesses, traveling beyond the borders of Attica to spread the knowledge of civilizing agriculture, which was by inference fostered in Athens. The Mission scene, therefore with Triptolemos preparing to depart in his cart, ranks as the most frequently rendered episode of this Eleusinian theme, which Dugas (p. 123) categorizes into three segments: the hero's education, his departure or mission, and his reunion with the two goddesses. The popularity of the Mission scene is maintained into the third quarter of the fifth century B.C. after which it wanes rapidly. The Raubitscheks (p. 117) have correlated the popularity of Triptolemos' mission on Attic vases of this era with Athenian propaganda during the rise and maintenance of the empire. Coinciding with Athens' losses is the decline in popularity of the mythical tale. K K I I

DIMENSIONS: H. of rim 32.2 cm.; Diam. of rim 14.6 cm.; Diam. with handles 33.9 cm.; Max. Diam. 28.4 cm.; Diam. of foot 12.2 cm.

CONDITION: Broken and repaired. Restored fragments to right of right female, and at root of rear handle. Restored, but not repainted, fragment encompassing torso of the left female.

SHAPE AND DECORATION: The kalpis or hydria with a continuous curve from neck to foot first appears early in the last quarter of the sixth century B.C. and continues in fashion throughout the fourth century B.C. Above and below the figure scene is a strip with meander pattern, separated every three meanders with a saltire (above) or a cross-square (below, with one saltire). On the rim is a tongue pattern.

BIBLIOGRAPHY: Galerie Günter Puhze, cat. 4 (Freiburg 1982) 21 no. 212.
LITERATURE: For the Painter of the Yale Oinochoe, see *ARV²* 501–03; *Para* 381; H. Fracchia, "The San Simeon Fruitpickers," *CSCA* 5 (1972) 103–11. For the bell-krater in Paris, Louvre G368, *ARV²* 502,10, see *EAA* VII 1238, fig. 1378. For stamnos Oxford 292, *ARV²* 501,1, see *CVA* (Oxford 1) pl. 27, 1–2. For the fragmentary hydria in Athens, see *Para* 381 (unpublished). For the mission of Triptolemos, see *LIMC* IV 890–91 s.v. Demeter; A.B. Cook, *Zeus* (Cambridge 1914) esp. 211–37; "La mission de Triptolème d'après l'imagerie athénienne," *Recueil Charles Dugas* (Paris 1960) 121–39; A. Peschlow-Bindokat, "Demeter und Persephone in der attischen Kunst des 6. bis 4. Jahrhunderts," *JdI* 87 (1972) esp. 78–92; I. and A. Raubitschek, "The Mission of Triptolemos," *Hesperia Supplement* 20 (1982) 109–17; G. Schwarz, *Triptolemos* (Graz 1987). For the earliest representations by the Swing Painter, see *ABV* 308–09, 82–83; E. Böhr, *Der Schaukelmaler* (Mainz 1982) pl. 104–05. For the shape, see E. Diehl, *Die Hydria* (Mainz 1964) 58–62.

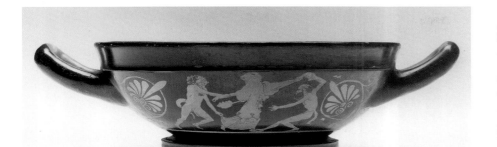

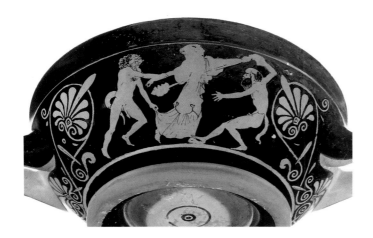

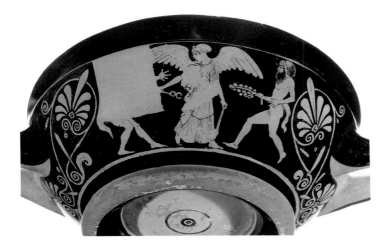

ATTIC RED-FIGURE
STEMLESS CUP
Attributed to the Penthesilea Painter
[J.R. Guy, A. Lezzi-Hafter]
Ca. 460–450 B.C.
Gift of Gilbert M. Denman, Jr.
86.134.72
A: Iris surprised by two satyrs
B: Two satyrs assaulting a maenad

Iris, her huge wings outspread, hurries
away from a slightly crouching satyr
whose upper body is lost. He might
have touched the *kerykeion* which Iris
holds in her right hand. The messen-
ger-goddess wears a chiton and a short
himation draped over one shoulder,
both rendered in an Archaic way, as is
the case with the Penthesilea Painter's
two other representations of Iris in the
same predicament. Her hair is covered
by a *sakkos*; with her free hand, she lifts
the hem of her skirt. Iris's escape will
be slowed down by a second satyr who
runs towards the center. A wreath, in
added red, decorates his bald head, and
he holds one of those ivy-sprigs so typ-
ical of the painter. Between the first
satyr and the goddess, at the level of
their knees, one reads, in red and on
two lines: ΗΟ ΠΑΙΣ ΚΑΛΟΣ ("the boy
is beautiful").

Our scene is an excerpt from a more
detailed story depicted on the famous
London cup (E65) by the Brygos
Painter. Hera had plotted mischief by
sending Iris to snatch the tongue of a
sacrificed animal from Dionysos's altar
at Athens. In defense of their master's
property, the satyrs rush after Iris to re-
cover the tongue and to chase away the
heavenly thief.

This rarely represented subject must
be inspired by a satyr-play, yet it can-
not be connected safely with an au-
thor's name. Like the San Antonio cup,
all the other vases showing the same
theme are drinking vessels.

Dionysos's world is present on Side
B as well. No two of the Penthesilea
Painter's *thiasoi* look alike. Ours shows
a "danse à trois" between two satyrs
flanking a maenad. The wild-haired
satyr on the left is an exceptional
figure, because his face is turned three-
quarters to the onlooker. He clutches
the woman by her arm and pulls her
chiton. The maenad is clad similarly to
Iris; with a long outstretched hand she

points a thyrsos towards the first satyr. The second satyr has his knees bent in an unbalanced position. As part of the vase's surface has been damaged, it is not clear whether he touches the maenad too. In contrast to his more lascivious companion, his head is not crowned with ivy. The same two-line inscription as on Side A is found between the heads of the satyr at left and the woman. AL-H

DIMENSIONS: H. 8.8 cm.; Diam. of rim 23.4 cm.; Diam. of foot 13.5 cm.
CONDITION: On Side A, a restored fragment in the bowl, one handle attached, otherwise well-preserved except for the sometimes heavily abraded surface. Almost no relief-contour for the figures.
SHAPE AND DECORATION: Stemless cup. Glazed along the inside of the foot. Underneath three concentric circles. Interior black. *Miltos.* The stemless cup developed from the cup-skyphos with a much deeper bowl. As a rule of thumb, in a cup-skyphos, the height is greater than one-half the diameter of the rim, while in a stemless cup, the height is less than one-half the diameter of the rim. Our variety of stemless, with heavy foot, thick wall and rim and handles of cup Type C, usually has no picture inside. In *ARV²*, chapter 48, there is, if one follows this definition, only one cup-skyphos by the Penthesilea Painter: Berlin F 2591, *ARV²* 888,150; P. Jacobsthal, *Ornamente griechischer Vasen* (Berlin 1927) pl. 120c. For other stemless cups see New York 96.18.76; *ARV²* 888,151; *Richter and Hall* pl. 181 no. 75; *ARV²* 898, no. 137,1674; *Beazley Addenda²* 303; and an example in a private collection, J. Dörig, ed., *Art Antique. Collections privées de Suisse Romande* (Mainz 1975) no. 222 (J.Chamay), both by the Splanchnopt Painter. For the two shapes see B.A. Sparkes and L. Talcott,

Agora XII (Princeton 1970) 101–02, 109–10. The friezes are framed by a reserved line. Under the handles the upper half of the double-palmette with side-palmettes are squeezed into the space available. No relief-contour; relief-lines as ribs on some of the petals. For a similar style, see Berlin F 2591, cited.
ADDED COLOR: Red for the wreath and the inscriptions.
BIBLIOGRAPHY: Galerie Günter Puhze, *Kunst der Antike*, cat. 4 (Freiburg 1982) 19 no. 200.
LITERATURE: For representations of Iris by the Penthesilea Painter, see Berlin F 2591, cited above, and G. Lücken, *Griechische Vasenbilder* (Berlin 1921) pl. 10, 2. For Paris, Cabinet des Médailles 840, *ARV²* 888,154, see F. Brommer, *Satyrspiele* (Berlin 1959) 27 fig. 19. Compare Harvard 1925.30.130, *ARV²* 881,29; D.M. Buitron, *Attic Vase Painting in New England Collections* (Cambridge, Mass. 1972) 114–15. For the ivy sprig, cf. Boston 01.8032, *ARV²* 888,155; in *CB* II pl. 52,A. For Iris see *ARV²* 1727, index mythological subjects, s.v. Iris assaulted by satyrs. For the London cup by the Brygos Painter, E 65, *ARV²* 370,13, 1649; *Para* 365.367; *Beazley Addenda²* 224, see E. Simon, "Satyr-plays on Vases in the Time of Aeschylus," in D. Kurtz and B. Sparkes, eds., *The Eye of Greece* (Cambridge 1982) 125–29 and pl. 30, with further references. Iris is depicted with the tongue on the vases in Berlin and London, without it on Cabinet des Médailles 840 and the San Antonio cup. For thiasos representations, see E. C. Keuls, "The Gentle Satire of the Penthesilea Painter: A New Cup with Dionysiac Motifs," in E. Böhr and W. Martini, eds., *Studien zur Mythologie und Vasenmalerie. Festschrift Konrad Schauenburg* (Mainz 1986) 83–86.

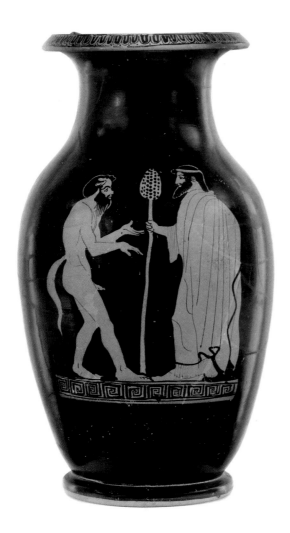
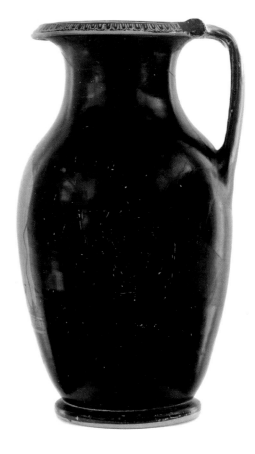

86

ATTIC RED–FIGURE OINOCHOE
Attributed to
the Florence Painter [J. R. Guy]
Ca. 450 B.C.
Gift of Gilbert M. Denman, Jr.
86.30
Satyr and Dionysos

The oinochoe of this rare type developed slowly from black-figure and early red-figure olpai. The latter still retain the continuous curve of the shoulder as well as the rotelles which have not yet turned into broad-ended handle-roots. How all this changed within a decade or two can be observed on the San Antonio oinochoe by the Painter of Munich 2335 (Cat. No. 93). There is only one other oinochoe Type V-A as big as ours, and this is the only one decorated by the Florence Painter, whose main interest lay in column-kraters.

A timid satyr stands in front of Dionysos, raising his awkward hands in adoration or perhaps only in a playful gesture of dance. The god wears a chiton and himation. His left hand is hidden under the mantle; the right one holds a thyrsos upright. Pictures of the wine-god in the company of a single satyr are rare, and ours may enrich the series, all the more so as it is an unusual depiction of a satyr confronting his god.

The hand of the Florence Painter (strictly speaking, the Painter of the Florence Centauromachy) is easily recognizable in this late piece. Characteristic are, above all, the ear-opening in the satyr's goat-ear (itself drawn in outline), the angular snub-nose, the beard ending in straggly locks, the thin waist, and the tail with no hair indicated.

A L – H

DIMENSIONS: H. 37.3 cm.; Diam. of mouth 15.8 cm.; Diam. of body 19.6 cm.; Diam. of foot 13.1 cm.
CONDITION: Reconstructed from fragments, with a few insignificant restorations. No relief-contour for the figures.
SHAPE AND DECORATION: On the mouth, dotted egg-pattern. On the body, band of stopt meander, unevenly done.
BIBLIOGRAPHY: Unpublished.
LITERATURE: For the Florence Painter, see *ARV²* 540–45, 1658; for his oinochoai of other types see *ARV²* 544; *Para* 385 and *Beazley Addenda²* 256. For the San Antonio satyr, cf. Ferrara T 1039, *ARV²* 543,53 and *Para* 385; S. Aurigemma, *La necropoli di Spina in Valle Trebba* II (Rome 1965) pl. 120a; for Dionysos' mantle, see *ibid*. pl. 120b. For the dotted thyrsos compare a column-krater in Ruvo, *GVU* pl. 6. For the iconography, see *LIMC* III s.v. Dionysos, 448 nos. 253–58 (C. Gasparri). On the oinochoe Type V-A, see J. R. Green, "Oinochoe," *BICS* 19 (1972) 7 and pl. 1g, 1f = London E 559, *ARV²* 539,45 by the Boreas Painter, a colleague of the Florence Painter. The San Antonio vase comes close in style to Athens 1415, *ARV²* 540,5 which is by a painter near the Boreas Painter. The biggest oinochoe Type V-A is Yale 1913. 143, *ARV²* 503,25; *Beazley Addenda²* 251; S.M. Burke and J.J. Pollitt, *Greek Vases at Yale* (New Haven 1975) 63–65.

ATTIC RED–FIGURE CUP
Interior: Attributed to
the Penthesilea Painter
A and B: Attributed to
the Painter of Brussels R 330
[J.R. Guy, A. Lezzi-Hafter]
Ca. 450–440 B.C.
Gift of Gilbert M. Denman, Jr.
86.34.2
Interior: Boy and youth
A and B: Two youths courting a
woman

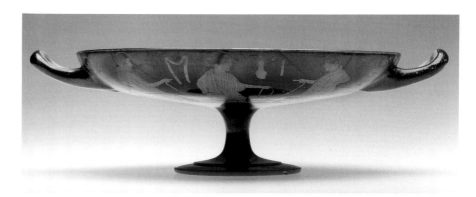

In the interior a boy, muffled in his hi-mation, part of which covers the back of his head, stands at left—the per-sonification of bashfulness. He listens to a somewhat older youth who is leaning on a stick cushioned by the mantle, which leaves his back uncovered. While talking intently, he rests one foot in a leisurely manner on the curve of the meander.

On the outside, repeated on each half of the cup, two youths meet a *het-aira*. The young men wear himatia, and each handles a knotty stick, an indis-pensable attribute for this sort of en-counter. The women, clad in chiton and himation, look very much alike.

On Side A, it seems, the youths are visited by the *hetaira* in their own quar-ters, since there is a covered shield and a sword on the wall beside two pairs of sandals and a wreath. The woman holds out a purse, rarely seen in female hands, which she must have obtained a moment ago, as payment for her future services. On Side B, the youths pay a visit to the same *hetaira*, bringing her a wreath. Her room is indicated by a pair of sandals and a sash hanging on the wall.

The Penthesilea Painter, an inventive and versatile painter, gives us here a modest example of his late work. On this small cup, the Penthesilea Painter's collaboration with the Painter of Brus-sels R 330 is identifiable for the first time. He usually preferred the Splan-chnopt Painter as a partner, who also shared cups with the Painter of Brussels R 330. A L–H

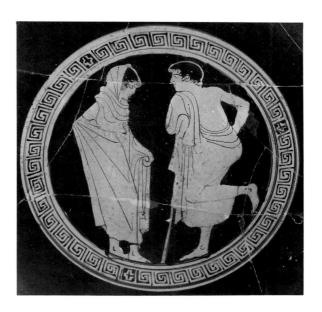

DIMENSIONS: H. 9.3 cm.; Diam. of rim 23.9 cm.; Diam. of foot 9.4 cm.
CONDITION: Broken and restored. Strong *miltos*. Hardly any relief-contour for inte-rior, not at all on Sides A and B. Prelimi-nary sketch on interior.
SHAPE AND DECORATION: Kylix of Type B. The cups of this small shape have not yet been given their adequate place in the Penthesilian Workshop. See the remarks of Beazley in CB II 64, no. 101 and the silhouette of a similar cup, *ibid*. p. 65, no. 102. In contrast to common practice in the Penthesilian Workshop, our cup has only one black band underfoot, and one reserved line as a base for the frieze on A and B. It has two reserved lines on both sides of the rim. The interior has a border of stopt meander, interrupted by the usual three cross-squares with dots in each cor-

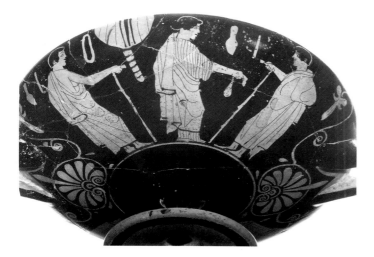

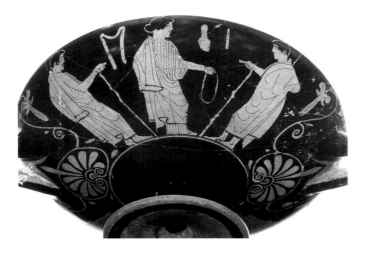

ner. Under the handles is a circumscribed palmette with side tendrils and hanging lotus-flowers, stylistically typical for the workshop. More often it recurs with a rounded background between the handles, e.g. Boston 13.84. Ours, with the mid-petal projecting out and a background rising to a point, seems to be rare.
BIBLIOGRAPHY: Sotheby's London, May 19, 1986, lot 309.

LITERATURE: For the Penthesilea Painter, see *ARV²* 879–90, 1673, 1703, 1707; *Para* 428, 516, 522; and *Beazley Addenda²* 300–02. For the Painter of Brussels R 330, see *ARV²* 925–31, 1674f.; *Para* 431 and *Beazley Addenda²* 306. For collaboration, see *ARV²* 877–79. For the attribution of our cup, cf. Paris, Cabinet des Médailles 814; *ARV²* 881,32; H. Diepolder, *Der Penthesilea-Maler* (Mainz 1976) pl. 26; Thorvald-

sen Mus. 114: *ARV²* 884,80; T. Melander, *Thorvaldsens græske vaser* (Copenhagen 1984) 97 above; Chicago 89.27: *ARV²* 884,77. For the boy in his mantle, see E. C. Keuls, *The Reign of the Phallus* (New York 1985) 226. For the back view of the youth cf. London E 72, *ARV²* 885, no. 93, 1703; H. Diepolder pl. 30 and Chicago 89.27 (see above). For profiles comparable to our cup see: *CVA* (Tübingen 5) 38, fig. 18; *CVA* (Amsterdam 1) 135, fig. 75. For the Three-edge Class, one other variety of the shape, see H. Bloesch, *Formen attischer Schalen* (Bern 1940) 103–07. For Boston 13.84 (*ARV²* 883,61), see *CB* II suppl. pl. 5,2 and 12, no. 102. For handle ornaments of the Penthesilea Workshop, see D. von Bothmer, "A Cup in Berne," *Hefte des Archäologischen Seminars der Universität Bern* 7 (1981) 39–40. Newly published cups by the Penthesilea Painter, since *Para*: 1. German private collection: W. Hornbostel, *Aus Gräbern und Heiligtümern, Die Antikensammlung W. Kropatschek* (Hamburg Mus. exh. cat. 1980) 129–30, no. 76 (on 133, he mentions two others) 2. Cup, Munich market, and 3. Cup, Nuremburg, private collection. 4. University of Wisconsin-Madison 1976.31: *Midwestern-Colls* 194–96, no. 110. 5. German private collection: W. Hornbostel, *Aus der Glanzzeit Athens* (Hamburg 1986) 127–30 no. 61.6. Würzburg H 5721; D. Metzler et al., eds., *Antidoron. Festschrift für Jürgen Thimme* (Karlsruhe 1983) 83–86, fig. 4 (F. Eckstein). 7. Cup, Spain: J. Barberà-E. Sanmartí, *Arte Griego en Espana* (Barcelona 1987) 204 fig. 265 (from El Puig); cf. G. Beckel,"Eine Schale des Penthesilea-Malers," *AA* (1988) 334–39; *GettyMusJ* 12 (1984) 247 no. 82. The attribution of sides A and B to the Painter of Brussels R 330 is easier than the tondo because this painter is much more dependent on stock-figures. Almost identical friezes to ours can be found on Avignon S 66, *ARV²* 926,22; Chr. Landes and A.F. Laurens eds., *Les vases à mémoire* (Lattes 1988) 107, 61; Adolphseck 33, *ARV²* 926,25; *CVA* (Schloss Fasanerie) pl. 27. For commercial transactions with *hetairai* compare the San Antonio oinochoe by the Berlin Painter (Cat. No. 70) with further references.

ATTIC RED–FIGURE
COLUMN–KRATER
Attributed to the Naples Painter
[J.D. Beazley]
Ca. 450–440 B.C.
Gift of Gilbert M. Denman, Jr.
86.134.73
A: Orestes at Delphi
B: Woman and two youths

Orestes, pursued by an Erinys, or Fury, for the murder of his mother Clytemnestra, seeks refuge and the protection of Apollo and Artemis. The hero, wearing a loose chlamys fastened near the right shoulder and leaving much of his chest and legs exposed, kneels on a crude pile of rocks. His longish, windswept hair, the ruffling garment, and awkward pose all suggest that he has at this very moment rushed in, followed in hot pursuit by the Fury. She wears a sleeveless, belted chitoniskos with fine, carefully rendered pleats and a coiffure much like that of Orestes. A thin snake coils about each of her arms, the one in the outstretched right hand dangling perilously close to Orestes' head. She is in mid-stride, and the bold device of her rear wing, breaking through the dotted ornamental band, heightens the breathless movement of the chase. The

hapless Orestes holds drawn sword, but avoids the Fury's gaze; instead he fixes on the snake in her lowered left hand, seemingly oblivious of the greater danger from above.

Excitement and peril are balanced by the stately, divine calm of the left half of the scene. Apollo, standing just behind his charge, holds up twin laurel branches in his left hand, with which the matricide will later be purified and, with the right, gestures his protection of Orestes from the Fury's onslaught. The god wears beneath his mantle an elaborately patterned sleeveless garment which may be identified with the *ependytes*, a cult vestment also known to have been used in stage productions. A laurel wreath crowns his hair, which falls in thick waves over the ears and long spirals over his shoulder. He is accompanied by Artemis, whose dress, too, is unusual and alludes to the religious aspect of the story, Orestes' necessary expiation of blood guilt. Over a thin chiton she wears a mantle drawn up over her head, like a priestess', and she has a broad fillet in her hair. The torch which she holds upright contains the Delphic fire known for its purificatory powers.

The reverse of the vase, like many in this period, is filled with an unambitious and sketchily drawn group of three young people in conversation. The woman in the center, her mouth open, turns to a youth holding out his walking stick, as a second youth with a similar stick looks on. The close-cropped, simple hair of these generic youths contrasts with the theatrical coiffures of the mythological figures of the principal scene.

In the two decades after its first production in 458 B.C., Aischylos' *Oresteia* trilogy inspired a number of vase-painters, though the fourth-century revivals of these plays in South Italy would have even more impact on the visual arts of their time than we find in

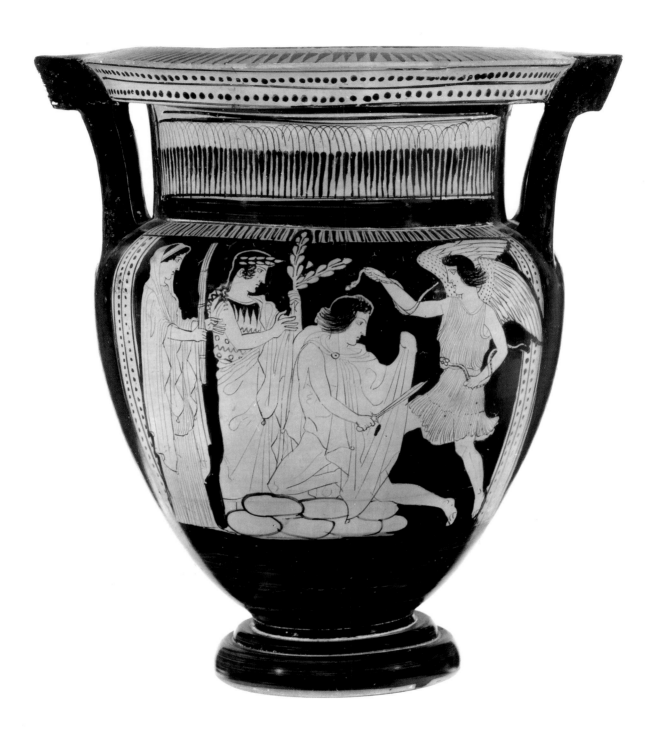

Athens itself. The San Antonio krater belongs to a group of a half dozen vases which illustrate the last moments of the *Choephoroi*, after the murder of Clytemnestra, and the first scene of the *Eumenides*, without, however, reproducing in faithful detail Aischylos' mise-en-scène. So, for example, Artemis does not figure in the Aischylean version, although another source says that she participated in the purification of Orestes. While Apollo's festive attire may well render a theatrical costume used in Aischylos' time, our Erinys surely bears little resemblance to those which Aischylos put on the stage. For his were of such horrible aspect, so the story went, that pregnant women in the audience suffered miscarriages. The beautiful, girlish Erinys on our vase is rather in keeping with a 'beautifying' trend in Attic red-figure of the Parthenonian Period, which turns even the Gorgons and Harpies into lovely girls. Her costume is that of a huntress—in another guise Artemis herself is shown wearing it—but the snakes of vengeance, once rendered as huge scaly monsters (in late black-figure) have been domesticated and attenuated. The rocks on which Orestes kneels, similarly rendered on other vases in this series, are somewhat ambiguous. Were he at Delphi, as in the opening scene of the *Eumenides*, we should expect a proper altar, any one of several types regularly depicted in vase-painting. It has been proposed instead that these are the "unwrought stones" in the sanctuary of the *Eumenides* in Athens, where Orestes later stood trial, and one of the other vases actually includes the figure of Athena. Thus, the scene on the San Antonio krater would conflate references to three distinct aspects of the myth: Orestes' pursuit by the Furies of his mother, his purification at Delphi, and his trial before a jury in Athens.

Beazley attributed our krater to the Naples Painter, a prolific artist who specialized in column-kraters, though he decorated other shapes too, in the years after the middle of the fifth century. Few of his compositions are as imaginative as ours, though a krater acquired not long ago by the Museum für Kunst und Gewerbe, Hamburg (Hamburg 1968.79) and very close to ours in the figure style and ornament, has a rather original rendering of Orpheus charming with his music three Thracian warriors, a turtle, and a rock.

HAS

DIMENSIONS: H. 38.1 cm.; Diam. of rim 29.3 cm.; Diam. with handles 33.7 cm.; Diam. of foot 14.5 cm.

CONDITION: Unbroken. Minor chipping on mouth interior. Small crack on B/A handle.

SHAPE AND DECORATION: The picture panel on each side framed by two rows of vertical dots between vertical lines, with tongue pattern above. On Side A, a row of thin inverted lotus buds fills the neck, separated by a black-glaze band from the tongues on the shoulder, while on Side B the neck is left plain. The rim is decorated with two rows of dots between glaze lines, the top of the mouth with a lotus chain; a large floral on each handle plate.

BIBLIOGRAPHY: *ARV²* 1907,21*bis*; *Para* 450; *Finarte* 5 (Milan Auction, 13–14 March 1963) lot 73; *The San Antonio Museum of Art: The First Ten Years* (San Antonio 1990) 66 (Side A; reversed); A.J.N.W. Prag, *The Oresteia* (Warminster 1985) 50 and pl. 32a; A. Kossatz-Deissmann, *Dramen des Aischylos auf westgriechischen Vasen* (Mainz 1978) 103–04 (esp. on the element of purification and the costumes).

LITERATURE: For other vases with Orestes and the Erinys, see Prag 48–51; for similar scenes on South Italian vases, see Kossatz-Deissmann 104–17. For the column-krater by the Naples Painter, Hamburg 1968.79, see H. Hoffmann, *Vasen der klassischen Antike* (Exh. Cat. Hamburg Museum 1969–1970) 30–31.

88

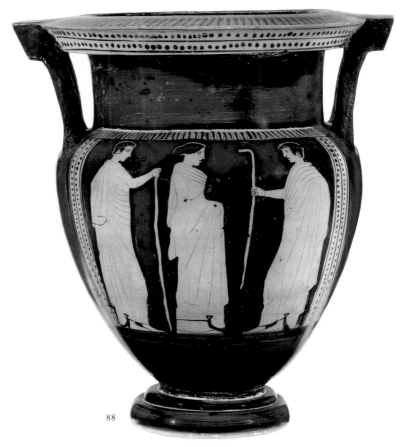

88

ATTIC RED–FIGURE LEKYTHOS
Workshop of the Achilles Painter and
the Phiale Painter
Ca. 440 B.C.
Gift of Gilbert M. Denman, Jr.
86.134.75
Artemis and Apollo

Artemis stands on the left in profile to
right. She holds the implements for li-
bation: a phiale in her left hand and a
black oinochoe in her right hand near
her waist. Dressed in a peplos, she
wears a diadem, and the end of her hair
is wrapped in a small piece of cloth at
back. Facing her is Apollo, who holds
out a phiale in his right hand and a lyre
in the left. He wears mantle and
wreath, and his long hair hangs down
over the shoulders. Behind him is a
Doric column which indicates an ar-
chitectural setting; probably we are
meant to imagine the interior of a tem-
ple or the area in front of one.

Apollo and Artemis preparing to
pour or pouring libations was a popular
scene on Attic vases of the fifth century
B.C. Many minor variations in compo-
sition on this simple yet somber theme
are known. Often Leto, their mother,
is also present, and the attributes for
each vary from vase to vase.

Although we do not know who the
painter of this vase is, the ornament and
shape of the vase clearly indicate that it
was made in the workshop of the
Achilles Painter and the Phiale Painter.
The shoulder ornament is of a type
used on many of the Phiale Painter's
red-figure lekythoi, while the orna-
mental bands found above and below
the picture field are types found on
lekythoi by both painters, and the foot
is by one of the potters who made
lekythoi for this workshop. JHO

DIMENSIONS: H. 41.1 cm.; Diam. of
mouth 7.5 cm.; Diam. of foot 7.6 cm.;
Max. Diam. 13.3 cm.; Diam. of shoulder
12.5 cm.
CONDITION: Restored from fragments.
Complete except for a few small frag-
ments. Considerable preliminary drawing.
No relief contour. Relief lines for lyre
strings. Black for details of lyre and oino-
choe. Dark dilute for strings of hairnet,
hems of peplos, and hem of Apollo's
sleeves.

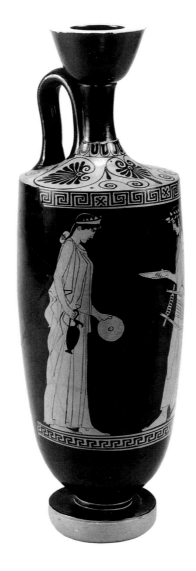
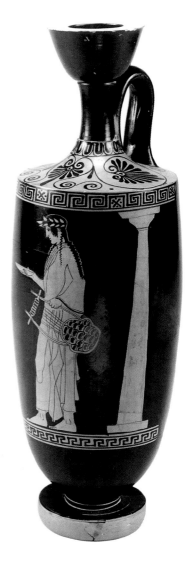

SHAPE AND DECORATION: Calyx mouth,
reserved on top; handle ovate in section;
disk foot with a groove near the top, re-
served on the outside and bottom, at-
tached to the body by a pad with grooves
on either side; three black palmettes with
dots, buds and tendrils on the reserved
shoulder; above the picture field a group
of three stopt meanders and saltire square
originating from the bottom, alternating
with a group of three stopt meanders and
a saltire square originating from the top
(this is the ULFA pattern which is typical
of many vases by the Berlin Painter and
his students, such as the Achilles Painter);
below, a running meander to the right.

BIBLIOGRAPHY: Christie's Geneva, 5
May 1979, lot 76; Sotheby's London,
6–7 May 1982, 81, lot 433.
LITERATURE: For the lekythoi from the
workshop of the Achilles and Phiale
Painters, see Kurtz, AWL 41–52; J. H.
Oakley, The Phiale Painter (Mainz 1990);
cf. ibid. fig. 14a for the same type of foot.
For Artemis and Apollo pouring libations,
see LIMC II 261–68 s.v. Apollo and
697–98 s.v. Artemis, with earlier bibliog-
raphy. For the hairstyle of Artemis, see
L. Byvanck-Quarles van Ufford, "La
coiffure des jeunes dames d'Athènes au
second quart du 5ème siècle av J.C.," in
Enthousiasmos 135–40.

ATTIC RED–FIGURE PLATE
Ca. 450–430 B.C.
Museum Purchase:
Grace Fortner Rider Fund
87.1
Interior: Head of a bearded man

The small plate, without overhanging or otherwise molded rim, is all black save for its decoration. Along the plate's rim, which is turned outward, is a black egg-pattern without border lines. In the central depression appears the head of a man, bearded and balding, looking left; his curly locks are clearly distinguished from the bulk of hair and beard. Wrinkles on his forehead speak also of his age.

Smaller than any other known example of this class, the so-called protofish-plates, this plate closely resembles one in Hannover (Kestner Museum 1986.258) showing a woman's head. Together, they are forerunners in shape to the later, much more numerous plates. These are usually decorated with fish, not in the central depression but on the slightly sloping surface. As is the case with the Hannover plate, the unidentified painter of the San Antonio plate has detached the head from the border of the medallion. In this, as in the potting, the two plates are different from other examples of the latter fifth century. A L–H

DIMENSIONS: H. 3 cm.; Diam. of rim 15.6 cm.; Diam. of foot 7.8 cm.
Conditon: Intact. Glaze worn slightly on underside.
SHAPE AND DECORATION: Three concentric rings in black glaze encircle a central dot on the underfoot. There are two holes in the foot to hang the plate on a wall, in which case the head would appear inverted.
BIBLIOGRAPHY: I. McPhee and A.D. Trendall, "Addenda to Greek Red-figured Fish-plates," *AntK* 33 (1990) 35–36.
LITERATURE: For the proto-fish-plates, see *GRFP* 28. For the more usual type of stemmed plates, see N. Alfieri, *Musei d'Italia-Meraviglie d'Italia* (Spina 1979) 94–96. For the Hannover plate see I. McPhee and A.D. Trendall 1990, 35. Compare also Sotheby's New York, 21–22 November 1985, lot 251, seemingly from the same workshop.

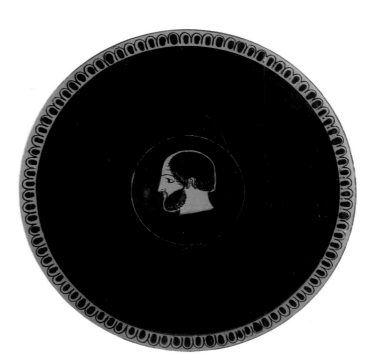

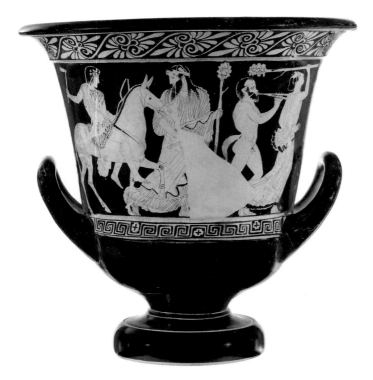

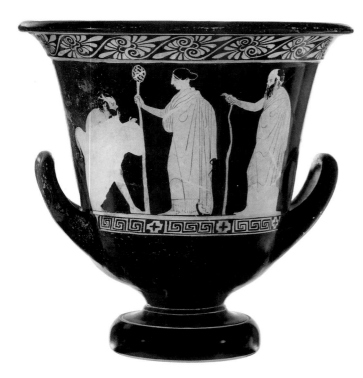

91

ATTIC RED-FIGURE
CALYX-KRATER
Curti Painter [M. Halm-Tisserant]
Ca. 440–430 B.C.
Gift of Gilbert M. Denman, Jr.
86.134.77
A: Return of Hephaistos
B: Satyrs and maenad

Hephaistos, mounted on a mule, is led back to Olympos by Dionysos and his cortège. Leading the procession on the right is a maenad in a peplos who throws her head back in excitement, holding a thyrsos horizontally above her head in the right hand. Her swirling drapery and left hand with fingers spread give further evidence of her state of mind. A thick band is visible on her forehead. Behind is a satyr who moves right, playing *auloi*. He is followed by the two gods. First is Dionysos who moves right, while looking back at Hephaistos. In his left hand he holds a thyrsos vertically, while in the right there is a kantharos of which only a part of the handle, lower body, and foot remain. He wears a chiton and mantle and has an ivy wreath and ribbon around his head. Hephaistos, obviously inebriated and immersed in the spirit of things, sits casually on the back of the mule, legs dangling freely, arms out to either side. In the left hand he holds a smith's tongs, and in the right a hammer, the tools of his trade. He wears a patterned tunic (*ependytes*), a mantle which runs diagonally across his chest and over his right shoulder and left arm, and an ivy wreath on his head.

On the back are two satyrs, one on either side of a maenad who stands in the center and faces left. She wears an earring, chiton and mantle, and holds a thyrsos in her right hand. Her hair is held in place by red strings. The satyr on the left stoops over, legs spread apart, posing as if he is about to make a sneak attack. His right hand is extended out, and the left is propped on his left knee. On the right a more elderly satyr stands facing left. He wears a mantle and a red wreath, and holds a staff in his right hand.

The return of Hephaistos was one of the most popular myths with Attic vase-painters, and there are over a hundred examples, almost equally divided between black-figure and red-figure.

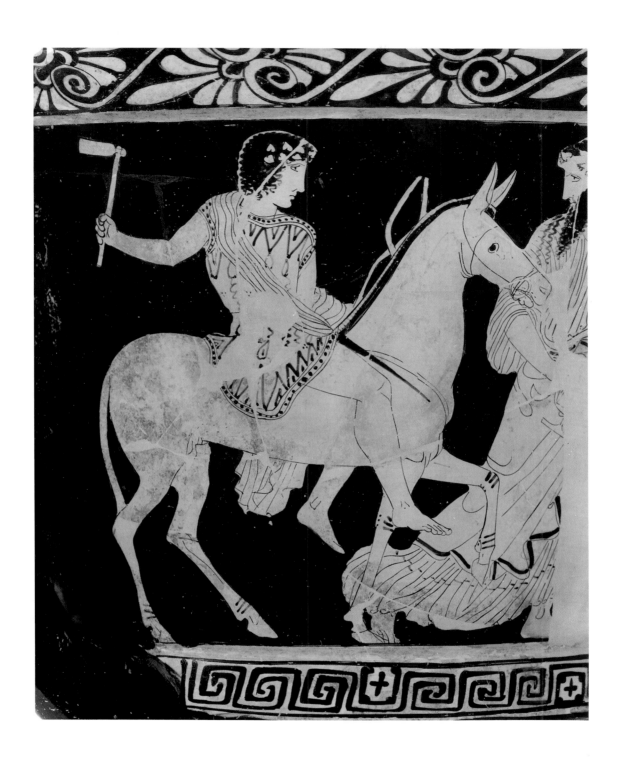

The earliest Attic depiction is probably that on the François vase of ca. 570 B.C. Here the procession comprises only half the scene, as the trapped Hera and other Olympian deities take up the rest. By the classical period usually only the procession is shown, and it is a much shortened and a more solemn affair. Hephaistos comes either on foot or on the back of a mule. He is sometimes beardless and, therefore, more youthful in appearance. His attributes can vary, but the tongs and hammer are common. Nearly the same composition and similar figures are found on a number of other vases by artists from the Group of Polygnotos; these scenes are based on Early Classical models.

The Curti Painter is related in style to the Peleus Painter, and both are members of the Group of Polygnotos. Eight vases by him are known, all large vessels, but this is his only calyx-krater. The Curti Painter liked Dionysiac scenes and those with processions, and he had a tendency towards scenes with violence and emotional involvement. His skyphos in Toledo also shows the return of Hephaistos, and the first three figures, Hephaistos, Dionysos, and a satyr playing flutes, are reminiscent of the same figures on this vase. On the right of the Toledo skyphos, however, are an enthroned Hera and an attendant who fans her instead of a maenad. Thus, there are two different versions of the same scene by the Curti Painter, an interesting phenomenon in view of the small size of his oeuvre. JHO

DIMENSIONS: H. 43.1 cm.; Diam. of mouth 42.2 cm.; Diam. of foot 18.1 cm.
CONDITION: Restored from fragments; lost are a large fragment from the center of the obverse with the lower parts of Dionysos, satyr, and the maenad's peplos; two large fragments from the reverse with most of the left satyr, the bottom of the right satyr, and half of the left handle; and other small splinters from both sides. One fragment from the rim above the right handle is restored and repainted. The foot is modern. An ancient mend with two sets of holes and a single hole from a third pair is located on the rim above the maenad on the right of the obverse. Parts of bronze staples remain in both the central set and the single hole on the right. Glaze peeled off in places, especially on the body above the handles. Preliminary drawing for both sides. Much relief contour only for Side A. Dark dilute glaze, A: stripes near the hems of the peplos and Dionysos's mantle, some interior marking of Dionysos's chiton, some of the markings on the mule, and the inner details of Hephaistos' tunic; B: details of thyrsos. Dilute glaze, A: some of the inner details of the maenad's peplos, interior anatomical details, and some interior anatomy of the mule; B: hems of mantle and lower interior of maenad's chiton.
SHAPE AND DECORATION: Rolled rim; upturned handles at either side below the cul-body join; restored disk foot attached to the body by a pad with an incised groove on either side; a slanting palmette frieze on the outside of the rim; two reserve bands 6.3 cm. apart on the inside of the rim; handle panels and inside of the handles in reserve; on the obverse below the picture an ornamental band with running meander and dotted cross-squares which originate alternately from the top and bottom; on the reverse running meanders alternating with dotted cross-squares.
ADDED COLOR: Red for wreaths of satyr and Hephaistos on Side A; satyr's wreath and hair-strings on Side B.
BIBLIOGRAPHY: *AntK* 29 (1986) pl. 1.1; *The San Antonio Museum Association Quarterly*, Winter 1987 (C.A. Picón), 18; *LIMC* IV 644 s.v. Hephaistos, no. 164b.
LITERATURE: For the return of Hephaistos, see F. Brommer, *Hephaistos. Der Schmiedgott in der antiken Kunst* (Mainz 1978) 10–17; Carpenter, *Dionysian Imagery* 13–29; M. Halm-Tisserant, "La représentation du retour d'Héphaïstos dans l'Olympe: Iconographie traditionnelle et innovations formelles dans l'atelier de Polygnotos (440–430)," *AntK* 29 (1986) 8–22; A. Schöne, *Der Thiasos* (Göteborg 1987) 24–27 and 253–63; *LIMC* IV 637–45 and 652–54 s.v. Hephaistos (A. Hermary and A. Jacquemin). For the skyphos by the Curti Painter, Toledo 82.88, see *CVA* (Toledo 2) pls. 84–87. See also E.G. Pemberton, "An Early Red-figured calyx-krater from Ancient Corinth," *Hesperia* 57 (1988) 227–35. For the Curti painter, see M. Halm-Tisserant, "Le Peintre de Curti," *REA* 86 (1984) 135–70.

92

ATTIC RED-FIGURE LEKYTHOS
Attributed to
the Klügmann Painter [J.R. Guy]
Ca. 425 B.C.
Gift of Gilbert M. Denman, Jr.
86.134.79
Amazon

On virtually all his lekythoi, the Klügmann Painter chose to put one single figure, nearly always a woman, a goddess or an Amazon, as on the San Antonio lekythos. Our Amazon wears a short dress over a garment with sleeves and trousers. Both are probably made of leather, hence this sort of pattern-work. They are complemented by shoes and an *alopekis* (Thracian cap) whose top overlaps the meander. The Amazon moves left and turns back, holding a spear horizontally. She lifts her shield, a Greek model seen from the inside.

The Amazon does not appear to be just a quotation from a battle-scene, but rather a manifestation of a martial woman in a special context. A rudimentary altar next to her right foot, as well as a bow on the wall (not an Amazon's bow), points to the realm of Artemis. We may compare the painter's lekythos in Solothurn on which the goddess inspects a deadly arrow. As an associate of Artemis, the Amazon becomes a messenger of the goddess's dark side.

The small altar almost becomes a distinguishing mark of the Klügmann Painter. It recurs with other Amazons and Muses. The San Antonio vase must belong to the final phase of this modest lekythos painter, who, before Beazley gave him his present name, was nicknamed the Amazon Painter. AL-H

DIMENSIONS: H. 34.4 cm.; Diam. of mouth 6.5 cm.; Diam. of body 9.8 cm.; Diam. of foot 6.6 cm.
CONDITION: Reconstructed from fragments. *Miltos*. Green discolorings on the body. No relief-contours.
SHAPE AND DECORATION: Lekythos of standard shape. On the shoulder five old-fashioned black-figure palmettes, linked

by tendrils (sub-Bowdoin-palmettes). On the front of the vase, touching the shoulder, a short running meander interrupted by two cross-squares with dots in each corner. As a base for the figure, also limited to the front, a reserved line.

BIBLIOGRAPHY: Sotheby's London, May 6–7 1982, lot 414.

LITERATURE: For the Klügmann Painter, see *ARV²* 1198–1200, 1686, esp. nos. 9–17; *Para* 462 and *Beazley Addenda²* 343.

For the leather dress, see G. Seiterle, *AntW* 16:3 (1985) 13 note 45. For the lekythos in Solothurn, see *ARV²* 1198,6; *Para* 462; *Antike Kunst aus Privatebesitz Bern-Biel-Solothurn* (Solothurn 1967) pl. 18 no. 128. For the connection of Artemis with Amazons, see *LIMC* I 644–45 s.v. Amazones (P. Devambez) with further references. See also C. Sourvinou-Inwood, "Altars with Palm-Trees, Palm-Trees and Parthenoi," *BICS* 32

(1985) 131–32. Also by the Klügmann Painter, not in *ARV²*: *CVA* (Palermo, Collezione Mormino I) pl. 6, 2; A. Adriani et al., eds., *Odeon* (Palermo 1971) pl. 75a. Perhaps also by the Klügmann Painter, but earlier, D. Bally, *Vases grecs du musée cantonal d'archéologie de Sion* (Martigny 1985) 17. For the shape and ornament of the Type BL lekythos, see Kurtz, *AWL* 15 and figs. 8c, 79.

93

ATTIC RED-FIGURE OINOCHOE
Attributed to the Painter
of Munich 2335 [A. Lezzi-Hafter]
Ca. 430–425 B.C.
Gift of Gilbert M. Denman, Jr.
86.134.81
Youth with spears pursuing girl

With the decoration of this type of
oinochoe, the Painter of Munich 2335
follows the trends of his time: he
shrinks the two-figure scene and pushes
it up to the concave neck, thus leaving
a plain black body. Over a band of
olive, a young man in traveller's cos-
tume and holding the two spears, ges-
tures with his right hand towards a girl
clad in a girded peplos. She holds out
her arms in desperation, and turns her
head back, recognizing that her flight
will be in vain.

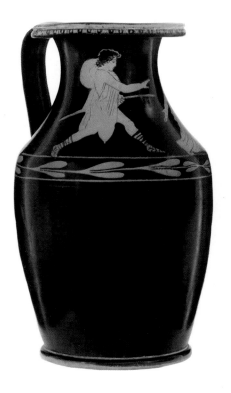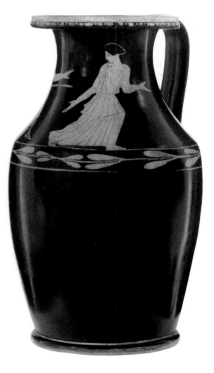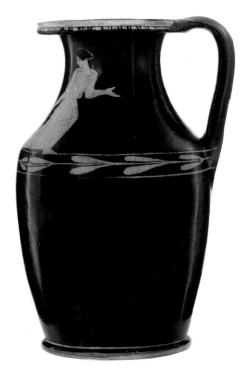

The interpretation of this quite common scene in Attic iconography of the Classical period is still somewhat controversial, because there are several readings. Even if one assumes the man to be Theseus, the woman remains anonymous. "Theseus" can, on the other hand, stand for a young Athenian in general, as the model hero in search of sexual fulfillment. By the same token, the pursued woman could be any Athenian girl who ventured too far from home and is now being hunted down. As the oinochoe, in all its different variations, is mainly a shape for women, one should be allowed to look at this picture from the female point of view. We know eight similar vases by the same hand; on five, the Painter of Munich 2335 depicted the same subject. They all might belong to a series of grave-oinochoai for girls, abducted before their time. AL-H

DIMENSIONS: H. 22.1 cm.; Diam. of mouth 9.6 cm.; Diam. of body 12.4 cm.; Diam. of foot 9.5 cm.

CONDITION: Reconstructed from fragments. The figures painted hastily without relief-contour.

SHAPE AND DECORATION: Oinochoe of Type V-A, with a three-edge handle. The San Antonio oinochoe is almost identical with Malibu L 80.AE.72B. Close also to one in Rome, Palazzo dei Conservatori M.A.I.84. For the earlier Type V-A, see the Florence Painter's oinochoe in San Antonio (Cat. No. 86). On the mouth, a dotted egg-pattern. Under the shoulder, two olive twigs meeting slightly to the right of center.

BIBLIOGRAPHY: Galerie Günter Puhze, cat. 5 (Freiburg 1983) 22, lot 200.

LITERATURE: For the painter, see *ARV²* 1161–70, 1685.1703, 1707, esp. nos. 110–14; *Para* 458–59; *Beazley Addenda²*

337–38. For two newly attributed oinochoai in Malibu (L 80.AG.72A and B), see *Greek Vases in the J. Paul Getty Museum* 1 (1983) 111, figs. 48–49. Palazzo dei Conservatori M.A.I. 84: A. Lezzi-Hafter, *Der Schuwalow-Maler* (Mainz 1976) pl. 24a. 155c, is close to Malibu L 80.AG.72B. Both are by the same potter, as is the San Antonio vase; moreover, both are decorated by the Painter of Munich 2335. For oinochoai Type V-A of this period, see Lezzi-Hafter 16–17, 34. For the iconography, see C. Sourvinou-Inwood, "Menace and Pursuit," in *Images et Société en Grèce ancienne* (Lausanne 1987) 41–55, esp. 44–48; and eadem, "A Series of Erotic Pursuits," *JHS* 107 (1987) 131–53, esp. 132–36 for the boy, and 136–40 for the girl. See also, E. Langlotz, "Der Sinn attischer Vasenbilder," in *Die griechische Vase* (Rostock 1967) 473–79.

94

ATTIC RED–FIGURE KYLIX
Attributed to the Eretria Painter
[D. von Bothmer]
Ca. 425–420 B.C.
Gift of Gilbert M. Denman, Jr.
86.134.80
Interior: Lyre-player and youth
A and B: Athletes and youths

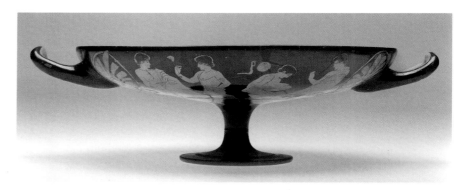

In the tondo stands a young man with
his lyre on a small platform, waiting to
receive a wreath of victory which a
companion is about to offer him. Both
youths are wreathed and wear the rich
Athenian himation worn on festive oc-
casions. The *plectron*, in added white,
hangs from the lyre, and is almost cov-
ered by the wreath, which might be a
sprig of laurel. Both the lyre and the
laurel tree are associated with Apollo.

The exterior sides each show two
athletes who are not totally absorbed in
their different occupations. Two hold
the discus, one an *akontion* or javelin.
They still find time to chat with their
admirers, all wrapped in himatia. Strigil
and aryballos, hung from the wall, indi-
cate the meeting place, the palaestra.

Scenes such as these are numerous
on drinking cups. While holding such a
cup the symposiast could sip in, with
the wine, the beauty of the naked boys
on the brink of manhood. The kylikes
were also meant as presents for the
ephebes themselves, when they had
successfully completed their education,
not only of the body but of mind and
soul, too.

The painter of this cup, the Eretria
Painter, is known as one of the major
cup-painters of the second half of the
fifth century B.C. (although his best
work is seen on other shapes). The
cup, as a vase type, was, in the late
420s, nearly at its formal end, and the
painter often repeated figures from
older repertoires. The Eretria Painter,
likewise, revived themes of his earlier
career. Another indication that this is a
late work is the difference in the qual-
ity of execution between interior and
exterior decoration. AL–H

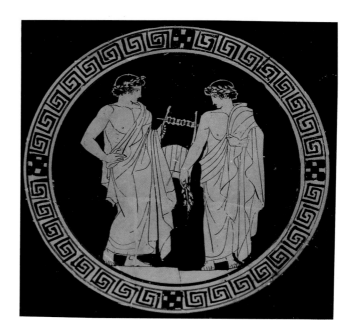

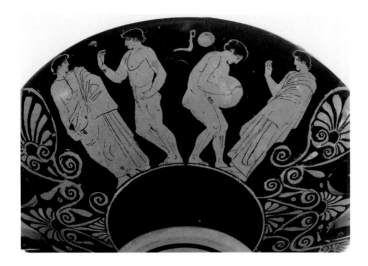

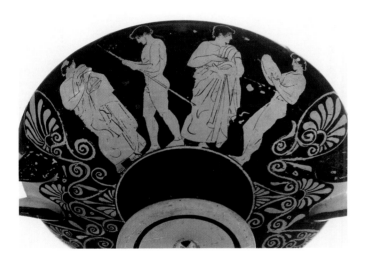

DIMENSIONS: H. 9.35 cm.; Diam. of rim 25.1 cm.; Diam. of foot 8.9 cm.

CONDITION: Reconstructed from fragments. Under the foot, a graffito: X; cf. A.W. Johnston, *Trademarks on Greek Vases* (Warminster 1979) 121,8D.

SHAPE AND DECORATION: Kylix of Type B, one of three types produced in a cupworkshop, in which the Eretria Painter was part of a team; cf. A. Lezzi-Hafter, 73. Around the tondo stopt meander with four dark checker-squares. Under each handle a palmette of acroterion-type with side-palmettes, rather rough in style and execution, partly contoured with relief-line, cf. Lezzi-Hafter 115.

BIBLIOGRAPHY: A. Lezzi-Hafter, *Der Eretria-Maler* (Mainz 1988) pl. 12, fig. 10e, no. 17.

LITERATURE: For the painter, see *ARV²* 1247–55, 1688, 1704, 1705, esp. 1252–55; *Para* 469–70, 522; *Beazley Addenda²* 176. For music-*agones* of young men, see I. Scheibler, "Bild und Gefäss," *JdI* 102 (1987) 108 and the column-krater Ferrara T 715, F. Berti and D. Restani, eds., *Lo specchio della musica* (Bologna 1988) 74, no. 19; for the wreath, see M. Blech, *Studien zum Kranz bei den Griechen* (Berlin 1982) 123, 238–42. On cups as presents, see G. Seiterle, *AntW* 19 (1988) 10. For older cups by the Eretria Painter with similar themes, see Lezzi-Hafter, pls. 15–16. For the acroterion-type, see P. Jacobsthal, *Ornamente griechischer Vasen* (Berlin 1927) 128–32.

95

ATTIC RED–FIGURE
CALYX–KRATER
Manner of the Kadmos Painter
[H.A. Cahn]
Ca. 420–410 B.C.
Gift of Gilbert M. Denman, Jr.
85.120.2
A: Sacrifice in a sanctuary of Apollo
B: Satyr and maenads

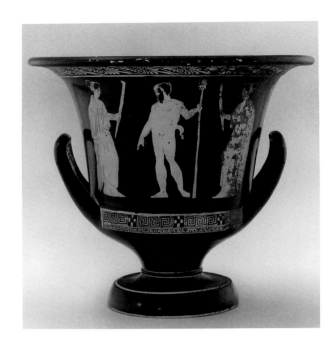

In the middle of Side A, slightly off center, is an altar with volutes and egg molding; on top sits a tray with a stack of burning wood. On the left stands a youth holding out a cup in his right hand from which he pours libation above the altar. His left hand and staff are at his side. Behind him at a lower level is a youthful *splanchnoptes* (one who roasts entrails) moving left, looking around. He holds a spit with entrails diagonally across his body. Another *splanchnoptes* stands to the right of the altar in a three-quarter view, holding the entrails over the altar to cook them. On the upper left of the scene sits a youth with staff next to a tripod. The lower part of both are hidden by the landscape setting. Another tripod atop an Ionic column is visible behind the altar. To the upper right are three more figures. First is Apollo who sits to the right, but turns his head to the left. In his right hand he holds a laurel branch diagonally. His left arm supports a lyre from which a ribbon hangs: both are common attributes of this god. Beneath his feet sits a hydria. Next is a youth in profile to the left playing *auloi*. Behind him, above the right handle of the vase, is a satyr who turns right, looking around. His arms are out at his sides, which along with the tilted head gives the impression that he is surprised by what he sees taking place. His lower shanks are hidden by landscape. All the figures except the satyr have wreaths, and all wear mantles except for the satyr and *splanchnoptai*.

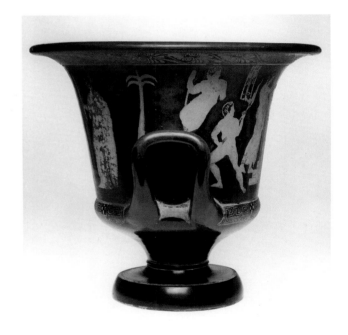

On the reverse a satyr stands nearly frontally in the middle with an upright thyrsos in his left hand. On either side is a maenad in profile who holds a torch in the right hand and faces him. Each wears a chiton, mantle, and earring; their hair is bound in back. To the upper right above the left handle is a palm tree.

The scene on A shows an offering at a sanctuary of Apollo. Other Apollonian elements besides the god himself are tripods and palm tree. Apollo was a god of music, which is underscored by his lyre and the youth playing auloi. Tripods were erected in connection with victories in dithyrambic contests associ-

ated with Apollo and Dionysos. The satyr on the far right hints at a connection with Dionysos and serves as a link with the satyr and maenad on the back of the vessel who neatly balance the vase: Apollo on one side, Dionysos on the other. The hydria beneath Apollo may also be a prize, or it may either hold water for putting out the fire or for cleansing the animal before it was sacrificed. It might also hold water to cleanse the *splanchnoptai* after the sacrifice. It has been suggested that the scene shows Xuthos making an offering at Delphi, where he had gone to learn why he and Kreusa had not been able to produce children, and that the scene is due to the influence of a contemporary play of Euripides, *Ion*, in which the story is fully told. Although this is an attractive suggestion, offering scenes were popular at this time, a number of which include Apollo, and there is nothing which clearly connects the scene with the play or story. The one slight hint of a connection between the two are the satyrs and maenads who could refer to a play performed at a festival of Dionysos.

The vase is in the Manner of the Kadmos Painter, an artist who was named from a scene of Kadmos slaying the dragon on a hydria in East Berlin (F 2634). There are similarities between scenes and figure types by this painter and those found on the San Antonio krater (cf. the sacrifice scene on Ruvo Jatta, 1093 and the satyrs on Munich 2360), but the details of drawing clearly indicate that this vase is not by the master himself. Tripods, which are often in scenes by the Kadmos Painter, are present, but drawn differently (cf. Bologna 301 and 303). Ian McPhee (in personal communication) has noted similarities in style between our vase and kraters in Salerno and Taranto. The ornament on the former is the same as ours, and that on the latter similar. JHO

DIMENSIONS: H. 37 cm.; Diam. of mouth 40 cm.; Diam. of foot 18.8 cm.
CONDITION: Intact; surface is badly abraded and many of the interior details of drawing are lost. Traces of preliminary drawing for Sides A and B visible. Much relief-contour for Side A only. Dark dilute glaze for molding on altar, stack of wood, and *kollopes* (tuning pegs) of lyre. Dilute glaze for pubic hair of satyrs and hair on their lower abdomens.

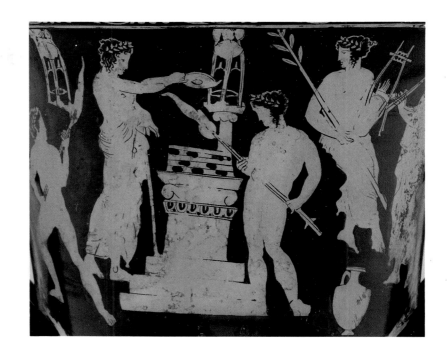

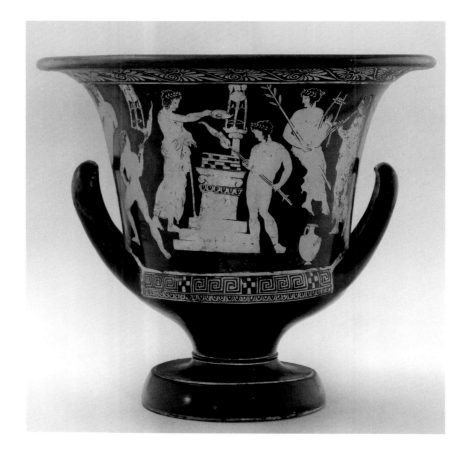

SHAPE AND DECORATION: Rolled rim; upturned handle at either side; disk foot with sloping top attached to the body by a pad with an incised groove on either side; two reserved bands 5.2 cm. apart on the inside of the rim; a frieze of slanting palmettes around the vase on the outside of the rim, inside of handles and the panels in reserve. Running between the handles on the cul beneath the scene on each side is an ornamental band with running meanders alternating with checkerboard squares above an egg band with dots in the interspaces. The lower .3 cm. of the outside of the foot and the bottom are reserved.

ADDED COLOR: Red for Side A, leaves of wreath of the youth seated on the upper left, traces of fire on the altar, and the ends of the palm leaves.

BIBLIOGRAPHY: Münzen und Medaillen, Basel, Auktion 56 (19 February 1980) no. 107; *AntK* 23 (1980) 104–05; F. Brommer, "Satyrspielvasen in Malibu," *Greek Vases in the J. Paul Getty Museum* 1 (1983) 120, no. 348; *LIMC* II 298 s.v. Apollon, no. 955; K. Schefold and F. Jung, *Die Urkönige, Perseus, Bellerophon, Herakles und Theseus in der klassischen und hellenistischen Kunst* (Munich 1988) 77–79, fig. 88.

LITERATURE: For the iconography, see V. Lambrinudakis et al., *LIMC* II 298–99 s.v. Apollon. On offering scenes, see F. van Straten, "Greek Sacrificial Representations: Livestock Prices and Religious Mentality," in *Gift to the Gods. Proceedings of the Uppsala Symposium 1985*, T. Linders and G. Nordquist, eds. (Uppsala 1987) 159–70. On *splanchnoptai*, see *CVA* (Bonn 1) 40–41 and G. Rizza, "Una nuova pelike a figure rosse e lo '*splanchnoptes*' di Styppax," *ASAthene* 37–38 (1959–60) 321–45. For the Kadmos Painter, see I.D. McPhee, "Attic Vase-painters of the Late 5th Century B.C." (diss., University of Cincinnati, 1973) 51–110. The Salerno Krater, 28443: E. Galasso, *Tra i Sanniti in terra Beneventana* 1983, 60–61; for Taranto krater, 52.399, see *ARV²* 1337,4; *JHS* 70 (1950) 38, fig. 3. Cf. Vienna 1024 (*ARV²* 1152,8) for a contemporary calyx-krater where the figures on the reverse are also set on a groundline well above the cul. For the close association of Apollo and Dionysos at this time, see A. Queyrel, "Scènes Apolliniennes et Dionysiaques du peintre de Pothos," *BCH* 108 (1984) 123–59, esp. 156–58. For prize tripods, see H. Froning, *Dithyrambos und Vasenmalerei in Athens* (Würzburg 1971) 16–28. For hydriae as prizes, see E. Fölzer, *Die Hydria* (Leipsig 1906) 13–15 and E. Diehl, *Die Hydria* (Mainz 1964) 24, 32, 155, 176–81, and 195.

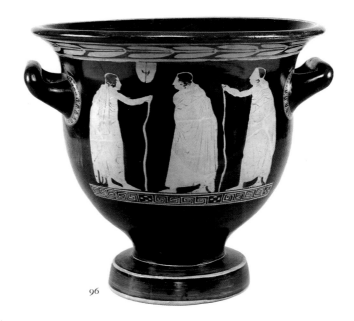

96

96

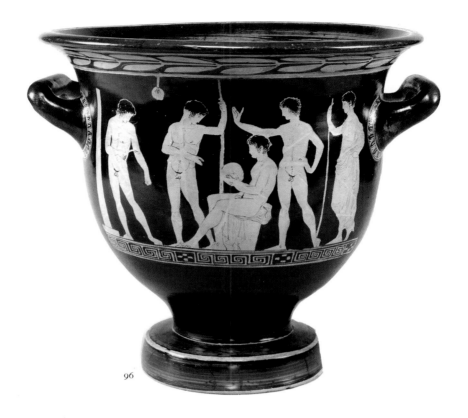

96

96

ATTIC RED-FIGURE
BELL-KRATER
Attributed to the Nikias Painter
[I. McPhee]
Ca. 420–410 B.C.
Gift of Gilbert M. Denman, Jr.
86.134.78
A: Athletes
B: Youths

On the front are four athletes in a
palaestra setting, and a mantled youth
who observes from the right. A youth
holding a discus sits to the left in the
center atop a folded mantle on a block
seat. Two other athletes, posed simi-
larly to each other, stand on the left.
One scrapes himself with a strigil; the
other holds a javelin in his left hand
and gestures in conversation with the
right hand to the seated *discophoros* (dis-
cus-thrower). To the right is a fourth
athlete who gestures in conversation
with his right hand, the left hand
propped on his hip. The mantled youth
stands with his right leg drawn back,
supporting himself with the staff he
holds in the right hand. All have head-
bands in added white and red. The pil-
lar on the far left and the aryballos (and

strigil?) hanging on the upper left indi-
cate a palaestra setting.

There are three mantled youths on
the reverse. The two outer ones face
in, and each holds a staff in his right
hand. The central one stands to the left.
All have headbands in added white,
now lost. A pair of *halteres* hangs on the
upper left between the central and left
youth.

The Nikias Painter takes his name
from a bell-krater in London (London
98.7–16.6) which is signed by the pot-
ter Nikias, son of Hermokles, of the
deme Anaphlystios. Athletes are com-
mon figures on Attic red-figure vases
of the late fifth and early fourth century
B.C., and another multi-figured scene
of athletes is found on a bell-krater by
the Nikias Painter in Vienna (Vienna
1034). Forty-four vases are known by
this artist, more than half of which are
bell-kraters, his favorite shape. Similar
ornament to that on this vase is found
on a number of these (cf. *ARV²* 1333–
34,7, 11, 18, 19, and 20). The painter
had a preference for compositions
which focus on a central lower point,
the *discophoros* in this case. JHO

DIMENSIONS: H. 37.4 cm.; Diam. of
mouth 41.2 cm.; Diam. of foot 19.8 cm.

CONDITION: Recomposed from frag-
ments. Restored with some repainting: a
large fragment from the middle of Side B
giving the lower part of the left youth's
staff and a section of the mantle of the
central youth is lost; parts of the handles
restored; other small fragments giving
parts of Sides A and B are missing; mis-
fired on the inside; surface abraded in
many places so that the details of drawing
are lost. Preliminary drawing and much
relief-contour for Side A only. Dark di-
lute glaze for pubic hair and hair on
lower abdomen.

SHAPE AND DECORATION: Rolled rim,
upturned handles at either side; spreading
foot; a wreath pattern going left on the
exterior of the rim, two reserve bands 7.5
cm. apart on the inside; a dotted egg pat-
tern runs around the outer two-thirds of
each handle root; handle panel left in re-
serve; pattern band with running mean-
ders alternating with checkerboard
squares below A and B; a reserve band
marks the top outer corner of the foot,
the lower .5 cm. and bottom left in re-
serve.

BIBLIOGRAPHY: Galerie Günter Puhze,
cat. 5 (Freiburg 1983) 21, no. 191.

LITERATURE: For the Nikias Painter, see
J. H. Oakley, "A Calyx-Krater in Vir-
ginia by the Nikias Painter with the Birth
of Erichthonios," *AntK* 30 (1987) 123–30,
with earlier bibliography.

97

ATTIC RED-FIGURE
BELL-KRATER
Near the Painter of London F 64
[I. McPhee]
Ca. 380 B.C.
Gift of Gilbert M. Denman, Jr.
85.120.1
A: Centauromachy
B: Athletes

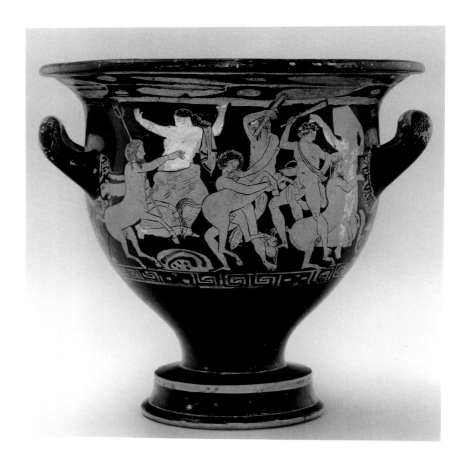

Drunken centaurs at the wedding of
Perithoos attempt to run off with Lap-
ith women. On the left a wreathed
centaur with a branch over his left
shoulder and an animal skin hanging
from the left arm pursues a fleeing Lap-
ith woman. Clearly distressed, she runs
right, arms up and out, while looking
back toward her pursuer. A mantle
hangs over her left arm and around her
lower body, and she wears a diadem.
Below is a cushion. In the center Peri-
thoos wrestles with another wreathed
centaur who attempts to push him
away with a left hand to the chin,
while preparing to strike him with the
torch he holds above in his right hand.
Perithoos, his mantle fluttering in the
background, has both arms locked
around the body of the centaur. Both
wear a white headband. On the right
are three other figures. First is Theseus
who grabs the hair of a third centaur
with his left hand, while preparing to
strike him with the club he holds up in
the right. Theseus wears chlamys and
wreath, the centaur a wreath. Behind
Theseus is a basket which is part of the
debris from the disturbed wedding
feast. The centaur, meanwhile, tries to
run off with the Lapith woman he
holds aloft in his arms. She reaches
back toward Theseus with her right
hand; her left is raised in the air. She
wears a gold chiton and a mantle.

Three athletes are shown on the re-
verse. The one on the left faces right
with the left hand extended; most of
the right hand disappears by the orna-
ment around the handle root. The cen-
tral athlete stands nearly frontally, look-
ing right. He holds a staff in the left
hand and in the right what may be ei-
ther an aryballos, somewhat too large,

or a bag with a disk. The athlete on the
right faces left, his left hand raised in
the air in conversation. Above him on
the right hangs a sponge. All three ath-
letes wear headbands.

Theseus, helping to fight off the
drunken centaurs at the wedding feast
of the Thessalian king of the Lapiths,
Perithoos, first appears on Attic vases
around 460 B.C. This vase is one of the
latest examples, and centauromachies of
any sort are relatively rare on fourth-
century Attic red-figure vases. The
centaur whom Theseus is about to dis-
patch is probably Eurytion, and the
Lapith woman the centaur carries Hip-
podameia (Deidameia in some sources),
Perithoos' bride. The manner in which
Theseus' chlamys falls and the way in
which he grabs the hair of the centaur

are common motifs in depictions of
this scene, and the picture on our vase
may have been influenced by a lost
wall painting. Earlier versions often
have more of the utensils and furnish-
ings for the feast scattered about.

The Painter of London F 64 is
known to have decorated only nine
bell-kraters. He drew scenes almost ex-
clusively dealing with the hero Herak-
les, and Herakles and Nike in a chariot
are found on five of these vases. The
athletes on the back of our vase are
very similar to those on the back of a
krater formerly on the Basel Market
(ARV^2 1420,8), and the shape and or-
nament are similar to others by him
(London F64; Ruvo, Jatta, 422, ARV^2
1420,8). JHO

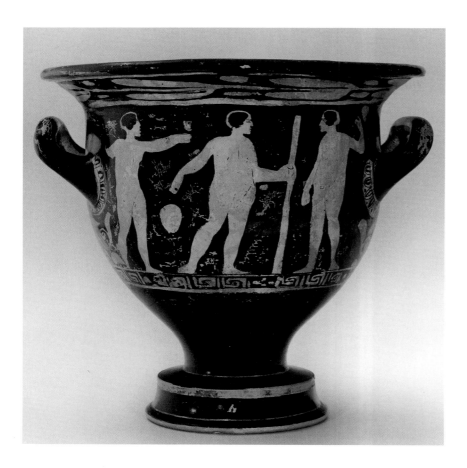

DIMENSIONS: H. 40 cm.; Diam. of mouth 41.5 cm.; Diam. of foot 20.1 cm.

CONDITION: Restored and repainted in places. Missing are one large fragment giving the head of the right hand Lapith woman and a number of small fragments from Side A; Side B was greatly restored and a number of fragments are lost. Preliminary drawing and much relief-contour for Side A only. Dark dilute glaze, A: ornamental band near hem of first woman's mantle and decoration of pillow. Dilute glaze, A: hair, details of skin worn by the first centaur, and some of the anatomical details. Golden dilute glaze, A: chiton of right Lapith woman and some anatomical details.

SHAPE AND DECORATION: Rolled rim; upturned handles at either side; foot in two degrees, a slightly concave offset on the top of the exterior of the upper degree, the lower splays out at a greater angle on top and is rounded; two reserve

bands 5.6 cm. apart run around the inside of the rim; the bottom of the inside is left in a reserve circle; an olive wreath pattern to the left on the outside of the rim; egg pattern around the lower root of each handle; handle panels partially in reserve; a palmette above a lyroid with tendrils and buds beneath each handle extends into and fills most of the handle panel; a band with groups of three or more stopt meanders alternating with a checkerboard square below the picture field and running around the vase; a reserve band at the top of the outside of the foot, the lower .7 cm. and bottom left in reserve.

ADDED COLOR: White for Side A, flesh of women, diadem of first Lapith woman, wreaths, headbands, and leaves on the first centaur's branch. Red for Side B, headbands.

BIBLIOGRAPHY: Münzen und Medaillen, Basel, Auktion 60 (21 September 1982) no. 38.

LITERATURE: For the iconography, see *CB* iii 85–87; B. B. Shefton, "Herakles and Theseus on a Red-figured Louterion," *Hesperia* 31 (1962) 330–68; *Vasenlisten*[3] 223–24; F. Brommer, *Theseus. Die Taten des griechischen Helden in der antiken Kunst und Literatur* (Darmstadt 1982) 104–10; B. Cohen, "Paragone: Sculpture versus Painting, Kaineus and the Kleophrades Painter," in *AGAI* 171–92; K. Schefold and F. Jung, *Die Urkönige: Perseus, Bellerophon, Herakles, und Theseus in der klassischen und hellenistischen Kunst* (Munich 1988) 264–71 and M. Prange, *Der Niobidenmaler und seine Werkstatt* (Frankfurt 1989) 99–101. For a new bellkrater by the painter which has recently come on the art market, see Sotheby's London, 12 December 1988, lot 134. For two others which are probably also by him see Sotheby's London, 11 December 1989, lots 124 and 126.

ATTIC WHITE-GROUND LEKYTHOS
Bird Group; Manner of
the Bird Painter
Ca. 440–430 B.C.
Gift of Gilbert M. Denman, Jr.
86.134.84
Youth and woman at a tomb

A stele with a palmette and volute finial stands in the center. The remains of two ribbons in bright red are tied around it; the base is lost. On the left stands a youth in chitoniskos and mantle who probably represents the deceased. His right leg is frontal, the left in profile; the right arm is akimbo, and he holds a spear upright in the left hand. On the right a woman in chiton stands facing left. In her hands she holds a bright red ribbon, which she is about to place at the tomb.

The motif of two people at a tomb, one on either side of it, is the most popular scene on classical white-ground lekythoi. It was championed by the Achilles Painter, who determined the course of the development of the white-ground lekythos. The painters of the Bird Group, to which this vase belongs, were greatly influenced by the Achilles Painter, but Beazley often had trouble determining the exact hand to which individual vases belonged. He isolated three major groups: the Bird Painter, Manner of the Bird Painter, and the Carlsberg Painter (*ARV²* 1231–36). A sarcophagus found in Anavysos with twelve white-ground lekythoi complicated the picture further. Beazley at first thought that they were all

fine, late works by the Bird Painter (*ARV²* 1687–88), but later hesitated about some of them (*Para* 467). Our vase is best paralleled with respect to ornament and style by a finer, more Achillean vase from this sarcophagus (*ARV²* 1687,1) and by larger vases listed as in the Manner of the Bird Painter (cf. New York 06.1021.137). A woman depicted with left leg drawn back is a popular pose in the Bird Painter's works (Harvard 59.221 and Cab. Med. 503), while the youth is reminiscent of figures by the Achilles Painter (e.g. Chicago 07.20), as is the composition of the scene. This vase is of finer quality than most from the group. JHO

DIMENSIONS: H. 38.4-8 cm.; Diam. of mouth 6.6 cm.; Diam. of foot 6.6 cm.; Max. Diam. of body 10.6 cm.; Diam. of shoulder 10.2 cm.

CONDITION: Intact, except for part of the handle which is restored; white-ground surface abraded and color and picture lost in places; slight misfiring of the neck and mouth. There may be a false bottom, but the mouth of the vessel has been closed with a metal pin which prevents confirmation of its existence, and there is no sign of the customary firing hole. No preliminary drawing. Dilute for vertical lines bordering the upper pattern band and the line below the picture field.

SHAPE AND DECORATION: Standard cylindrical lekythos: calyx mouth, reserved on top; handle ovate in section; disk foot with a groove near the top, joined to the body by a pad with grooves on either side, outside and bottom in reserve; on the shoulder, beneath a dotted

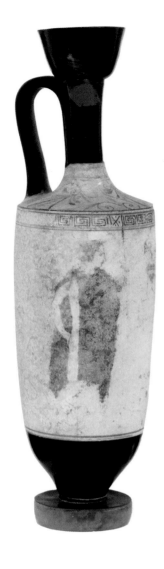

egg pattern are three palmettes with leaves in dark matt red and bright red connected by volutes with buds at the joins (cf. Athens 19333: *ARV²* 1687,1; Kurtz *AWL* Fig. 24b); above the picture field an ornamental band with groups of three stopt meanders alternating with saltire squares (cf. Oxford 544); below, a line.

ADDED COLOR: Matt red for all outlines, hair, mantle of youth, the interior folds of the woman's chiton, meanders and saltire squares of the upper ornamental band, and the shoulder palmettes, less the parts in bright red. Bright red for the first, fourth, sixth and ninth leaf of each palmette from left to right, the heart of the palmettes and the leaves at the joins of the tendrils. Matt black for tip of spear.

BIBLIOGRAPHY: Summa Galleries, Inc., cat. 4 (Beverly Hills 1978) no. 13 and back cover.

LITERATURE: For the Bird Group, see Kurtz, *AWL* 52–56; F. Felten, "Weiss-grundige Lekythen aus dem Athener Kerameikos," *AM* 91 (1976) 99–103; and E. R. Williams, *The Archaeological Collection of the Johns Hopkins University* (Baltimore and London 1984) 180–83. For the grave stele, see N. Nakayama, *Untersuchung der auf weissgrundigen Lekythen dargestellten Grabmäler* (Freiburg 1982). For his type D-III, of which the San Antonio Lekythos is a member, see 93–118.

99

ATTIC WHITE-GROUND
LEKYTHOS
Attributed to the Woman Painter
[D.C. Kurtz]
Ca. 430–420 B.C.
Gift of Gilbert M. Denman, Jr.
86.134.170
Youth and woman at tomb

A stele with palmette finial above an egg molding stands behind a *tymbos* (mound) on a base in the center. To the right and left of the finial hangs a red ribbon, mostly lost. A faded red ribbon hangs around the shaft, and the mound is also decorated with red ribbons, now mostly lost. On the left is a youth in profile to the right. He stands motionless with his head tilted slightly down; his arms are hidden beneath his mantle. Very likely he represents the deceased. Opposite him, on the other side of the tomb, is a woman who stands to the left, feet and face in profile, torso and legs in three-quarter view. She is mourning, as indicated by the position of her hands: right extended, palm up, towards the tomb, the left arm bent, the hand moving towards her head. The original coloring for the garments is lost; only the outlines remain.

The Woman Painter was named for the beauty of the women he depicted. There are now nearly thirty vases by him known, all white-ground lekythoi. At this time most painters of white-ground lekythoi specialized in decorating only this shape. Nearly the same number of vases exist in his manner, and it is often difficult to tell to which group a particular vessel belongs. The Woman Painter was fond of mourning figures, hands to heads as here (cf. Berlin 3372, Athens 1956 and Dresden ZV 2038), and his compositions often consist of two, but sometimes more figures. All have funerary iconography, the vast majority scenes at a tomb.

Ours is an early work. If we had only the figure of the woman, we might think the vase was connected with the Painter of Munich 2335 or the Bird Group—there are some similarities among the works of all three. The stele with palmette finial above an egg molding, however, is drawn almost exactly as others by the Woman Painter (cf. Berlin 3372 and Athens 1799). The head of the youth compares well with that of the woman on his most famous lekythos, the one in Carlsruhe (Carlsruhe 234), as does his drapery with that of a youth on a lekythos in Athens (Athens 12534). The subsidiary ornament is typical of the Woman Painter. These indicate that the vase should be securely attributed to the painter's hand, not his manner. JHO

DIMENSIONS: H. 29.9 cm.; Diam. of mouth 5.1 cm.; Diam. of foot 5.2 cm.; Max. Diam. of body 8.1 cm.; Diam. of shoulder 8 cm.
CONDITION: Intact except for the neck and foot which are reattached; the coloring for the garments and most other details are lost; the white slip is lost in places; small chips are missing from the rim; lower body is slightly misfired. No preliminary drawing. Dilute glaze for vertical lines bordering the upper ornamental band and the line beneath the scene.
SHAPE AND DECORATION: Standard cylindrical lekythos; calyx mouth, reserved on top; handle ovate in section; disk foot with a groove near the top, reserved on the outside and bottom; groove at join of foot and body. On the shoulder are three palmettes with rounded hearts and alternating petals in matt red/brown and bright red which are connected by volutes: Kurtz's Type II A (*AWL* fig. 23c). Beneath the body-shoulder join is a band of stopt meanders between sets of parallel lines (cf. Louvre CA 1329); below the scene is a broad, glaze line.
ADDED COLOR: Matt red/brown for the meander and the entire shoulder ornament except for the alternating leaves in bright red. Matt red for hair and all outlines of the picture. Bright red for alternating palmette leaves of the shoulder ornament and ribbons on the grave.

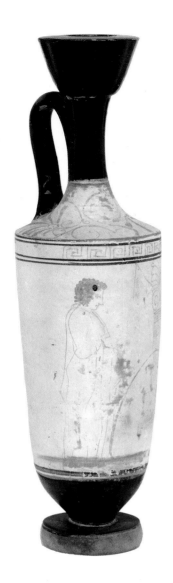
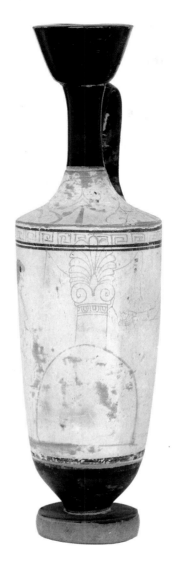
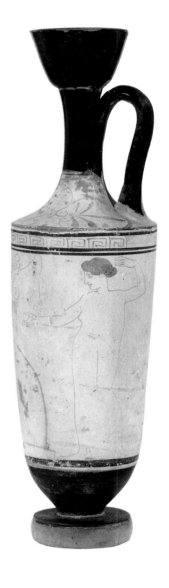

BIBLIOGRAPHY: Christie's London, 13 July 1983, lot 249; Christie's London, 16 July 1985, lot 407.

LITERATURE: For the Woman Painter, see Kurtz, *AWL* 57; F. Felten, "Weiss-grundige Lekythen aus dem Athener Kerameikos," *AM* 91 (1976) 105–08. For grave monuments on white-ground leky-thoi, see N. Nakayama, *Untersuchung der auf weissgrundigen Lekythen dargestellten Grabmäler* (Freiburg 1982). The San Antonio lekythos is an example of Naka-yama's Type D-III; for this type, see 93–118. For the woman's profile, see *ARV²* 1372,18 and 1373,25; for the scene, see Cat No. 100.

PARALLELS: Berlin 3372: *ARV²* 1371,2; Athens 1956: *ARV²* 1371,3; Dresden ZV 2038: *ARV²* 1373,25; Athens 1799: *ARV²* 1372,10; Carlsruhe 234: *ARV²* 1372,17; Athens 12534: *ARV²* 1373,21; Louvre CA 1329: *ARV²* 1372,20.

AN INTRODUCTION TO THE SOUTH ITALIAN VASES

Apulian

The San Antonio collection as yet includes no Apulian vases from the earliest phase of that fabric, but three may be assigned to Middle Apulian in the second quarter of the fourth century B.C. All are bell-kraters of the so-called "plain" style, two by the Painter of the Long Overfalls, Cat. Nos. 102 and 103, and one by the Dechter Painter, Cat. No. 104. The volute-krater, Cat. No. 105, looks to be associated with, if not actually by, the Varrese Painter, and makes the transition from Middle to Late Apulian. The rest all belong to the second half of the century and thus may be classed as Late Apulian. In that period there appear to be two main schools of vase-painting, one associated with the workshop of the Darius and Underworld Painters and their followers, the other with that of the Baltimore and White *sakkos* Painters. The former was probably located at Taranto and the latter at Canosa, to judge from the large number of its products which have been found in that area. From about 350 B.C. onwards, the distinction, which earlier was very clearly marked, between the so-called "Plain" and "Ornate" styles begins to fade out, although it never entirely disappears. The bell-krater, Cat. No. 107, is a good illustration of how, in the late fourth century, the general principles on which the "Plain" style had been based still continue (simple compositions on a single level, absence of elaborate ornamental decoration, etc.), but the increasing influence of the "Ornate" is visible in the greater use of added white and yellow for various adjuncts and for decorative elements. The contrast, however, with the much more elaborately decorated vases of the "Ornate" style, with their more liberal use of added colors, is well illustrated by the Baltimore Painter's amphora, Cat. No. 110. In the second half of the fourth century B.C. the larger vases of the "Ornate" style frequently depict funerary scenes with a *naiskos* on one side and a stele on the other, each surrounded by a group of mourners, not necessarily relatives of the deceased, though these often appear within the *naiskos* itself, since they all look remarkably alike and appear to be the same age. They may well be initiates of some cult, with offerings in support of the deceased fellow-member. The *naiskos* itself usually consists of a shrine-like structure (see Hans Lohmann, *Grabmäler auf unteritalischen Vasen*, Berlin 1979) with engaged Ionic columns and shallow side-walls; the ceiling-beams are often shown and the structure is usually crowned by a pediment with acroteria. It stands on a base normally decorated with ornamental motifs. Within it are one or more figures, or occasionally only objects associated with the cult of the dead. The figures, which represent the deceased, often together with one or more members of his family or a servant, are normally painted in added white (with additional colors for drapery, etc.) to simulate the marble or stuccoed limestone of the actual monuments; sometimes, however, the deceased may appear in red-figure, but this normally occurs only on the reverses of

large funerary vases. The obverse of the amphora, Cat. No. 110, provides a typical example of such a *naiskos*; on the reverse it contains an elaborate floral structure instead of human figures. Otherwise the larger vases are commonly decorated with multi-figured compositions illustrating a wide range of mythological subjects, often connected with the themes of Greek tragedy. With the workshops of both the Darius and the Baltimore Painters are also associated large numbers of vases of small dimensions, decorated with single- or two-figure compositions and often only with a female head. From ca. 350 B.C. onwards the production of red-figured vases in Apulia increases rapidly and the workshops must have employed a large number of what have been described as "well-drilled hacks," turning out hundreds of vases very uniform in style and decoration. Of such minor vases, Cat. No. 109 is a good example. In Late Apulian, therefore, while many artists emerge as well-defined personalities, others can be regarded only as mass-producers, almost impossible to identify as individuals.

Campanian

Only three Campanian vases are at present in the San Antonio collection, a bail-amphora, an oinochoe and a fish-plate. Campanian is dealt with in *LCS* and its three *Supplements* (see Introduction to Lucanian), and a summary account of the fabric will be found in *Red-figure Vases of South Italy and Sicily*, Chapter Five, pp. 157–74 with illustrations 271–338.

Paestan

Nine Paestan red-figure vases are included in the San Antonio collection; of these, two are large vases of considerable importance signed by Asteas, five more are products of his workshop, and two are by later followers, the Painters of Naples 1778 and 2585.

The fabric of Paestum is now very well attested, over 1000 vases having been found in tombs excavated during the past forty years in the cemeteries surrounding the ancient city and in the near vicinity, bringing the known total to nearly 2000. Of all the South Italian fabrics it is the most consistent and, once its stylistic canons had been established by Asteas, they persist with little fundamental change until the production of red-figure vases comes to an end about 300 B.C. In their choice of shapes Paestan potters were conservative; most popular are bell-kraters, hydriae, neck-amphorae, lebetes gamikoi, lekanides and squat lekythoi. The volute-krater is extremely rare, and mostly confined to the Apulianizing phase; the column-krater does not appear at all.

Particularly characteristic of Paestan vases is the tendency to provide frames for the pictures which decorate them. This may be done, especially on kraters, hydriae and lekythoi, by means of "framing palmettes," which consist of a free-standing palmette scroll on either side of the picture, with a central spiral, above and below which is a small fan-palmette (cf. Cat. No. 117). On neck-amphorae and lebetes gamikoi reserved vertical bands serve the same purpose. It is also worth noting that, with the exception of calyx-kraters and larger vases with mythological scenes, there is a band of wave-pattern beneath the pictures rather than the meanders and crossed squares commonly used in Apulian.

One of the most characteristic features of Paestan drapery is the frequent use of the dot-stripe; this regularly appears as a border on the pieces of drapery which often cover the lower part of the body and on the himatia of the draped youths on the reverses, after an early phase in which it is simply a plain black stripe. It can also appear as either a single or a double stripe running down the center or the side of women's garments, and examples of its use in both ways can readily be found on most of the vases listed below. In mythological scenes, where the characters wear more elaborate drapery, perhaps influenced by stage costumes, checker and ray borders are also used, and the garment itself is often adorned with embroidered stars, rosettes and other patterns. Apart from mythology, which is represented on a number of the larger vases, Dionysiac scenes predominate, depicting the god in the presence of his followers, maenads, satyrs and papposilens (elderly silens), or of phlyax actors; bridal preparations, women grouped around a laver for lustral rites, and scenes of courtship, in all of which a small Eros appears regularly, are also popular, especially on lebetes gamikoi. It is interesting, however, to note that the funerary scenes, with mourners beside a *naiskos* or a stele, which are so common in Apulian, play almost no part in Paestan; the former are unknown, the latter very often connected with the meeting of Orestes and Elektra at the tomb of Agamemnon, and having therefore more of a dramatic or literary connection. The reverses of most kraters and neck-amphorae normally depict two (and very seldom any more) draped youths in a restricted range of poses (see *RVP*, p. 15, fig. 2), wearing himatia, which soon adopt the typical dot stripe border.

The chief of the Paestan vase-painters was Asteas, known to us from eleven signed vases, of which the San Antonio Museum of Art is fortunate to possess two (Cat. Nos. 117 and 118). His earlier work strongly reflects the influence of the Sicilian school and especially that of the vases in the Group of Louvre K 240 (*RVP*, pp. 42–49), from which he derives his ornamental patterns, his treatment of drapery and his fondness for Dionysiac themes, in which papposilen and phlyakes play a significant part. He and his slightly junior colleague Python, who signed two extant vases, were the principals in a large workshop, from which more than 1000 vases have survived; recent discoveries have enabled us to identify a number of the lesser artists who collaborated with them, though many of the minor works, produced by what Beazley referred to as "well-drilled hacks," cannot be more closely attributed than to the workshop as a whole. These are often decorated with single figures excerpted from larger compositions (e.g. the hydria, Cat. No. 121), and often with only a female head or a bird. Asteas and Python had a number of followers among whom the Painters of Naples 1778 and 2585 are the most important. Somewhere early in the last third of the fourth century, a painter who had been trained in Apulia came to Paestum and worked with Asteas, infusing into the local style a number of Apulian elements. He is known as the Aphrodite Painter, after his most important vase, a large neck-amphora found in Paestum in 1967 and decorated with a colorful figure of Aphrodite supported by two Erotes; the ornamental decoration is purely Apulian, but the shape is not, and the scenes on the neck show him assimilating regular Paestan practices, and this is even more apparent in his later work. A similar phenomenon can be observed in the work of his contemporary, the APZ Painter, at Cumae where he grafted certain Apulian Elements onto the local Campanian style. During the last third of the fourth century other Apulian migrants seem to have established an independent pottery workshop at Paestum, where they produced vases hardly distinguishable in style from Late Apulian, but made from local Paestan clay, readily identifiable from its high mica content, and adopting un-Apulian shapes and

ornamental patterns. Red-figured pottery can barely have outlasted the century and seems to have died out somewhat before the Roman conquest of 273 B.C.

Centuripe Ware

Centuripe is a small hill-town in eastern Sicily, some twenty miles southwest of Mt. Etna and rather less than thirty from Catania, which lies to the southeast. During the past century numerous classical antiquities have come to light in the surrounding area, especially terra-cottas and vases decorated in a polychrome technique, but as yet there has been little scientific excavation of the site. The vases have generally been regarded as local products, although they certainly reflect the polychrome style of the later Sicilian red-figure, as particularly manifest in the vases from Lipari (see M. Cavalier, *Le peintre de Lipari*, Naples, 1976; L. Bernabò Brea and M. Cavalier, *La ceramica policroma liparese di età ellenistica*, Milan, 1986; *RVSIS*, pp. 239–42). They are probably to be dated to the early Hellenistic period (second and third quarters of the fourth century B.C.), a time when Centuripe seems to have enjoyed a period of development and prosperity. Centuripe vases are decorated with ornamentation in relief, probably of architectural inspiration, and with figured scenes executed in tempera in several colors against a rose-pink or black background. The most popular shapes are a lidded bowl (sometimes referred to as a pyxis) and a type of lekanis with a tall, stemmed foot and a knobbed lid (Cat. No. 127). The subjects are usually connected with nuptial ceremonies, or with the cult of Dionysos, and they normally appear only on the front of the vase, the back being left undecorated. Their purpose must be funerary, since the fugitive nature of the decoration and the fragile added ornamentation in relief would have made them impractical for everyday use.

The vases are of particular stylistic importance since their drawing comes closest to what little we know of contemporary free-painting of the period, especially in the use of light and shade on the faces. They stand rather by themselves, although a somewhat similar development towards polychromy may be seen in a number of late fourth and early third century vases from Canosa in Apulia.

Bibliography

Useful introductory sections on Apulian red-figure vase-painting will be found in Margaret Ellen Mayo and Kenneth Hamma (eds.), *The Art of South Italy: Vases from Magna Graecia* (Catalogue of an Exhibition held in the Virginia Museum of Fine Arts, Richmond, 1982) and especially in Christian Aellen, Alexander Cambitoglou and Jacques Chamay, *Le Peintre de Darius et son milieu* (Catalogue of an Exhibition held in Geneva, 1986 = Hellas et Roma, vol. IV).

A full study of Apulian red-figure vase-painting will be found in A. D. Trendall and Alexander Cambitoglou, *The Red-Figured Vases of Apulia* (2 vols. Oxford, 1978 and 1982, = *RVAp*), with *Supplement* I (Institute of Classical Studies, London, Bulletin *Supplement* no. 42, 1983) and *Supplement* II (forthcoming). Extensive bibliographies are given in *RVAp*, vol. I, pp. xl–xlv, and vol. 2, pp. xlv–xlvi, *Supplement* I, pp. xv–xix. A shorter survey is given in A. D. Trendall, *RVSIS* (London 1989), Chapter Two, pp. 23–28 (for the early stages) and Chapter Four, pp. 74–102 (for the later) with illustrations 31–57 and 101–270, and bibliography on pp. 273–76.

A detailed history of red-figure vase-painting at Paestum will be found in A. D. Trendall, *The Red-figured Vases of Paestum* (British School at Rome, London, 1987 hereafter referred to as *RVP*), with an extensive bibliography on pp. xxv–xxxi, and with 242 plates of illustrations. A shorter survey is given in the same author's *Red-figure Vases of South Italy and Sicily* (London 1989) 196–209, with illustrations 340–418.

For the history of Centuripe and the vases and other antiquities from that area, see: Filippo Ansaldi, *Memorie storiche di Centuripe* (Catania 1871), reprinted in 1981 with a new introduction and notes by Prospero Cacia, and numerous illustrations of vases, terra-cottas, coins, etc. from the site. Guido Libertini, *Centuripe* (Catania 1926).

For Centuripe vases see, in particular: G. M. A. Richter, "Polychrome Vases from Centuripe in the Metropolitan Museum," in *MMS* 3 (1930) 187–205, with addendum "A polychrome vase from Centuripe," in *MMS* 4 (1932) 45–54. G. Libertini, "Nuove ceramiche dipinte di Centuripe," in *Atti e Memorie della Società Magna Grecia 1932* (Rome 1933) 187–212. A. D. Trendall, "A new polychrome vase from Centuripe," in *BMMA* 13/5 (1955) 161–66. P. Deussen, "The Nuptial Theme of Centuripe Vases," in *Opuscula Romana* IX, 14 (1973) 125–33. Ulrike Wintermeyer, "Die polychrome Reliefkeramik aus Centuripe", in *JdI* 90 (1975) 136–241, with a complete catalogue of the then known vases and sixty-four illustrations. J. R. Green, "Centuripe," in *VMG* 282; see also the two following entries nos. 143 and 144 (pp. 283–85). Elda Joly in *Sikanie* (Collana Antica Madre 8, Credito Italiano, Milan, 1985), pp. 352ff., figs. 434–36.

A. D. TRENDALL

100

APULIAN RED-FIGURE
EPICHYSIS
Attributed to the Menzies Group
Late 5th century B.C.
Museum Purchase:
Stark-Willson Collection
86.138.92
Seated woman

The figural decoration, which is confined to the curving surface of the upper part of the body, consists of a seated, draped woman wearing a long tunic girdled at the waist by a black ribbon and fastened on each shoulder by a brooch. Her head is shown in profile to the left. Her hair is bound up in a *kekryphalos* with white decoration above the brow. She wears a bead necklace on a black string and slippers with white adjuncts. In her right hand she holds a phiale containing a white egg and from her left hand hangs a ball.

ADT

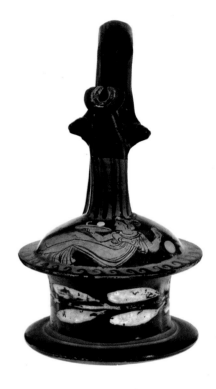

DIMENSIONS: H. 15.7 cm.; H. of "bobbin" 4.7 cm.; Diam. of base 8.6 cm.
CONDITION: Body unbroken. Neck, handle and mouth broken and repaired. Some loss of applied white paint.
SHAPE AND DECORATION: The cylindrical body of the epichysis is decorated with a laurel wreath in added white which has now largely disappeared. This vase, like Cat. No. 109 belongs to the Menzies Group. The epichysis is a comparatively popular shape with the minor painters of both the Darius and Patera workshops. This example follows the standard form with a figural scene on the upper part of the body and decoration in added white on the lower, which takes a "bobbin" form. The upper part of the neck is decorated with tongues on a reserved background. The back of the handle is a fan palmette with an oval core, flanked by spiral scrolls with palmette fans between them. The projecting upper edge of the "bobbin" is decorated with a wave pattern on a reserved background and there is a reserved stripe at the bottom of the cylindrical lower body. The underside is reserved with a groove around the center.
PROVENANCE: Ex coll. Stark (Orange, Texas)
BIBLIOGRAPHY: Unpublished.

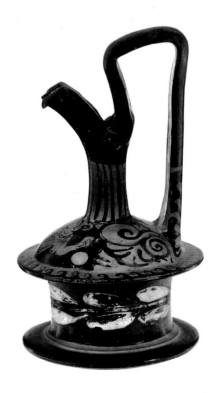

101

TWO JOINED APULIAN
EARLY ORNATE FRAGMENTS
Attributed to the Black Fury
Group [A.D. Trendall]
Ca. 390–380 B.C.
Gift of Gilbert M. Denman, Jr.
86.134.91 a,b
Woman and child (Prokne and Itys?)

The fragments are from a big closed
vessel, A. D. Trendall has suggested a
hydria or amphora. A young woman is
seated above something which is
painted in diluted glaze and perhaps
was originally white as in other vase-
paintings of the Black Fury Group, to
which this very fine work is attributed.
The figure is preserved only from the
chin (beneath which are two circular
'Venus rings') to the legs. Her feet,
face, right shoulder and arm are lack-
ing. Her upper left arm, which frames
the full breast, is without sleeve. Thus
her star-spangled garment is, in spite of
its very thin fabric, a peplos and not a
chiton. In her décolleté she wears a
necklace with a white pendant and red
beads, and on her left ring finger a
white ring—surely thought of as silver.
With this hand she touches the breast
of a naked male child kneeling at her
right side and shown in three-quarter
view, turned to the left. He is looking
back and up to her; the tip of his nose,
his mouth and left eye are preserved.
Round his neck circle the same 'Venus
rings' as round the woman's.

This is not an idyllic group of a
mother with her child. The dishevelled
hair above her shoulder and the big
waves of her striped coat indicate ex-
citement, perhaps also the meander
pattern of her peplos, which runs irreg-
ularly. Furthermore the boy is behaving
as if in danger. The movement of his
legs—one strongly bent, the other
stretched out—is what Aby Warburg
has called a "Pathosformel." Falling
warriors in battles or Orpheus assaulted
by the Thracian women in classical art
may be compared. The child's left hand
disappears beneath the woman's arm,
and his gaze seems to be frightened. A
tragic fate surely impends over these
two figures.

There are two main possibilities for
the interpretation. The woman and the
boy could be threatened by somebody
approaching them, for example in an
Ilioupersis scene, or the boy is threat-
ened by the woman herself. In this case
he could be Itys, son of the Thracian
king, Tereus. Itys was killed by his own
mother and his aunt, Prokne and
Philomela, and was given as a meal to
his father, Tereus, who had violated
Philomela and cut out her tongue. Af-
terwards Prokne became a swallow and
Philomela a nightingale, always sighing
for Itys.

The interpretation depends on the
object upon which the woman is
seated. If it is an altar, the group may
belong to an Ilioupersis; if it is a chair
(a *klismos*) or a folding stool, the
woman could be Prokne with Itys. I
think the object looks more like a
chair, perhaps with some tapestry or
hide upon it. Thus the woman may
have held a sword in her lost right
hand, suggesting an identification as
Prokne about to kill her son. Her sister
may have approached from the left or
the right side, gesturing with her hands
since Tereus had rendered her mute.

The myth of Prokne and
Philomela—or of Chelidon and Ae-
don, the Greek names for the swallow
and the nightingale—is already repre-
sented on a clay metope from the tem-
ple of Apollo at Thermos. The two sis-
ters are killing Itys on a table. This
cruel scene was not often chosen as a
theme in Greek art. In monumental
sculpture there is the marble group on
the Acropolis, about 430 B.C. Accord-
ing to conventions of classical art,
Prokne is not killing her son in front of
us, but is contemplating the murder.
The scene on our fragment would be
similar, though Itys behaves differently.
In the group by Alkamenes he nestles
against his mother, whereas on the
fragment he is already frightened. His
hand beneath his mother's arm shows
that she had held him on her lap be-
fore. In Ovid's Metamorphoses there is
the full story of Itys (6,620 ff.). Some
verses sound like a description of our
picture (6,639 ff.): Itys "stretches his
hands out, sees the impending fate,

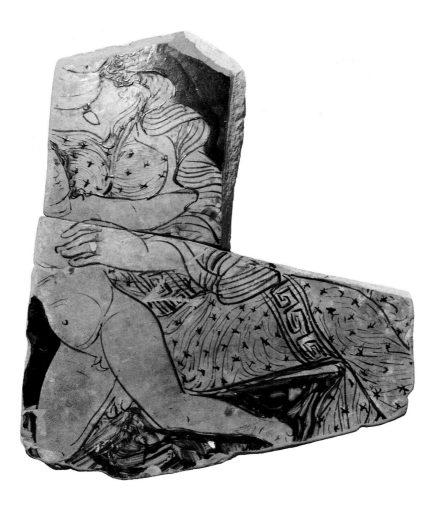

cries 'mother, mother!' and tries to embrace her neck; she hits him with the sword between his breast and flank" (*tendentemque manus et iam sua fata videntem et "mater! mater!" clamantem et colla petentem ense ferit Progne, lateri qua pectus adhaeret*.)

Ovid depends on Sophokles, whose *Tereus* was one of his famous tradegies (TrGF IV *frg.* 581–95b). Among the western Greeks the myth of Itys of course was known. On a skyphos fragment by the Painter of the Berlin Dancing Girl (ca. 430 B.C.) the upper part of a man with the inscription Tereus is preserved. A Campanian fragment in Dresden shows Tereus pursuing Prokne and Philomela towards the end of Sophokles's tragedy. The actor who played Tereus, after the end of the drama, is perhaps represented on the

well known Gnathian fragment by the Konnakis Painter in Würzburg. If the above interpretation is correct, the San Antonio fragment also shows a scene from the *Tereus* of Sophokles. ES

DIMENSIONS: Preserved H. 9.7 cm.; Preserved W. 7.6 cm.
CONDITION: Clay on back is white-tan with red-slip applied over the outside. Traces of preliminary drawing. Relief-contour and relief lines. Dilute glaze used for shading in drapery folds and hair, also, less carefully for parts beneath the added white: pendant of necklace and ring, object on which the woman is seated. On this chair (?) the white has faded. The beads of the necklace are red.
BIBLIOGRAPHY: Unpublished.
LITERATURE: For the Black Fury Group, see *RVAp* I 165ff. pl. 53, 3–5 and 54, esp. 7–17. For the myth of Prokne and Itys,

see K. Schefold, *Die Urkönige* (Munich 1988) 73–79. For the Thermos metope, see R. Hampe and E. Simon, *Tausend Jahre Frühgriechischer Kunst* (Fribourg 1980) 66ff., fig. 107. For the marble group of Prokne and Itys from the Acropolis, see W. Fuchs, *Die Skulptur der Griechen*[3] (Munich 1983) 200, fig. 214; J. Boardman, *Greek Sculpture: The Classical Period* (London 1985) fig. 135. For Tereus on the skyphos fragment Paris, Cab. Méd. (ex. Coll. Groehner), see A. D. Trendall, *Early South Italian Vase-Painting* (Mainz 1974) 46, no. 13 (Painter of the Berlin Dancing Girl): *RVAp* I 8–16, pl. 3,2. For Tereus pursuing the sisters on the Dresden fragment, see Trendall, *LCS* 309, no. 585 (Caivano Painter). For Tereus on the Gnathia fragment in Würzburg, see *Werke der Antike im Martin von Wagner-Museum der Universität Würzburg* (Mainz 1983) 142 f. Nr. 64 (E. Simon).

102

APULIAN RED-FIGURE
BELL-KRATER
Attributed to
the Painter of the Long Overfalls
Early second quarter of
the 4th century B.C.
Museum Purchase:
Stark-Willson Collection
86.138.91
A: Draped woman
B: Bearded satyr

This is a very typical early work of the Painter of the Long Overfalls and the running woman is closely to be compared with those on Turin 4130 and Taranto 8087. She wears a peplos with the painter's characteristic long overfall, through which her bent right leg is clearly visible. Her hair is tied with a reserved bandeau; she wears a black earring and a necklace. The tambourine she holds in her left hand has a wavy pattern on the edge and in the center, a white rosette on a black disk with a circle of dots around it.

The satyr is completely nude, save for a white wreath around his head. The phiale in his extended right hand is shaded in yellow and dilute black glaze to indicate that it is made of metal. The leafy wreath in his left hand is in added white and yellow. He moves to the left, looking to the right.

ADT

DIMENSIONS: H. 14.8 cm.; Diam. of mouth 15 cm.; Diam. of foot 7 cm.
CONDITION: The vase is intact and in good condition.

SHAPE AND DECORATION: It is unusual to find a bell-krater of such small dimensions, but compare with the two referred to above. The shape follows the normal pattern for the larger kraters. There is a band of black waves on a reserved stripe beneath the rim and beneath each picture is a band of meanders divided in the middle with a single saltire square. The disk foot has a groove immediately below the upper edge; the lower edge and the underside are reserved. There is no decoration below the handles or at the handle joins, between which is the usual reserved band extending onto the actual handles.
PROVENANCE: Ex coll. Stark (Orange, Texas)
BIBLIOGRAPHY: Unpublished.
PARALLELS: Turin 4130 and Taranto 8087: *RVAp* I pl. 81, 4/111 & 112.

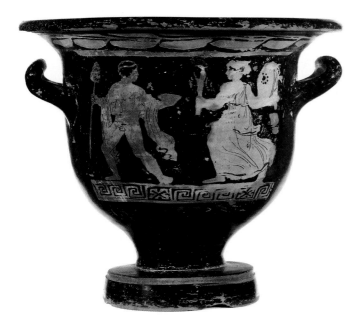
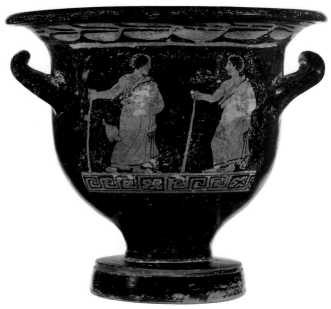

103

**APULIAN RED-FIGURE
BELL-KRATER**
Attributed to
the Painter of the Long Overfalls
Early second quarter of
the 4th century B.C.
Gift of Rodman A. Heeren
62.177.17
A: Nude youth and running maenad
B: Two draped youths

The youth (probably Dionysos, in view
of the thyrsos in his right hand) has a
piece of drapery with a wavy black
border over both arms and behind his
back. He wears a white fillet around his
head, which he turns to the right to
look at a maenad who follows him. She
wears a peplos with an overfall, a sak-
kos on her head and carries a flaming
torch in her right hand and a tam-
bourine, decorated in black, in her left.

Both of the youths on the reverse
hold sticks in their right hand. Their
cloaks are so draped as to leave the
right shoulder and extended arm bare.
The left arm is akimbo beneath the
drapery which assumes a 'sleeve' pat-
tern. Typical of the Painter of the Long
Overfalls is the treatment of the black
borders of the cloaks where they meet
below the concealed arm (see *RVAp* I
fig. 2f).

The Painter of the Long Overfalls
(*RVAp* I 79–89) is one of the most
productive followers of the Tarporley
Painter in the second quarter of the
fourth century. Characteristic of his
work is the way in which the youth on
the left of his reverses is given an al-
most frontal pose with the head turned
in profile to the right, as on our vase
(cf.*RVAp* I, pl. 28). ADT

DIMENSIONS: H. 23.2 cm.; Diam. of
mouth 25.2 cm.; Diam. of foot 12.3 cm.

CONDITION: The vase is complete, but
the surface of the obverse is considerably
abraded with the loss of most of the
added white (flame of the torch) and a
good deal of the surface, especially across
the upper part of the maenad's body and
left arm. There are abrasions, also, of the
black glaze on the reverse.

SHAPE AND DECORATION: The body of
the krater is slightly convex below the
handles, and tapers downward toward the
stem. The disk foot has a reserved band
slightly inset at the top, and the underside
is left reserved. Beneath the rim is a band
of red-figure laurel leaves to the left with
a reserved stripe below it. Beneath the
pictures on both sides is a band of mean-
ders interspersed by saltire squares with
black strokes in the center of each side.
There is no decoration below the handles
or at the handle joins, but there is a re-
served band between them which extends
onto the actual handles.

BIBLIOGRAPHY: Unpublished.

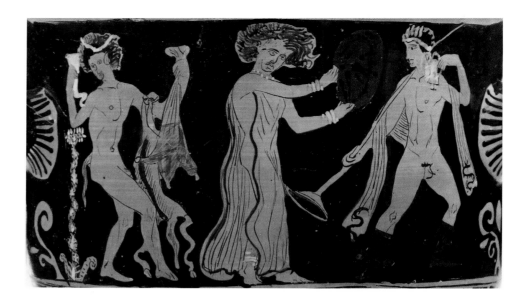

104

APULIAN RED-FIGURE
BELL-KRATER
Attributed to the Dechter Painter
[A. D. Trendall]
Ca. 350 B.C.
Gift of Mr. and Mrs. Walter F. Brown
90.104.2
A: Satyr, maenad and nude
youth (Dionysos?)
B: Nike driving a biga
Below left handle: Head of youth
in profile to right

The Dechter Painter, who is closely associated in style with the Berkeley Painter, is an artist of some importance although of rather inferior quality. He decorated a number of vases with interesting subjects, of which our vase is a very typical example. The painter is named after the owner of a private collection in Los Angeles, which contains two vases by his hand.

To the left, on the obverse, is a young satyr, his head shown in three-quarter view, the lower body in profile. In his upraised right hand he holds a yellow drinking horn and over his upper left arm is a fawn-skin. In his left hand he holds a wine skin by the top. Immediately below his right arm is a tall flowering plant decorated in added yellow, to the left of which is a single palmette scroll. In the center of the scene is a maenad wearing a long filmy chiton, with a black border, through which the outline of her body is clearly visible. Her head is in three-quarter view with her hair spread out around it. She wears a yellow bead necklace, bracelets and an anklet. In both hands she held a tambourine, originally painted in added color, which has now completely disappeared. The youth on the right, who is naked save for a narrow piece of drapery over both arms and behind his back, wears a white fillet around his head with four radiate spikes and carries a *kottabos* stand in his right hand, the shaft of which passes over his shoulder. In his left hand he holds up a yellow kantharos. On his feet were tall boots with side flaps, the added color on which has now disappeared leaving them in a shade of deep purple.

On the reverse, Nike holds in her hands the reins of the two horses which are drawing the chariot in which she stands and which is shown in added yellow. She is draped in a flowing tunic which leaves the right shoulder bare. Her wings are upraised and her head is seen in profile against the left wing. Her hair is done in a bunch at the back. Above the horses is a star in added yellow, and the ground line is a row of yellow dots and strokes.

Immediately beneath the left handle is the head of a youth in profile to the right. He wears a chlamys over his shoulders, caught in the front by a yellow brooch. ADT

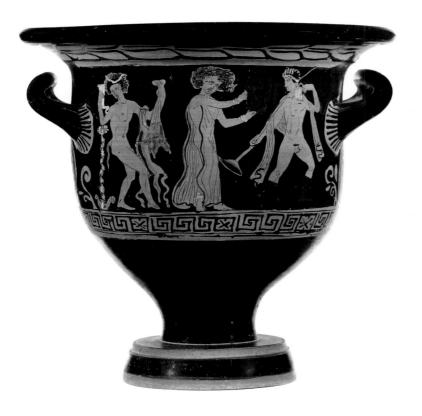

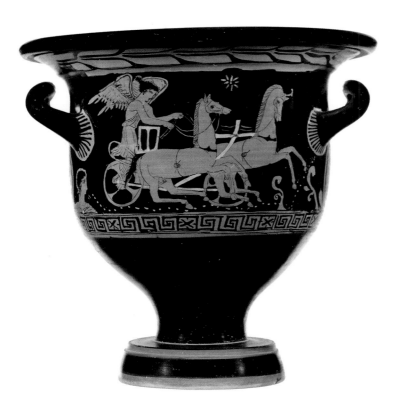

DIMENSIONS: H. 27.8 cm.; Diam. of mouth 28 cm.; Diam. of foot 13.6 cm.

CONDITION: The vase is intact and in good condition, except for the loss of some added color on the obverse.

SHAPE AND DECORATION: The krater is of the standard form. There is a narrow reserved band where the stem joins the foot; the rim of the foot is inset and reserved and there is a reserved stripe around its lower edge. The underside is reserved. Below the rim of the mouth is a band of laurel to the right with a reserved stripe above the picture on each side. Beneath the pictures, encircling the vase, is a band of meanders with saltire squares, and a reserved stripe above and below it. Below the handles is an enclosed palmette with a side scroll on the left. At the handle joins is a row of black strokes on a reserved background which continues beneath the handles themselves.

BIBLIOGRAPHY: Hôtel des Ventes d'Auxerre, 24 March 1985, no. 275.

LITERATURE: For the Dechter Painter, see *RVAp* I 270–73; *The Dechter Collection*: Exhibition Catalogue, ed. K. Hamma (San Bernardino, California, May 1989) nos. 28 and 29.

PARALLELS: The figure of the satyr to the right on the obverse finds a close stylistic parallel in the youth to the right on the front of Ruvo 1050 (*RVAp* I pl. 90, 3). For the treatment of the drapery with the leg visible beneath it, compare *RVAp* I pl. 90, 1 and 4. The treatment of the eyes with the large black pupil is also characteristic of this painter.

105

APULIAN RED-FIGURE
VOLUTE-KRATER
Associated with the Varrese Painter
Ca. 350 B.C.
Gift of Mr. and Mrs. Walter F. Brown
in honor of Gilbert M. Denman, Jr.
90.104.1
A (Neck): Hermes, Athena
and Marsyas
(Body): Eight warriors, in two rows
of four
B (Neck): Large fan-palmette
(Body): Two youths and two women
at a *naiskos*

The neck of Side A shows the moment
before Athena plays the flute, which,
on seeing her distorted features in the
mirror, she casts aside; it will be picked
up later by Marsyas. To left stands Her-
mes, with white *petasos*, *kerykeion* and
winged sandals, bending forward over
his left leg, the foot of which rests on a
rock-pile. In front of him is a fruit-
bearing tree, beside which sits Athena,
holding one reed of the flute in each
hand. Around her head is a beaded
bandeau; she wears a short-sleeved tu-
nic, with studded belt, long wavy-bor-
dered overfall, and a palmette border
on the lower hem. Beside her is a
lopped tree, at the base of which is her
helmet and against the right side of
which rests her shield. To right is a
bearded satyr (Marsyas), wearing a pan-
ther-skin knotted at the neck, and
holding up a mirror in his right hand.
At the far right is a plant, and there are
two rosettes in the field above.

On the body are depicted eight
young nude warriors in two groups of
four, all with various pieces of armor,
of which the shields and helmets are
shown in added white (restored). In the
upper row, from left to right, the war-
riors are: (1) seated on a piece of drap-
ery, which passes over his left arm, and
holding a sheathed sword in his right
hand, while his left rests on a shield;
above him hangs a *pilos* (brimless trav-
elling hat); (2) seated to right, with al-
most frontal body, and head turned to
left, to converse with the first youth;
there is a piece of drapery over his
thighs, a spear across his body, and his
left hand touches the rim of his shield,
above which is a *pilos*; (3) seated to
right, with drapery behind his back and

holding a sheathed sword in his left
hand. He faces (4), whose left foot rests
on an eminence and who holds a
sheathed sword in his right hand and a
shield in his left. In the lower row they
are: (5) standing, a spear in his right
hand and his left resting on a shield; he
wears a chlamys fastened by a brooch at
the neck and turns his head to right to-
wards (6) seated on drapery, a sheathed
sword in his right hand, his left arm
resting on his shield; (7) bends forward
to left, holding up a helmet in his right
hand; there is a piece of drapery over
his raised right leg; (8) seated to left on
drapery, resting his left hand on a
shield. The ground lines are shown as
rows of white dots.

The neck of Side B is decorated only
with a palmette composition, but the
body shows a youth and a woman on
either side of a tall and narrow *naiskos*
in which is a palmette-scroll. The *nais-
kos*, in added white, has Ionic columns
in the front, a pediment and palmette
acroteria; on the upper portion of its
two-stepped base is a band of white
laurel pattern to the right on a pink
background; the lower part is white.
To the left of the *naiskos*, above is a
nude youth seated on a piece of drap-
ery, a wreath in his right hand and a
phiale in his left, with a branch in front
of him; below, a draped woman bend-
ing forward over her raised left leg and
holding a fruit-bearing branch in her
right hand. To the right, above, a
draped woman seated on folded drap-
ery, with a phiale in her right hand and
a beaded wreath in her left; in front of
her are two palm branches; below is a
youth running up, a flowering plant in
his right hand, and a stick in his left,
which is enveloped in a piece of drap-
ery. The chiastic arrangement of the
figures (woman, youth : youth,
woman) is very typical of Apulian
naiskos scenes.

The volutes are decorated with mas-
caroons consisting of diademed female
heads; on Side A they have black hair
and red faces, on Side B the face is in
added white.

The musical contest between Apollo
and Marsyas is a popular theme with
Greek vase-painters, and the scene on
the neck of this krater illustrates the
first stage in the development of the

story. Athena, having doffed her armor,
sits beneath a tree, holding one reed of
the flute in each hand. While playing
the flute, Athena looked into the mir-
ror (cf. Boston 00.348 = *RVAp* I 267,
no. 10/48; an unpublished Early Apu-
lian bell-krater in a private collection in
Bari), here held ironically by Marsyas
himself, and on seeing her swollen
cheeks cast the instrument aside. It was
picked up by Marsyas who subse-
quently challenged Apollo to a musical
contest in which he was defeated and
lost his skin.

The main scene seems to have no
specific mythological significance and
probably represents a group of young
warriors resting in preparation for
battle.

In view of the extensive repainting
on this vase, it is not easy to make a
specific attribution. It looks, however,
to be closely associated in style with the
work of the Varrese Painter, and may
well be by his own hand. For the ren-
dering of the head of Athena, cf. the
heads of the women on *RVAp* I pl.
111,2–3 and for the drapery of the
youth to right on Side B that on pl.
111,1; for the two draped women on
Side B cf. pl. 110,6 and 111,1. The vase
would look to be contemporary with
the later work of the Varrese Painter
around the middle of the fourth cen-
tury B.C. A D T

DIMENSIONS: H. to top of volutes
81.5 cm.; H. to rim of mouth 71.6 cm.;
Diam. of mouth 39.8 cm.
CONDITION: In its present state the vase
has been extensively restored, especially
in regard to the added white and yellow,
and the drawing of the faces and the
drapery.
SHAPE AND DECORATION: The shape is
typical of the mid-fourth century Apulian
volute-krater with high handles rising
from an arched element at the shoulder
and decorated with masks on the volutes;
black swan-heads flank the joins at the
shoulder. On Side A, the outer edge of
the rim is decorated with egg-pattern,
with a band of waves immediately be-
neath; then a row of white strokes and a
band of ivy with leaves half reserved and
half in added white, with incised stems
and white berry-clusters. On the shoul-
der, tongues with egg-pattern beneath;
below the pictures, meanders interspersed
with quartered and dotted squares. On

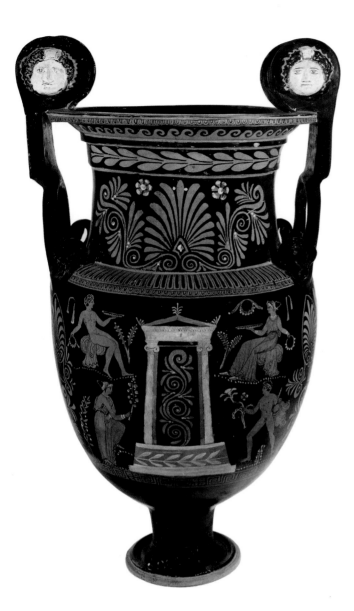

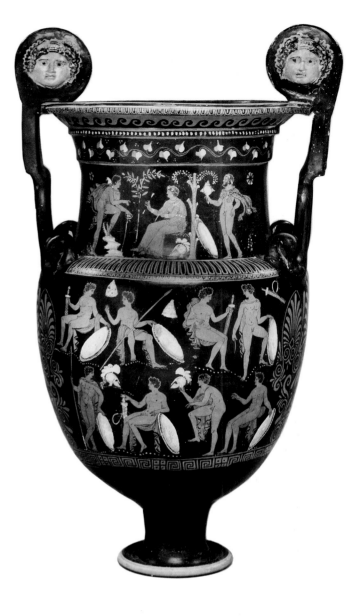

Side B, the decorative pattern-work is somewhat simpler, with egg-pattern on the rim, a band of reserved waves beneath, and a frieze of red-figure laurel to left. Beneath the handles are elaborate superposed palmettes. The vase has a pedestal foot with a disk base, the outer edge of which is left reserved.

BIBLIOGRAPHY: Auxerre Market, *Sale Cat.* 24 March 1985; *RVAp, Suppl.* II, 89, no. 13/36a.

LITERATURE: On Apollo and Marsyas, see Chr. Clairmont, "Apollo and

Marsyas", in *YCS* 15, 1957, pp. 161–78; K. Schauenburg, "Marsyas," *RM* 65, 1958, pp. 42–66; P. Demargne in *LIMC* II, pp. 1014–15. For a detailed, illustrated discussion of the *Aulos*, see D. Paquette, *L'Instrument de musique dans la céramique de la Grèce antique* (Paris 1984) 23–61. On the main scene of warriors a somewhat similar scene on a smaller scale will be found on a Campanian neck-amphora by the Parrish Painter in Boston (03.832 = *LCS* 249, no. 2/144, pl. 99,1; J.D. Beazley, *JHS* 63 (1943) 72, pl. 4), where the

scene is described as a "bivouack." Flowering plants or palmette-scrolls appear not infrequently in naiskoi on Apulian funerary vases: see H. Lohmann, *Grabmäler auf unteritalischen Vasen* (Berlin 1979) 319, where 53 examples are listed, and pl. 50,1 for a palmette-scroll similar to the one on the San Antonio krater; cf. also *RVAp* I pl. 124,1 and 3. For the ornament on Side A, cf. the volute-krater by the Painter of Copenhagen 4223, illustrated in *Le Peintre de Darius* 91.

I06

APULIAN RED-FIGURE
LOUTROPHOROS (TYPE I)
Attributed to
the Painter of Louvre MNB 1148
Ca. 350–340 B.C.
Gift of Gilbert M. Denman, Jr.
86.134.85
A: Woman in *naiskos*
B: Woman and youth beside a stele

The representations on both sides of
this vase are typical of the larger Apu-
lian vases of the second half of the
fourth century, a *naiskos* scene on Side
A, a stele scene on Side B. The *naiskos*
on the obverse, painted as usual in
added white, has a pediment with a
central disk, palmette acroteria, and a
frieze of egg-pattern in diluted glaze on
top of the achitrave below the pedi-
ment floor. It has engaged Ionic col-
umns, the side walls and ceiling are
shown in added red-brown, as is the
floor, which rests on a solid base, deco-
rated on the outside with a band of
white scrollwork on a black back-
ground. The two columns descend past
this base to the plinth on which the
naiskos stands; the front is decorated
with a frieze of enclosed white pal-
mette-fans on a black background, with
clusters of three white dots between
them, above and below. On top of and
beneath this frieze are white and black
stripes.

Within the *naiskos* stands a woman in
added white; she wears a long garment,
also in white, with diluted glaze used to
mark the fold-lines and borders. Her
left leg is flexed at the knee and runs
diagonally in front of the right leg,
which bears her weight. Round her
head is tied a ribbon, in purple with
white dots, in a bow looped on the
right side. She has light brown curly
hair, of which two locks fall across her
left shoulder. Her head is inclined to
the right, with the face in three-quarter
view. In her left hand she holds up a
mirror, into which she appears to be
looking; in the other she holds a piece
of reddish-purple drapery (perhaps a
shawl) with a white-dotted border; it
falls down below her right hand, and
passes behind her body to emerge be-
neath her left armpit, falling down
again between her and the large lou-
trophoros which rests on the molded
stand beside it. This loutrophoros,
which is of similar form to the actual

vase, was presumably made of metal; it
had a frieze of figures between scroll-
work on the body, ribbing above and
below this, spiralling S-shaped handles,
and a lid with a pointed knob, against
which the woman's left arm rests. Part
of the lid is covered by the piece of red
drapery. On the left of the *naiskos*
stands a woman wearing a peplos, with
a black ribbon girdle, and a piece of
drapery across the front of her body,
running over her left arm. In her right
hand she holds a large white fan, from
her left hangs a rosette-chain, with
white centers to the rosettes, and dot
clusters in between them and at the
bottom. On her head is a *kekryphalos*,
with white stripes; a bunch of hair
emerges from it at the back, where it is
tied with a long white ribbon; there is
a white diadem above the hair over her
forehead. She wears pendent earrings, a
double-strand bead necklace, bracelets
and slippers, all in white. Immediately
beneath her, beside the plinth of the
naiskos, is a large *kalathos* (wool-basket)
in added white, with bands of geomet-
ric decoration in diluted glaze, match-
ing the similar one on the other side.
Above this stands a nude youth, his left
arm covered by a piece of drapery, be-
neath which there emerges the white
stick held in his concealed left hand.
The other hand grasps a long-handled
patera by the handle, which, as usual, is
anthropomorphic in form, consisting of
a nude figure with upraised hands
which support the bowl. Between the
youth and the *naiskos* is a hanging fillet
in pink with white dots and another in
reddish-purple, with a piece of similar
drapery above this.

The stele scene on Side B follows
the standard pattern for such represen-
tations. In the center stands a tall stele,
shown in perspective; round the shaft,
about three-quarters of the way up, is
tied a looped black fillet; the top of the
stele is painted white, and below is a
row of white dots between two white
lines. On the top of the stele stands a
kylix, with curving handles, ribbed on
the exterior, and with three white dot-
clusters above it. The original would
also have been in metal, like the
loutrophoros in the *naiskos*. The plinth,
of similar appearance to that of the
naiskos, is decorated in the central sec-
tion with a wreath of white vine-leaves
and tendrils. On the left stands a draped
woman, holding a rosette-chain in her

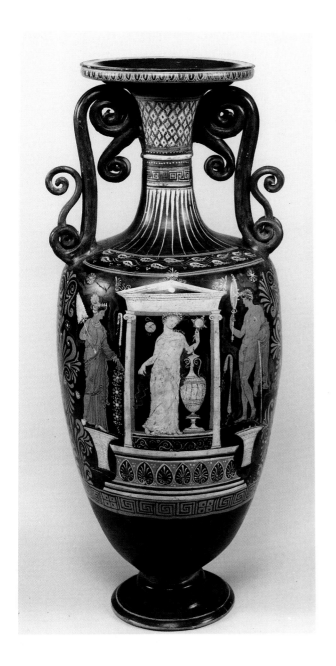

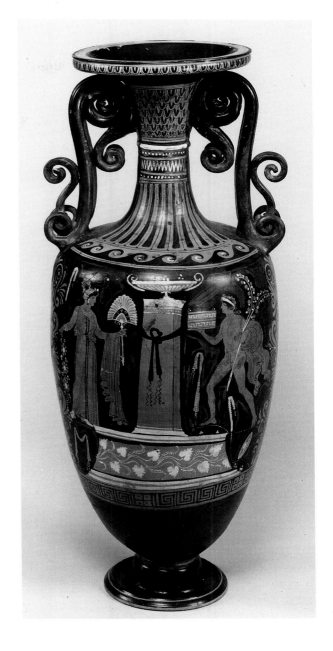

right hand, and a fan in her left; over her left arm hangs a piece of drapery with a wavy black border. She wears a long peplos, with a double black stripe running down the center; her hair-style and adornments are similar to those of the woman on Side A. On the right side of the stele a youth is stepping forward, again naked except for a piece of drapery over his left arm. In his left hand, concealed beneath the drapery, he holds a long branch with white berries, and in his right a closed box

(*cista*). Between him and the stele, and between his legs, are fillets in added white. The plinth of the stele is flanked by a fillet on the left and a *mesomphalic phiale* on the right. Ground lines are dotted.

The Painter of Louvre MNB 1148 (now identified by H. Giroux with K 77) is an artist who flourished around the middle and early in the second half of the fourth century; he is a slightly earlier contemporary of the Darius Painter and a close follower of the Var-

rese Painter. In *RVAp* II (pp. 588–91) his true importance had not been fully recognized, as much of his better work came to light only after its publication; some of the new material is discussed in *Suppl.* I, 98–101 and in *Suppl.* II, 87–91. He emerges as one of the major artists of this period, to whose hand a number of monumental vases may now be ascribed, including several with mythological subjects. A D T

DIMENSIONS: H. to top of rim 69.5 cm.; H. to top of body 43 cm.; Diam. of mouth 21.5 cm.; Diam. of foot 15 cm.

CONDITION: Broken and repaired.

SHAPE AND DECORATION: There are three principal types of loutrophoroi which regularly appear in Apulian; the first, of which the San Antonio vase is an

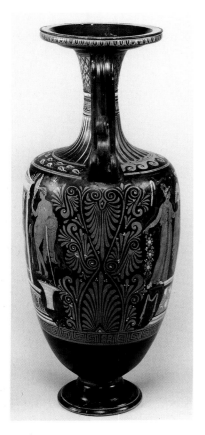

106

example, has an ovoid body, tapering gently downwards to the foot; the second has a slightly concave cylindrical body, which curves outward at the bottom before curving in again to join the stem or the foot; the third is similar to the second, but lacks the handles, and is sometimes referred to as a barrel-amphora. Our vase has a wide open mouth with a reserved edge, and is decorated with egg-pattern on the outer rim; the neck is comparatively short and is flanked by two spiralling flanged handles, with further

spirals rising upwards from those at the handle-joins. The neck and shoulder are elaborately decorated on both sides. On A there is (i) a panel of lozenge pattern in white on a black background, (ii) a band in white relief between two bands of black with white dots, (iii) a band of swastika meanders, with hollow dotted squares in added white, with a red stripe above and red and white stripe below, (iv) coming down onto the shoulder, long white rays on a black background, (v) on the shoulder, between the handle-joins, a row of lily-pattern with dot clusters between the flowers, all in added white. Side B has (i) a panel of egg-pattern, (ii) a band in white relief, with one row of white dots on a black background below it, (iii) a band of white zigzag, with a row of white dots below it, (iv) running down onto the shoulder, black tongues divided by thin black lines ending in a dot, on a reserved background, (v) a band of black wave-pattern on a reserved background, the tip of each wave decorated with a white dot, and below it a reserved stripe. Beneath the pictures running right round the vase is a band of meanders interspersed with quartered squares, with dots in each division. Beneath the handles is an elaborate palmette composition, consisting of two large fans one above the other, pointing downwards and upwards respectively and flanked by palmette scrolls and fans. All have touches of added white at the base of the fans and on the tips of the scrolls. The spreading foot is pierced and reserved on the underside. There is a reserved stripe where it joins the stem, and the base is concave with a reddish border decorated with reserved stripe.

BIBLIOGRAPHY: K. Schauenburg, "Zu einer Gruppe polychromischer apulischer Vasen in Kiel," *JdI* 100 (1985) 413, figs. 23–24; *RVAp, Suppl.* II, 180, no. 20/278–1, pl. XLVII, 1.

LITERATURE: For mythological scenes by the same painter cf. loutrophoroi: Malibu 86 AE 680, with Zeus and Aphrodite, Leda and the swan (*RVAp, Suppl.* II, 180, no. 20/278–2, pl. XLVII, 2; *CVA* [Malibu 4] pls. 186–88 and 189, 3–5); Kiel B 787, with Eos and Kephalos (*RVAp,*

Suppl. II, 181, no. 20/278–3, pl. XLVII, 3; K. Schauenburg, *RA* 2 (1988) 291ff., figs. 1–4 and *Jb. Mus. Hamburg* 6–7 (1988) 41–44, figs. 1–3); Malibu 82 AE 16, with the Tantalidae = *RVAp, Suppl.* I, 100, no. 278a, pl. XIX, 1–3; Trendall, in *Greek Vases in the J. Paul Getty Museum* 2 (1985) 129–44, figs. 1–4 and 8–9; *CVA* (Malibu 4), pls. 183–85; tall lekythos: Melbourne, Geddes coll. A 3:14 = *Suppl.* I 101, no. 278d, pl. XIX, 3–4; Trendall, loc. cit., fig. 11, with an Amazonomachy. The Tantalidae loutrophoros offers good parallels to our vase in both style and decoration. The rendering of women's drapery, with the bold fold-lines, the black stripe between the rather pronounced breasts, the drawing of the face, especially the mouth and chin, and the treatment of the metal loutrophoroi show how closely these two vases are connected, and similar figures will be found repeated on many of the painter's other works. Likewise there are close correspondences in the pattern-work both on the necks and below the handles; in shape our vase goes more closely with the painter's name vase (Louvre MNB 1148), with Malibu 86 AE 680, and with an, as yet unpublished, loutrophoros in an Italian private collection showing Andromeda on one side and Amymone on the other. It may also be noted that all these three vases have structures (naiskoi or a fountain-house) upon them very similar to the *naiskos* on our vase. For the principal types of Apulian loutrophoroi, see K. Schauenburg, in *JdI* 100 (1985) 409 ff., figs. 17–25.

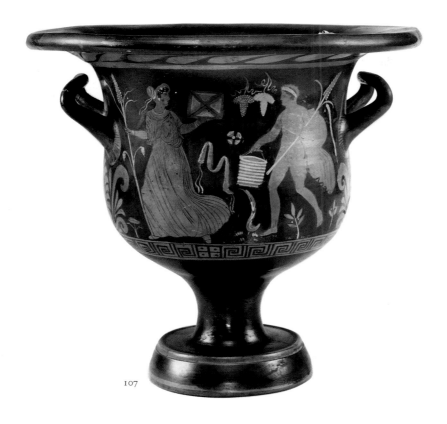

107

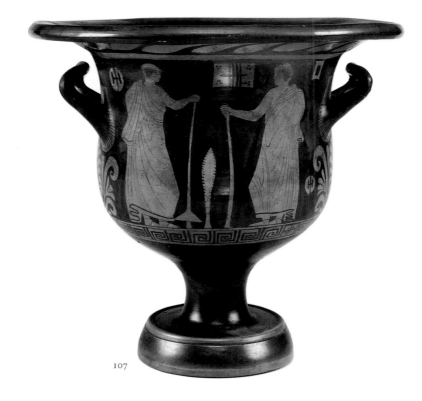

107

**APULIAN RED-FIGURE
BELL-KRATER**
Attributed to the Haifa Painter
Ca. 340–330 B.C.
Gift of Gilbert M. Denman, Jr.
86.134.88
A: Draped woman and nude youth
B: Two draped youths

When it appeared on the London market in 1971, this vase had been recomposed from a number of fragments and the missing parts restored, with a good deal of repainting. It has now been cleaned and the earlier restorations removed; this affects, in particular, (i) the upper right side and arm of the female figure on the obverse; (ii) the lower part of her left leg and of the drapery, where it billowed out to right; (iii) a small portion of the drapery just below the waist of the youth to right on the reverse; and (iv) the curious triangle which formerly appeared at the foot of the stick held by the youth to left, which has now disappeared. The other restorations were insignificant.

The scene on the obverse is typical of the two-figure compositions, often with Dionysiac associations, which appear regularly on Apulian bell-kraters. To left runs a draped woman, perhaps a maenad in view of the thyrsos she holds in her right hand, turning her head to right to look at the youth who follows her. She wears a long, flowing chiton of light material, through which the outlines of her body are clearly visible. On her head is a *sakkos* tied with white ribbons, there are beads on the hair above her brow, white earrings, necklace and bangles. In her left hand she holds up a rectangular box (*cista*), the visible front of which is divided diagonally into four sections, each of which is decorated with a solid white triangle. The youth who follows her, perhaps to be identified with Dionysos since he holds in his left hand a thyrsos, from which hangs a white fillet, is naked save for a piece of drapery over his left arm and a white headband. In his right hand he holds by its handle a cylindrical bucket (situla) decorated with rows of white bands. Two bunches of grapes, one entirely in added white, the other with white to indicate the indivdual grapes, hang in the field above the two figures; between them are a looped fillet and a

rosette, and below, various flowering or berried plants spring up from the ground, including a lily, the right side of which is worn away.

Both the youths on the reverse hold sticks in their right hands and wear himatia so draped as to expose their right shoulders and arms (Types B and F on *RVAp* I pl. 97); the left arm of the youth to the right is bent beneath his cloak to produce a sleeve-like effect. Both cloaks have a black border at the bottom with a wavy curl in the corner. Above, from left to right, are a pair of

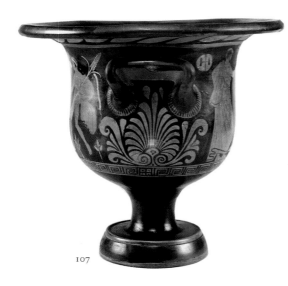

107

halteres (jumping weights), a diptych, and a window—the first two symbolic of the palaestra and the schoolroom. Between the two youths is a large palm-leaf with a serrated edge.

The Haifa Painter is one of the lesser artists in the workshop of the Darius Painter; some thirty bell-kraters, very uniform in style and treatment, may be attributed to his hand, as well as a number of vases of other shapes. His bell-kraters regularly have two-figure compositions, usually consisting of one male and one female figure, mostly with Dionysiac connections, and with the figures shown in rapid motion.

ADT

DIMENSIONS: H. 37.5 cm.; Diam. of mouth 40.9 cm.; Diam. of foot 17.2 cm.
CONDITION: Broken and repaired. Restored, unpainted fragments to left and beneath female figure on Side A, and on himation of both youths on Side B.
SHAPE AND DECORATION: The body of the krater has a slight outward curve below the handles, before it tapers downwards to the stem. The foot, in two degrees, has a reserved band slightly inset at the top, and a reserved stripe round the bottom; the underside is reserved. Beneath the rim is a band of red-figure laurel to left with a reserved stripe below it; below the pictures, running right round the vase, is a band of stopt meanders with dotted squares. Below the handles, a large palmette-fan, with branching side-scrolls with a three-leaf palmette between them; a band of strokes around the handle-join.
BIBLIOGRAPHY: Sotheby's London, 25 October 1971, lot 186; *RVAp, Suppl.* II, 175, no. 20/59b.
LITERATURE: For the Haifa Painter, see *RVAp* II 564–69. Our vase is closely comparable to the painter's name vase (Haifa 3316 = *RVAp* II 566, no. 44), except that the positions of the two running figures on the obverse have been interchanged. The *cista* decorated with white triangles is popular with the Haifa Painter (cf. nos. 34, 36, 53, 57a, 59, 63), and the banded bucket is repeated on no. 57. For the drapery of the running woman, with the left leg clearly visible beneath it, cf. nos. 45, 61–64; for the youths on the reverse, cf. nos. 39, 44, 46, 55—a diptych regularly appears above, between them; for the serrated leaf cf. pl. 211,6. Closest in style and treatment to our vase is a bell-krater once on the New York market (Ariadne Galleries; *RVAp, Suppl.* II, 175, no. 20/59a, pl. XLV, 1–2) which has an almost identical scene on the obverse, with a similar banded situla in the right hand of the youth and a lily between the two figures on the obverse; and on Side B two draped youths with a tall leaf between them and a diptych between two windows above.

108

APULIAN RED-FIGURE BULL'S HEAD RHYTON
Attributed to the Workshop of the Darius Painter-Group of Ruvo 1401
Ca. 330 B.C.
Gift of Gilbert M. Denman, Jr.
86.52
Woman and Eros

On the bowl, between enclosed fan-palmettes with side scrolls, are two figures—a draped woman bending forward and holding out a wreath towards Eros, seated on a rock-pile and holding a phiale in his outstretched right hand. She wears a long chiton; her hair is caught up in a *kekryphalos*, with a bunch emerging at the back. She has a necklace, bracelets and slippers. The hair of Eros is caught up in a similar *kekryphalos*, with a bunch above the brow and another emerging at the back. He wears a necklace, bangles on both arms, and slippers. His wings, spread out at the back, are touched up with white. The vase might well be placed in the Group of Ruvo 1401 (*RVAp* II, p. 619). ADT

DIMENSIONS: H. 19 cm.; Diam. of mouth 13.6 cm.
CONDITION: The projecting portion of both ears has been restored, but otherwise the rhyton is in good state, although the surface is slightly worn in places.
SHAPE AND DECORATION: The eyes on our head have a solid black elliptical pupil outlined by a reserved band and a black band. Above are folds of skin. The outer rim of the bowl is decorated with a band of egg-pattern, with black dots between the ovoli and a reserved stripe beneath it; on either side of the handle is a large enclosed fan-palmette, with a tall side-scroll and a couple of palmette leaves between the two at the top. Below the picture is a reserved stripe with a thin black line in the center.
ADDED COLOR: Added white is used for adjuncts and details.
BIBLIOGRAPHY: Sotheby's London, 9–10 July 1984, lot 334; New York, Andre Emmerich Gallery GR 281, *Ancient Vases from Magna Graecia* (May 1986), no. XV; *RVAp*, Suppl. II, no. 21/125a.
LITERATURE: Parallels to both figures will be found on many of the vases from the Darius workshop, listed in *RVAp*, chapter 21, *RVAp*, no. 21/125; H. Hoffmann, *Tarentine Rhyta* (Mainz 1966), 17, no. 53 (G1), pl. 9,1–2, where the rendering of the eye and of the flanking fan-palmette

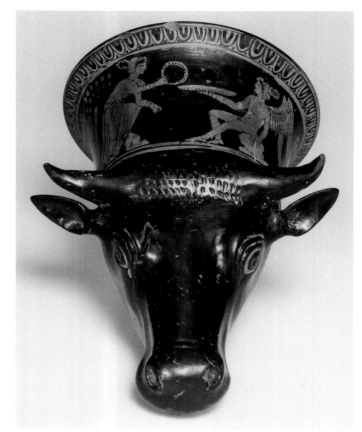

108

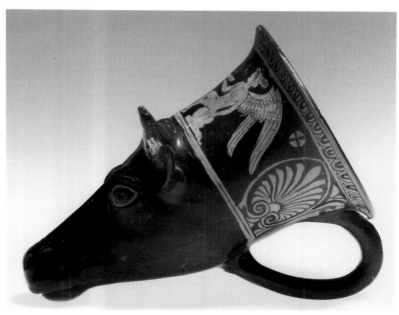

108

is similar. For Apulian rhyta in the form of bull-heads, see Hoffmann, *Tarentine Rhyta*, where it is pointed out that the heads seem to represent those of a "small stocky animal with a remarkably wide upper cranium and a narrow muzzle... Their poll is strongly developed. Their horns, thick and sharply pointed, are shorter than those of Attic bull-heads, and there is rarely a dewlap."

109

APULIAN RED-FIGURE
OINOCHOE (EPICHYSIS)
WITH FLATTENED BODY
Attributed to the Menzies Group
Ca. 330 B.C.
Gift of Gilbert M. Denman, Jr.
86.134.86
Seated woman

The figural decoration, which is con-
fined to the curving surface of the up-
per part of the body, consists of a
draped woman seated on a white rock-
pile. The lower part of her body is
turned to the left, the upper part
slightly to the right, with the head
completely in profile. In her right hand
she holds up a rectangular box, from
which hangs, by a white ribbon, a flap-
ping fillet; in the hand of her out-
stretched left arm she holds a fan,
painted in white with inner markings
in dilute glaze. Her hair is tied in a
kekryphalos, decorated with white dots;
a large bunch emerges from it at the
back and there is another bunch above
the brow. She wears a long chiton, fas-
tened on each shoulder by a brooch,
and caught up at the waist with a black
ribbon; between the breasts is a row of
short fold lines, with longer ones above
and below the girdle on her left side
and below her left leg, which, like the
other, is stretched out in front of her.
She wears earrings, a two-strand bead
necklace, bangles and slippers. In the
field, below to left and above to right,
are two rosettes, the petals of which are
touched up with white dots.

The vase is one of the minor prod-
ucts of the workshops of the Patera and
Baltimore Painters, generally classified
as the Menzies Group. Such vases are
not always easy to distinguish from
those in the contemporary group from
the workshop of the Darius and Un-
derworld Painter, but here the drawing
of the seated woman, especially the pir-
iform shape of her left breast, seems
closer to the style of the Patera Painter
and his followers, as also does the orna-
mental decoration (notably the black
strokes on the central palmette leaves).

ADT

DIMENSIONS: H. to top of handle
16.3 cm.; Diam. of base 10.2 cm.
CONDITION: Unbroken. Cracks at base
of handle. Minor chipping on foot and
top of handle.
SHAPE AND DECORATION: The shape is
most unusual in Apulian. The neck,
spout and handle resemble those of the
oinochoe shape 10 (e.g. *RVAp* II, nos.
20/230 ff.), but the body instead of being
globular as on other examples of this
shape, has a flattened form, not unlike the
upper portion of the body of an epichysis
(cf. pl. 315,3), without the cylindrical ele-
ment beneath it. On either side of the
beaked spout is a molded head in relief; at
the bottom of the neck, a band of
tongues in black on the reserved back-
ground, and below it at the top of the
body a band of ovoli, with a reserved
stripe below it. At the foot of the high
handle is a spreading fan-palmette, the
central leaf of which is flat-topped and
extends up onto the handle. The fan is
flanked by detached scrolls with a central
spiral; on either side of the upper scroll is
a palmette fan, the central leaf of which is
decorated with black dots or strokes; the
tips and base of the palmette leaves are
enlivened with touches of white. The
foot, which is slightly concave, is sepa-
rated from the body by a reserved stripe,
and there is a wider reserved stripe in the
central portion, painted over with a red
wash, as is the reserved base.
BIBLIOGRAPHY: *RVAp, Suppl.* II, 259,
no. 26/261b.
PARALLELS: Good parallels for the style
may be found in the women represented
on a number of epichyseis and lekanis lids
in the Menzies Group (cf. *RVAp* II, 836–
37, nos. 238–46 and pp. 842–43, pl. 315,5
and 7). A similar form appears in con-
junction with a squat lekythos in a vase in
a private collection in Bari (*RVAp,
Suppl.*, 259, no. 26/294b, pl. LXVIII,1)
and it may be noted that other hybrid
shapes appear also in this Group (e.g. the
lekythos Philadelphia L.64–223; *CVA* 1,
pl. 25, with J.R. Green's comment in the
Text on p. 19).

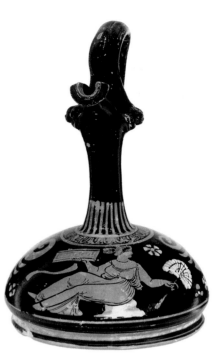

110

APULIAN RED-FIGURE PSEUDO-PANATHENAIC AMPHORA

Attributed to the Baltimore Painter
Ca. 330–320 B.C.
Gift of Gilbert M. Denman, Jr.
86.134.87
A (Shoulder): Female head
(Body): Woman and youth
by horse in *naiskos*
B (Body): *Naiskos*

On Side A is a *naiskos* of standard form, with engaged Ionic columns, side-walls, ceiling-beams and floor in red-brown, a pediment with a disk flanked by solid triangles within it, and two white birds with trailing ribbons flying above it. Its base is decorated with white scrollwork on a pink back-ground. Inside stands a draped woman holding a phiale in one hand and a wreath in the other, as if to offer a liba-tion to the youth who stands beside her, grasping the bridle of the horse be-hind him. The woman wears a white chiton, with a girdle at the waist; the fold-lines and borders are rendered in diluted glaze. Her right leg is crossed rather clumsily in front of her left. Her hair is caught up in a *kekryphalos*, tied at the back, from which a bunch of hair emerges, with a white ribbon; her necklace and bracelets are painted in diluted glaze. The youth is naked, save for a red chlamys, fastened at the throat with a brooch and falling down behind his back. He has curly hair, rendered in diluted glaze, carries a spear in his left hand, and has a *petasos* behind his head. Above to right is a muscled cuirass, the anatomical details of which are ren-dered in diluted glaze, the inside, where visible through the holes for the neck and left arm, painted crimson red. To the left of the *naiskos* are two women: the one above, wearing a chi-ton with a piece of drapery across her lap, is seated and holds a bunch of grapes in her right hand and an open box in her left. In front of her is a pat-era with anthropomorphic handle; the woman below, similarly draped, holds up a parasol in her right hand and a *cista* in her left. In front of her is a situla (cylindrical bucket), with figured deco-ration in added yellow on the body, and behind her a knob-handled patera in added yellow and red. On the other side are two more women, both

dressed in similar fashion, except that the one below wears a *sakkos* instead of a *kekryphalos*. The woman above is seated and holds a phiale, with a spray above it and a fillet below, in her right hand and a handled *cista* in added white in her left. The woman below bends forward over her raised right foot, with a flat basket in one hand and a fan in the other. Immediately in front of her is a *mesomphalic phiale*.

On Side B the *naiskos* is narrower and lacks ceiling-beams and pedimental decoration; it is otherwise similar to the one on A, but has a leaf pattern instead of scroll-work on the base. In it is a flowering plant, with three large white-petalled flowers between spreading acanthus leaves, with white edges. Such plants appear frequently in naiskoi. As on Side A, the *naiskos* is flanked by two women on each side, those above seated, those below standing. All wear peploi, only one (below left) has a cloak, which is draped over her left arm. All carry various objects; the two above, a tambourine and a phiale, the two below *cistae* in their right hands, the one to left with a wreath in her left, the other a mirror. On the edge of the base of the *naiskos* to the right is a situla; above on either side is a fillet

bordered in white, and below on the left, beside the *naiskos*, an ivy-leaf.

A D T

DIMENSIONS: H. 88 cm.; H. to top of body 56 cm.; Diam. of mouth 27 cm.; Diam. of foot 20 cm.

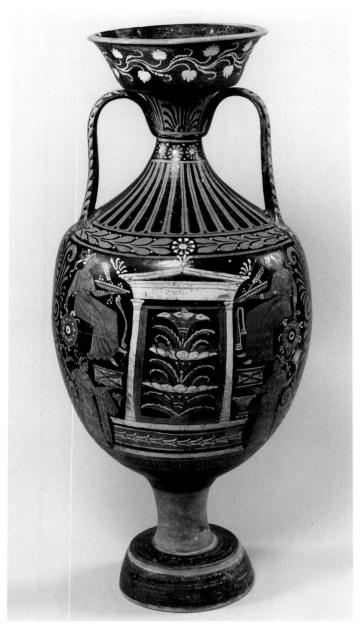

110

simpler—at the top of the neck a panel containing one black figure fan-palmette with side scrolls; below, a black band in relief; above, a band with three rosettes, then running down onto the shoulder a panel of thick black tongues, separated by thin black lines ending in a dot, on a reserved background; beneath this, between the handle-joins are two laurel wreaths facing inward, with a central rosette between them, with white-tipped petals and center. The strap handles are decorated with red-figure laurel with white berries. Below the pictures is a meander band, interspersed with hollow squares with a dot in the center of each side. The ovoid body of the amphora tapers sharply inward to join the comparatively tall stem, the greater part of which is left reserved, attached to a convex foot, with a reserved band slightly inset running round the top. The foot is pierced and reserved on the underside.

BIBLIOGRAPHY: *RVAp, Suppl.* II, 276, no. 27/39c, pl. LXXII, 2; Galerie Günter Puhze, *Kunst der Antike*, 5 (Freiburg 1983) no. 216.

LITERATURE: This is one of a long series of amphorae by the Baltimore Painter showing a youth beside his horse in a *naiskos*, sometimes, as here (cf. also Melbourne, Geddes coll. A 1:24 = *RVAp, Suppl.* I, 153, no. 39a; and once Paris Market, Antonovich, inv. 883, *La Gazette de l'Hôtel Drouot*, vol. 93, no. 34, 5 October 1984, ill. on p. 69; *RVAp, Suppl.* II, 277, no. 27/39d) in the presence of a woman, who might be the mother of a deceased horseman. For other examples of the *naiskos* with plant inside by the Baltimore Painter see *RVAp* II, 861ff., nos. 6, 14, 14a, and 41 (cf. also op. cit., p. 799, nos. 18–21 by the Ganymede Painter; and for a list of such representations see H. Lohmann, *Gräbmaler auf unteritalischen Vasen* [Berlin 1979] 319, 1: "Ranken und Bluten"). The vase is a very typical product of the Baltimore Painter; some parallels for the subject represented are given above, and in the drawing of the figures we may note several features characteristic of his style—the drawing of the faces in profile, with a flat line for the mouth and a rectangular chin; the well-defined fold-lines of the drapery, and the thin black line that runs down one of the legs (as on the two seated women on Side B); the white striped *sakkos* worn by the woman below to right on Side A; the muscled cuirass in the *naiskos*; the heavy-chested and rather stocky horse (See *RVAp*, II 856–60; *RVSIS* 97–99). Regarding *naiskoi* of standard form, see *RVSIS* 266–67.

CONDITION: Body unbroken. Mouth broken and repaired. Losses on *naiskos* on Side B, seated right figure and B/A handle. Cracks at handle joins. Spalling on Side B shoulder and Side A body. Loss of applied white paint across mid-region of youth and horse on Side A. Minor chipping on mouth.

SHAPE AND DECORATION: The amphora of panathenaic shape is very popular in Apulian and especially with the Baltimore Painter, to whose hand some thirty may now be ascribed. The mouth is fairly wide with flaring rim and tapers downwards to join the top of the neck; its exterior is decorated with a wreath of vine-leaves and tendrils in added white below which is a reserved band. At the top of the neck on Side A is a panel with two red-figure palmette-fans. Below is a raised band of bead-and-reel in white, then a row of rosettes, and leading down to the shoulder, white rays on a black background. The shoulder, between the handle-joins, is decorated with a female head in added white in three-quarter view to left, rising from a campanula flower amid a maze of spiralling tendrils and flowering plants; below is a band of egg-pattern. On Side B the decoration is

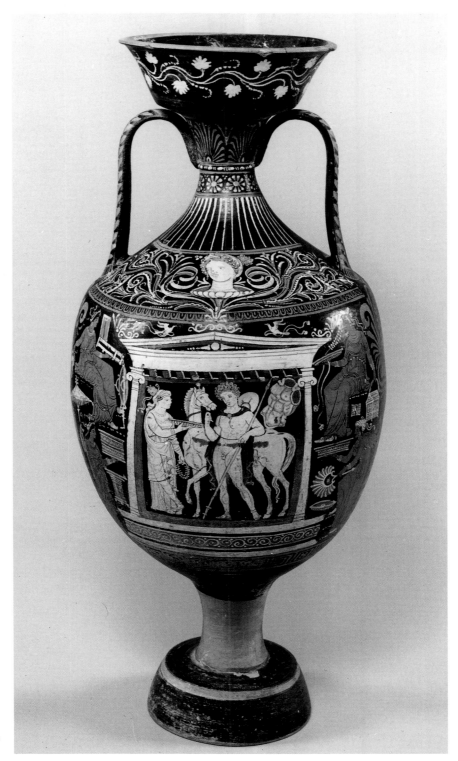

110

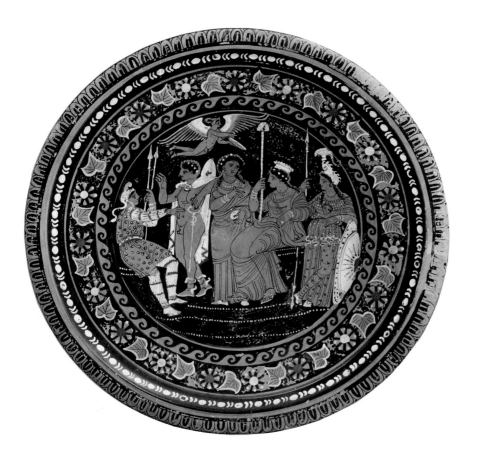

111

APULIAN RED-FIGURE PLATE
Attributed to
the Painter of Berlin F 3383
Last quarter of the 4th century B.C.
Gift of Gilbert M. Denman, Jr.
86.134.192
Interior: The Judgment of Paris

The scene shows Paris, dressed in ori-
ental costume (Phrygian cap, patterned
tunic over long-sleeved and trousered
garment, in white with red stripes),
holding two white spears in his left
hand, while his right points to the three
goddesses. He looks up towards Her-
mes, a youthful figure who stands in
front of him, his right leg bent at the
knee, a *kerykeion* lightly held by the tip
in his left hand, his right raised in an
admonitory gesture to Paris. He is
naked, except for a red-bordered white
chlamys, fastened at his throat by a
brooch and hanging down his back; a
row of beads encircles his head, behind
which hangs a white *petasos*; on his feet
are boots with white tops and white

projections at the heels, which are
probably meant to represent wings.
Next is Aphrodite, shown in a frontal
pose, with her head and face in three-
quarter view to right. A cloak is draped
across her body and over her left shoul-
der; beneath it she wears a short-
sleeved tunic. Her hair falls down in
curling locks onto her shoulders; she
has a diadem of beads in her hair above
the brow, a double-strand necklace,
bracelets and slippers, all in added
white. In her left hand she holds the
golden apple, shown in white and yel-
low, which was to be awarded to the
winner of the beauty contest; in that
case the judgment has already been
made, and this could explain the rather
disappointed looks on the faces of the
other two goddesses. Above Aphrodite
flies a small Eros, the upper portion of
whose wings is painted white, and who
holds a white-edged phiale in his left
hand. Beside Aphrodite sits Hera, hold-
ing a white scepter with a top like a
flabellum in her right hand. Her cos-
tume is similar to that of Aphrodite,

but she has a white polos-crown on her
head, and a ring with a white stone on
the third finger of her left hand. Her
head is in profile and her gaze is di-
rected towards Paris. Last comes
Athena in full panoply, the aegis,
fringed with white snakes and with the
gorgoneion in the center, over her long
chiton, the lower portion of which is
decorated with stars. She wears a white
crested helmet of Phrygian type and
rests her left arm against a large, round
white shield, with a red star pattern
around the center and a dotted border
also in red. Like Hera, she looks to-
wards Paris. The ground lines are
shown as rows of white dots.

The Painter of Berlin F 3383, to
whose hand this plate may be ascribed,
is one of the more important followers
of the Baltimore Painter. He decorated
some sixty extant vases, mostly with
naiskos, Dionysiac or genre scenes, but
seldom ventured into the realm of
mythology. Particularly characteristic is
his treatment of drapery; the fold-lines
are drawn very distinctly, running
down the garment in a series of parallel
lines, often in bunches of two (as with
Aphrodite). Female breasts are clearly
indicated, with black dots or circles for
the nipples, and connecting cross-folds
on the drapery over them (as with
Hera). On youths (e.g. Hermes) the
nipples are also clearly defined, project-
ing outward when seen in profile.

ADT

DIMENSIONS: H. 8.5 cm.; Diam. 47.9 cm.
CONDITION: Recomposed from several
large fragments, with small portions miss-
ing (below and in front of the head of
Hermes; to right of Aphrodite's head),
which have been restored. There is some
repainting at the joins and on the back-
ground beneath the figures.
SHAPE AND DECORATION: The plate is a
fairly common shape in Apulian, but usu-
ally of rather smaller size and often deco-
rated with only a single figure or with a
female head. Our example is unusually
large and has a low foot, which was
pierced for suspension. The scene in the
tondo is encircled by a band of wave-
pattern in black against a reserved back-
ground, with a narrow reserved stripe be-
low it; next to the wave-pattern comes a
band of ivy leaves alternating with
rosettes. The ivy leaves are pointed,
veined inside and bordered with white;
the petals of the rosettes are tipped in
white, and in the center is a yellow disk.
Around this band is a reserved stripe;

then comes a band of bead-and-reel pattern in added white and yellow on a black background. The outer edge of the plate is decorated with a border of egg-pattern, with a reserved stripe below it. The underside is painted black, except beneath the rim where there is a red wash over a reserved background. There is a reserved stripe and red band where the floor of the plate joins the foot and the underside is decorated with black with reserved sides, the latter with a red wash.

ADDED COLOR: Added white, yellow and shades of red are extensively used for drapery, details, adjuncts and in the pattern-work; the white has in places (e.g. in the centers of the rosettes in the borders) been rubbed off.

BIBLIOGRAPHY: *RVAp, Suppl.* I, 172, no. 28/73a; once Los Angeles Market, Summa Galleries, inv. 2054, then Sotheby's New York, 8 June 1984, lot 33 and 21–22 November 1985, lot 84.

LITERATURE: The Judgment of Paris was always a popular subject with Greek vase-painters: see Clairmont, *Das Parisurteil in der antiken Kunst* (Zurich 1951) esp. 59–63, K 184–99 for South Italian examples; I. Raab, *Zu den Darstellungen des Parisurteils in der griechischen Kunst* (Frankfurt and Bern 1972); J.-M. Moret, "Le Jugement de Paris en Grande-Grèce," *AntK* 21 (1978) 76–98; *LIMC* I, 498–500, s.v. Alexandros, B. Parisurteil; II, 992–93, s.v. Athena B2(b), Le Jugement de Paris; see also Trendall, *RVP*, 112–16, dealing primarily with this subject on Paestan vases. For vases by the Baltimore Painter, see *RVAp* II 856–81; *Suppl.* I 170–72; *Suppl.* II, 267–96.

PARALLELS: Closest perhaps in style and treatment to our vase is the barrel-amphora Naples 3236 (*RVAp* II 918, no. 60, pl. 354,2–4; K. Schauenburg, *Festschrift für Frank Brommer* (Mainz 1977), pl. 69,1) on which may be noted the similarity between the three-quarter face of the seated Fury and that of Aphrodite, as well as between the wings of the Erotes on the two vases, and the drawing of the faces and drapery of the female figures. Even the pattern-work offers a close parallel in the veined and pointed ivy leaves which appear on the borders of both vases. This is the only plate so far known by the Painter of Berlin F 3383. He did, however, decorate three knob-handled paterae (dishes), one of which in the Lagioia collection in Bari (*RVAp* II 920, no. 74) has a somewhat similar composition in the tondo showing a youth seated beside two women, with a small Eros flying above, but it is not in a good state of preservation; the second, from Sotheby's London, 9–10 July 1984, lot 347 = *JdI* 101 (1986) 171, fig. 13; *RVAp, Suppl.* II, 331, no. 28/74–1), shows two seated youths and a seated and a standing woman disposed at different levels. The rendering of the drapery and the drawing of the faces in profile have much in common with our plate, and there are the same dotted groundlines. The third (*RVAp, Suppl.* II, 331, no. 28/74-2, pl. LXXXVI, 1) shows Nike driving a biga.

112

GNATHIAN BLACK-GLAZED HYDRIA AND STAND

Ca. 340–300 B.C.
Museum Purchase:
Grace Fortner Rider Fund
86.119.3 a,b

Around the opening of the mouth of the hydria is a flat area with a raised edge in black. Beneath is a band of egg pattern, partly in relief. The neck is decorated with a wreath of vine leaves and tendrils in added white. The ribbing which covers the entire body begins on the shoulder beneath a band in added red. At the join to the foot there is a reserved stripe. The foot consists of a stem terminating in a saucer-like base attached to a convex foot which is reserved. The underside of the foot is also reserved.

The stand consists of two elements: the lower, a square base, to which the upper is affixed. The top of the stand corresponds to the top of the hydria. The stem has a band in relief between two reserved stripes, below which a concave leaf pattern in relief joins it to a cylindrical support, again with a raised edge in black, below which is an inset reserved stripe. The square base is painted black with a reserved line where it joins the outer edge. The underside is reserved and the stem is hollow. ADT

DIMENSIONS: H. of hydria 38.9 cm.; H. of foot 14 cm.; H. of hydria on stand 52.6 cm.; Diam. of mouth 13.8 cm.; H. of stand 3.3 cm.; W. of stand 19.8 cm.

CONDITION: Hydria unbroken; repaired cracks in body. Minor glaze loss inside mouth. Foot of stand broken and repaired.

BIBLIOGRAPHY: Unpublished.

PARALLELS: This hydria came from the same tomb as a number of similar vases and the stand may not belong. A very similar hydria with a stand appeared on the New York market at Sotheby's, June 23, 1989, lot 205; it is rather more elaborately decorated, with ornamental details in red-figure and, on a band between the handles, a frontal female head in added white and yellow in a floral setting.

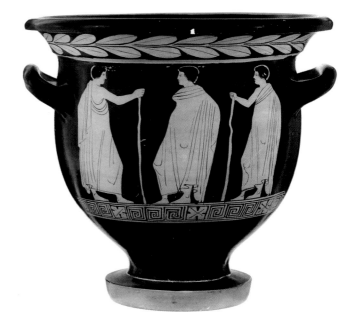

113

**LUCANIAN RED-FIGURE
BELL-KRATER**
Attributed to the Amykos Painter
Ca. 420–410 B.C.
Gift of Gilbert M. Denman, Jr.
86.10.1
A: Palaestra scene:
draped woman, Nike, nude athlete
B: Three draped youths

The palaestra scene on the obverse is
very typical of those which frequently
appear on the bell-kraters of Early Lu-
canian artists, especially the Pisticci and
Amykos Painters, and which are de-
rived from Athenian prototypes of the
forties and thirties of the fifth century.
To the left stands a woman wearing a
sleeved chiton and a cloak which falls
down over her left shoulder and runs
across her body. Round her head is a
reserved bandeau. With her right hand
she grasps a stick; her left projects
slightly forward beneath the cloak,
which falls down beneath it in a series
of parallel fold-lines. In front of her
stands a winged female figure, presum-
ably Nike, similarly dressed, but with
her left hand concealed beneath her
drapery, while the right is outstretched
towards a nude athlete, who stands be-
fore her, holding a fillet in his right
hand and a stick in his left. Three-

figure compositions like this are com-
mon on vases by the Amykos Painter
depicting palaestra scenes; these usually
show two athletes in the presence of a
woman (e.g. *LCS*, nos. 147–50, 153–
55, 157–58) or two women with an
athlete (e.g. nos. 152, 152a, 160); Nike
appears less frequently, as on Ruvo 427
(*LCS*, no. 159), or by herself with an
athlete on Leiden K 1945/8.7 (*LCS*,
no. 162), where she closely resembles
her counterpart on our vase.

The reverse depicts the three draped
youths who appear on almost all the
reverses of Early Lucanian bell-kraters.
Here the central youth is wrapped up
in his cloak, while the other two ex-
tend their right arms, grasping a stick
with the right hand, a composition
favored by the Amykos Painter (e.g.
LCS, nos. 111, 114, 117a, 120–21, 124).

That this vase is by the Amykos
Painter is very clear from the poses of
the woman and Nike (cf. *LCS*, nos.
112, 159, 160–62) and the rendering of
their drapery, notably in the way in
which the outline of the body appears
beneath it, as well as from the drawing
of the body of the athlete (cf. *LCS*,
nos. 147, 151a, 155–56). They may all
be counted among the painter's stock
figures (see *LCS*, pp. 30–31).

The recent discovery of potters' kilns
at Metaponto containing several frag-

ments of large vases by the Amykos
Painter (see *LCS*, *Suppl.* III, pp. 3–4
and 12) indicates that at least for part of
his career he must have worked at that
site; his main activity may be dated to
the last quarter of the fifth century and
our vase is probably to be assigned to
his middle period. A D T

DIMENSIONS: H. 32.6 cm.; Diam. of
mouth 33 cm.; Diam. of foot 14.5 cm.;
H. of foot 2.2 cm.
CONDITION: The vase is intact and well
preserved, although there are some traces
of misfiring, especially on the reverse.
SHAPE AND DECORATION: The shape is
that of the typical Early Lucanian bell-
krater, based on Attic models of ca. 440–
420 B.C.; the height of the vase nearly
matches the diameter of the mouth, the
rim curves outwards, and beneath it, be-
tween reserved bands, runs a laurel
wreath to right, with veined leaves. The
body assumes a convex curve, tapering
downward to the low stem, which termi-
nates in a very narrow reserved band
where it joins the foot. The disk foot,
which is 2.2 cm. in height, curves slightly
inwards and its outer edge is left reserved,
as is the underside. Below the pictures on
either side is a band of meanders, in
groups of three except at the far end
where there is only one, interspersed by
saltire squares with black strokes in the
center of the four sides. There is no dec-
oration below the handles, or at the han-

dle joins; beneath the handles, however, there is a reserved area.

BIBLIOGRAPHY: Christie's London, 26 November 1980, lot 274 and 12 December 1984, lot 121; Charles Ede Ltd. London, inv. 2235, *Greek Pottery from South Italy* XI, no. 2; *LCS, Suppl.* III, p. 14, no. 159a, pl. II, 1.
LITERATURE: For the history of this fabric see *LCS*, Book I, with later additions in *Supplements* I–III (Institute of Classical Studies, London: *Bull. Supp.* 26, 1970; 31, 1973; 41, 1983), in all of which the relevant bibliographies are given. A brief survey of the fabric will also be found in A.D. Trendall *RVSIS* 18–23 (for the early stages) and 55–63 (for the later), with illustrations 1–30 and 64–100.

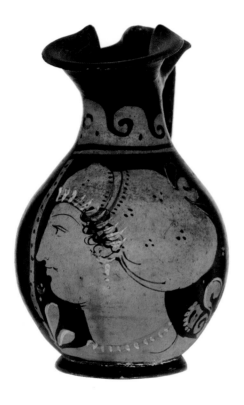

114

CAMPANIAN RED-FIGURE OINOCHOE (SHAPE 3 [CHOUS])
Attributed to the Seated Nike Painter in the Spotted Rock Group
Ca. 350–340 B.C.
Museum Purchase:
Stark-Willson Collection 86.138.90
Female head in profile to left

The hair is completely covered beneath a *sakkos*, with a bow at the top tied with a white ribbon and decorated with dot-clusters and two dot-stripes across the top. A small bunch of curly hair emerges over the left ear, from which hangs a drop earring. A *stephane* with white and yellow spikes rises above the brow and there is a white bead necklace around her neck. The eyebrow is placed high above the eye, the pupil of which is shown as a black stroke.

The head is typical of the work of the Seated Nike Painter, one of the artists in the Cassandra Group and finds a close parallel on the bell-krater Warsaw 147273. ADT

DIMENSIONS: H. 21.7 cm.; Diam. of foot 7.6 cm.
CONDITION: Unbroken. Minor chipping of black glaze on handle, mouth and body.
SHAPE AND DECORATION: The oinochoe has a trefoil mouth, beneath which, on the neck, is a band of reversed waves with black dots between the waves. Above the head is a reserved stripe and to the left, a reserved vertical stripe with black dots. To the left of the head are two palmette leaves and a white floral with two dots. To the right, a palmette scroll with the white fringed floral typical of the Seated Nike Painter. The disk foot is black, as is also the underside. The terracotta has the characteristic Campanian buff color.
PROVENANCE: Ex coll. Stark (Orange, Texas)
BIBLIOGRAPHY: Unpublished.
PARALLEL: Warsaw 147273, *LCS* pl. 92,7.

115

CAMPANIAN RED–FIGURE
FISH–PLATE
Attributed to the Elliott Painter
Ca. 330–320 B.C.
Gift of Gilbert M. Denman, Jr.
86.134.89
Two fish and a torpedo

The Elliott Painter, who takes his name
from the J.R. Elliott Museum of Clas-
sical Archaeology in the University of
Tasmania, Hobart, which contains two
of his fish-plates (*GRFP*, nos. IIb/31
and 37), belongs to a group of fish-
plate painters connected with the Ixion

the varieties of perch (*serranidae*). The
third fish, shown in the leaping posi-
tion favoured by this painter looks to
be similar to the other. The fins, gills
and mouth are all shown in added
white; the eyes here take the form of a
black disk, with a white dot in the cen-
ter, as commonly on the painter's later
vases. The bodies of the two bony fish
are decorated with a black lateral stripe
and rows of white dots; the leaping fish
is repeated on Oxford V 449, which is
very close to our plate. A D T

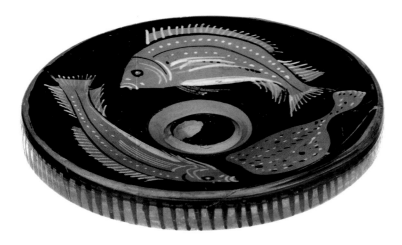

Painter, and this plate is probably one
of the minor products of his workshop.
His earlier fish-plates, on which the
drawing is neater and more precise,
regularly depict a dolphin, which is no
longer to be found on his later works,
where instead a torpedo makes a regu-
lar appearance. Its body is speckled, as
on our plate, with small black and
white dots with a line of black dots
down the center, and two large black
dots for the eyes. The fish confronting
the torpedo has a dorsal fin clearly di-
vided into two sections and may well
represent a stylized version of one of

DIMENSIONS: H. 4.5 cm.; Diam. 16.5 cm.
CONDITION: Unbroken. Fire-cracks to
left of torpedo and on underfoot. Encrus-
tation on underfoot.
SHAPE AND DECORATION: The plate is
of standard shape; the central depression
is painted black, with a reserved edge sur-
rounded by a broad reserved band. There
is a reserved band round the outer edge
of the plate and the overhanging rim is
decorated with thick black strokes. The
underside is left reserved. A narrow stem
connects the floor of the plate with a foot
in one degree.
BIBLIOGRAPHY: *GRFP* 79, no. IIB/35,
pl. 22e. See also under Cat. No. 122.
PARALLEL: Oxford V 449: *GRFP* no.
IIB/36, pl. 22f.

116

CAMPANIAN RED–FIGURE
BAIL–AMPHORA
Attributed to the Ixion Painter
Ca. 320–310 B.C.
Gift of Gilbert M. Denman, Jr.
86.134.188
A: Standing warrior
B: Draped youth

Side A shows a warrior standing to left,
with a white spear in his right hand and
a round shield in his left. The shield has
a white outer rim, a band of white
strokes on a pinkish background and a
white star (or rosette) in the center on a
black background. Round his head is a
wreath with the tall spikes favoured by
the Ixion Painter; there are white slip-
pers on his feet, the right being planted
slightly in front of the left. In the top
left-hand corner is a phiale with a black
center. The reverse shows a draped
youth, with a similar headdress; he is
completely enveloped in his himation,
which assumes a "sleeve"-like shape
over his slightly bent left arm. He
wears white slippers decorated with
dots.

Comparable representations appear
on many other bail-amphorae, as well
as on skyphoi, from the workshop of
the Ixion Painter (*LCS* 342, nos. 822–
25, and p. 243, no. 843; *Suppl.* III, p.
160, nos. 822 a-h; pp. 162–63, nos. 843
a-b, 857a). That these vases are minor
works by the painter's own hand seems
highly probable from a comparison be-
tween the draped youth on Side B and
the corresponding youths on the re-
verses of some of his larger vases (e.g.
LCS and *Suppls.*, nos. 792c, 795, 801),
as well as from the use of a spiky
wreath (cf. nos. 792 b and c, 795, 806a,
830), and the palmette decoration be-
tween the figures (as on 816a, 827e,
828).

As the body of the warrior is com-
pletely concealed beneath his shield, it
is not possible to determine what he
was wearing, but on *LCS, Suppl.* III,
no. 822g he wears the typical Samnite
short tunic with a broad metal belt, and
it is probable that our vase also repre-
sents a Samnite. Most of the other war-
riors depicted on these vases carry a
round shield with a white on black star

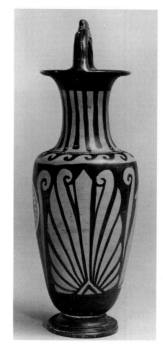

in the center, and a white border, sometimes decorated with studs. It is the typical armor of a hoplite. A D T

DIMENSIONS: H. to top of handle 36.5 cm.; Diam. of mouth 10.1 cm.; Diam. of foot 8 cm.

CONDITION: Unbroken. Small cracks on handle. Minor glaze chipping on foot.

SHAPE AND DECORATION: In South Italian red-figure, the bail-amphora is unique to Campanian; it appears to be of local origin and goes back at least to the beginning of the fifth century B.C., when a number of such vases were decorated in the black-figure technique. In Italian a vase of this shape is often referred to as a situla, but as this could lead to confusion in English where situla is used to describe vases of a rather different shape, it seems preferable to adopt Beazley's designation of bail-amphora, bail being the technical term for the semi-circular arching handle of a kettle. In red-figure Campanian the

shape is used extensively in all the regional fabrics; the handle may be smooth or knotted, and it often has a protuberance on top, which may be pierced to allow for suspension (as on our vase). The comparatively tall neck is decorated with black tongues on a reserved background, and the shoulder with a frieze of reverse wave-pattern. Beside the figures is an outward-curving single scroll, on only the right side on the obverse, on both sides on the reverse, giving a frame-like effect. Between the figures on both sides is a large fan-palmette, rising from a triangular core, with a diamond-headed central leaf, inward-curving leaves on either side of it, the remaining leaves also turning slightly inwards. The body tapers gently down to the disk foot; there is a relief band at the join to the body, the outer edge of the foot has a groove just above the base; the underside is painted black.

BIBLIOGRAPHY: Charles Ede, *Collecting Antiquities* (London 1976) fig. 58a; Charles Ede Ltd., *Greek Pottery from South Italy*, IV (London 1975) Cat. no. 3; Sotheby's New York, 9 December 1981, lot 211; *LCS*, Suppl. II 206, no. 822B, and III 160.

LITERATURE: On Samnite armor see, in particular, F. Weege "Bewaffnung und Tracht der Osker," *JdI* 24 (1909) 141–62; Saulnier, *L'armee et la guerre chez les peuples Samnites* (Paris 1983); Connolly, *Greece and Rome at War* (London 1981) 105–12. On Campanian black-figure bail-amphorae, see P. Mingazzini, *CVA* (Capua 3), text to IV Es, pp. 1–2, pls. 1–3; with lists on pp. 12 and 16f.; see also F. Parise Badoni, *Ceramica Campana figure nere* (Florence 1968) 87ff., 111–13; pls. 28, 30–31, 38.

117

PAESTAN RED-FIGURE
NECK-AMPHORA
WITH TWISTED HANDLES
Signed by Asteas
Ca. 340–330 B.C.
Gift of Gilbert M. Denman, Jr.
86.134.168
A (Body): Orestes at Delphi
(Shoulder): Bird, youth and
woman, Eros, woman
(Neck): Siren
B (Body): Youth between two
women; two female busts above
(Shoulder): Laurel wreath
(Neck): Profile head of woman

Side A depicts Orestes at Delphi, a sub-
ject very popular with South Italian
vase-painters, and perhaps distantly
reflecting the *Oresteia* of Aischylos. In
the center is the *omphalos* (conical stone
at Delphi, supposed to be the center of
the earth), decked with a network of
fillets and with wide red ribbons
around it, in front of a single fluted
column on a low, flat base which may
stand for the stylobate of Apollo's tem-
ple; Orestes, naked save for a chlamys
behind his back, a *petasos* and sandals
with laces, clutches the *omphalos*, while
he brandishes a sword in his right hand,
and turns his gaze upwards towards the
menacing figure of a Fury, Megaira
(ΜΕΓΑΙΡΑ), who threatens him from
above. Beside him, to the left, is a half-
draped youth, bending slightly forward
over his raised left foot, his right arm
uplifted in a gesture of horror. The
lower part of his body is covered with a
piece of patterned drapery with the
usual checker border. Like Orestes, he
has no identifying inscription, but he is
probably Pylades, who appears on
other vases showing this scene, notably
Python's krater in London (B.M.
1917.12–10.1). To the right is the
white-haired priestess Mantikleia
(ΜΑΝΤΙΚΛΕΙΑ) who may be compared
with Manto on Paestum 4794; in her
left hand she holds the temple key, her
right is raised in a gesture signifying
terror. She wears a short-sleeved chiton
with a central stripe, and across the
lower part of her body is a piece of pat-
terned drapery with a dot-stripe bor-
der. Her name may be intended, like
that of Manto, to indicate her oracular
skill as priestess, rather than to be her
true personal name.

Above, seen as a row of half-figures,
are Apollo (ΑΠΟΛΛΩΝ), laurel-crowned

and holding a scepter, but very badly
preserved, then Megaira, balanced on
the other side of the column by a sec-
ond Fury, Allecto (ΑΛΛΗΚ..), both
wearing elaborate costumes and hold-

ing snakes in their hands. Lastly is a
bearded satyr, a fawnskin knotted
round his neck, who looks down on
the scene taking place below, with
which, however, he seems to have no
direct connection (cf. the papposilen in
the same location on Python's signed
neck-amphora = *RVP* pl. 89,1).

The shoulder of Side A is decorated
with four figures between standard
Paestan "framing" palmettes. To the
left is a speckled bird, which reappears
on other vases from the Asteas-Python
workshop (e.g. Cat. No. 123 and *RVP*
pl. 137 d and e), then comes the nude
youth, bending forward over his left
foot which rests on a pile of rocks, and
holding a wreath in his left hand with a
purple fillet looped through it. He is
engaged in conversation with a draped
woman seated to right on a pile of
rocks, but turning her head back to the
youth. She wears a peplos with a cen-
tral stripe and has a piece of drapery
with a dot-stripe border over the lower
part of her body; her hair is caught up
in a dotted *sphendone* and in each hand
she holds a purple fillet. A small figure
of Eros runs up towards her from the

right, with a fillet in his hand, and lastly
is a seated woman, wrapped in a cloak
with a dot-stripe border, from which
her right hand emerges. This is a popu-
lar pose in Paestan (cf. *RVP*, pls. 42c,
135c, 136e, 190 e–f), especially on the
minor vases. In a rectangular panel on
the neck is a siren, holding a wreath in
her left hand and bead-necklace in the
other. The upper half of her body is
that of a woman, the lower that of a
speckled bird, like the one on the
shoulder. A siren is an appropriate dec-
oration on the neck of a vase used for
funerary purposes, where they are to be
found with some frequency, since it is
their function to convey the soul of the
deceased from this world to the next
(e.g. *RVP*, pls. 15a, 89a, 111a, 112a,
114c, 158a). On Side B there is only a
laurel wreath with veined leaves on the
shoulder, and the neck-panel contains a
female head in profile to left, with the
shoulders just visible, wearing a dotted
sphendone (cf. *RVP*, pls. 35–36).

The main scene on the reverse fol-
lows the usual pattern for larger Paestan
vases, and gives us three full-size figures
in the lower register, with two busts
above. Below is a nude youth, with a
piece of dot-stripe bordered drapery
over both arms and behind his back,
who stands between two draped
women. The one to the left wears a

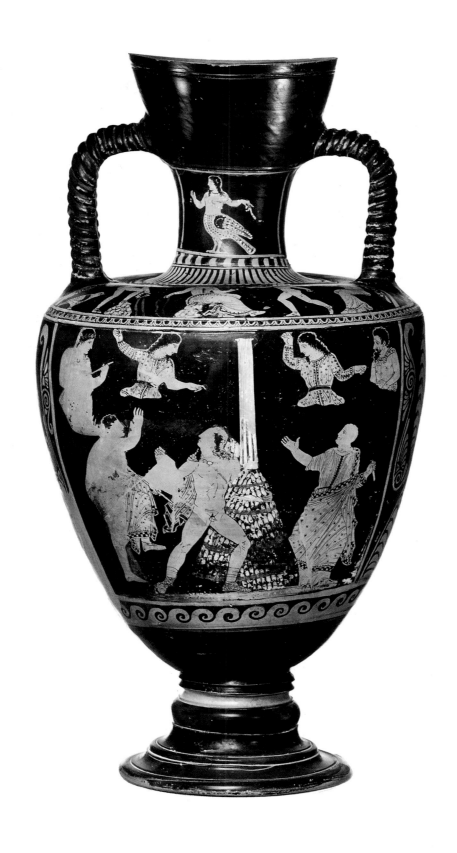

peplos with an overfall; a dot-stripe runs vertically down the center and the fold-lines below the waist are shown with almost columnar clarity; as usual, the right leg is slightly flexed; the other woman is wrapped in a himation, also with dot-stripe border, over her tunic, and her right leg is bent at the knee and drawn back beneath the drapery. Above are the busts of two women, both looking downwards towards the central youth, the fingers of the one to right are clearly visible on the ground which conceals the lower part of her body. Their chitons both have dot-stripe borders at the neck; that of the one to right a central dot-stripe also. In the field above are three hanging fillets in added pink (red on white). ADT

DIMENSIONS: H. 67 cm.; Diam. of mouth 19.5 cm.; Diam. of foot 21.7 cm.
CONDITION: The vase has been recomposed from numerous fragments, with some pieces (notably in the area above and to the left of Orestes and to the right of the priestess) missing. The surface has been considerably abraded on the left side of the obverse, where both the figures are in poor condition. The upper part of the vase and the foot are in a better state of preservation. The added colors have largely disappeared.
INSCRIPTIONS: The inscriptions which identify most of the figures were in added white and have now largely disappeared, though legible traces of the letters still remain. The signature (ΑΣΣ.... ..ΡΑΦΕ), of which the middle letters are now lost, is on the base in front of the column.
SHAPE AND DECORATION: The shape is unusual for Paestan, where, as in Campanian, the neck-amphora normally has a wide, open mouth with grooved rim, a tall, comparatively slender neck of cylindrical shape, flat (strap) handles, springing out from the top of the neck and joining the shoulder on either side, and a body tapering downwards to a relatively low foot. Here the mouth is very solid, and shaped rather like a funnel with a grooved, but not projecting, rim and decorated with a laurel wreath in added white, the neck is low and narrow, the handles are thick and twisted (the so-called rope pattern), the shoulder clearly defined and decorated on Side A with a figured scene and on Side B with a laurel wreath meeting in a central rosette, the body is markedly ovoid and curves downward to a profiled foot in several degrees, with a single reserved band near the top. The vase has something of the

appearance of a mixture between the normal Paestan neck-amphora and the amphora of panathenaic shape, in general use in Apulian in the fourth century B.C. and it might possibly have been an experiment carried out under the influence of one of the Apulian migrant potters (e.g. the Aphrodite Painter) who seem to have come to Paestum in the last third or so of the century. This particular shape does not seem to have found favor at Paestum and was not repeated. The pictures on both sides are framed between reserved vertical bands in the typical Paestan manner for amphorae; below the handles, between the framing bands, are superposed palmette-fans, with side-scrolls, which at the upper level assume the form of the typical Paestan "framing" palmette. On Side A the siren in the panel on the neck is also framed by reserved bands and like the female head on the other side has a

band of reserved squares alternating with black ones below it ("metope-pattern" cf. Malibu 81 AE 78), beneath which is a panel of black tongues. The figured scene on the shoulder of Side A is framed between the typical palmettes; beneath it and above the picture is a band of egg and dot pattern between two reserved stripes, the lower of which is grooved; on Side B this is left plain black. Below the pictures, running round the entire vase is a band of reserve wave-pattern.
BIBLIOGRAPHY: Münzen und Medaillen, Basel, *Sonderliste U*, 1984, 25, no. 42; *LIMC* III, 832, s.v. Erinys 51; *RVP* 85, no. 133, with discussion on pp. 96–98, pls. 53 and 54a. The vase is said to have come from the same tomb-group as the calyx-krater, Cat. No. 118.
LITERATURE: On Orestes at Delphi in South Italian vase-painting see: *Vasenlisten*[3] 455–56; see also Watzinger in FR

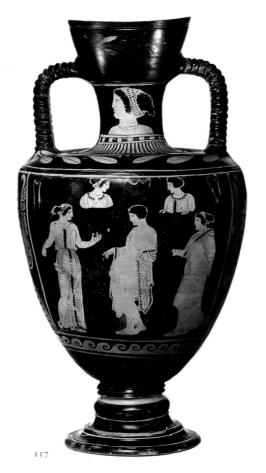

117

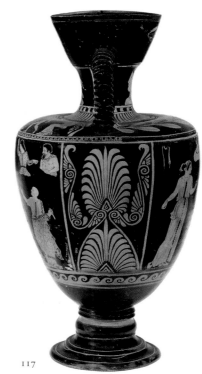

117

iii, pp. 362ff., with a list on pp. 365f.,
note 8; L. Séchan, *Études sur la tragedie
grecque dans ses raports avec la céramique*
(Paris 1926) 94ff.; Bock in *AA* 1935, 493–
511; P.C. Sestieri, *Dioniso* 22 (1959) 40–
51; Trendall and Webster, *Illustrations of
Greek Drama* (London 1971) 46–49; A.
Kossatz-Deissman, *Dramen des Aischylos
auf westgriechischen Vasen* (Mainz 1978)
102ff., nos. K32–42. For Orestes at Del-
phi in Attic red-figure, cf. Cat. No. 88,
with bibliography. On the *Oresteia* in
general in Greek vase-painting see
A.J.N.W. Prag, *The Oresteia* (Warminster
1985).

PARALLELS: For other Paestan examples
depicting Orestes at Delphi, cf. Python's
bell-krater B.M. 1917.12-10.1 = *RVP*
145, no. 244, pl. 91, and the squat leky-
thos Paestum 4794 = *RVP* 109, no. 142,
pl. 62a, attributed to Asteas, showing the
purification.

118 COLOR PLATE XIV

PAESTAN RED-FIGURE CALYX-KRATER

Signed by Asteas
Ca. 340 B.C.
Gift of Gilbert M. Denman, Jr.
86.134.167
A: Telephos on the altar, holding the
infant Orestes, between Agamemnon
and Clytemnestra; above: Kalchas,
Apollo, Hermes and woman
B: Dionysiac scene in two registers;
below: Dionysos between satyr and
maenad; above: busts of youth,
woman, maenad and satyr

Side A represents the well-known story
of Telephos and the infant Orestes.
Telephos, the son of Herakles and
Auge, became King of Mysia, and
when the Greeks landed there in their
first attempt to reach Troy, he fought
against them. He had, however, in-
curred the wrath of Dionysos through
neglect of his worship, and in his fight
against the Greeks caught his foot in a
vine which sprang forth unexpectedly
from the ground, tripped, and was
wounded in the thigh by the spear of
Achilles. The wound would not heal,
and, in response to an oracle of Apollo
which revealed that the wound could

be cured only by the weapon which
caused it, Telephos went to Greece,
where he found the Greeks assembling
at Argos for a second attempt on Troy.
There he seized the infant Orestes, son
of Agamemnon and Clytemnestra, and
threatened to kill him unless Agamem-
non would persuade Achilles to heal his
wound. As Agamemnon had been
warned that the Greeks could not take
Troy without the help of Telephos, he
undertook to ask Achilles to heal him,
provided that Telephos would guide
the fleet to Troy; Achilles did so by ap-
plying rust from his spear to the wound.

The obverse gives a vivid representa-
tion of the scene where Telephos is
threatening to kill the child Orestes. In
the center is a large altar in added
white, with side-fenders, a triglyph-
frieze at the front, and a three-stepped
base, bearing on the lowest step the
signature of the Painter Asteas. On the
altar, Telephos (ΤΗΛΕΦΟΣ) kneels on
his bent left leg, while his right leg, on
which the bandage round his wounded
thigh is clearly visible, is stretched
stiffly downwards, with the foot just
touching the base. He wears a *pilos*
(brimless traveling hat) on his head, and
a short tunic, with embroidered pat-
terns, over the upper part of which is a
crossed shoulder-cord. The tunic has a
black girdle at the waist, and a thick
black stripe in its lower border. He has
high laced boots and in his right hand
held a sword, in added white, now
mostly vanished, while with his left he
grasps the small Orestes (ΟΡΕΣΤΗΣ)
who holds out both hands in a gesture
of entreaty towards his mother Clytem-
nestra (ΚΛΥΤΑΙΜΗΣ). She moves off to
right, one arm upraised in a gesture of
horror. She has a polos-crown on her
head, a long robe over her body, across
the lower half of which is a piece of
drapery, embroidered with stars and
having the typically Paestan checkered
border. From the left Agamemnon
(ΑΓΑΜΕΜΝΩΝ), whose head is now
completely missing, comes up bran-
dishing a drawn sword in his right
hand. Like Telephos, he wears a short
tunic with embroidered patterns, a
checkered border at the lower hem and
a ray pattern on each side of the black
girdle at the waist. Behind the altar, di-
viding the scene into two, rises a fluted
column with an Ionic capital, on top of
which there was originally a tripod in

added white, perhaps an indication that
the scene is taking place in the sanctu-
ary of Lycian Apollo.

On the upper level are four half-
length figures looking down upon the
event taking place below. To left is the
white-haired seer Kalchas (ΚΑΛΧΑΣ),
holding a staff in his left hand, then the
half-draped seated figure of Apollo
(.ΠΟΛΛΩΝ), a laurel branch in his left
hand, and a piece of drapery with a
checkered border over the lower part
of his body. Then comes Hermes
(ΗΕΡΜΗΣ), holding his *kerykeion* in his
right hand, and finally a woman, whose
right hand clutches the hair on her
head, in a conventional gesture of sur-
prise or grief, and who is inscribed
(ΘΡΙΣΑ). It has been suggested that this
might stand for ΘΡΑΙΣΣΑ (*Sonderliste U*
[see below], p. 28), who could well be
the Thracian nursemaid of Orestes,
since Thracian women often served in
that capacity; it might also possibly
stand for some local personification, as
on other vases of Asteas (e.g. Krete on
the Europa krater in Malibu, Thebe on
the Naples Kadmos krater or the Basel
Kadmos Lekanis = *RVP* nos. 2/129,
132, 141).

Side B shows a typical Dionysiac
scene in two registers, of the sort
greatly favored by Asteas for his re-
verses (cf. *RVP* nos. 2/126–27, 129,
132 = pls. 45b, 47, 50, 52b), with a row
of busts or half-length figures above,
and full-size below. Here on the lower
level is Dionysos, bending forward to
conversation with a bearded satyr, with
a draped woman standing to right.
Dionysos has his right foot raised on
some eminence and bends forward
with his right arm extended in a ges-
ture to the satyr; the lower part of his
body is covered by a piece of drapery
with the characteristic dot-stripe bor-
der; around his head is a dotted ban-
deau, the hair falls in curling locks
down his back—again in a manner
very typical of Asteas. The woman
wears a sleeved chiton with a central
dot-stripe, and has a piece of drapery
across the lower part of her body, also
with a dot-stripe border. Above are
two half-length figures and two busts—
first a youth, then a woman (probably a
maenad), wearing a sleeved chiton with
a dot-stripe border round the neck, and
a double dot-stripe down the center; it
is patterned with rosettes. Next to her

is the upper half of a seated maenad, draped in somewhat similar fashion, but with a piece of dot-stripe bordered drapery across the lower part of her body, of which only the upper edge is visible, and holding a thyrsos in her left hand. Lastly, the bust of a nude satyr, whose face is now missing, holding a "skewer of fruit" (see Cat. No. 120) in his outstretched right hand. A D T

DIMENSIONS: H. 56.5 cm.; Diam. of mouth 50 cm.; H. of foot 14.5 cm.
CONDITION: The krater has been recomposed from many fragments, with quite substantial portions missing; there is some restoration, especially at the joins on the reverse, but apart from the face of the satyr, the figures are not seriously affected. Much of the added color has now disappeared.
INSCRIPTIONS: The principal figures are all identified by inscriptions in added white, which has now largely disappeared. The signature, ΑΣΣΤΕΑΣ ΕΓΡΑΦΕ is painted in black glaze in the first step of the three-stepped base of the altar.
SHAPE AND DECORATION: In shape and decoration the vase stands between the earlier calyx-kraters by Asteas (like Berlin F 3044 and Madrid 11094) and the later one in Malibu (81 AE 78), with its more elaborate foot. On the earlier vases the foot is comparatively simple, with a convex base and a band in relief where it joins the stem; on our vase there is an overhanging lip at the join, with reserved bands at the top and in the center, connected to a low stem which curves gently outwards to join the molded foot, which is not decorated as on the Malibu krater. The rim is decorated with ivy leaves with incised stems and white berries on Side A and, on Side B, with a laurel wreath to right. On the zone between the handles there was a band of palmette and floral decoration on the obverse (now largely disappeared), and on the reverse a checkered rectangle flanked by three meanders on either side. A reserved stripe runs round the top of the vase above the pictures which, exceptionally for Paestan, are not framed. On the reverse between the figures in the lower register are two palmette scrolls, the second following the typical Paestan framing type (see *RVP* 16, fig. 3, IVD), and terminating on top with an "Asteas flower" (*RVP* 18, fig. 4; see *RVSIS* 197, fig. 16). The underside of the foot is black.

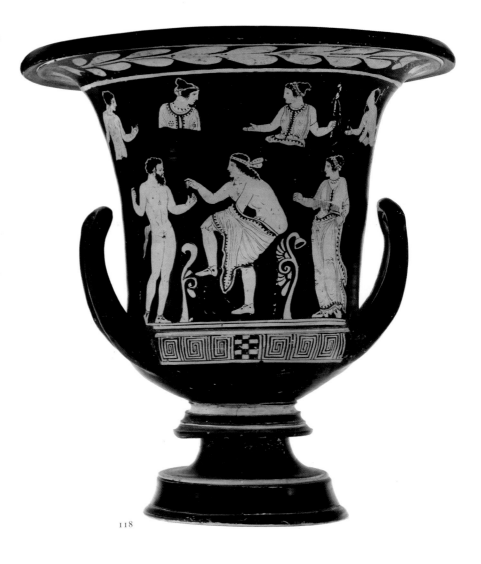

118

BIBLIOGRAPHY: Münzen und Medaillen, Basel, *Schweizerische Kunst- und Antiquitätenmesse*, 1983, Stand 143, p. 7; K. Schauenburg, *RM* 90 (1983) pl. 84,1; Münzen und Medaillen, Basel, *Sonderliste U*, 1984, 28, no. 43; *RVP* 85, no. 128, with discussion on pp. 90–92, pl. 48. *The San Antonio Museum of Art: The First Ten Years* (San Antonio 1990) 69 (Side A).
LITERATURE: For the Telephos legend see, in particular, C. Bauchhenss-Thuriedl, *Die Mythos von Telephos in der antiken Kunst* (Würzburg 1971), with a list of the representations of the Telephos-Orestes episode on pp. 87–90. A list of those on South Italian vases is also given by F. Brommer in Vasenlisten³, p. 472, with additions by K. Schauenburg in "Zur Telephossage in Unteritalien," *RM* 90 (1983) 339–58, where this krater is mentioned by p. 347. See also A.D. Trendall and T. B. L. Webster, *Illustrations of Greek Drama* (London 1971) 103–04, III.3, 47–49 for connections with the *Telephos* of Euripides, and T. B. L. Webster, *The Tragedies of Euripides* (London 1967) p. 302. On the shoulder-cord worn by Telephos, see E.B. Harrison, "The Shoulder-Cord of Themis," in *Festschrift für Frank Brommer* (Mainz 1977) 155–61.
PARALLELS: This vase is said to have come from a large tomb-group which also included the Orestes amphora, Cat. No. 117, listed above, as well as a number of other Paestan vases from the workshop of Asteas and Python (e.g. *RVP* nos. 2/138, 141, 142, 220, 222). Many of these are illustrated in *Sonderliste U* of Münzen und Medaillen (Basel, November 1984), pp. 25ff., but they have now been widely dispersed.

118

PAESTAN RED–FIGURE CALYX–KRATER

Attributed to the Workshop of Asteas;
close to the painter's own hand,
[A. D. Trendall]
Ca. 350–340 B.C.
Gift of Gilbert M. Denman, Jr.
86.32.2
A: Papposilen and Dionysos; bust
of woman
B: Two draped youths

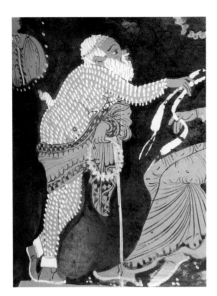

The scene on the obverse is one that
figures frequently on Paestan kraters
from the Asteas-Python workshop. On
the left is a papposilen, whose body is
covered with small tufts of white hair,
arranged in very regular rows; he has
receding white hair, a wreath around
his head, and a white moustache and
beard. A small piece of drapery, with a
checker and ray-pattern border, is
drawn across the upper part of his legs
and covers his left arm, the hand emer-
ging from it to hold a white leafy
wreath. In his outstretched right hand,
as he leans forward, he offers a white
fillet to a half-draped Dionysos, seated
upon a dotted mound, and extending
his right hand to clasp the fillet. A
wreath, of which the ends flap in a typ-
ical Paestan manner, encircles his head;
curling locks of hair fall down onto his
shoulders. In his left hand is a phiale
(yellow to represent metal) with white
eggs and a wreath. His lower limbs are
covered by a piece of dot-stripe bor-
dered drapery, and he wears slippers,
outlined in white. Beside the mound
on which he is seated is a three-legged
table, with three eggs on top. Above in
the left-hand corner is the bust of a
woman within a frame of white dots.
Her hair is caught up in a *sphendone*,
with a white radiate *stephane* above the
brow; she wears a peplos with a vertical
dot-stripe with a white center, and a
necklace. Such busts are not uncom-
mon in scenes on smaller vases and
were perhaps inspired by those which
regularly appear on the upper registers
of the Dionysiac scenes on the reverses
of the larger vases (e.g. Cat. Nos. 117
and 118 above); good examples will be
found on Sydney 49.01, Berlin F 3058,
Naples 1786 (*RVP* pls. 58a, 82d, 121c;
also pl. 75a, where the bust is placed in
a frame of white dots).

Papposilens, like the one on our
vases, and shown in very similar guise,
will be found on Salerno 1813, Paes-

tum 26633 (= *RVP* pls. 28e and 66b),
both attributed to Asteas and on Sydney
47.04, Naples 2846, Mannheim Cg3
(= *RVP* pls. 99c, 105 a-b), attributed
to Python, though in most of these
cases it is a skin and not a piece of drap-
ery that is worn across the body. The
best parallel is perhaps the papposilen
on Paestum 26633 (*RVP*, pl. 66b),
where we may note an almost identical
treatment of the body, as well as of the
face, with the white highlight in the
eye; also the same red-brown slippers
with a band of white at the top. For the
seated figure of Dionysos we may com-
pare those on *RVP* pls. 31e, 59a, 72e,
74a; the bold treatment of the trans-
verse fold-lines on the drapery below
the knees, which run in bunches of
two or three, finds a clear parallel in
the drapery of the seated woman on
Sydney 49.01 (*RVP* pl. 58a). All these
vases have been attributed to Asteas,
but the bell-krater in a Florentine pri-
vate collection showing a papposilen
bending forward in front of Dionysos
(*RVP* pl. 99a), also has stylistic affinities
with our vase, and this, as the reverse
clearly indicates, is to be attributed to
Python. It would seem, therefore, that
the composition of, and the figures on,
the obverse are, as it were, the com-
mon property of the Asteas-Python
workshop, but that on the whole they
are nearer to the former artist than the
latter, probably around the middle stage
of his career.

The reverse, which might be ex-
pected to settle the matter, in fact raises
new problems in regard to both the
poses and the drapery of the two
youths. The pose of the youth to left is
unusual in Paestan; here the head is in
profile to right, but the body is almost
frontal, with the cloak draped over it to
leave the right arm and shoulder bare,
but to cover the left. The left arm is
bent to produce a sleeve-like drape and
the hand beneath it holds a white stick,
which emerges from the "sleeve." The
border of the cloak is decorated with
the standard dot-stripe, and where the
two edges meet on the left side of the
youth, the dot-stripes run down in par-
allel lines. The other youth is of Type
A2r (*RVP* 15, fig. 2), completely en-
veloped in his cloak, with a "sleeve"
draped over the left arm, and the right
hand just visible as it emerges from be-
neath the drapery, holding a white
fillet. The left hand, concealed beneath

the cloak, held a white stick like that of his companion. The edge of his "sleeve" has no clearly defined border, but below it two dot-stripes run down to join the border at the bottom, which ends in a wavy line with a swirling double curve. No extant vase provides an exact parallel for these two youths—the former, in pose, may be compared with the corresponding youths on *RVP* pls. 17f and 20d (early bell-kraters by Asteas, before he adopted the dot-stripe on his cloaks); the latter with those on *RVP* pls. 72f, 73 b and d, where the dot-stripe border has come into use. There are also connections with the youths on some of the early bell-kraters by Python in the Altavilla Group (e.g. *RVP* pl. 85 b, d and f), but otherwise the vase does not seem to belong there. It would be difficult to ascribe the vase specifically to Asteas; it is obviously a product of his workshop and looks nearer in style to him than to Python; it therefore seems best placed with vases from the middle phase of Asteas's career, when some of the earlier mannerisms still linger and Python's first works are still very close to his.

ADT

DIMENSIONS: H. 33.5 cm.; Diam. of mouth 32 cm.; Diam. of foot 15.6 cm.
CONDITION: The vase is intact and in good condition.
SHAPE AND DECORATION: The calyx-krater is not a very popular shape in Paestan and its use is largely confined to the workshop of Asteas and Python. Its prototypes will be found among the Sicilian forerunners, especially in the Group of Louvre K 240 (*RVP* 43ff., nos. 90–92, 99–101), where shape and ornamental decoration are similar. Our krater is closest in shape to Paestum 21306 (*RVP* 104, no. 137), on which we may note the same slightly concave cylindrical body and the fairly tall handles curving inward towards it. The stem is comparatively short, with a single relief band at the join to the disk foot, the upper edge of which is grooved and left reserved (as on Paestum 21306). Below the rim is a wreath of laurel; on the band between the handles, stopt meanders with a saltire square in the center on Side A, reverse wave on Side B, as on *RVP* 126, no. 181. Accessory decoration is minimal; the pictures are not framed; in the field above, on the obverse is a leafy wreath, in added white; beside the youth to left on the reverse is a quartered disk.
BIBLIOGRAPHY: *RVP* 106, no. 139a, pl. 241 a-b.

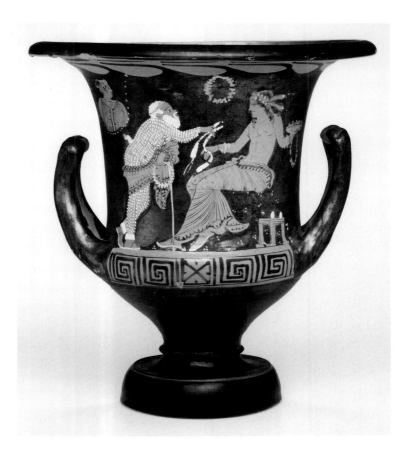

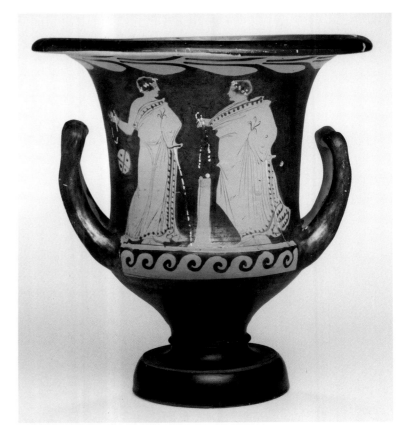

120

PAESTAN RED-FIGURE
NECK-AMPHORA
Attributed to
the Painter of Würzburg H 5739
Ca. 330 B.C.
Gift of Gilbert M. Denman, Jr.
86.10.2
A: Seated woman
(Neck): Female head
B: Nude youth (Dionysos)
(Neck): Female head

This is one of the minor vases from the Asteas-Python workshop which we can now attribute to a specific artist, the Painter of Würzburg H 5739, thanks to the new material which has recently come to light (*RVP* 174–83). His style is very closely modelled upon that of Asteas, but he has certain individual characteristics, especially in his rendering of the drapery, which serve to distinguish his work from that of his master. The seated half-draped woman on Side A finds a good parallel on the pelike Paestum 5047 (*RVP*, pl. 122f) or on the bell-krater in Salerno (*RVP*, pl. 121b), both having the same long hair, and one rounded and one pointed breast, as well as a similar treatment of the drapery. The figure of Dionysos on the reverse may be compared with the corresponding ones on *RVP*, pls. 121c, 124b, and 129c for the drawing of the head and the body. A good parallel to the dotted mound on which the woman sits and Dionysos rests his foot can be found on *RVP*, pl. 122 b and f. The heads on the neck are very similar to those illustrated on *RVP*, pls. 118–19, though on our vase both are cut off at the neck.

The scenes on both sides are standard for minor Paestan from the workshop of Asteas and Python and are repeated on a large number of other vases. Side A shows a half-draped woman, the lower part of her body covered by a piece of drapery with a dot-stripe border, seated upon a dotted mound, and holding in one hand a wreath, in the other a dish of eggs in added white and a circlet of beads, either for a wreath or for ornament. She has a wreath round her head, bracelets round her wrists, a beaded necklace and slippers with white soles. Her counterpart on Side B who, from the thyrsos in his left hand, is probably to be identified as Dionysos, bends forward in a very characteristic pose, over his right foot which rests on top of a dotted mound like the one on Side A but not as high, in his right hand he holds a bead circlet and what is conventionally referred to as a "skewer of fruit" (see *RVP*, pl. 14), from the name given to it by E. Tillyard (*The Hope Vases* [Cambridge 1928] 140), though as Beazley pointed out (*AJA* 48 [1944] 357) it is more probable that the round objects are cakes of some sort. No sign of the actual "skewer" has so far appeared, so it is not easy to see how the objects were supported; the device is very common on Paestan vases, but extremely rare elsewhere and, until further evidence reveals their true nature, it seems safer to use the conventional description.

The heads on the neck are both in profile to left, as regularly on the painter's other amphorae. There is a string of white beads across the hair over the brow; the rest, save for the chignon emerging at the back, is caught up in a *kekryphalos* patterned with black lines and rows of black and white dots. The line of the brow and nose is rather flat; the chin rounded and slightly projecting. A D T

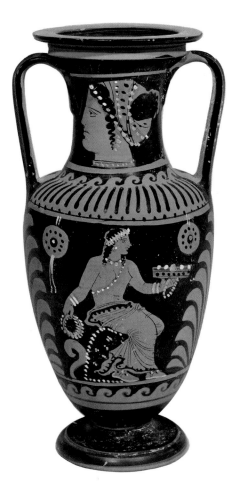
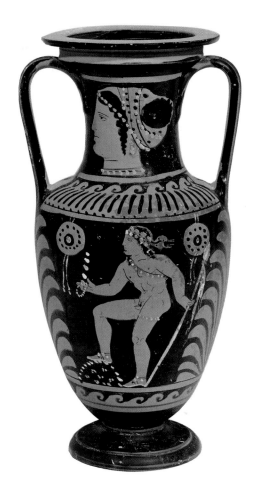

DIMENSIONS: H. 33.2 cm.; Diam. of mouth 13 cm.; Diam. of foot 10 cm.

CONDITION: Unbroken. Crack at base of B/A handle.

SHAPE AND DECORATION: In shape the vase closely follows the standard Paestan type of neck-amphorae of smaller dimensions. The mouth has a flaring rim, beneath which is a reserved band. The neck is decorated on either side with a female head, above and below which is a reserved stripe, then a band of reverse wave-pattern, moving down onto the shoulder, decorated with black tongues on a reserved ground, dots below them and a reserved band above the pictures, which are separated by large fan-palmettes. Below, round the vase, is a band of reversed wave-pattern, with a reserved stripe above and below it. The body of the amphora is ovoid, tapering down to the very short stem, which connects it to a disk foot, in two degrees, with a slightly convex base. In the fields on either side above the two figures hang tambourines with white ribbons.

BIBLIOGRAPHY: Christie's London, 16 July 1985, lot 389; Charles Ede Ltd., *Greek Pottery from South Italy* XI, 1985–86, no. 21; *RVP* 178, no. 389, pl. 122 d and e.

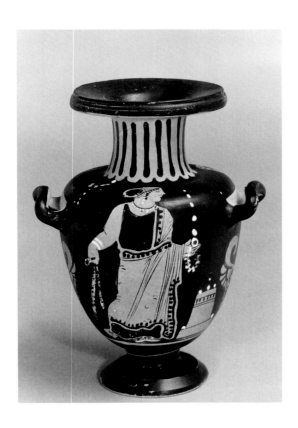

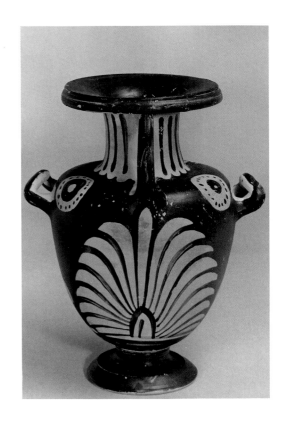

121

PAESTAN RED-FIGURE HYDRIA
Minor vase
from the Asteas-Python Workshop
Ca. 330 B.C.
Gift of Gilbert M. Denman, Jr.
86.134.190
Draped woman beside a small stele

This is a very typical example of the smaller vases from the Asteas-Python workshop, decorated with single figures adapted from the painters' larger compositions. Here we have a draped woman, holding a fillet in her right hand, and a white wreath, with a "skewer of fruit" in her left, standing beside a small stele, rising from a low base, on which are two eggs, one on each side of the shaft, with a further three on the top. Her body is shown almost frontally, but her head is turned in profile to the right. She wears a black garment with a central white stripe (now vanished), with a cloak draped across the front of her body and over her left shoulder; it has the usual dot-stripe border. Black drapery, which should be a sign of mourning, appears

quite frequently on Paestan vases (e.g. *RVP*, pls. 56a, 68e, 123d); often it is patterned with red or white stripes and dots. Here the chiton was originally decorated with white dots, as on Louvre K 358 (*RVP*, pl. 115f), which offers a very close parallel to our vase; traces of these remain on the lower part of the black garment below the cloak. The head and features of the woman correspond closely with those of the heads on the necks of amphorae of Asteas and Python; the hair is bound up in a black and white dotted *sphendone*, with a large bunch emerging at the back. She wears the usual jewelry (earring, necklace, bracelet) and slippers like those on the neck-amphora Cat. No. 120. ADT

DIMENSIONS: H. 22.9 cm.; Diam. of mouth 11 cm.; Diam. of foot 8 cm.
CONDITION: Unbroken. Minor loss of applied white paint on figure.
SHAPE AND DECORATION: The vase is intact; the hydria has a wide mouth, with molded rim, the neck is left reserved and decorated with black tongues; the body is covered with black glaze except for the area beneath the two side-handles. Below

the back handle is a large fan-palmette, beside which, on either side, is a small standard "framing" palmette, with side-scroll and single leaf in between. Below the picture is a reserved band, and in the field on the shoulder, a bead-chain to left of the figure, and a tambourine to either side of the rear handle. A low stem joins the body to the spreading foot.
BIBLIOGRAPHY: Sotheby's London, 9-10 July 1984, lot 341; Charles Ede Ltd., inv. 1807; *RVP* 197, no. 530, pl. 134h.

122

PAESTAN RED-FIGURE
FISH-PLATE
Workshop of Asteas and Python
Ca. 340 B.C.
Gift of Gilbert M. Denman, Jr.
87.17
Three fish: striped perch, wrasse and
bass

The fish-plate plays an important role in South Italian vase-painting and about 1,000 of them have been preserved from a wide variety of sites. The earliest come from Sicily, from where their manufacture spread to Paestum, Campania and Apulia in the second quarter of the fourth century B.C., though they do not appear in quantity until after 350 B.C. The standard plate, which is based on Attic models, has a floor which slopes gently downwards towards a central depression, normally left undecorated, except for a possible border of wave-pattern, in Campanian and Paestan, but decorated with a rosette or similar motifs in Apulian. It should be noted that on South Italian fish-plates the bodies of the fish normally face the central depression and not, as in Attic, the outer border. They are decorated with a wide variety of Mediterranean fish, among which bream, perch, mullet and wrasse figure most frequently, together with torpedoes, cepholopods (octopus, squid, cuttlefish), and various other forms of seafood (shrimps, scallops, shellfish, etc). Three fish is the standard quota for the average fish-plate; they normally follow one another moving to left around the plate, though occasionally two may be confronted.

Our plate belongs to a group of about forty, which, on the ground of the proveniences of many of them, may be associated with the workshop of Asteas and Python; most of those from Paestum and the vicinity were found in tomb-groups which contained vases associated with Asteas or Python, one (Paestum 20188), from Agropoli, along with the Stheneboia hydria signed by Asteas. We may note the Paestan fondness for stripes and dots on the bodies of the fish and, in particular, for a circle of dots round the eye. The identification of the fish is not always easy (see Bibliography). ADT

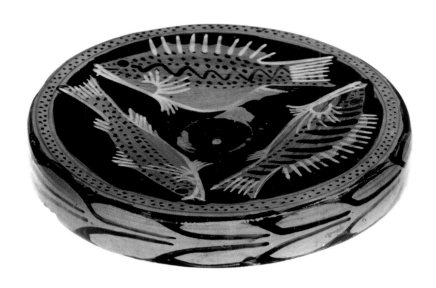

DIMENSIONS: H. 4.5 cm.; Diam. 17.2 cm.

CONDITION: Intact and in good condition.

SHAPE AND DECORATION: The row of double dots (dicing) in black on a reserved band round the outer border of the plate is very characteristic of the earlier Paestan fish-plates and is taken over from Sicilian. The overhanging rim is here decorated with red-figure laurel. The underside of the foot is black with a reserved stripe around the edge. The inside of the rim and underside of the floor are decorated with purple-black bands and a reserved stripe.

ADDED COLOR: White used for details (fins, gills, etc.).

BIBLIOGRAPHY: Sotheby's London, 8–9 December 1986, lot 300; Charles Ede Ltd., Greek Pottery from South Italy XII, 1987, no. 6; GRFP 106, no. IIIA/11; RVP 232, no. 930.

LITERATURE: On fish-plates in general see GRFP, with bibliography on pp. 10–

11. For the actual fish and their identification, the following works are most useful: N. Kunisch, A. Palombi and M. Santarelli, Gli animali Commestibili dei mari d'Italia⁴ (1979); Alan Davidson, Mediterranean Seafood³ (1987); J. Delorme and Ch. Roux, Guide illustré de la faune aquatique dans l'art grec (Juan-les Pins 1987); and the F.A.O. Catalogue of the Names of Fishes, Molluscs and Crustaceans of commercial importance in the Mediterranean by G. Bini (Rome 1965). For a discussion of the difference between Attic and South Italian fish-plates, see N. Kunisch, Griechische Fischteller (Berlin 1989), esp. 77ff.

PARALLELS: Our plate finds close parallels in several of those illustrated on pls. 54–55 of GRFP, notably Paestum 20188, 6113, 22325 and Salerno PC 1322, all of which are similar in their decoration and in the treatment of the fish depicted upon them, among which the striped bream and the wrasse recur frequently.

123

PAESTAN RED-FIGURE
LEBES GAMIKOS
Attributed to
the Painter of Paestum 21602
Ca. 340–330 B.C.
Gift of Gilbert M. Denman, Jr.
87.34
(Body) A: Youth and woman
beside a laver, with Eros
B: Eros and woman
(Lid's lower portion: lekanis lid)
A: Female head B: Bird
(Lid's upper portion: lebes
gamikos) A: Bird B: Female head
(Shoulder) A: Plastic female heads
B: Plastic cones

The picture on the obverse, framed be-
tween two vertical stripes decorated
with ivy in black and bordered at the
top by a band of egg-pattern, probably
depicts a pre-nuptial scene. To left is a
youth, the central part of whose body
is covered by a piece of drapery with a
wave-pattern border and with clearly
marked vertical fold-lines; in his ex-
tended right hand he holds a mirror,
painted in purple-red with white ad-
juncts, and in his left a phiale (now
partly vanished) with a purple fillet. He
stands on a slight eminence of small
stones and faces a woman, draped in a
peplos with an overfall, also with a
wave-pattern border, which is repeated
at the V-shaped opening below the
neck; over her left shoulder and down
her back falls a piece of drapery which
she grips in her right hand at her left
breast. The upper part of the drapery is
covered with a mass of small vertical
fold-lines, which run down onto the
overfall, where they spread out fanwise.
On the lower part of the peplos, the
fold-lines fall vertically straight down to
the hem, except across her flexed left
leg where they appear as short horizon-
tal strokes. She wears no headdress, but
there is a bunch of hair on top at the
back; she has a bead necklace, bracelets
and slippers. To right is a laver, only
half of which is shown, and on it sits a
small Eros, with long hair falling down
onto his shoulders, and upspread wings.
He is naked, save for a bandolier,
bracelets and slippers. His right arm is
extended and in his hand he holds a
"skewer of fruit" and a bead-wreath in
added white, now mostly vanished. Be-
hind his arm rises a white spray (now

no longer visible). The groundline is
shown as pebbles, some in added
white; in the top left corner is a fillet in
added red, looped over the reserved
band beneath the egg-pattern above
the picture, and falling vertically down
on the left but flapping out to the right
in a wavy horizontal line. A bead-
wreath with a central dot in white
(now almost completely gone) appears
above between the wings of Eros.

The design on Side B is simpler and
shows a nude figure of Eros bending
forward over his raised left foot in front
of a standing draped woman. She wears
a peplos, with an overfall bordered
with a dot-stripe; down it runs a cen-
tral double dot-stripe which takes a
sweeping curve below the overfall over
her bent left leg. The hair of Eros is
drawn up in a bun at the back, as with
the woman on Side A; that of the

woman falls in curling locks onto her shoulders, and has a white radiate *stephane* in front. Eros holds a round fruit in his left hand and a mirror in his right (in added white, now completely gone), the woman holds a bead-wreath in white. Above in either corner is a pendent bead-chain in white.

On the lekanis element of the lid there is on Side A a female head in profile to right, the hair caught up in a red *sphendone*, and on Side B a bird, which might be either a duck or a goose; both are flanked by a single scroll, with palmette-fans between. On the bowl of the lebes above is a speckled bird, facing to right, but turning its head back to left. (For the black eye surrounded by a row of dots cf. the bird on Cat. No. 117 and the eye of the fish on Cat. No. 122.) On the other side is a female head in profile to

left, the hair bound up in a *sphendone*, with a double row of white beads across the brow.

The vase is clearly a product of the Asteas-Python workshop and reflects the influence of both Asteas and the Painter of Würzburg H 5739—of the former on the female heads on the lid, of the latter on the two figures on the reverse. The rendering of the drapery is, however, highly individual and finds no very good parallel in the works of either of those two painters. It does, however, fit in very closely with that of the woman represented in the tondo of a cup in Paestum (21602 = *RVP* pl. 129e), which appears to be the work of the same hand, and from which the painter has taken his name. As yet no other vases by this artist have turned up, but he must have been one of the several secondary painters in the Asteas-Python workshop, whose identities are only now beginning to emerge. ADT

DIMENSIONS: H. to top of lid (as preserved) 42.6 cm.; H. to top of bowl 24 cm.; H. to top of handles 32.5 cm.; Diam. at shoulder 19.4 cm.; Diam. of foot 10.8 cm.

CONDITION: Unbroken. Plastic ornaments which were originally affixed to handle tops are lost. Some loss of applied white paint on figural scenes and on ornament. Spalling under A/B handle. Lid unbroken; but lid of lebes-lid missing.

SHAPE AND DECORATION: The lebes gamikos is a comparatively popular shape at Paestum, where it is often provided with a very tall and elaborate lid, sometimes almost as high as the vase itself. These lids are made up of several components: usually a lekanis-like element at the bottom, joined by a stem to a smaller lebes gamikos, which may itself have a lid in the form of a plastic vase or bird. The various parts of which the lid is composed usually bear figured decoration, generally female heads or birds, though occasionally something more elaborate. Typical examples are illustrated in *RVP* on plates 76–79, 147, 148c, 152 a-b, 184e, 187c, 198b, 206 and 207 a-b. Such lids are fragile and seldom survive intact, but, when they do, the complete vase makes quite an impressive structure, attaining heights of up to 70 cm. The lid on our vase is almost complete; only the upper part of the lid of the lebes is missing. The foot of the lebes is attached to the knob of the lekanis lid which forms the base of the whole complex; it is decorated with a profile female head and a bird, with reverse wave on the outer rim. The shoulder of the lebes on top is decorated with tongues. There are also two small plastic knobs on either side, corresponding in reduced form to the plastic heads and cones on the main part of the vase. Tongues appear as well on the shoulder of the main part of the vase on Sides B; on the shoulder on Side A was a floral pattern, now largely disappeared. Below the handles, separating the pictures, are superposed palmette-fans with side-scrolls, and below the pictures, running right round the vase, is a band of reverse wave. The stem has a black band in relief; the foot has a groove at the top and bottom of its slightly convex edge. The underside of the foot is reserved.

ADDED COLOR: White and red were used for details, but little of the former now remains.

BIBLIOGRAPHY: The Summa Galleries Inc., *Auction 1*, Beverly Hills (Calif.), 18 September 1981, no. 30; *RVP* 184, no. 419, pl. 129 c-d.

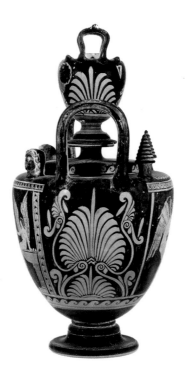

PAESTAN RED-FIGURE
LEBES GAMIKOS
Attributed to
the Painter of Naples 1778
Ca. 320 B.C.
Gift of Gilbert M. Denman, Jr.
86.134.162
A: Erotic scene: embracing couple
between two draped women,
with Eros
B: Woman and youth

The center of the picture on Side A
shows a couple embracing. A youth
places both his hands on the breast of a
half-draped woman, who raises her
right arm to encircle his head. The
lower part of her body is covered by a
piece of drapery with a fine dot-stripe
border. Much of the upper part of her
body and her face is badly worn, so de-
tails are no longer visible; her long hair
falls down in three ringlets on either
side of her neck. Beside her to left a
woman, wearing a chiton, with a dou-
ble dot-stripe down the side and a pur-
ple girdle, bends forward stretching out
her right hand to the couple; behind
her is a small figure of Eros, whose
wings in added white have all but dis-
appeared. To the right of the couple is
a seated woman; she wears a sleeved
chiton with a purple girdle and has a
piece of drapery with a dot-stripe bor-
der over the lower part of her body.
Her hair is bound up in a *sphendone*,
from which a bunch emerges at the
back. Red fillets are draped over the
cross-pieces, which form triangles in
the top corners of the frame.

Side B shows a half-draped woman,
the lower part of whose body is cov-
ered by a piece of drapery with a dot-
stripe border. She holds up a phiale in
her right hand and turns her head, on
which she wears a *sphendone*, to look at
the nude effeminate youth seated on a
piece of drapery beside her and turning
his head towards her. He holds a phiale
in his left hand, and has a narrow shawl
over each arm and behind his back. In
the Basel sale catalogue (see below) he
was described as a woman, but in the
light of similar scenes on other vases by
the same painter (cf. *RVP*, pl. 175 b-d,
or the obviously male figure on pl.
174d) this does not seem likely. In the
field above is a tambourine on each
side.

The bowl of the smaller lebes which
serves as the upper portion of the lid is

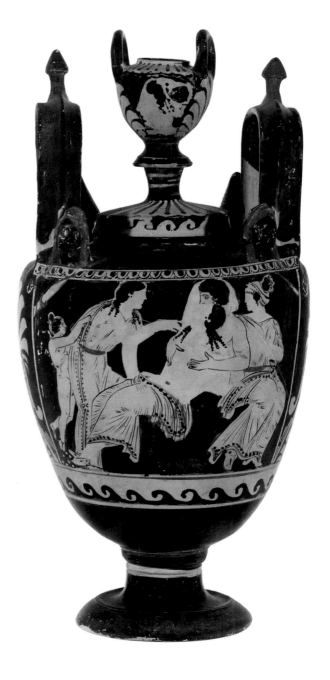

decorated on each side with a female head in profile to left; both have their hair tied up in a *sphendone*, decorated with a row of black dots, and are comparable with some of the heads which provide the sole decoration on the painter's smaller vases (cf. *RVP*, pl. 188, a, d, f).

That the vase may be attributed to the Painter of Naples 1778 is clear not only from the close resemblance of Side A to Paestum 4831 (*RVP*, pl. 171a), but also from the drawing of the faces, the hair and the drapery, as well as of the use of the painter's typical dot-stripe, with smaller dots than appeared on the earlier Paestan vases (cf. *RVP*, pls. 175–76 which afford excellent parallels). ADT

DIMENSIONS: H. to top of preserved lid 38.3 cm.; H. to top of handles 37.5 cm.; H. of lid 13.5 cm.; Diam. of mouth 8.5 cm.; Diam. of foot 10.7 cm.
CONDITION: The vase is intact, but not in good condition. Much of the surface of Side A has worn off, especially on the upper part of the central group; the added colors have also largely disappeared.
SHAPE AND DECORATION: The shape is similar to that of the preceding lebes gamikos (Cat. No. 123), although the lid is simpler, consisting of a lekanis-like portion joined with a small lebes gamikos. This lid is decorated with tongues. The shoulder is decorated with tongues; between the female heads on the bowl are fan-palmettes. The foot combines with the knob of the lekanis, the surface of which is decorated with tongues, the rim with reverse wave. On the shoulder of the body of the vase there is a floral decoration on Side A in added white, now worn off, and on Side B a panel of black tongues on a reserved background. Beside the handles on the obverse are plastic female heads: on the reverse, cones. The picture on Side A is framed between reserved bands, triangulated at the top, with a band of egg-pattern above. Beneath the handles are superposed palmettes with side-scrolls; below the picture black wave-pattern to left on a reserved stripe. There is a relief band at the join of body to stem, on which is a reserved stripe; the upper edge of the spreading foot is slightly raised, creating a depression between it and the stem; the underside is reserved.
BIBLIOGRAPHY: Münzen und Medaillen, Basel, *Sonderliste U* (1984), 37, no. 57; *RVP* 275, no. 24, pl. 171 c-d.

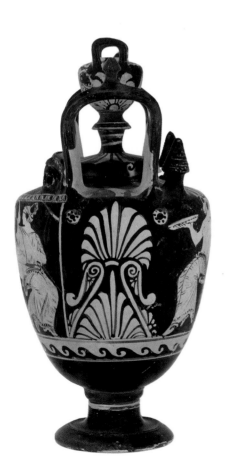
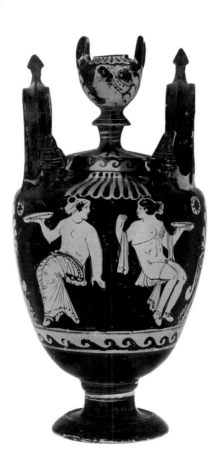

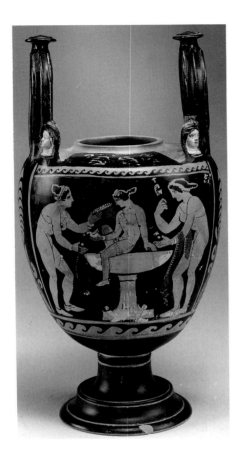

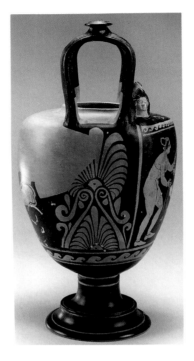

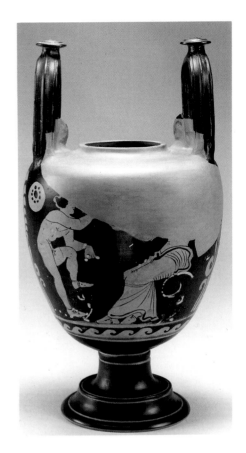

125

PAESTAN RED-FIGURE
LEBES GAMIKOS
Attributed to
the Painter of Naples 2585
Ca. 320–310 B.C.
Gift of Gilbert M. Denman, Jr.
86.134.163
A: Two nude women at a laver
with boy
B: Youth and woman

Side A depicts a laver scene (cf. Cat.
No. 123); the laver was originally all in
white, with the flutings of the pedestal
column in dilute black glaze; upon it is
seated a nude boy, rather effeminate
looking, with his hair tied up to pro-
duce a bunch at the back, and a radiate
stephane above the brow, a bandolier
across his chest and a bead-chain round
his left thigh. In his right hand he holds
out a small white bird to a nude
woman on the left, who bends slightly
forward, a phiale in her upraised left
hand, a red fillet and a "skewer of
fruit" in her right. Her hair is done up
in a *sphendone*, she wears a bandolier
across the upper part of her body,
bracelets and a beaded circlet round her

left thigh; her slippers are plain. Behind
the laver to right is another nude
woman, also bending slightly forward
and holding in her right hand a mirror
and in her left a "skewer of fruit."
Round her left arm is looped a red
fillet with white dots on it. She is
dressed in a similar fashion to her com-
panion. Above in the field are red
fillets, the picture is framed between
reserved bands, with a frieze of wave-
pattern across the top.

Side B is ill-preserved, but it shows,
to the left, a nude youth bending for-
ward over his left foot, which rests
upon a white tendril. In his left hand
he holds a circlet of white beads and in
his right something now lost which he
offers to a seated half-draped woman,
who stretches out her right hand to-
wards it. The lower half of her body is
covered by a piece of drapery with a
plain black border; she sits upon a curl-
ing white tendril. This is a scene greatly
favored by the Painter of Naples 2585
and is repeated on many of his vases
with but minor variations (cf. *RVP* pls.
193f, 194d, 201d, e); he is particularly
fond of depicting nude youths bending
forward (e.g. *RVP* pl. 193b, c, e; 195c,
e), with varying degrees of effeminacy,

which increases as his work progresses.
The influence of Asteas is to be seen in
the laver scene on Side A; the Painter
of Naples 2585 is a late follower of that
artist. A D T

DIMENSIONS: H. to top of vase 26.4 cm.;
H. to handle-knobs 36.6 cm.; Diam. of
mouth 8.1 cm.; Diam. of foot 12 cm.
CONDITION: The lid is missing, as is the
upper portion of Side B.
SHAPE AND DECORATION: The body is
ovoid, tapering inwards as it runs down
to the stem, which is comparatively high
and decorated at the top with a band in
low relief, with a reserved stripe above
and below it. The foot is in two degrees,
with reserved molded edges. The shoul-
der on Side A is decorated with a floral
pattern in added white (now mostly
gone) and has two plastic female heads,
with white flesh on their faces and black
hair and veils. This picture is framed be-
tween reserved bands, that on Side B is
not. Beneath the handles are superposed
palmettes with side-scrolls; beneath the
pictures a band of reverse wave.
ADDED COLOR: Red and white for ad-
juncts and for the laver, but much of it
has now disappeared.
BIBLIOGRAPHY: *RVP* 312, no. 394,
pl. 197d.

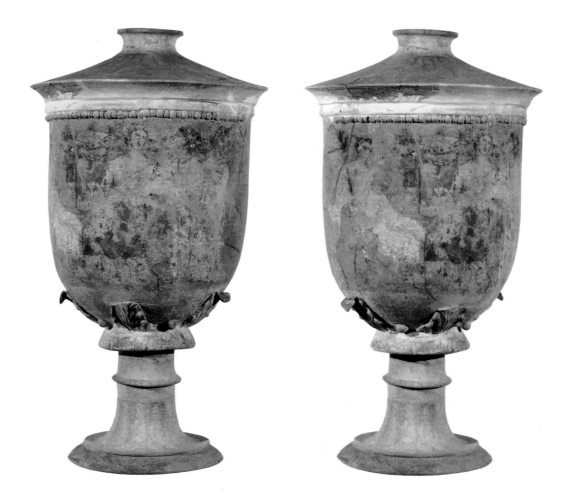

126 COLOR PLATE XV

CENTURIPE-WARE LIDDED BOWL WITH STEMMED FOOT
Mid-3rd century B.C.
Gift of Gilbert M. Denman, Jr.
86.134.193 a,b

The front of the lid is decorated with a lozenge pattern in applied red. The knob is missing. Above the picture, on the obverse, is a bead-and-reel border in relief. The reverse is left undecorated.

The figures do not emerge with sufficient clarity to establish specific details. The figures on the obverse are painted on a pink background. From the left is a seated woman in three-quarter view wearing a pale blue cloak over her white drapery. A tall cylindrical urn with a knobbed lid, the body of which is painted pink with edges in dark red, stands to the right of her. The second seated woman, in three-quarter view to the right, is so draped as to expose the right breast. Her drapery is pale blue-green. Beside her stands another woman, in profile to the left, wearing a chiton with a V-shaped border at the throat and a cloak which passes over her right shoulder. Beside her stands a fourth woman with her head in three-quarter view, turned to the right. The drapery across the lower part of her body is painted in pale blue-green. Below the picture are plastic acanthus leaves in added white with round plastic beads between them.

The foot consists of a tall stem terminating in a saucer-like base attached to the convex foot. In the center of the stem is a band in relief. The upper part is decorated with a band in pink and the front of the lower part, with a band of ray pattern, also in pink. The outer edge of the base of the foot is painted a deeper pink. ADT

DIMENSIONS: H. to rim 36.4 cm.; H. of foot 14.7 cm.; Diam. of foot 16.4 cm.; Diam. of mouth 7.2 cm.
CONDITION: Broken and repaired. Some overpainting on figures and in area around leaves.
BIBLIOGRAPHY: Münzen und Medaillen, Basel, *Sonderliste U* (November 1984) no. 115.
PARALLELS: For similar examples in shape and decoration see U. Wintermeyer, *JdI* 90 (1975) Katalog nos. 30–69, and especially figs. 14, 16, 50. The vase finds a close parallel in New York 28.57.30 (Richter, *MMS* 2 [1930] 191, fig. 4), where the knob of the lid is preserved.

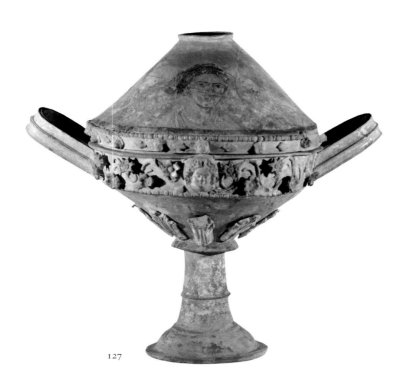

127

127 COLOR PLATE XVI

**CENTURIPE-WARE LEKANIS
WITH LID, HANDLES
AND STEMMED FOOT**
Mid-3rd century B.C.
Gift of Gilbert M. Denman, Jr.
86.134.154

The background of the lekanis lid is a
blue-green color over which the figural
decoration is painted in shades of red,
white and yellow. Below the figures
runs a thick band of applied purple-red.
The lid has a bead-and-reel border in
relief. On the outer edge, a band of ap-
plied plastic decoration consists of lion
heads alternating with lotus buds, only
on Side A. The knob is missing.

Side A of the lid shows a bust of a
woman in three-quarter view to right.
Her hair is shown in dark red with a
white wreath above the brow. Around
her neck is a white bead necklace. She
wears blue-green drapery with a red-
dish-pink shawl draped over her shoul-
der and behind her neck. The eyes are
shown as ovals with black pupils with a
white dot in the center. The eyebrows
are clearly defined, as are the lines of
the eyelids. To the right is an ivy
branch with red stems and white
leaves. In front of the branch, a large
bird, perhaps a dove, appears. To the
left, a similar ivy branch flanked by a

scroll with a floral between the spirals
and a large white rosette. To the left,
another bird, probably a dove also; its
plumage is in added red with touches
of blue, white and a dark grey color.

Side B of the lid, which has been re-
constructed from very small fragments,
with a good deal missing, is in such a
ruined state that identification of the
subject (if any) is no longer possible.

On the band below the rim of the
lekanis bowl is a female head in relief,
surrounded by a garland of flowers, also
in relief, and projecting outward from
the surface. The flowers spring from
spiralling tendrils and the background is
pink and the flowers were originally
painted white. The flowers look to be
daisies, dianthus and, perhaps, four-
petaled rock-rose (*xystus*). Below the
floral decoration is a bead-and-reel
border in relief. The lower part of the
conical bowl, which tapers sharply
downwards, is decorated with applied
acanthus leaves in shades of white and
blue. Side B was undecorated.

The flanged handles are painted deep
pink over white on the outer side only.

The foot of the lekanis, which is in
very poor condition and has been re-
constructed from numerous fragments,
was originally decorated in added pink

on white, nearly all of which has disap-
peared. It consists of a stem, increasing
in width as it runs down to join the
foot, which consists of a convex upper
portion and a flat base. About two-
thirds of the way down the stem is a
band in relief, with another where the
stem joins the foot. ADT

DIMENSIONS: H. of lid 18.2 cm.; H. of
bowl 17 cm.; H. of stand 22.6 cm.; Diam.
of bowl 36 cm.
CONDITION: Reconstructed from frag-
ments, especially the lid, with a good deal
of repainting over the joins.
BIBLIOGRAPHY: Christie's London, 10
July 1974, lot 6; Sotheby's London, 8 De-
cember 1975, lot 190.
PARALLELS: For similar examples in shape
and decoration see U. Wintermeyer, *JdI*
90 (1975) Katalog nos. 1–29 and espe-
cially figs. 1, 3, 17, 30, 33.

128

PEUCETIAN (?) KANTHAROID
Late 5th century B.C.
Gift of
Mr. and Mrs. N. Theodore Villa
83.113

The decoration is in chocolate and
brown. The vertical strap-handles are
decorated on the outside with dots and
on the sides with strokes. On the inside
rim of the mouth is a band of egg-like
pattern, above a chocolate stripe, and
the lower edge of the mouth is deco-
rated with a brown stripe. Below the
rim is a band of chocolate color from
which descends small pendants ending
in dots. On the shoulder is a wavy
band, a band of chocolate and a row of
dots. Around the body are nine con-
centric bands in chocolate and brown.
At the join of the foot is a band of
chocolate with a band of yellow-brown
below it. On the flaring foot is a band
of chocolate, a row of dots, and on the
outer edge, another band of chocolate.
The underside is left reserved. ADT

DIMENSIONS: H. to rim 19.5 cm.; H. to
handles 22.4 cm.; Diam. of mouth
12.6 cm.; Diam. of foot 9.2 cm.
CONDITION: Unbroken. Spalling on
lower body. Encrustations on lower body
and the underfoot.
SHAPE AND DECORATION: Various
names have been given to this particular
shape, which somewhat resembles the so-
called *nestoris* type III in Lucanian and
Apulian red-figure, which, however, has

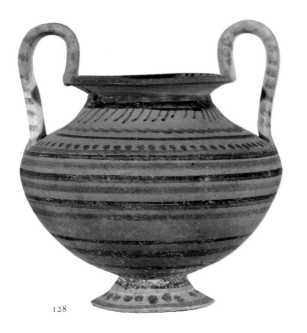

128

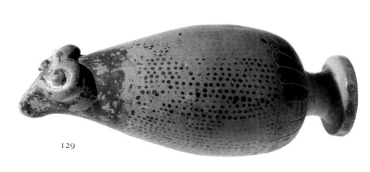

129

a very different mouth and neck: see G. Schneider-Herrmann, *Red-figured Lucanian and Apulian Nestorides* (Amsterdam 1980) figs. 1–5a. It is commonly referred to as a *kantharos*, though perhaps *kantharoid* would be a better term; Yntema calls it by the generic name of *olla* and elsewhere, e.g. in F. Tinè Bertocchi, *Le necropoli daunie di Ascoli Satriano e Arpi* (Genova 1985), the term *krateriskos* has been used, perhaps unwisely.

PROVENANCE: Ex coll. N. Theodore Villa.

BIBLIOGRAPHY: Unpublished.

LITERATURE: This vase was originally classified as Messapian but it differs in the treatment of the handles, mouth and foot from standard Messapian examples of this shape, as illustrated by D.G. Yntema in "Messapian Painted Pottery," *BABesch* 49 (1974) 8, fig. 2, I 1–5. It looks nearer to the type found in Peucetia (Central Apulia), of which good examples are reproduced in *Archeologia di una città: Bari dalle origini al X secolo* (Exhibition Catalogue, Bari, 1988), eds. G. Andreassi and F. Radine, figs. 342 (no. 581), 360 (no. 619), 386 (no. 661), 500 (no. 754), 541 (no. 791), 543 (no. 793), mostly from the later fifth century. Also comparable are the vases from the same general area illustrated by M. Mayer in *Apulian* (Berlin 1914), pls. 19,2–3; 20,14; 22,7.

129

ETRUSCO–CORINTHIAN ALABASTRON ENDING IN A RAM'S HEAD
6th century B.C.
Gift of Gilbert M. Denman, Jr.
86.134.158

The shape is that of an elongated aryballos or alabastron with a relatively long neck and aryballos-type lip. The body tapers to a crude ram's head with applied, curved horns. The animal's muzzle is pig-like, with an incised straight line for the mouth and two holes for the nostrils. The principal body zone is dotted, while the head and neck of the ram are covered with flaky purple paint. Crude tongues of alternating purple and black are incised on the shoulder of the vase; incised petals decorate the mouth, and black blobs adorn the edge of the lip.

The strange proportions, the painting scheme and, to a lesser extent, the fabric indicate that this vase was made in Etruria and is an example of the local industry in figure vases. Deriving their inspiration from both East Greek and Corinthian imports, Etruscan figure vases are a fascinating and little studied phenomenon. In this ram vase, the dotted decoration reflects Corinthian decorative schemes but the method of decoration and proportions are clearly local. W R B

DIMENSIONS: Max. H. 12.4 cm., Diam. of mouth 3.1 cm.

CONDITION: Complete. Part of lip restored; numerous cracks on body. Surface very worn. Fabric slightly micaceous, Munsell 5YR 6/3 (light reddish brown), read by artificial (tungsten) light.

SHAPE AND DECORATION: Incision used for petals on mouth and roughly shaped tongues on shoulder. Black glaze for petals (trace), blobs on edge of lip, alternate tongues on shoulder, dot decoration· on body. Purple paint used for head and neck of ram and alternate tongues on shoulder. Traces of white spots at base of neck over the black glaze at edge of dot decoration.

ADDED COLOR: Possible traces of white pigment in curve of horns. Purple for head and neck, and for dotted pattern on body.

BIBLIOGRAPHY: Presumably same piece as Sotheby's London, 29 April 1963, lot. 152.

PARALLELS: For an almost exact parallel, but better preserved see *CVA*, Fiesole, Collezione Constantini, fasc. 1 (1980) 7–8, pl. 6,6.

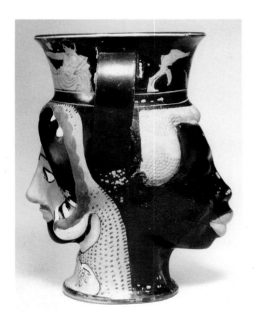

130

ATTIC RED-FIGURE
KANTHAROS IN THE FORM
OF CONJOINED HEADS
OF HERAKLES
AND A BLACK MAN
Assigned to Class M: The Vatican
Class [J.R. Guy]
Red-figure pictures
attributed to the Syriskos Painter
Ca. 470 B.C.
Gift of Cecil von Furstenberg and the
Sarah Campbell Blaffer Foundation
91.24
Lip: Symposion
A. Male figure and youth reclining
B. Hound, youth reclining

The moldmade head of a white man,
forming the obverse of the bowl of this
drinking vessel, is instantly recognizable
as Herakles from his famous attribute,
the skin of the Nemean lion. Here the
lion's head is worn like a helmet so that
its gaping, white-fanged jaws frame the
hero's face. Carefully aligned short
strokes of black glaze suggest fur on the
skin's reserved surface. The lion's paws
are painted on smaller than a housecat's
and knotted under Herakles' chin,
rather than across his chest, so that they
may be included in an image terminat-
ing along the base of the hero's neck.
Herakles' rounded mass of black-glazed
hair meets his black beard, entirely
concealing his ears. (Originally, Herak-
les' beard would have had a red central

tuft that has not been restored.) In ad-
dition to such strongly three-dimen-
sional features as the prominent,
straight Greek nose and smiling mus-
tached lips, other details such as black
brows and eyes with black irises and
pupils (borders between the two re-
served) and the whites of the eyes are
conveyed primarily by glaze or added
color.

The reverse side of the plastic vase
brings to mind Beazley's comment, "it
seemed a crime not to make negroes
when you had that magnificent black
glaze." From the surviving fragments a
keenly modelled, beautifully realized
rendition of a black man's head has
been reconstructed. The facial features,
most notably the thick, puffy, protrud-
ing lips, and flat, broad-nostriled nose,
are of purest pronounced Negroid
type. Unlike the schematized, generic
white man's face employed for Herak-
les, the black's head evidences more
particular observation from life. The
flesh areas are, indeed, suitably covered
with lustrous Attic black glaze. The
opening of each nostril of the black
man's nose is reserved. His eyes, now
missing, would have had slightly low-
ered lids, and originally the whites,
irises and pupils would have been
painted on like Herakles'. The brows
also were painted on, but in white
rather than black. The black man's
characteristically woolly short hair is
suggested by raised dots covering its
compactly modelled mass, and origi-
nally red color would have been ap-
plied directly over the hair's now-
reserved surface.

The vessel's provocative contrast of
human skin colors and physiognomies
is best appreciated in side view rather
than en face. The two moldmade heads
join at the sides of the neck. Here the
kantharos' handles have been displaced
from the median toward Herakles' side.
The tectonic black-glazed handle zone
stands between the hero's reserved
lionskin and the black's red hair, but
below the black glaze simply merges
with the naturalistic surface of the black
man's head.

The simple red-figure symposium on
both sides of the tall, flaring wheelmade
lip fittingly caps the kantharos' mold-
made janiform bowl. The two male
figures over the head of Herakles as-
sume similar reclining poses. Both have
draperies wrapped around their lower
bodies as well as over their left arms, on

which they lean. Both extend their
right arms toward the left, straight out
over their bodies. The leftmost figure
rests on two striped cushions. Traces of
an inscription appear over his extended
arm. His head is missing, and, although
it cannot be determined whether he
was bearded, a fragment of his hair, as
well as the shadow of the long ends of
a fillet, once tied at the back of his
head, reveal that he faced the beardless
youth reclining at the right.

An amusing vignette appears over
the black's head on the reverse. Like
the male figures on A, here the youth
at the right reclines with his garment
wrapped around his lower body as well
as his left arm and extends his right
arm. This youth, however, is shown in
rear view, and, as he looks left, he sees
not a fellow banqueter, but a disgrun-
tled hound, with his mouth down-
turned and its tail hanging between its
legs. All the symposiasts recline directly
on the groundline on which the hound
stands.

Herakles, a great lover of wine, often
uses the two-handled kantharos rather
than a simple cup in Greek art. An
elaborate drinking-vessel in the form of
the hero himself, therefore, comes as
no surprise. The arresting combination
of his head with a black man's, how-
ever, may have had specific inspiration
with Herakles' encounter with the
Egyptian king Busiris, a story particu-
larly popular on Attic red-figured vases
during the Late Archaic period. Vase-
painters, who treated this episode hu-
morously, pictured the Egyptians with
Negroid features; and somewhat later
Herakles with Busiris was the subject of
a lost satyr-play by Euripides.

As Snowden has shown, the first
African blacks to appear in Greek art,
during the Archaic and Early Classical
periods, are normally of purest Negroid
types. These exotic foreigners, called
Aethiopes in antiquity, probably be-
came well known in Greece itself by
accompanying Xerxes during the Per-
sian War. The early depictions evi-
dently antedated black and white racial
mixtures, common after the war and
subsequently represented in later fifth-
century Athenian art. In an age when
traits such as black skin and woolly hair
were believed to have been effects of
exposure to the sun, Greek artists, par-
ticularly in head vases such as this one,
often portrayed Negroid Aethiopes ob-
jectively and sympathetically rather
than humorously.

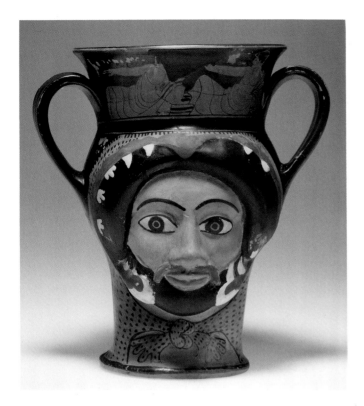

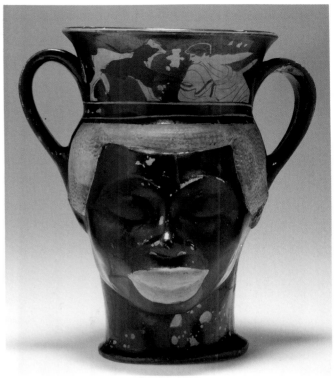

Attic janiform head vases afforded potters and painters an intriguing opportunity for pointed contrasts, particularly of race and/or gender. Cleverly juxtaposed fleshtones of black and white individuals conveyed by means of glaze and reserve on some plastic drinking cups of the Late Archaic period arguably make these the ultimate bilingual vases. The Vatican Class, to which the vessel in San Antonio belongs, was named by Beazley after another janiform kantharos with conjoined heads of Herakles and a black man in the Museo Gregoriano Etrusco. In several members of the Class the moldmade head of Herakles is combined with the head of a woman or that of a satyr, and in others the woman's and satyr's heads appear together.

The wheelmade lip of the name-vase is decorated with ivy, but the lips of most kantharoi of the Vatican Class, including the one in San Antonio, are decorated with red-figure pictures attributed to the Syriskos Painter. This painter of a red-figured astragalos in the Villa Giulia was named by Beazley after that plastic vase's potter. The Group of Negro alabastra, consisting of white-ground vessels bearing images of black men rendered in black glaze, also associated with the Syriskos Painter, may be particualry relevant in the present context. B C

DIMENSIONS: H. 20.2 cm.; Diam of mouth 13.1 cm.; Max. Diam. of foot 9.1 cm.
CONDITION: Restored from fragments; many areas missing, including much of the right side of Herakles' face and his chin; the eyes, left cheek and right side of black man's face. Much pitting of black glaze.
SHAPE AND DECORATION: Interior of wheelmade lip glazed black; reserved line around exterior of rim; reserved lines run around the vase beneath the figure scenes and at the juncture of lip and bowl. Interior of moldmade body glazed black (streaky). Broad strap handles glazed black inside and out. Line of black glaze around top of base on Herakles' side. Underside of base flat and reserved.
ADDED COLOR: Red for Side A, gums of lionskin, Herakles' mustache, traces beneath his lower lip, inscription (flaked), fillet of left symposiast (flaked); Side B, hair of black man (flaked). White for Side A, teeth of lionskin, white of Herakles' preserved eye, fillet of right symposiast; Side B, brows of black man; fillet of symposiast.

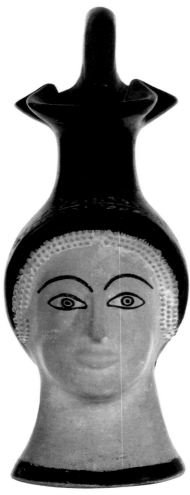

131

BIBLIOGRAPHY: Unpublished.
LITERATURE: For the association with
Herakles and Busiris see H. Speier, ed.,
W. Helbig, *Führer durch die öffentlichen
Sammlungen klassischer Altertümer in Rom*
(Tübingen 1963) 703, no. 981 (H. Sich-
terman). On the myth see *LIMC* III,1,
147–52, s.v. Bousiris (A.-F. Laurens). For
blacks in antiquity and their representa-
tion in Greek art see F. M. Snowden, Jr.,
"Iconographical Evidence on the Black
Populations in Greco-Roman Antiquity,"
in L. Bugner, ed., *The Image of the Black in
Western Art* (New York 1976) especially
148–60, 167; figs. 159, 164, 170–73, 193,
199, and *LIMC* I,1, 413–19, s.v.
Aithiopes. On head vases and the Vatican
Class see J. D. Beazley, "Charinos," *JHS*
49 (1929) 39, 42, 60, 67–68; *ARV²* 1538–
39; *Beazley Addenda²* 387. For the Syris-
kos Painter and the Group of the Negro
Alabastra see *ARV²* 259–69, 1640–41;
Para 351–52; *Beazley Addenda²* 204–06;
Boardman, *ARFV* 113–14, figs. 202–04,
208.

131

ATTIC HEAD VASE
Cook Class,
Ca. 475–450 B.C.
Gift of Gilbert M. Denman, Jr.
86.134.82

Beginning at the end of the sixth cen-
tury B.C., a class of vessels molded in
the form of human heads became pop-
ular in Athens. These Attic head vases
were produced primarily as drinking
cups (kantharoi), wine-pouring vessels
(oinochoai), or oil vases (aryballoi) and
could be in the form of satyrs, Herak-
les, or other exotic types. The most
popular subject, however, was the fe-
male head, as here, shown wearing a
simple *sakkos*, a form of hair covering,
decorated with a wreath in added
white, variously identified by scholars
as being made up of olive, myrtle, or
laurel leaves. Perhaps the most interest-
ing feature of these vases is their
method of construction, combining the
talents of the painter, the potter, and
the coroplast, or modeller, in that often
wheelmade, handmade, and molded
sections are combined to construct a
single vase. Here, the handle, slim
neck, and trefoil-shaped lip are added
to the head portion, which was made
in a two-piece mold. The concept of
using a human head as a container is an
old one, and the Attic head vases are
part of a long tradition that extends
down to modern times—one thinks
immediately of the Toby jug, for in-
stance.

The vase rests on a flat, slightly flar-
ing base, emphasized by a broad, black
stripe at its lower edge. The face is re-
served; the nose is prominent while the
lips are indistinctly molded with per-
haps a trace of the "archaic smile," to
be seen rather in the treatment of the
cheeks than of the mouth itself. The
hair appears below the *sakkos* in the
form of three rows of applied dots of
clay. WRB

DIMENSIONS: H. to rim (front) 12.7 cm.;
H. to handle top 15.8 cm.; Max. Diam.
of foot 5.8 cm.; H. to top of face (black
glaze) 8.8 cm.
CONDITION: Complete. Part of the han-
dle and a portion of the lip are restored.
There is some light restoration on the
hair over the forehead.
SHAPE AND DECORATION: Beazley di-
vided these vases into classes in 1929
based on their molded portions; our ex-
ample belongs to the largest class, the

Cook Class. The members of this class
were considered by Beazley as "unpre-
tentious little works with an archaic alert-
ness of expression." Black glaze is used
for the vase's neck, mouth and handle,
and for the *sakkos* and the black line
around the base. The glaze on the *sakkos*
overlaps the top row of dotted forehead
hair, and was too thinly applied towards
the back of the head where it now has a
streaky appearance. Eyebrows and eyes
are outlined with black glaze; the pupil
rendered by a dot in a circle.
ADDED COLOR: Traces of added white
can be seen in the left eye; white is also
used on the dotted forehead hair and for
the wreath.
PROVENANCE: Ex coll. W. R. Hearst.
BIBLIOGRAPHY: *ARV²* 1543, 143. Parke-
Bernet Sale, New York 1963, lot 31.;
*Classical Art from New York Private Collec-
tions*, André Emmerich Gallery (New
York 1977) no. 48.
LITERATURE: For the basic work on the
Attic head vase, see J. D. Beazley,
"Charinos," *JHS* 49 (1929) 38–78.

132

ATTIC MINIATURE HYDRIA
WITH RELIEF DECORATION
Ca. 400–375 B.C.
Gift of Gilbert M. Denman, Jr.
86.25.2
Orestes at Delphi (?)

This small vase belongs to an unusual
class of objects made in Athens (as well
as other areas) in the late fifth century
and the first half of the fourth. As the
red-figure style seemed to have run its
course, potters experimented with
other techniques, including the applica-
tion of clay figures, often painted or
gilded, to the black-glazed surface of
the vase. A few large and spectacular
examples were made, such as a hydria
from Cumae nicknamed the Regina
Vasorum, but the great majority are
small shapes, most often lekythoi. The
San Antonio vase is a rare hybrid shape,
combining the body of a miniature hy-
dria with a lekythos neck and mouth.

Three figures, neatly spaced and well
defined, occupy the surface between
the handles, yet the subject is elusive.
At the left a youth, his chest bare and a
garment draped over his thigh, sits on a
rock or small square altar. He holds a
sword in his right hand. The central
figure is a standing woman, facing and
looking down at the youth. She holds a

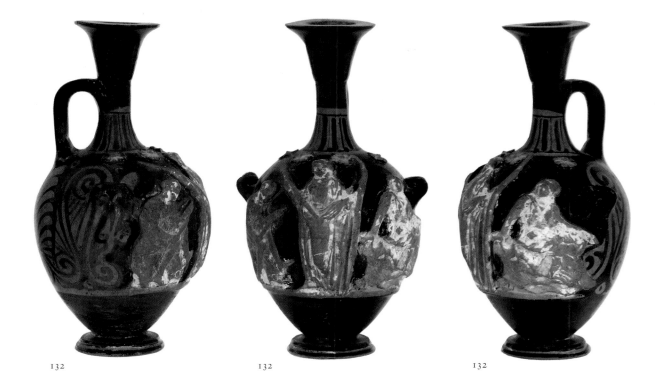

132 132 132

long object in her right hand, possibly a torch. She may have held a second one, now broken off, in the other hand, for a flame-like pattern runs across her left side. At the right, a young woman in sleeveless chiton sits on a rock and turns to look back to the center.

The first interpretation suggested for the scene was the Suicide of Ajax. But this subject is quite rare in Attic red-figure, and, when it occurs, looks very different. Also, it would be hard to explain the presence of two women, since the sources explicitly say that Ajax was quite alone at his death.

There is one relief vase of this class depicting Telephos threatening the baby Orestes at an altar in the presence of a nurse or Clytemnestra. The youth on our vase recalls Telephos, but the crucial element, the baby, is missing.

The type of a youth sitting on an altar is, however, familiar from the story of the grown-up Orestes, when he sought refuge at Dephi after the murder of his mother. The sword and the agitated pose of his legs both accord with depictions of the story in red-figure, as on the San Antonio krater (Cat. No. 88) by the Naples Painter. The woman at right would be an Erinys and the central figure, who in-

tervenes to protect Orestes, Artemis. It is Artemis who holds the torches of purification on the Naples Painter's krater. HAS

DIMENSIONS: H. 15.1 cm.; Diam. at handles 8.3 cm.; Diam. of foot 3.6 cm.
CONDITION: Body unbroken; part of mouth restored. Extensive loss of applied white paint on relief figures. Lower back of body misfired.
SHAPE AND DECORATION: Applied decoration of four rosettes on the shoulder; reserve palmette complex with vertical volutes below the neck handle; seven black tongues on the neck.
ADDED COLOR: White on all figures (much flaked off); yellow on plastic rosettes.
BIBLIOGRAPHY: Unpublished.
LITERATURE: On relief vases see E.A. Zervoudaki, "Attische polychrome Relief Keramik des späten 5. und des 4. Jahrhunderts v. Chr.," *AM* 83 (1968) 1–88. Add to her lists a recently published example: *Classical Antiquity* (André Emmerich Gallery, New York, 22 November 1975–10 January 1976) no. 23. For the shape of our vase cf. Zervoudaki pl. 15,3 (Cabinet des Médailles 482) and pl. 8 (Louvre MNL 694). The Telephos lekythos: Zervoudaki pl. 14,2 (New York 28.57.9). For the bibliography on Orestes at Delphi see Cat. No. 88.

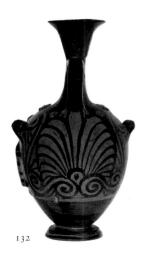

132

APPENDIX A

Unattributed Whole Vases

133

**EARLY CYCLADIC KANDILA
WITH LUG HANDLES**
Ca. 2700–2400 B.C.
Gift of Gilbert M. Denman Jr. 89.15.2

DIMENSIONS: H. 16 cm.; Diam. of rim 8.5 cm.; Diam. of
foot 9.6 cm.
CONDITION: Complete. Encrustations on rim and interior.
BIBLIOGRAPHY: Unpublished.

134

CYCLADIC MINIATURE VASE
3rd millennium B.C.
Gift of Gilbert M. Denman, Jr. 86.134.201

DIMENSIONS: H. 3.4 cm.; Max. Diam. 4.4 cm.; Diam. of
base 1.6 cm.
CONDITION: Unbroken; minor chipping on mouth.
DECORATION: Wave pattern.
BIBLIOGRAPHY: Galerie Günter Puhze, *Kunst der Antike*,
cat. 6 (Freiburg 1985) 21, no. 222.
PARALLELS: A vase similar in shape and decoration appears
in C. Doumas, *Cycladic Art from the N. P. Goulandris Collection* (Houston Museum of Fine Arts) 1981, no. 68.

135

MYCENEAN PYXIS
Mycenean II B, 1300–1230 B.C.
Museum Purchase: Stark-Willson Collection 86.138.89

DIMENSIONS: H. 9 cm.; Diam. of mouth 7 cm.; Max.
Diam. 11.3 cm.
CONDITION: Unbroken; surface abraded with some
glaze loss.
SHAPE AND DECORATION: For shape, see Furumark, *MPA*
shape 93. The decoration, in red-brown glaze, consists of
broad bands and fine lines encircling the vase; vertical
strokes decorate the shoulder. The mouth, neck, and
handles are covered in the same glaze.
PROVENANCE: Ex coll. Stark (Orange, Texas).
BIBLIOGRAPHY: Unpublished.
PARALLELS: Brussels A20, *CVA* (Brussels 1), pl. 2, 8 & 10;
Copenhagen 5586, *CVA* (Copenhagen 1), pl. 46,6.

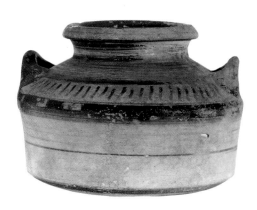

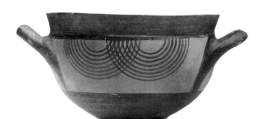

136

PROTOGEOMETRIC CUP
(POSSIBLY EUBOEAN)
9th century B.C.
Gift of Gilbert M. Denman, Jr. 89.15.1

DIMENSIONS: H. 10.3 cm.; Diam. of foot 5.3 cm.
CONDITION: Unbroken; chipping on rim.
DECORATION: Cup covered in a dark brown glaze with the exception of a broad reserved band on body containing, on each side, two overlapping sets of concentric semicircles.
BIBLIOGRAPHY: Unpublished.
LITERATURE: J. Boardman, *The Greek Vases Overseas* (1980) 41, fig. 13.

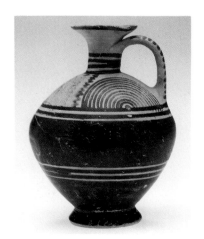

137

PROTOGEOMETRIC OINOCHOE
9th century B.C.
Gift of Joan Brown Winter 90.8.5

DIMENSION: H. 16.1 cm.; Diam. of mouth 5.5 cm.; Max. body Diam. 11.5 cm.; Diam. of foot 5.7 cm.
CONDITION: Broken and repaired with some glaze loss; chip on foot.
DECORATION: Four black bands encircle the neck. The shoulder is decorated with three sets of concentric semicircles between vertical zigzags, with two bands in black below. Body and foot glazed; three reserved bands appear on lower body.
BIBLIOGRAPHY: Unpublished.
PARALLELS: Copenhagen 7325, *CVA* (Copenhagen 2), pl. 66,2.

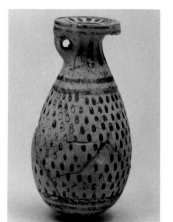

138

CORINTHIAN ALABASTRON
Early Corinthian, ca. 625–600 B.C.
Gift of Judith L. Smith 68.192.57.1

DIMENSIONS: H. 9.2 cm.; Diam. of mouth 3 cm.
CONDITION: Broken and repaired; large fragment missing below handle and at bottom.
DECORATION: Two bands in red glaze on rim; tongues in red-brown on neck. The body is decorated with a stippled pattern in red-brown glaze between double red lines. A single rosette in red appears on bottom.
BIBLIOGRAPHY: Unpublished.
PARALLELS: Cambridge G26, *CVA* (Cambridge 1), pl. 4,29.

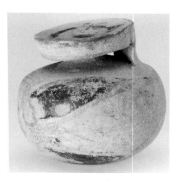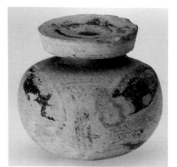

139

CORINTHIAN ARYBALLOS
Late Corinthian, ca. 550 B.C.
Gift of Judith L. Smith 68.192.57.15

DIMENSIONS: H. 6.3 cm.; Max. Diam. 6.4 cm.; Diam. of lip 4.3 cm.
CONDITION: Unbroken. Majority of glaze is lost.
DECORATION: Quadrifoil motif on front.
BIBLIOGRAPHY: Unpublished.
PARALLELS: Copenhagen 7594, *CVA* (Copenhagen 2), pl. 87, 20; Yale 1913.83, S. M. Burke and J. Pollitt, *Greek Vases at Yale* (New Haven 1975), no. 20.

140

BOEOTIAN BOWL
Late Archaic, ca. 500 B.C.
Museum Purchase: Stark-Willson Collection 86.138.86

DIMENSIONS: H. 6.5 cm.; Diam. of rim 9.3 cm.; Diam. of foot 5.9 cm.
CONDITION: Unbroken; chipping on rim and foot. Two holes, possibly for hanging, have been drilled into the rim.
DECORATION: Geometric motifs consisting of a horizontal zigzag line with dots between glaze lines and single rows of dots. Lip exterior, lower body, and foot glazed.
PROVENANCE: Ex coll. Stark (Orange, Texas).
BIBLIOGRAPHY: Unpublished.
LITERATURE: H. Froning, *Katalog der griechischen und italischen Vasen* (Essen 1982) 177–78.

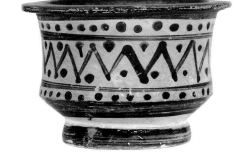

141

ITALO–CORINTHIAN KERNOS
8th–7th century B.C.
Museum Purchase: Grace Fortner Rider Fund 87.2.1

DIMENSIONS: H. 6.2 cm.; Diam. of ring 20.8 cm.; Diam. of Skyphoi 4.6–5.3 cm.
CONDITION: Restored and repainted.
DECORATION: Ray motifs on exterior and interior sides of ring; cross-hatched lines appear on top in dilute glaze. The ring is surmounted by seven miniature skyphoi covered in dilute glaze.
BIBLIOGRAPHY: *Summa Auction* I, 18 September 1981, lot 17; Sotheby's London, 13/14 December 1982, lot 387; Sotheby's London, 8/9 December 1986, lot 234.

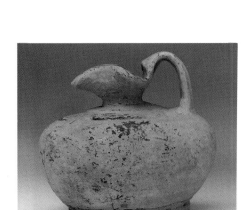

142

ITALO–CORINTHIAN OINOCHOE
7th century B.C.
Gift of Joan Brown Winter 90.8.1

DIMENSIONS: Max. H. 10.3 cm.; Max. Diam. 11.5 cm.; Diam. of foot 7.6 cm.
CONDITION: Broken and repaired. The majority of painted decoration has been lost.
BIBLIOGRAPHY: Unpublished.

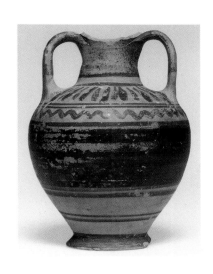

143

ITALO–CORINTHIAN AMPHORISKOS
7th century B.C.
Gift of Joan Brown Winter 90.8.7

DIMENSIONS: Preserved H. 12 cm.; Max. Diam. 8.9 cm.; Diam. of foot 5 cm.
CONDITION: Body unbroken, but top of neck and lip missing; foot is chipped. Substantial loss of black glaze.
DECORATION: Sub-geometric motifs in red and black glaze consisting of alternating red and black tongues on shoulder between double red lines (above on neck, below on shoulder). Below handles, a zigzag line in black, below which is a broad black band between red lines.
BIBLIOGRAPHY: Unpublished.

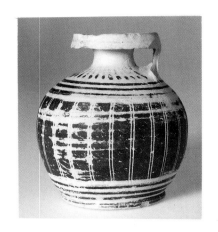

144

ITALO–CORINTHIAN ARYBALLOS
7th century B.C.
Gift of Joan Brown Winter 90.8.6

DIMENSIONS: H. 11.5 cm.; Diam. of lip 5.8 cm.; Diam. of
foot 7.1 cm.
CONDITION: Unbroken; large crack in neck and chipping
on handle. Some glaze loss on body.
DECORATION: Incised vertical and horizontal lines on a
broad black band between black lines (three above, three
below) on body. Tongue pattern on shoulder.
BIBLIOGRAPHY: Unpublished.

145

ITALIC CUP
Archaic, 6th century B.C.
Gift of Joan Brown Winter 90.8.4

DIMENSIONS: H. 5.7 cm.; Diam. of mouth 12.1 cm.;
Diam. of foot 5.5 cm.
CONDITION: Unbroken. Spalling on interior and exterior;
chipping on rim. A drilled hole, perhaps for hanging the
cup, exists near its rim.
DECORATION: Sub-geometric motifs consisting of a check-
ered pattern on the cup's bottom, rays extending upward
from base, meeting three lines on a reserved background.
Upper portion of cup glazed.
BIBLIOGRAPHY: Unpublished.

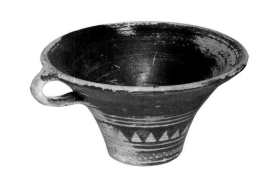

146

ITALIC ONE–HANDLED CUP
Archaic, 6th century B.C.
Gift of Joan Brown Winter 90.8.3

DIMENSIONS: H. 7.5 cm.; Diam. of mouth 12.6 cm.;
Diam. of foot 4.9 cm.
CONDITION: Unbroken. Chipping on rim and loss of ap-
proximately fifty percent of glaze on interior and exterior.
DECORATION: Sub-geometric motifs consisting of a check-
ered pattern on the cup's bottom and pendent rays between
lines (three) decorating the lower portion of the cup's
exterior; upper half covered in black glaze.
BIBLIOGRAPHY: Unpublished.

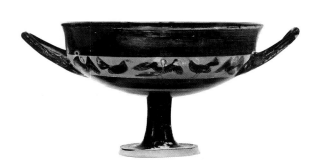

147

ATTIC BLACK–FIGURE BAND CUP
Ca. 540 B.C.
Gift of Lenora and Walter F. Brown 90.104.3

DIMENSIONS: H. 14.4 cm.; Diam. with handles 20.2 cm.;
Diam. of mouth 21.3 cm.; Diam. of foot 8.9 cm.
CONDITION: Broken and repaired; surface abraded with
some glaze loss.
DECORATION: On bowl, a frieze of birds on a reserved
ground; a narrower reserved band below.
BIBLIOGRAPHY: Unpublished.
PARALLELS: Brussels A69, *CVA* (Brussels 1), pl. 2,3.

148

ATTIC BLACK-FIGURE BAND CUP
Ca. 540 B.C.
Gift of Lenora and Walter F. Brown 90.104.4

DIMENSIONS: H. 13.5 cm.; Diam. with handles 27.9 cm.;
Diam. of mouth 21.1 cm.; Diam. of foot 9.5 cm.
CONDITION: Broken and repaired; abrasion on tondo and
on Side B frieze.
DECORATION: On bowl, a frieze of panthers and rams on a
reserved ground; a narrower reserved band below.
BIBLIOGRAPHY: Unpublished.

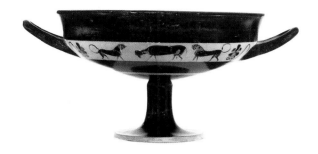

149

ATTIC WHITE-GROUND SQUAT LEKYTHOS
6th century B.C.
Museum Purchase: Stark-Willson Collection 86.138.87

DIMENSIONS: H. 11.1 cm.; Diam. of foot 5.5 cm.
CONDITION: Body unbroken; mouth and upper neck
restored.
DECORATION: On white-ground body, a panel containing a
lozenge pattern in black glaze. On shoulder, a tongue pat-
tern on a reserved ground. Mouth, handle, lower body and
foot covered in black glaze.
PROVENANCE: Ex coll. Stark (Orange, Texas).
BIBLIOGRAPHY: Unpublished.

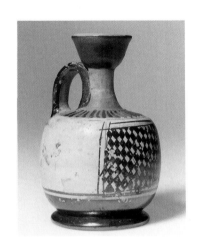

150

ATTIC BLACK-FIGURE COLUMN-KRATER
Late 6th century B.C.
Gift of Gilbert M. Denman, Jr. 86.134.45
A and B: Two mounted Amazons within panel

DIMENSIONS: H. 31 cm.; Diam. of rim 27.5 cm.;
Diam. with handles 32.6 cm.; Diam. of foot 15 cm.
CONDITION: Broken and restored with numerous fragments
missing. Chipping on mouth; surface is abraded.
DECORATION: Two rows of ivy on rim exterior, and on
each side of figural panel. Rays on a reserved band on lower
body.
BIBLIOGRAPHY: Sotheby's New York, 24 February 1982,
lot 497.

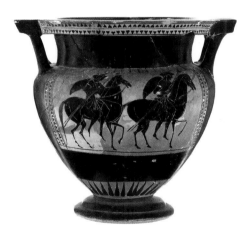

151

ATTIC BLACK GLAZED VOLUTE-KRATER
Early 5th century B.C.
Gift of Gilbert M. Denman, Jr. 86.134.171

DIMENSIONS: H. to rim 40.5 cm.; H. to volutes 45.8 cm.;
Diam. of rim 31.2 cm.; Diam. of foot 14.5 cm.
CONDITION: Broken and repaired with minor restoration.
Misfiring on body; encrustations on interior.
DECORATION: No figural decoration. Black ivy-leaf bands
on volutes; running meander on rim exterior; rays on
reserved band on lower body.
BIBLIOGRAPHY: Christie's London, 16 July 1985, lot 417.

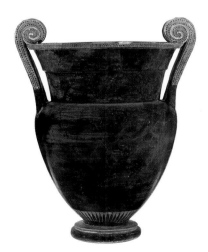

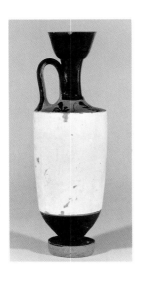
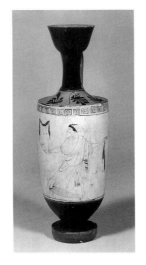

152

ATTIC WHITE-GROUND LEKYTHOS
Ca. 480 B.C.
Gift of Gilbert M. Denman, Jr. 86.134.83

DIMENSIONS: H. 24.5 cm.; Diam. of mouth 5.3 cm.;
Diam. of foot 5.1 cm.
CONDITION: Broken and repaired. Body decoration, con-
sisting of a woman in chiton and himation holding an
alabastron and a fillet, was modern and has been removed
in conservation.
DECORATION: Black-figure palmette chain on reserved
shoulder.
BIBLIOGRAPHY: Unpublished.

153

ATTIC SKYPHOS WITH VARIANT HANDLES
Ca. 480–450 B.C.
Gift of Nola and Gail Sheldon 86.133

DIMENSIONS: H. 6.2 cm.; Diam. of mouth 8.2 cm.;
Diam. of foot 4.9 cm.
CONDITION: Broken and repaired; surface abraded with
some glaze loss.
DECORATION: Covered in matt black glaze with small
swastika incised to left of vertical handle.
BIBLIOGRAPHY: Unpublished.

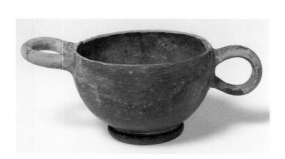

154

ATTIC BLACK-GLAZED CUP
WITH STAMPED DECORATION
Mid-5th century B.C.
Museum Purchase: Antiquities Acquisition Fund
89.26.1

DIMENSIONS: H. 8.5 cm.; Diam. of rim 20.2 cm.
CONDITION: Broken and reconstructed from fragments.
INSCRIPTION: (on underfoot) **MAIO**
BIBLIOGRAPHY: Unpublished.
PARALLELS: Copenhagen 5193, *CVA* (Copenhagen 4),
pl. 179,7.

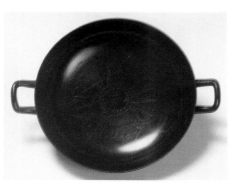

155

ATTIC BLACK-GLAZED CUP
WITH STAMPED DECORATION
Mid-5th century B.C.
Museum Purchase: Antiquities Acquisition Fund
89.26.2

DIMENSIONS: H. 8.7 cm.; Diam. of rim 19.9 cm.
CONDITION: Unbroken except for one restored fragment
at rim; small chip on interior at A/B handle.
BIBLIOGRAPHY: Unpublished.
PARALLELS: See Cat. No. 154.

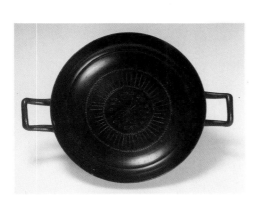

156

ATTIC RED–FIGURE SKYPHOS
Ca. 440 B.C.
Gift of Joan Brown Winter 89.65
Side A: Seated maenad
Side B: Standing female

DIMENSIONS: H. 13.3 cm.; Diam. of
mouth 16.5 cm.; Diam. of foot 11 cm.
CONDITION: Unbroken; chipping on
rim. Misfiring on B/A handle.
DECORATION: Addorsed palmettes under
each handle with spiralling tendrils.
Reserved band below figures.
BIBLIOGRAPHY: Sotheby's London,
1 December 1969, lot 105. Christie's,
Castle Ashby sale, 2 July 1980.

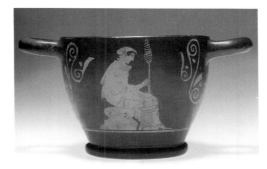

157

ATTIC RED–FIGURE CHILD'S CHOUS
Ca. 420–410 B.C.
Gift of Mr. Tracy Watson in memory of Eleanor Watson
84.87.2
Standing child, facing right with arms extended

DIMENSIONS: Preserved H. 4.6 cm.; Diam. of foot 4.8 cm.
CONDITION: Body unbroken, but neck and mouth lost.
BIBLIOGRAPHY: Unpublished.

158

SOUTH ITALIAN (PROBABLY APULIAN)
EPICHYSES WITH VERTICAL RIBBING
Second half of the 4th century B.C.
Museum Purchase: Grace Fortner Rider Fund
88.11.1a, b

DIMENSIONS: a) H. to handle top 11.8 cm.; Diam. of base
7.6 cm. b) H. to handle top 11.6 cm.; Diam. of base 7.3
cm.
CONDITION: a) Body unbroken; neck and spout broken
and repaired. Crack on body below spout. b) Unbroken;
crack at base.
BIBLIOGRAPHY: Sotheby's London, 14 December 1987,
lot 228.

159

MESSAPIAN TROZELLA
WITH STRAP HANDLES
Late 4th to early 3rd century B.C.
Gift of Joan Brown Winter 90.8.2

DIMENSIONS: H. 25.4 cm.; Diam. of foot 8.8 cm.
CONDITION: Unbroken.
DECORATION: On the body, a frieze of water-birds between
fine, vertical lines in red glaze. Two palmettes, framed by
fine diagonal lines, bracket a lotus on the neck. A tongue
pattern decorates the shoulder.
BIBLIOGRAPHY: Unpublished.

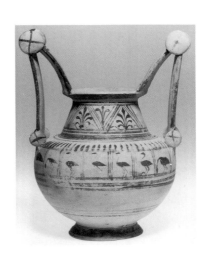

160

CENTURIPE PLATE
Third quarter of the 3rd century B.C.
Gift of Gilbert M. Denman, Jr. 86.134.90
Bust of woman

DIMENSIONS: Diam. 25 cm.
CONDITION: Broken and repaired.
DECORATION: The woman faces front, but looks to the left.
Her flesh is depicted in white paint, her hair in black. She
appears on a pink background surrounded by a black band.
Facial features are represented in dark pink paint.
BIBLIOGRAPHY: Unpublished.

161

**ATTIC PLASTIC VASE IN
THE SHAPE OF AN ALMOND**
Late 5th century B.C.
Museum Purchase: Grace Fortner Rider Fund 88.104.2

DIMENSIONS: H. 8.9 cm.; Depth 3.6 cm.
CONDITION: Unbroken.
DECORATION: Mouth, neck and handle are covered in
black glaze. The body is reserved, but covered with a de-
pressed stipple pattern; some traces of white remain in de-
pressions.
BIBLIOGRAPHY: Unpublished.

APPENDIX B

Attributed Fragments

162

ATTIC BLACK-FIGURE SKYPHOS FRAGMENT
Attributed to the Theseus Painter [D. von Bothmer]
Late 6th century B.C.
Gift of Gilbert M. Denman, Jr. 86.134.51
Head of bearded male

DIMENSIONS: H. 5.2 cm.; W. 4.3 cm.
BIBLIOGRAPHY: Unpublished.

163

ATTIC RED-FIGURE
COLUMN-KRATER FRAGMENT
Attributed to the Triptolemos Painter [J.R. Guy]
Early 5th century B.C.
Gift of Gilbert M. Denman, Jr. 86.134.187
Head of female

DIMENSIONS: H. 8 cm.; W. 8.7 cm.
BIBLIOGRAPHY: Unpublished.

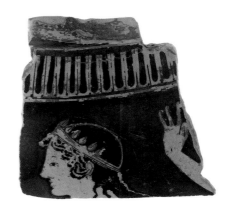

164

TWO NON-JOINING ATTIC
RED-FIGURE CUP FRAGMENTS
Attributed to the Triptolemos Painter [J.R. Guy]
Ca. 480 B.C.
Gift of Gilbert M. Denman, Jr. 86.134.181a & b
Symposiast and woman

DIMENSIONS: a) H. 5.6 cm.; W. 3 cm.
b) H. 7.2 cm.; W. 7.5 cm.
BIBLIOGRAPHY: Unpublished.

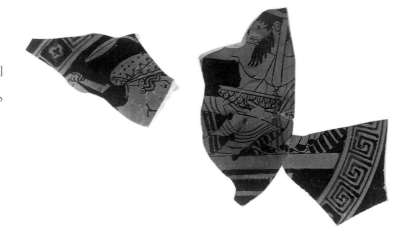

165

ATTIC RED-FIGURE CUP FRAGMENT
Attributed to the Triptolemos Painter [J.R. Guy]
Ca. 480 B.C.
Gift of Gilbert M. Denman, Jr. 86.134.180
Head and arm of youth

DIMENSIONS: H. 5.1 cm.; W. 5.5 cm.
BIBLIOGRAPHY: Unpublished.

166

ATTIC RED-FIGURE
CALYX-KRATER FRAGMENT
Attributed to the Kleophrades Painter [J.R. Guy]
Ca. 490–480 B.C.
Gift of Gilbert M. Denman, Jr. 86.134.178
Drapery

DIMENSIONS: H. 3.6 cm.; W. 5.5 cm.
BIBLIOGRAPHY: Unpublished.

167

ATTIC RED-FIGURE CUP FRAGMENT
Attributed to the Colmar Painter [J.R. Guy]
Ca. 480 B.C.
Gift of Gilbert M. Denman, Jr. 86.134.179
Head of youth

DIMENSIONS: H. 3.7 cm.; W. 7.5 cm.
BIBLIOGRAPHY: Unpublished.

168

ATTIC RED-FIGURE CUP FRAGMENT
Attributed to the Brygos Painter [J.R. Guy]
Ca. 480 B.C.
Gift of Gilbert M. Denman, Jr. 86.134.182
Female head

DIMENSIONS: H. 2.2 cm.; W. 2 cm.
BIBLIOGRAPHY: Unpublished.

169

ATTIC RED-FIGURE CUP FRAGMENT
Attributed to a painter
of the Brygan Workshop [J.R. Guy]
Ca. 480–470 B.C.
Gift of Gilbert M. Denman, Jr. 86.134.183
Female drapery

DIMENSIONS: H. 4.4 cm.; W. 3.3 cm.
BIBLIOGRAPHY: Unpublished.

170

ATTIC RED–FIGURE CUP FRAGMENT
Attributed to the Pistoxenan Circle [J.R. Guy]
Ca. 470–460 B.C.
Gift of Gilbert M. Denman, Jr. 86.134.185
Head and torso of youth

DIMENSIONS: H. 7.4 cm.; W. 3. 5 cm.
BIBLIOGRAPHY: Unpublished.

171

ATTIC RED–FIGURE NOLAN
AMPHORA FRAGMENT
Manner of the Berlin Painter
Ca. 470 B.C.
Gift of Gilbert M. Denman, Jr. 86.134.195
Draped youth holding two spears in his right hand

DIMENSIONS: H. 10.1 cm.; W. 11.9 cm.
BIBLIOGRAPHY: Galerie Günter Puhze, *Kunst der Antike*,
cat. 6 (Freiburg 1985) 21, no. 222.

172

ATTIC RED–FIGURE LIPPED CUP FRAGMENT
Attributed to the Euaion Painter [J.R. Guy]
Ca. 470–460 B.C.
Gift of Gilbert M. Denman, Jr. 86.134.186b
Head and chest of bearded male

DIMENSIONS: H. 2.3 cm.; W. 2 cm.
BIBLIOGRAPHY: Unpublished.

173

ATTIC RED–FIGURE CUP FRAGMENT
Attributed to the Euaion Painter [J.R. Guy]
Ca. 460 B.C.
Gift of Gilbert M. Denman, Jr. 86.134.186a
Head and chest of youth

DIMENSIONS: H. 2.2 cm.; W. 9 cm.
BIBLIOGRAPHY: Unpublished.

174

ATTIC RED-FIGURE CUP FRAGMENT
Attributed to the Euaion Painter
Ca. 450 B.C.
Gift of Gilbert M. Denman, Jr. 86.134.177
Woman holding oinochoe

DIMENSIONS: H. 6.3 cm.; W. 7.4 cm.
BIBLIOGRAPHY: Unpublished.

175

LUCANIAN (BELL-KRATER?) FRAGMENT
Attributed to the Creusa Painter [A.D. Trendall]
Ca. 380 B.C.
Gift of Gilbert M. Denman, Jr. 86.134.92c
Head and shoulders of youth

DIMENSIONS: H. 5.3 cm.; W. 7.9 cm.
BIBLIOGRAPHY: Unpublished.
PARALLELS: Bell-krater, Rome, American Academy
1840 (477), *LCS*, pl. 45,5 & 6.

APPENDIX C

Unattributed Fragments

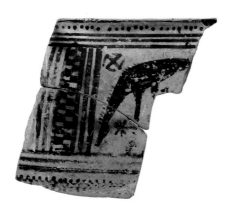

176

TWO JOINING GEOMETRIC
(AMPHORA?) FRAGMENTS
Ca. 780–750 B.C.
Gift of Mr. Tracy Watson in memory of Eleanor Watson
84.87.21 & 84.87.22
Head and forefront of horse

DIMENSIONS: a) H. 9.6 cm.; W. 13.2 cm.
b) H. 8.3 cm.; W. 9.7 cm.
BIBLIOGRAPHY: Unpublished.

177

RHODIAN OINOCHOE FRAGMENT
Middle "Wild Goat Style"
Last quarter of the 7th century B.C.
Gift of Giacomo Medici
88.18.2
Head of bird and scrolling foliate motif

DIMENSIONS: H. 5.3 cm.; W. 7 cm.
PROVENANCE: Ex Comtesse de Béhague.
BIBLIOGRAPHY: Sotheby's Monaco,
5 December 1987, lot 142(b).

178

JOINED FRAGMENTS
OF LITTLE MASTER CUP
Ca. 560–530 B.C.
Gift of Gilbert M. Denman, Jr.
86.134.196a

DIMENSIONS: Diam. at upper
edge 13.9 cm.
BIBLIOGRAPHY: Unpublished.

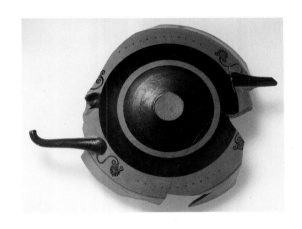

179

ATTIC BLACK–FIGURE
LARGE CUP FRAGMENT
Late 6th century B.C.
Gift of Giacomo Medici
88.18.1
Charioteer in a race

DIMENSIONS: H. 7.6 cm.; W. 7.9 cm.
PROVENANCE: Ex. Comtesse de Béhague.
BIBLIOGRAPHY: Sotheby's Monaco,
5 December 1987, lot 142(a).
PARALLELS: Comparable figures appear
on the oinochoe Brussels R323, *CVA*
(Brussels 1), pl. 6,3, and on the
Panathenaic amphora Brussels R229,
CVA (Brussels 1), pl. 13,3.

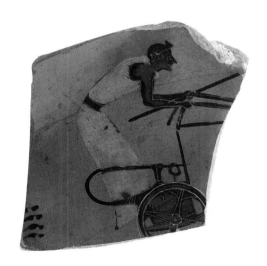

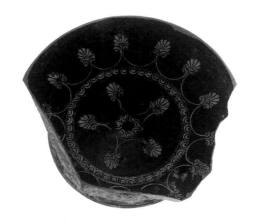

180

ATTIC BLACK-GLAZE
CUP TONDO FRAGMENT
WITH STAMPED DECORATION
5th century B.C.
Gift of Mr. Tracy Watson in memory
of Eleanor Watson
84.87.5

DIMENSIONS: Preserved Diam. 6.9 cm.;
Diam. of foot 5.4 cm.
BIBLIOGRAPHY: Unpublished.

181

ATTIC RED-FIGURE
CUP FRAGMENT
Ca. 460 B.C.
Gift of Gilbert M. Denman, Jr.
86.134.184
Youth at laver

DIMENSIONS: H. 4.9 cm.; W. 5.1 cm.
BIBLIOGRAPHY: Unpublished.

182

ATTIC RED-FIGURE
(KRATER ?) FRAGMENT
Ca. 460 B.C.
Gift of Mr. Tracy Watson in memory
of Eleanor Watson
84.87.19
Head of satyr, hand and thyrsos

DIMENSIONS: H. 4.7 cm.; W. 11.1 cm.
BIBLIOGRAPHY: Unpublished.

183

TWO ATTIC NON-JOINING
RED-FIGURE FRAGMENTS
FROM AN OPEN-FORM VASE
Late 4th century B.C.
Gift of Gilbert M. Denman, Jr.
86.134.92a & b
a) Reclining male
b) Chest and leg of horse
and male leg

DIMENSIONS: a) H. 5.4 cm.; W. 7.4 cm.
b) H. 6.8 cm.; W. 9.6 cm.
BIBLIOGRAPHY: Unpublished.

184

RED-FIGURE VASE
FRAGMENT (POSSIBLY
APULIAN) FROM A
CLOSED-FORM VASE
Early 4th century B.C.
Gift of Gilbert M. Denman, Jr.
86.134.92d
Head and chest of youth

DIMENSIONS: H. 4.8 cm.; W. 4.9 cm.
BIBLIOGRAPHY: Unpublished.

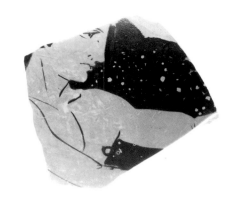

185

FOOTED MEGARIAN
BOWL FRAGMENT
Mid-3rd to mid-2nd century B.C.
Gift of Herbert G. Mills
67.261.82.1

DIMENSIONS: Preserved H. 8.5 cm.;
Diam. of foot 6.2 cm.
BIBLIOGRAPHY: Unpublished.

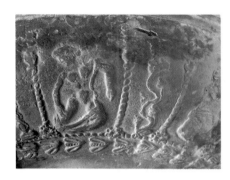
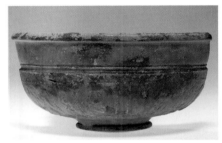

BIBLIOGRAPHY WITH ABBREVIATIONS

I. PERIODICALS, SERIES, etc.

AA	Archäologischer Anzeiger
Agora	The Athenian Agora. Results of Excavations Conducted by the American School of Classical Studies at Athens
AJA	The American Journal of Archaeology. The Journal of the Archaeological Institute of America
AthM	Mitteilungen des Deutschen Archäologischen Instituts, Athenische Abteilung
AntK	Antike Kunst
AntW	Antike Welt. Zeitschrift für Archäologie und Kulturgeschichte
ArchCl	Archeologia classica
ArchDelt	Archaiologikon deltion
ArchEph	Archaiologike Ephemeris
ArchNews	Archaeological News
ASAtene	Annuario della Scuola Archeologica di Atene e delle Missioni Italiane in Oriente
BABesch	Bulletin Antieke Beschaving. Annual Papers on Classical Archaeology
BCH	Bulletin de correspondance hellénique
BICS	Bulletin of the Institute of Classical Studies of the University of London
BMMA	Bulletin of the Metropolitan Museum of Art, New York
BSA	The Annual of the British School at Athens
BSR	Papers of the British School of Archaeology at Rome
BWPr	Winckelmannsprogramm der Archäologischen Gesellschaft zu Berlin
CQ	Classical Quarterly
CSCA	California Studies in Classical Antiquity
CVA	Corpus Vasorum Antiquorum

GazArch	Gazette archéologique
GettyMusJ	The J. Paul Getty Museum Journal
Gnomon	Gnomon. Kritische Zeitschrift für die gesamte klassische Altertumswissenschaft
Gymnasium	Gymnasium. Zeitschrift für Kultur der Antike und humanistische Bildung
Hesperia	Hesperia. Journal of the American School of Classical Studies at Athens
JdI	Jahrbuch des Deutschen Archäologischen Instituts
JHS	Journal of Hellenic Studies
JRGZM	Jahrbuch des Römisch-Germanischen Zentralmuseums, Mainz
Kadmos	Kadmos. Zeitschrift für vor- und frühgriechische Epigraphik
MEFRA	Mélanges de l'École Française de Rome, Antiquité
MMS	Metropolitan Museum Studies
MüJb	Münchener Jahrbuch der Bildenden Kunst
Muse	Muse. Annual of the Museum of Art and Archaeology, University of Missouri
MusHelv	Museum Helveticum
OJA	Oxford Journal of Archaeology
ÖJh	Jahreshefte des Österreichischen Archäologischen Instituts in Wien
RA	Revue archéologique
REA	Revue des études anciennes
RM	Mitteilungen des Deutschen Archäologischen Instituts, Römische Abteilung
StEtr	Studi etruschi
StMisc	Studi miscellanei. Seminario di Archeologia e Storia dell'Arte Greca e Romana dell'Università di Roma
YCS	Yale Classical Studies

II. TEXTS

ABFV
J. Boardman, *Athenian Black Figure Vases* (London, 1974).

ABL
C. H. E. Haspels, *Attic Black-figured Lekythoi* (Paris, 1936).

ABV
J. D. Beazley, *Attic Black-figure Vase-painters* (Oxford, 1956).

AGAI
W. G. Moon, ed. *Ancient Greek Art and Iconography* (Madison, 1983).

Agora XXIII
M. B. Moore and M. Z. Pease Philippides, with the collaboration of D. von Bothmer, *The Athenian Agora, XXIII: Attic Black-figured Pottery* (Princeton, 1986).

ARFV
J. Boardman, *Athenian Red Figure Vases: The Archaic Period* (London, 1975).

ARV²
J. D. Beazley, *Attic Red-figure Vase-painters*, 2nd ed. (Oxford, 1963).

BeazleyAddenda²
T. Carpenter, *Beazley Addenda. Additional References to ABV, ARV² , and Paralipomena* (Oxford, 1989).

Brijder, *Siana Cups I*
H. A. G. Brijder, *Siana Cups and Komast Cups I* (Amsterdam, 1983).

CB
L. D. Caskey and J. D. Beazley, *Attic Vase Painting in the Museum of Fine Arts, Boston* (Oxford, 1931–1963).

Carpenter, *Dionysian Imagery*
T. H. Carpenter, *Dionysian Imagery in Archaic Greek Art* (Oxford, 1986).

Copenhagen Proceedings
J. Christiansen and T. Melander, eds. *Proceedings of the Third Symposium on Ancient Greek and Related Pottery. Copenhagen 1987* (Copenhagen, 1988).

CorVP
D. A. Amyx, *Corinthian Vase-Painting of the Archaic Period I–III* (1988).

Development²
J. D. Beazley, *The Development of Attic Black-figure*, eds. Dietrich von Bothmer and Mary B. Moore (Berkeley, 1986).

Doumas, *Burial Habits*
C. Doumas, *Early Bronze Age Burial Habits in the Cyclades* (Göteborg, 1977).

Doumas, *Cycladic Art*
C. Doumas, *Cycladic Art: Ancient Sculpture and Pottery from the N.P. Goulandris Collection* (London, 1983).

EAA
Enciclopedia dell'arte antica, classicae orientale.

Enthousiasmos
Enthousiasmos: Essays on Greek and Related Pottery Presented to J.M. Hemelrijk, eds. H. A. G. Brijder, A. A. Drukker, and C. W. Neeft (Amsterdam, 1986).

EVP:
J. D. Beazley, *Etruscan Vase-painting* (1947).

FR
A. Furtwängler and K. Reichhold, *Griechische Vasenmalerei* (Munich, 1900–1932).

Furumark, *MPA*
Arne Furumark, *The Mycenaean Pottery: Analysis and Classification* (Stockholm, 1972).

GGP
J. N. Coldstream, *Greek Geometric Pottery* (London, 1968).

GRFP
I. McPhee and A. D. Trendall, *Greek Red-figured Fish Plates* (*AntK Beiheft* 14, 1987).

Graef and Langlotz
B. Graef and E. Langlotz, *Die Antiken Vasen von der Akropolis zu Athen* (Berlin, 1925–1933).

GuH
K. Schefold, *Götter- und Heldensagen der Griechen in der spätarchaischen Kunst* (Munich, 1978).

GVU
H. Sichtermann, *Griechische Vasen aus Unteritalien* (Tübingen, 1966).

Johansen
K.F. Johansen, *Les Vases Sicyoniens* (Paris, 1923).

Kurtz, *AWL*
D. C. Kurtz, *Athenian White Lekythoi* (Oxford, 1975).

LCS
A. D. Trendall, *Red-figured Vases of Lucania, Campania and Sicily* (Oxford, 1967).

LIMC
Lexicon Iconographicum Mythologiae Classicae.

Mertens, *AWG*
J. Mertens, *Attic White-Ground* (New York, 1977).

Mountjoy
P. A. Mountjoy, *Mycenaean Decorated Pottery: A Guide to Identification* (Göteborg, 1986).

MidwesternColls
W. G. Moon and L. Berge, *Greek Vase-painting in Midwestern Collections*, exh. cat., The Art Institute of Chicago, Chicago, 1979.

NC
H. Payne, *Necrocorinthia: A Study of Corinthian Art in the Archaic Period* (Oxford, 1931).

Para
J. D. Beazley, *Paralipomena, Additions to Attic Black-figure Vase-painters and to Attic Red-figure Vase-painters* (Oxford, 1971).

RE
Pauly-Wissowa, *Real-Encyclopädie der klassischen Altertumswissenschaft*.

Richter and Hall
G. M. A. Richter and L.F. Hall, *Red-figured Athenian Vases in the Metropolitan Museum of Art* (New Haven and London, 1936).

RVAp
A. D. Trendall and Alexander Cambitoglou, *The Red-Figured Vases of Apulia* (2 vols.; Oxford, 1978 and 1982).

RVAp, Suppl. I
Institute of Classical Studies, London, Bulletin *Supplement* no. 42, 1983.

RVAp, Suppl. II
1992 and 1993.

RVP
A. D. Trendall, *Red-figured Vases of Paestum* (British School at Rome, 1987).

RVSIS
A. D. Trendall, *Red-figure Vases of South Italy and Sicily* (London, 1988).

SouthernColls
H. A. Shapiro, ed., *Art, Myth, and Culture: Greek Vases from Southern Collections*. New Orleans Museum of Art, exh. cat. 1981.

StudiesRobinson
G. E. Mylanos and D. Raymond, eds. *Studies Presented to David Moore Robinson* II (Saint Louis, 1953).

Thimme, *Cyclades*
J. Thimme, ed. *Art and Culture of the Cyclades* (Karlsruhe, 1977).

Tiverios, *Lydos*
M. H. Tiverios, *Ho Lydos kai to Ergo tou* (Athens, 1976).

Tocra I
J. Boardman and J. Hayes, *Excavations at Tocra 1963–65* (Oxford, 1966).

Vasenlisten [2]
F. Brommer, *Vasenlisten zur griechischen Heldensage*, 3rd ed. (Marburg, 1973).

VMG
M. E. Mayo and K. Hamma, eds., *The Art of South Italy: Vases from Magna Graecia* (Exhibition catalog, Virginia Museum of Fine Arts, Richmond, 1982).

Zapheiropoulou
Zapheiropoulou, "The Chronology of the Kampos Group," *The Prehistoric Cyclades* (Edinburgh, 1984).

GLOSSARY OF TERMS

Term	Definition
Akontion:	Javelin.
Auloi:	Wind instrument consisting of double pipes.
Chiton:	Lightweight tunic worn by both men and women. A short-length version is referred to as a *chitoniskos*.
Chlamys:	Short woollen mantle or cloak worn by men and Amazons. It was generally worn while riding or traveling.
Diphros:	Stool (Plural, *diphroi*).
Dipinto:	A painted inscription on a vase.
Halteres:	Hand-held weights (either stone or iron) used by athletes.
Hetaira:	Courtesan.
Himation:	Long mantle generally made of wool which was worn by both men and women.
Kalos:	Inscription on vases which praised the beauty of a named youth, athlete or hero.
Kekryphalos:	Cloth used for binding up a woman's hair, but allowing some to project from the back in the manner of a ponytail.
Kerykeion:	Messenger's staff, most frequently carried by Hermes and Iris. (*Caduceus* in Latin.)
Kithara:	Stringed musical instrument with a wooden sound box related to the lyre, but more elaborate and more difficult to master.
Klismos:	High-backed chair.
Komasts:	Jovial male dancers, seeming to be padded, and frequently wearing red tunics. They appeared first on Corinthian vases, then Attic.
Komos:	Revel.
Mesomphalic Phiale:	Wide, shallow saucer (phiale) with a hollow boss rising in the center.
Miltos:	Red ochre, usually painted on a reserved area of the vase.
Naiskos:	Small shrine.
Nebris:	Fawn-skin, most frequently worn by Dionysos and his female followers, the maenads.
Pelta:	Small round or crescent-shaped shield.
Peplos:	Woollen tunic worn by women, which fastened on both shoulders and often opened on one side. Customarily, it was belted at the waist allowing for an overfold.
Petasos:	Wide-brimmed felt hat mostly worn by travelers, including Hermes.
Phlyax:	Comedy or farce performed in South Italy. (Plural, *phylakes*.)
Plectron:	Small pick used to strum a stringed musical instrument consisting, perhaps, of a piece of animal horn.
Sakkos:	Cloth covering for women's hair.
Slip:	Liquid clay, applied as a coating on vases.
Sphendone:	Headband worn by women which was broad in the front and narrowed towards the ends that tied at the back of the head.
Stephane:	Wreath worn on the head.
Tainia:	Cloth band worn around the head as a sign of victory.
Thyrsos:	Fennel stalk terminating in a pine cone and decorated with ivy and vine leaves. It was carried by Dionysos and his followers, the satyrs and maenads.

GLOSSARY OF SHAPES

Alabastron: A flask with an elongated body, rounded bottom, and narrow neck, used to contain perfume. Egyptian vessels made of alabaster were the models for the Attic shape.

Amphora: A two-handled jar used for storing oil, wine and grain.

The *Neck-Amphora* has its neck set off from the body by a change in contour.

The *Nolan Amphora* is a special, smaller version of the Neck-Amphora, so called because of the many examples found at Nola in South Italy. It was especially popular in red-figure vases from the first half of the fifth century B.C. Early examples generally have triple handles, those from the second half of the fifth century have handles with a central rib.

The *Panathenaic Amphora* was awarded to athletic victors at the Panathenaic games. It has a broad body tapering sharply downward. The shape, along with specific iconography and inscription ("one of the prizes from Athens") designates an official prize vase, although the shape and iconography were borrowed for *Pseudo*-Panathenaic Amphorae.

The *Bail Amphora*, associated primarily with South Italian ware, has a single handle which is attached at the lip and extends across the mouth.

Aryballos: A small bottle with a globular body and narrow neck used by athletes as an oil container.

Chous: See *Oinochoe*.

Cup: See *Kylix*.

Epichysis: See *Oinochoe*.

Hydria: A water jar with a broad belly and narrow neck. It has two horizontal handles for lifting, and a third, vertical handle for pouring.

The *Kalpis* is a variation of the Hydria, the body of which forms one continuous curve from lip to foot.

Kalpis: See *Hydria*.

Kantharos: A two-handled cup with a deep bowl and, usually, a high foot.

Krater: A large vessel with a wide mouth and broad body used for mixing wine and water.

The *Bell-krater* has horizontal lug handles and an inverted bell-shaped body.

The *Calyx-krater* has a body in two parts, the lower convex, the upper slightly concave. The handles are set at the top of the lower part and curve upward.

The *Column-krater* has vertical, columnar handles which support the overhanging section of its broad lip.

The *Volute-krater* is so called because the handles terminate in rounded volutes at the lip.

Kyathos: A footed, cup-shaped ladle with a single upward-curving handle.

Kylix: A two-handled drinking cup with a shallow bowl and, generally, a high foot.

Lebes Gamikos: A vase often depicted in marriage scenes. The bowl and high foot are in one piece; double handles are set on the shoulder.

Lekanis: A shallow, low-footed dish with lid; the two handles are set horizontally.

Lekythos: A slender jug with a narrow neck and one handle, used to contain oil and unguents.

The *Squat Lekythos* has a rounded body offset at an angle from the base of the neck.

Loutrophoros: A tall vase with a slender body, a high, funnel-shaped neck, and a flaring mouth. The two handles are frequently in the form of elaborate scrolls. It was used for bringing water to the nuptial bath and as a tomb offering for an unmarried person.

Oinochoe: A small pitcher used for ladling or pouring wine. It has a rounded or trefoil mouth and a single handle.

In the *Chous*, the body and neck form one continuous curve; the mouth is trefoil and the foot is low.

The *Epichysis* has a long neck, a single upward-curving handle and either a spool-shaped or flattened body.

The *Olpe* is an oinochoe which has its body and neck formed by a continuous curve; it has a rounded mouth and, generally, a stemmed foot.

Olpe: See *Oinochoe*.

Pelike: A variety of amphora with a lower center of gravity and a continuous curve from neck to body.

Plate: A round plaque made for dedicatory purposes, often with suspension holes and a footed base.

The *Fish Plate* has a central depression, a low foot and a hanging rim.

Pyxis: A round, lidded box, used to contain cosmetics and other small toilet articles for women.

Rhyton: A handled drinking cup attached to a molded animal head, sometimes on a footed base.

Skyphos: A deep drinking cup with nearly vertical sides, a low base or no base at all, and two handles, either both horizontal or one horizontal and one vertical.

Stamnos: A high-shoulder, short-neck wine jar with two handles set horizontally.

Trozella: A wide-mouthed jar with two vertical handles rising high from the shoulder, then descending to the lip; often the handles are decorated with plastic ornament. The neck is offset from the body. The shape is identified with Messapia in South Italy.

The *Nestoris*, derived from the Trozella, may have an offset neck (shape 1) or one continuous with the body (shape 2). The vertical handles are less dramatic than on the Trozella, but a second pair of horizontal handles may be added.

CONCORDANCE

Museum Accession Number	Catalogue Entry Number
62.177.17	103
67.261.82.1	185
68.192.57.1	138
68.192.57.15	139
75.59.15	41
83.113	128
84.87.2	157
84.87.5	180
84.87.19	182
84.87.21–22	176
85.106.1(a–g)	6
85.106.2	4
85.106.3	3
85.119.1–6	1
85.119.8	29
85.119.9	14
85.120.1	97
85.120.2	95
86.10.1	113
86.10.2	120
86.25.1	66
86.25.2	132
86.30	86
86.32.1	16
86.32.2	119
86.33	20
86.34.2	87
86.52	108
86.100.1a, b	12
86.100.2a, b	11
86.119.1	42
86.119.2	49
86.119.3a, b	112
86.133	153
86.134.17	5
86.134.18–21	8
86.134.22	9
86.134.23	10
86.134.24	18
86.134.25	19
86.134.26	15
86.134.27a, b	17
86.134.28	24
86.134.29	23
86.134.30	22
86.134.31	36
86.134.32	39
86.134.33	33
86.134.34	32
86.134.35	34

86.134.36	47	86.134.70	84
86.134.37	38	86.134.71	68
86.134.38	37	86.134.72	85
86.134.39	21	86.134.73	88
86.134.40	40	86.134.74	79
86.134.41	52	86.134.75	89
86.134.42	53	86.134.76	80
86.134.43a, b	55	86.134.77	91
86.134.44	43	86.134.78	96
86.134.45	150	86.134.79	92
86.134.46	45	86.134.80	94
86.134.47	54	86.134.81	93
86.134.48	58	86.134.82	131
86.134.49	48	86.134.83	152
86.134.50	64	86.134.84	98
86.134.51	162	86.134.85	106
86.134.52	61	86.134.86	109
86.134.53	59	86.134.87	110
86.134.54	62	86.134.88	107
86.134.55	57	86.134.89	115
86.134.56	50	86.134.90	160
86.134.57	67	86.134.91a, b	101
86.134.58	69	86.134.92a, b	183
86.134.59	70	86.134.92c	175
86.134.60	72	86.134.92d	184
86.134.61	71	86.134.93	27
86.134.62	74	86.134.152	60
86.134.63	77	86.134.154	127
86.134.64	81	86.134.157	56
86.134.65	76	86.134.158	129
86.134.66	75	86.134.159	25
86.134.67	78	86.134.160	30
86.134.68	82	86.134.161	28
86.134.69	83	86.134.162	124

86.134.163	125	86.138.88	7
86.134.165–166	27	86.138.89	135
86.134.167	118	86.138.90	114
86.134.168	117	86.138.91	102
86.134.169	35	86.138.192	100
86.134.170	99	87.1	90
86.134.171	151	87.2.1	141
86.134.172	73	87.17	122
86.134.173	31	87.20.4	26
86.134.174	65	87.20.5	51
86.134.175	46	87.34	123
86.134.176	13	87.58	44
86.134.177	174	88.11.1a, b	158
86.134.178	166	88.18.1	179
86.134.179	167	88.18.2	177
86.134.180	165	88.104.2	161
86.134.181a, b	164	89.15.1	136
86.134.182	168	89.15.2	133
86.134.183	169	89.26.1	154
86.134.184	181	89.26.2	155
86.134.185	170	89.65	156
86.134.186a	173	90.8.1	142
86.134.186b	172	90.8.2	159
86.134.187	163	90.8.3	146
86.134.188	116	90.8.4	145
86.134.190	121	90.8.5	137
86.134.192	111	90.8.6	144
86.134.193a, b	126	90.8.7	143
86.134.194	2	90.104.1	105
86.134.195	142	90.104.2	104
86.134.196a	178	90.104.3	147
86.134.201	134	90.104.4	148
86.138.86	140	91.24	130
86.138.87	149	91.80.1	63

INDEX

This book was produced by the San Antonio
Museum of Art, San Antonio, Texas 78215.
Distributed by The University of Texas Press,
Austin, Texas 78712.

Designed by Sue Allen.
Typeset by Highwood Typographic Services.
Printed and bound by Dai Nippon
Printing Company, Ltd.